Mesmerists, Monsters, and Machines

Mesmerists, Monsters, and Machines

Science Fiction and the Cultures of Science in the Nineteenth Century

Martin Willis

THE KENT STATE UNIVERSITY PRESS
KENT, OHIO

© 2006 by The Kent State University Press, Kent, Ohio 44242
All rights reserved

Library of Congress Catalog Card Number 2005032093
ISBN-10: 0-87338-857-7
ISBN-13: 978-0-87338-857-3

Manufactured in the United States of America

10 09 08 07 06 5 4 3 2 1

Library of Congress Cataloging-in-Publication Data
Willis, Martin, 1971–
 Mesmerists, monsters, and machines : science fiction and the
cultures of science in the nineteenth century / Martin Willis.
 p. cm.
 Includes bibliographical references and index.
 ISBN-13: 978-0-87338-857-3 (pbk. : alk. paper) ∞
 ISBN-10: 0-87338-857-7 (pbk. : alk. paper) ∞
1. Science fiction—History and criticism. 2. Fiction—19th century—
History and criticism. 3. Literature and science. 4. Science—
History—19th century. I. Title.
 PN3433.6.W55 2006
 809.3'762—dc22 2005032093

British Library Cataloging-in-Publication data are available.

Contents

Acknowledgments

THIS BOOK HAS BEEN MADE POSSIBLE by the support of many institutions, colleagues, and friends. The University of Edinburgh Library, National Library of Scotland, University of Birmingham Library, Senate House Library, Cavendish Laboratory Library, and University College Worcester Library all provided useful materials and excellent service. The award of a Wellcome Trust research grant made possible the research for the final chapter of the book, and my praises go to the Trust and to their archivists at the Wellcome Library for the History and Understanding of Medicine. I should also like to thank the staff at the Kent State University Press—in particular my editor Tara Lenington—for their professional help and guidance.

Colleagues at University College Worcester and the University of Glamorgan have supported me in many ways throughout this project, as have colleagues whose work in the history of science and

nineteenth-century literature has given me both information and inspiration. My thanks go especially to Catherine Wynne, Alex Warwick, Liz Wadge, and David Clifford, with whom I have enjoyed working immensely.

My friends—in Edinburgh, Worcester, and Glamorgan—have lent their time and intellectual rigor to the reading and discussion of different parts of this project. Christoph Lindner, James How, and Douglas Glickman were invaluable allies, as well as critical readers, throughout my time at the University of Edinburgh. Roger Ebbatson continued that tradition at Worcester and was succeeded by Andy Smith, Jeff Wallace, and Diana Wallace at Glamorgan.

I owe a much greater debt to Ruth McElroy, whose encouragement and inspiration, as well as insightful and honest criticisms, gave me confidence in what I was trying to achieve. Her spirit, modesty, intellectual courage, and sense of morality make me a better person and this a better book.

This book is dedicated to my parents, who may never have an interest in nineteenth-century fiction or the history of science but who have supported me since my first undergraduate studies. This could not have been completed without them.

Literature, Science, and Science Fiction

IT MAY SEEM PECULIAR, BUT IT IS nevertheless true that extended readings of the use of science in science fiction texts are extremely rare. They are even rarer if we limit the science fiction texts to those written in the nineteenth century, as this book does. Why might this be? Several explanations can be offered: the lack of attention paid to nineteenth-century science fiction, the motivation of science fiction scholarship, and the difficulty of gaining expertise in more than one discipline. Whatever the reason, there is a significant lack of interdisciplinary work on science fiction and science, a lack that is not apparent in other areas of literary study. The interaction of science with literature has been widely explored in Renaissance drama, the Victorian novel, and the modernist poem. In genre fiction too—if we would like to characterize science fiction as a genre—there has been a broad consideration of the impact of science on the literary imagination. In studies of gothic or crime fiction, scientific

developments are accepted as having some influence on the shaping of the text. Yet in science fiction criticism there is only infrequent study of science—the kind of detailed and sustained study that characterizes the best in interdisciplinarity.

This book attempts to show how readings of science fiction texts benefit from extended exposure to the specific scientific histories that were so important in their making. The focus is the nineteenth century: from E. T. A. Hoffmann's "The Sandman" (1816) to H. G. Wells's *The Island of Dr. Moreau* (1896). In that eighty-year period between publications, science and science fiction changed dramatically. Science fiction emerged from the gothic romances of science made so influential by Hoffmann and Mary Shelley into a fully fledged genre of fiction under the directorship of, first, Jules Verne and, thereafter, H. G. Wells. Science, too, was expanding and finding new definition. Romantic science gave way to Newtonian methodologies of theory and experiment; scientific disciplines began to rise from the more general category of natural philosophy; and professionalization and institutionalization marked the end of uncoordinated amateurism. The vitality and continual impetus for change that characterizes nineteenth-century science and science fiction make it an exciting and challenging period in which to bring the two together.

The challenges this book sets for itself are not entirely the result of the texts and contexts it aims to consider. First, by considering the relationship between cultures of science and science fiction literature, I hope to show that the genre of science fiction is as intellectually complex, as socially significant, and as historically revealing as any other form of fiction the nineteenth century produced. Turn to any number of critical books on nineteenth-century literature and culture and you are unlikely to discover many references to science fiction. In comparison, gothic, sensation, and crime fictions have all gained some critical currency in the last two decades. By drawing on similar methods of analysis used by critics of these genres or of nineteenth-century literature broadly—by writing as a "nineteenth-century scholar" rather than as a "science fiction critic"—I hope to promote the genre of science fiction as an area of literary production that deserves greater attention.

Second, this book aims to illuminate for the science fiction critic

the energizing influence of a more focused contextual eye. Analyses of science fiction texts have lost sight of the varied histories of science that are such important touchstones for the genre. George Eliot and Bram Stoker have received more detailed investigations of their use of science than have Jules Verne and H. G. Wells. Interdisciplinary readings of nineteenth-century literary texts and their scientific contexts have become the forte of the Victorian scholar rather than of the science fiction critic. The academic science fiction community has been ever more greatly interested in the extrapolation of the science fiction text and increasingly less interested in its foundations. Yet these foundations, almost always grounded in scientific theory and development, offer a great deal more to the science fiction critic than has been assumed. I would hope that the new contexts and fresh analyses that I detail in the following chapters will go some way toward reminding the science fiction critic that the genre is *science* fiction as well as science *fiction*.

Trying to speak to two audiences at one time may engender some moments of schizophrenia as this book develops. This would be a common problem in any work that aims to be interdisciplinary but is perhaps more so here in a work that tries to persuade two critical communities of two different things. The six chapters that follow this introduction attempt to show that E. T. A. Hoffmann, Mary Shelley, Edgar Allan Poe, Jules Verne, Villiers de L'Isle-Adam, and H. G. Wells all contributed immeasurably to our understanding of scientific culture in the nineteenth century. They also aim to reveal the powerful influence that mesmerism, mechanics, electricity, natural history, spiritualism, laboratory science, and animal experimentation had on the creation of science fiction literature. To examine the interrelationship of science and science fiction by using particular examples of science fiction texts and scientific disciplines raises questions of coverage and status. Why these texts and not others? Are they regarded as canonical science fiction texts? Are these sciences indicative of the spread of science into separate disciplines in the nineteenth century? Can mesmerism even be called a science? In writing to more than one audience, the answers to such questions become vital. One cannot simply nod toward the critical consensus of which one community knows well but that the other

The nineteenth century also witnessed the continual rise to prominence of the applied sciences, or technology. The makers of technological objects—from James Watt to Thomas Edison—were key members of the scientific community and popularly regarded as scientists in the same way as those working in more abstract disciplines, such as astronomy. It is important to remember that the rigorous boundaries that came into existence in the twentieth century, say, between the "inventor" and the "scientist," were not in place at all in the nineteenth century. Indeed, such differentiations would have been entirely alien to a community that did not even use the word "scientist" until the 1830s. The technological object—commonly a machine—came to represent, especially for the Victorians, the material value of science. The machine was an embodiment of the scientific ideal of nature tamed by human knowledge, physical evidence of the power of scientific discovery.

What forms of discovery science appeared to be making was still very much a subject of controversy at the beginning of the nineteenth century. Many scientific communities were riven by methodological and philosophical opposition. One group of scientists, wedded to traditional understandings of the workings of the natural world drawn up by alchemists and occult scientists, believed in a set of cosmic rules that were as magical as they were scientific. This Romantic science was at odds with the newly emerging scientific theories first proposed by Francis Bacon in the late seventeenth century. New science, as this was called, based its understandings of the natural world on inductive reasoning borne out of observation rather than on teachings derived from ancient and venerated sources. As the nineteenth century began, then, science was tied to the many traces of magic and alchemy that were "reflected among the activities of the membership of the Royal Society."[1] Science was still an esoteric hobby undertaken by those with access to preternatural knowledge, and the scientist was as much a magus as a natural philosopher.

By the 1830s, many forms of Romantic culture had begun to give way to Victorian pragmatism, and science was no exception. New science gained in authority while magic and the occult became increasingly marginalized. For half a century, many forms of science enjoyed

unprecedented success and public support. The machine became an icon of scientific discovery across Europe and North America. Science was discussed in the pages of the most prominent newspapers and periodicals, and the scientist was perceived less as a Faustian figure and more as a heroic investigator of the secrets of the natural world.

As the public embraced science in the media and in the modern world around them, so too did they embrace the practices of science. The popularity and apparent accessibility of scientific investigations led many men and women to take up the sciences as a leisurely pursuit. In doing this, of course, they were only following the great tradition of scientific amateurism that still held sway, especially in Britain and North America. Crossing boundaries of class, gender, and education, science became a common pastime for nonworking hours. Working-class women combed the beaches of Devon for fossils while educated Englishmen trawled in rock pools for rare molluscs. Collecting and cataloging became a popular entertainment, and the shelves of lending libraries and bookshops were replete with books on popular science for the amateur enthusiast.

While those involved in science in a more professional capacity often looked askance at the ignorant peddling of science by a significant portion of the population, they too were guilty of such transgressions. With science not yet entirely defined according to discipline, and with so many new forms of scientific inquiry available to the professional scientist, it is unusual, even in the midcentury, not to find scientists involved in the investigation of phenomena beyond their immediate area of expertise. University of London clinician John Elliotson, for example, led several investigations into mesmerism while playing a central role in hospital doctoring.[2] Similarly, the biologist Edwin Ray Lankester became, with some ease, an important figure in the developing science of paleontology. The peripatetic careers of many scientists reflect the continual change and development of the sciences throughout the early to mid-nineteenth century. It also highlights the difficulty in attributing status to different areas of scientific research. If a respected doctor found mesmerism of interest, does this suggest its equivalence to medical science or not?

Such questions of authority and position were a defining feature of mid-nineteenth-century science, in which there was such a complex

negotiation between different forms of scientific knowledge. It was impossible simply to disregard mesmeric phenomena as "semioccult" or to banish phrenology as a "pseudoscience" when the claims made for them often came from reliable and scientifically respected sources.[3] Of course numerous attempts were made to marginalize many of the new branches of investigative practice that arose in the nineteenth century. In response, proponents of newer areas of research tried to undermine the power of the central scientific orthodoxy and those who spoke on its behalf. Indeed, from approximately 1830 to the end of the century, there was continued conflict over the high ground of scientific authority from sciences that, in the twentieth century, seem much more stably pigeonholed as either orthodox or heterodox, science or pseudoscience.

Equally, these debates cannot be sidelined as the internal squabbles of a small, if important, community. The discourse of science was still the discourse of the educated public rather than the specialized language more recognizable in the twentieth century. In fact, scientific language (in both the written treatise and the lecture) was the language of literary culture: ideas were expressed through metaphor and simile, with poets and dramatists cited as sources of authority alongside scientific predecessors. While Charles Darwin's *On the Origin of Species* (1859) is the most obvious example of science writing's literary qualities, any number of others can be found in the pages of nineteenth-century periodicals, from *Nature* and *Scientific American* to *Harper's Weekly* or the *Cornhill Magazine*. Science, therefore, was firmly in the public domain and "particularly close to the shared stories" of nineteenth-century society.[4]

Science, however, was not merely using literary language as a simple tool of expression. By the mid-nineteenth century, scientific methodology gave much more credence to a hypothetical analysis of the natural world than it had when Bacon's inductive method was in the ascendancy. As the stress shifted from what could be "seen" to what could be "thought," so the imagination of the scientist became much more important.[5] The language of literature, therefore, was a vital part of the scientist's armory in imagining the principles of the natural world and articulating that imaginative understanding to others. This is not

to suggest that literary language had become science's handmaiden. Rather, it played a vital role in giving the scientist the tools with which to understand the workings of nature; science and literature were cooperating in determining the principles by which nineteenth-century society functioned.

This close relationship between science, literary language, and the educated public did not last long. By the 1870s the scientific community had begun a process of professionalization that would, by the end of the century, make it less accessible to a general audience. The instigation of state funding (although far from systematic), the rise of the laboratory, and the placement of career scientists at the head of important institutions all contributed to a shift in scientific culture from the amateur to the professional.[6] With this shift came a number of important changes in the relationship between the scientific communities and the general public. No longer was science as accessible as it had been: the sciences quickly became more discipline based and therefore more specialized; a set of specific scientific vocabularies emerged that were alien to a general audience, and publication of scientific theories and discoveries became the responsibility of journals dedicated to the scientific community rather than the general public. All of this transformed the ostensibly open scientific community into one that was closed off from both an interested lay audience and the enthusiastic amateurs who practiced science in their hours of leisure. Of course part of the professionalizing project had been to do exactly that: to take science out of the hands of amateurs and pseudoscientists and place it much more firmly within the central scientific disciplines. This, certain parts of the scientific community believed, would give the sciences a stronger position at the center of nineteenth-century life from which to promote their interests. However, professionalization did not only have this effect. It also led to a perceived insularity on the part of the scientific community (or what were now multiple communities) that detracted from its attempts to speak with a more powerful voice.

As the sciences began to specialize, so too did they begin to withdraw from public life. No longer obliged to offer their theories to a general audience, scientific research and publication looked only to its

peer group. Such apparent secrecy—as this process of turning inward was often viewed—was more like the scientific practices of the early years of the nineteenth century than the transparency and celebratory inclusiveness of the four decades since 1840. Certain scientists did little to counter this impression. Francis Galton, for example, did more to promote the image of the aloof scientist than he might have suspected when he called for "the establishment of a sort of scientific priesthood" that would stand separate from the government and the public.[7] The idea of a "religion of science" became common at this time, further reinforcing the perception of the professional scientific community as a cabal of adepts in possession of arcane knowledge.[8] To some extent, the return to secrecy suggested a direct correlation with science at the beginning of the nineteenth century, when its links to magical and alchemical traditions also set it outside the usual apparatus of culture and society. Although the professionalization of science was not simply a regression into earlier modes of operation, it did make equivocal science's moral and cultural position at the close of the nineteenth century.

There were also positive benefits to professionalization. Increasing financial and political power, further entrenchment in sites of intellectual excellence (particularly the universities), and control over the nature and range of scientific investigation gave the mainstream sciences significant influence in deciding the direction of late-nineteenth-century society. Government sponsorship of important laboratories or scientific projects, such as the British Institute for Preventive Medicine and its vaccination experiments, meant that scientists had access to those at the center of policy decision making. Institutional support also helped give science a more secure base from which to pursue its investigations over a longer time period, train the next generation of scientists, and discuss and disseminate its theories and findings. Those sciences that benefited most from such patronage began to appear more professional; their places of investigation were well equipped, their structures of management transparent and finely tuned. Most importantly, their scientific practice was exemplary, from focused theories and rigorous evidence gathering to sound experiments and detailed reporting. This, more than anything else, gave to those sciences a gravitas that helped enormously

in capturing the trust and respect of the government, institutions, and, ultimately, a broader audience. The powerful impression made by investigative techniques can be seen most clearly in a brief analysis of the practice of a marginalized branch of the scientific community in the late nineteenth century. Psychical research, never fully part of the mainstream of scientific disciplines, nevertheless took on the methodology of more orthodox science in an attempt to appear as professional—and thereby as credible—as their sister disciplines. The Society for Psychical Research (SPR) tried, therefore, to apply the techniques of the scientific experiment to the spiritualist séance and to the haunted house. Their reports, lengthy and detailed, drew conclusions based on scientific possibility rather than supposition based on faith. The SPR's methods highlight the perceived importance of professional practice throughout the scientific community. They also reveal the successes engendered by the professionalization of science in the late nineteenth century.

Unlike the more rigid, discipline-based, institutionalized science characteristic of the twentieth and twenty-first centuries, nineteenth-century science is both chaotic and unregulated. In the first three decades of the century, science was still closely allied, at least in the public imagination, with magic, alchemy, and the occult. While the scientific successes of the midcentury—especially in the applied sciences and technology—rid the image of that association, they did not give the various scientific communities better access to political influence, wealth, or institutional support. Nor did this period of popularity instigate a move toward disciplinary entrenchment or self-regulation. Indeed, the growth of scientific organizations in this period reflects science's openness, its willingness to embrace the amateur, rather than any shift toward professionalization. When this did eventually occur, when science began to order and regulate itself in accordance with various pressures associated with professional practice, its relationship with the public became as equivocal as it had been at the beginning of the century. The scientific community's perceived secrecy appeared to parallel the opacity of alchemical work that was science's inheritance in the early nineteenth century. Even as science became organized, regulated, and

therefore "trustworthy," its image was also a partially opposite one of untrustworthiness and moral insensibility.

Science also encapsulated areas of understanding and belief that are now not given such status. The inclusion of such forms of knowledge as mesmerism, phrenology, and spiritualism may seem wrong in the twenty-first century when such practices have been sidelined as esoteric beliefs. However, their standing in the nineteenth century was as alternative scientific approaches that may have had as much value in our attempts to understand the workings of the natural world as many other fields of investigation. Science was, after all, without any firm disciplinary boundaries, without many paradigms of the mechanisms of the natural world that could cast doubt on the veracity or potential of other approaches. This did not, of course, stop many scientists from questioning the claims of mesmerism or spiritualism or from denying them scientific status, and it was often, although not always, at the margins of the scientific community that these alternative wisdoms found a niche. Nevertheless, it is important to recognize that there was no unequivocal position from which mesmerism or spiritualism could be denied a place within the scientific hierarchy, however combative the alternative sciences' defense of their scientific position had to be. Science in the nineteenth century was therefore a wide range of practices and beliefs without strict boundaries or accepted regulations, a melting pot of discordant models of the natural world struggling for supremacy and legitimacy.

A HISTORY OF SCIENCE FICTION CRITICISM

The critical study of science fiction began in the late 1950s and early 1960s in response to the explosion of interest in the genre after the Second World War. The earliest date for the inception of this criticism is 1959, when the first issue of the academic journal *Extrapolation* was published. This was followed by the first semiacademic book on the subject, Kingsley Amis's *New Maps of Hell* (1961), and the first academic study, Robert M. Philmus's *Into the Unknown: The Evolution of Science*

Fiction from Francis Godwin to H. G. Wells (1970).[9] From the 1970s to the present day, the output of science fiction scholars has continued to increase. There are now a number of academic and popular journals devoted to science fiction scholarship and several publishing houses with series dedicated to the study of the genre.

The first critical studies of science fiction—at least those appearing until the end of the 1970s—were partly written in response to the mainstream academic view of science fiction as a literature of little value. These early critical works were polemical in their defence of SF as a genre of literary, social, and intellectual merit. They also took a very broad and introductory view of science fiction, hoping to explain and define the large territories covered by the genre. Amis's and Philmus's work suggest such an approach in their titles. Amis hopes to map something as yet unseen, and Philmus introduces us to the hitherto undiscovered. These early works may have been wide ranging in their scholarship, but they were very influential on the succeeding generations of scholars. The directions taken or suggested by the pioneering critics of SF were to define the investigations of science fiction critics from the 1980s to the present.

The two keynotes of the early debates were the boundaries of the science fiction canon and the importance of science as a context for fiction. The views that came to dominate each of these areas of discussion have continued to hold sway over contemporary science fiction criticism. In the first, science fiction has come to be seen as a genre that has its beginnings in the early twentieth century, with some important precursors in the late nineteenth century. In the second, the importance of science has been relegated to that of a checklist against which the critic can check the correctness of a fiction writer's knowledge of scientific fact. The supremacy of these critical positions has led to a disregard for nineteenth-century science fiction and the history and philosophy of science that was so influential in the creation of these fictions.

Thomas D. Clareson's collection of essays entitled *SF: The Other Side of Realism. Essays on Modern Fantasy and Science Fiction* (1971) was one of the first pieces of science fiction scholarship to deal with the issue of the canon.[10] In his introductory remarks, Clareson dates the

beginning of science fiction to the same period as realism. The name science fiction, he argues "has been given to a kind of fantasy which took shape as a diverse, recognisable genre during the same period which saw the rise of literary realism, 1870–1910."[11] In the same collection, Judith Merril dates "modern" science fiction to the work of Jules Verne and considers all his predecessors either "classical antecedents" or those writing in "the Gothic vein."[12] James Blish, again in the same collection, agrees to some extent with Clareson's and Merril's views but places far more emphasis on the twentieth century: "There are, to be sure, a few dead giants—Verne, Wells, C. S. Lewis, Orwell—but the field as a modern phenomenon dates back only to 1926 (when it diverged from the mainstream of fiction into specialized magazines of its own)."[13] Brian Aldiss was one of the first to stress the importance of the earlier nineteenth century. His semischolarly 1973 book, *Billion Year Spree: The True History of Science Fiction,* took Mary Shelley's *Frankenstein* as a starting point for the genre.[14]

The various perspectives are easily categorized. At the extremes, the science fiction canon either includes all of the fictions of the nineteenth century or does not include anything before the first small magazines in 1926. The middle road is the most common: the canon begins with the parents of the genre—most often Verne and Wells—but is thereafter a decidedly twentieth-century affair. As the 1970s progressed, this middle line was reinforced. Robert Scholes and Eric Rabkin, in the coauthored *Science Fiction: History, Science, Vision* (1977), noted that nineteenth-century science fiction was "the as yet unbaptized genre."[15] Mark Angenot, writing in Patrick Parrinder's 1979 collection of essays, agreed: "Before Verne, SF never established a tradition. It was a production without cultural continuity, deprived of any institutional legitimacy."[16] By the early 1980s, this view of science fiction had been widely accepted. The science fiction canon began at the point when writers and their audiences were conscious of SF writing as a genre. This would date the beginning of SF to the 1920s, where James Blish and others have placed it. However, a couple of important writers of the late nineteenth century would also be given canonical status due to their acknowledged influence over the infant genre. Jules Verne and

H. G. Wells thus entered the SF canon too, creating a starting point for the majority of critics at approximately 1870.

In his 1981 book, *Alien Encounters: Anatomy of Science Fiction,* Mark Rose typified the new canonical thinking: "From a historical point of view it may be misleading to speak of even such relatively recent writers as Shelley, Hawthorne and Poe as science fiction writers. They were clearly important in the formulation of the genre—Poe, for example, was a major influence on Verne—but we should understand that in labelling, say, *Frankenstein* as science fiction we are retroactively recomposing that text under the influence of a generic idea that did not come into being until well after it was written."[17] Already, by the early 1980s, the generic boundaries are beginning to be drawn. Shelley, Hawthorne, and Poe are beyond those boundaries, but Jules Verne is safely within. Even Thomas D. Clareson, who argued for the importance of nineteenth-century science fiction in the early 1970s, feels obligated, in his 1985 monograph, to highlight the dominant position of those who see the beginnings of the genre in the early twentieth century: "It is difficult, if not impossible, to assert that the field of science fiction came into being at a specific date. Some would see it appear full blown with the works of Jules Verne; others, with H. G. Wells. Many would delay its birth until after the appearance of Hugo Gernsback's pulp magazine *Amazing Stories* (1926), although both Gernsback himself and the Munsey magazines published SF earlier."[18] Clareson's previous advocacy of the nineteenth century as a vital point in SF's evolution is clear here, especially in his caveat about Gernsback and the Munsey magazines. Yet he recognizes that such a view is already the minority. "Many" critics place the boundary of the canon at 1926. Regarding the genre as a twentieth-century phenomenon was the dominant critical position of the 1980s and 1990s. Although the odd critic voiced concerns, as Peter Stockwell did in complaining that "there is not enough discussion of pre-twentieth-century science fiction," the twentieth century has continued to prevail in the critical works of the twenty-first century.[19]

The scholarly SF community has not only relegated nineteenth-century science fiction from a position of importance but also disregarded the centrality of science in the production of SF literature. This is a bold claim to make, but it is not made without justification. Although

many critics of science fiction (both nineteenth and twentieth century) do recognize the importance of science as a foundation for the work of SF writers, very few investigate that science in a sustained and analytical way. Science is viewed by the scholarly community in two ways, neither of which is particularly productive in gaining further insight into the literary text. In the first, science is considered as "fact," and the SF text is read only to discover if the writer has the facts of science correct. In the second, science is seen as nothing more than a chronological checklist of events and discoveries within which the SF text can be placed. Thus, in the first view, Arthur C. Clarke is widely considered a "good" writer of SF, as he is remarkably precise in his scientific detail. In the second view, Aldous Huxley can be seen as a visionary because his *Brave New World* prefigures many later discoveries in genetic engineering.

That science has been reduced from a vibrant set of political and social cultures to an encyclopedic entry or a set of facts is in itself surprising. Early science fiction critics—although not investigating the scientific contexts of SF in any detail—were proponents of a critical practice that would include substantial investigation of the scientific influence on SF. In 1976 Robert Scholes and Eric Rabkin insisted that "as the literature of science, science fiction can be most richly experienced if we understand something of science itself. Science is of interest not only as a necessary tool in understanding science fiction but as a demonstration of the nature of the materials that originally motivated science fiction."[20] Although they are rather vague over the "something of science" that critics should understand, Scholes and Rabkin highlight science as an essential element of the SF genre. Patrick Parrinder, an astute critic of the contexts of science fiction, placed Scholes's and Rabkin's view in a historical frame: "The period of ascendancy of the scientific outlook—an ideology justifying scientific research as intrinsic to the nature and purpose of human existence—began with the technological triumphs and the erosion of traditional religious beliefs caused by the Industrial Revolution. The growth of science fiction as a separate genre would be unthinkable without this ascendancy."[21]

As Parrinder's opinion shows, there were critical voices calling for an interrogation of the historical development of science alongside any investigation of science fiction. Yet there still remained some skepticism

over the relevance of science to science fiction: "The problems of writing about the relationship between science and science fiction are manifold. It is necessary not only to define one's terms but to dispel the widespread suspicion that the relationship is accidental rather than essential."[22] As Parrinder here reveals, the connections between science and science fiction, however often they were paraded by a number of critics, were not readily accepted. Robert Philmus, in his 1970 critical monograph, which we should remember was the first full-length scholarly work on SF, argued that "science fiction . . . is not as strictly dependent on an extra-literary reality as the extrapolative theory of its nature unavoidably suggests."[23]

Contemporary SF criticism has accepted Philmus's views more than they have Parrinder's. It has also gone along with Scholes's and Rabkin's assertion that knowing something of science is useful. The "something" has, however, been the scientific fact or the encyclopedic list. Recent critical readings of science fiction clearly verify this. Gary Westfahl, in a 1996 monograph, *Cosmic Engineers: A Study of Hard Science Fiction*, explains why he will not concentrate on the scientific aspects of the science fiction he aims to discuss: "While my B.A. in mathematics and experience teaching math at the college level arguably provide minimal qualifications, I am not a scientist and do not feel fully qualified to discuss purely scientific issues. My considerations of the complex relationship between science and hard science fiction will be limited to some basic comments about the scientific process and the eventual conclusion that some type of purely scientific evaluation is a necessary element in examinations of hard science fiction."[24]

Westfahl regards science as factual knowledge that is either known or unknown. His failure to understand scientific fact makes him, in his own opinion, unable to judge the scientific content of science fiction that deals explicitly with science (as hard science fiction purports to do). Yet Westfahl does not recognize that science is a cultural phenomenon as much as it is a discipline of fact. This failure leads him to make claims for science fiction that are hugely misleading: "I am now prepared to venture a different hypothesis: namely, that despite public pronouncements, science fiction was in fact largely indifferent to science before

1950 and conspicuously tolerated frequent errors and inattentiveness to scientific fact and scientific thinking."[25] Westfahl's determination to view science only as fact allows him to cast out all other facets of science employed by science fiction writers. It is historical revisionism to argue that neither Mary Shelley nor H. G. Wells was interested in science, even if their scientific facts reflect the understanding of a layperson rather than a scientific specialist. Rather, Westfahl rejects the importance of science's place within the human cultural sphere, one of the key themes of a great majority of science fiction.

Even when there is recognition that science takes place within a social and political world, it still receives cursory treatment. The publication of a recent collection of essays on disease and medicine in science fiction suggested at first that a critical renegotiation of the importance of science might be underway.[26] This was reinforced on the opening page of H. Bruce Franklin's essay on *Frankenstein:* "To comprehend the relevance of Shelley's achievement to our medical environment today, we need to look at the medical environment of her day, including both its history and its direct effects on her own life."[27] Yet what followed these introductory remarks was a chronology of obstetrics from the eleventh century to the early nineteenth century that only in the latter stages was made relevant to Shelley's own life, if not her fiction. This encyclopedic referencing of science is common. Even Thomas D. Clareson, one of the most sympathetic critics to the importance of science, could say that he hoped his work would "help us to understand the manner in which writers have made use of materials which they regarded *at the time they wrote* as having a basis in science," and then offer nothing more than a chronological list of scientific discoveries as evidence.[28]

The history of science fiction criticism has militated against an extended reading of science fiction and the cultures of science in the nineteenth century. It has denied nineteenth-century science fiction a significant place in the canon and has reduced science to factual knowledge. Even those critics—Patrick Parrinder, Thomas D. Clareson, Eric Rabkin, Robert Scholes, and others—who have registered the importance of contextualizing science fiction within the scientific culture of its own period have not taken the opportunity to produce a

piece of scholarship that reveals the benefits of such investigation. Like Mark Rose, who introduced his own work by stating that "an extended discussion of the milieu . . . would include . . . an account both of nineteenth-century science and of the growth of popular interest in science," they offer the opportunity to other scholars.[29] No one has yet taken up their offer, although recent scholarship has suggested that a return to historical context, at least, is imminent. A recent collection of essays on SF and medicine, despite surveying the field too superficially, did focus on the sciences as an important element in science fiction. In another recent collection, Farah Mendlesohn made an explicit plea for the introduction of "alternative approaches and methodologies to science fiction criticism"[30]:

> If science fiction is to have a respected place in the canons of the academy—which presumably is a goal shared by all of its supporters—then the genre must be considered as more than a collection of texts aspiring to be recognized for their literary excellence. Today, with science fiction forced to compete within literary criticism on the basis of a value system designed for a very different form of writing, it is imperative that, in at least one area of academic discourse, science fiction should be taken on its own merits and values and examined in its own historical and social context. I contend that historians, not literary critics, are best situated, and most qualified, to make these contributions.[31]

Mendlesohn's argument is a strong one, based on a correct reading of the present state of science fiction scholarship. The historical and social contexts of science fiction, which would of course include science itself, have been consistently undervalued in SF criticism. Where Mendlesohn's argument is contentious is in her final statement. It may well be that historians are best suited to discuss history, but this does not mean they are best suited to discuss history through the lens of the literary text. Yet historical expertise is essential, particularly in a project such as the present one, where the history of science is given prominence.

Mendlesohn's final comment is actually about the necessity of interdisciplinary study—for her, the disciplines of literature and history. Her

certainty about the historian's ability to undertake an interdisciplinary analysis of science fiction is paralleled by Gary Westfahl's certain belief (quoted earlier) that he is not well enough qualified to discuss both literature and science. Who is qualified to analyze science fiction from an interdisciplinary perspective? What are the problems associated with taking on such a project? If the future of science fiction criticism is to become increasingly interdisciplinary—because science fiction itself is well suited to interdisciplinary analysis—then it is worth considering in greater detail what interdisciplinarity might mean. In fact, it is essential that this introduction does that job. The chapters to follow are, after all, an attempt at a particular form of interdisciplinary work: the combination of literature and the history of science. The final section of this introduction will investigate the costs and the benefits of interdisciplinarity in literature and the sciences.

INTERDISCIPLINARITY: LITERATURE AND SCIENCE

Interdisciplinary research is considered boundary breaking, innovative, and revealing. Its key characteristics are trespass, challenge, and the ability to offer fresh insight. Gillian Beer, an influential advocate of interdisciplinary research in literary criticism, believes that "interdisciplinary work crosses over between fields: it transgresses. It thus brings into question the methods and materials of differing intellectual practices and may uncover problems *disguised* by the scope of established disciplines."[32] Joe Moran, in his recent book-length study of interdisciplinarity, is similarly laudatory: "[Interdisciplinary approaches] can challenge traditional, outmoded systems of thought which are kept in place by institutional power structures; they can produce new, innovative theories and methodologies which open up the existing disciplines to new perspectives; they can help people think more creatively about their own subject and other ways of doing things both within and outside universities."[33]

For both Beer and Moran, interdisciplinarity offers an opportunity to view a particular set of materials from a new perspective, one that may

well uncover unforeseen problems or lead to entirely new conclusions, or both. Undertaking such a project has its difficulties. Beer believes interdisciplinarity "propels us to the edge of our own competence and makes necessary new skills and new readings," while Moran understands that "interdisciplinary ways of thinking have a tendency to be more disorganised, error-prone and incomplete than established forms of knowledge."[34] For each critic, interdisciplinarity is a challenging but rewarding disruption of disciplinary analysis.

Some of the most innovative interdisciplinary work has come from the field of literary criticism. The subject of English has always "been at the centre of academic debates about the shaping and division of knowledge," a truth reflected in the number of different interdisciplinary projects that have arisen from the academic study of literary texts.[35] Science fiction literature—as a genre of fiction that immediately voices its status as a disciplinary hybrid—should surely be at the forefront of literary critical advances in interdisciplinary scholarship. This would certainly be the case, were it not that the connections between literature and science (connections explicitly demanded by science fiction) have been skewed by the highly public and acerbic disagreement between C. P. Snow and F. R. Leavis in the early 1960s. When Snow advocated an increase in dialogue between the humanities and the sciences, Leavis bitterly opposed Snow's vision of closer links between disciplines he thought of as anathema to one another. Leavis's rhetoric won the argument, and the division between the humanities and the sciences remained intact.

From the early 1960s, then, there was a belief that a continual "policing of the distinction between objective 'facts' and subjective 'interpretations'" separated science and literature.[36] Early critics of science fiction accepted this powerful philosophical divide when they began to offer scholarly analyses of the genre in the late 1960s and 1970s. Even in the 1990s, this view remains partially in place. It is on this that Gary Westfahl relies, for example, when he argues that his lack of scientific knowledge (the objective facts) makes it impossible for him to critique the scientific content of a science fiction text. "The long-standing division between the humanities and the sciences," argues Joe Moran, "still

remains a resilient obstacle to interdisciplinary study."[37] Nevertheless, he continues, "it is still capable of being challenged."[38]

In fact, the division between literature and science was challenged in the 1960s, although it took until the cultural turn in the early 1980s for the dissident voices to be heard. Barbara T. Gates sets out the keynotes of the opposition to the Leavisites: "Literature and science no longer two cultures? Back in the 1960s, Thomas Kuhn headed us towards this conclusion when he emphasized how deeply science was embedded in culture. . . . Since then, both cultural and literary analysts have theorized about just how literary texts actualize cultural assumptions, including those of science. . . . Science offers but one of a number of competing discourses within a culture."[39] When Thomas Kuhn and other philosophers of science began to stress the influence of culture on scientific method and understanding, they made it available to other disciplinary perspectives. Historians could now consider the changes wrought on science by the forces of historical evolution while literary critics could engage with the scientific content of a literary text for its cultural importance rather than its attention to objectivity. This turn toward science as a cultural form occurred slowly but has led to a consensus of opinion that "science is now increasingly seen not as a neutral account of phenomena based on the pursuit of pure knowledge, but as a way of making sense of the world, one influenced by the contexts within which scientific problems are framed, discussed and 'solved.'"[40]

Even though science is now accepted as a cultural phenomenon that can be investigated using the tools of cultural criticism, science fiction scholarship has still to argue that science fiction is a literature that most ably represents the link between literary and scientific culture. This is not simply because science fiction criticism is either old fashioned or peculiarly ignorant to intellectual developments in the field. It is, firstly, that the critical appraisal of science fiction began at a point when science was still regarded as an objective discipline that worked outside of culture. Early SF scholarship implicitly accepted this model of science and has so greatly influenced the succeeding criticism that the attempts to rebut it (outlined in the previous section) have had little impact. It is also, secondly, that the primary impetus of SF criticism has

been to argue for science fiction as a credible genre. The creation of a canon, the construction of boundaries, and the articulation of a series of defining features are all part of the attempt to give science fiction a unique typography. These are also, of course, the key components of a discipline. In the period, then, when established categories of literature were considering how their own boundaries might be stretched or broken by the introduction of other disciplinary motivations, the genre of SF was still involved in the necessary work of building those boundaries. No discipline would be likely to seek out a methodology of research that appears to undo what it is still in the process of completing. The timing of the turn toward interdisciplinary work in literature and science meant that science fiction criticism was unable to exploit the innovations it introduced.

Although science fiction scholarship has still not capitalized on the opportunities offered by a cultural model, literary criticism in other fields has made significant progress toward a fully interdisciplinary method of analysis into the connections between literature and science. Since Gillian Beer's work on Charles Darwin and George Eliot (1983) or George Levine's evolutionary readings of Victorian fiction (1988), literature and science have been the focus for many critics, especially in the field of nineteenth-century studies.[41] How does interdisciplinarity function in the work of these scholars? How are literature and science brought into useful dialogue, and what might science fiction criticism learn from this?

For Beer and Levine, interdisciplinary work is based on a notion that "no community can be sufficiently described in its own terms."[42] Their analyses of nineteenth-century fiction consider the use of Darwinian metaphors and models in constructing a fictionally "real" world. Beer also highlights Darwin's literary writing, in particular his use of metaphor and simile, as well as his referencing of literary works. Their method is to place a literary text and a scientific text alongside each other in order to reveal their cross-correspondences. Darwin draws on literary works, Victorian writers draw on Darwin's works. Such a method is predominantly text based, acknowledging culture as the place of correspondence rather than as a site of change as well as exchange.

Lawrence Rothfield, in his book on literature and medicine, offers an alternative interdisciplinarity based on a continual shifting from one discipline to another. "We need to interpret . . . by identifying the specific discourses that are woven into the novel and tracing them in the culture at large back to their disciplinary precincts, the local sites where they exercise their power."[43] Rothfield proposes a more one-sided model in which interdisciplinarity occurs predominantly in the literary text. To trace its meanings, we need to take the discourses of science out of the text and place them back in their original context. It is there, Rothfield argues, that we will discover their varied disciplinary meanings that we can then transport back to the literary text. Doing this will allow us to consider how the literary text has been altered by these new understandings or, indeed, how the text has altered their original meanings in its use of that discourse for fictional purposes. Rothfield's interdisciplinary method allows for a greater consideration of culture than the work of Beer and Levine, but it is also privileges the discipline of literature over the discipline of science. It investigates the science only to discover its impact on the literary text. Beer's work on Darwin and Victorian novelists, we will recall, considered the importance of literary writing on Darwin's science, as well as the importance of Darwin's science on fiction writing.

John Limon, in a book on American fiction of the nineteenth century, stresses the importance of recognizing disciplinary differences when conducting interdisciplinary work. He argues that it is all too common to find disciplinary incongruity overlooked: "The conclusion appears to be that a single line of jurisdiction extends from science to popularization of science to philosophy of science to the rest of philosophy to literary criticism to fiction. A work . . . will be in the mainstream if it finds literary history easily correspondent, concurrent point for point, with scientific history."[44] Although he overemphasizes the problems associated with interdisciplinarity, Limon does go on to suggest a methodology for interdisciplinary scholarship that attempts to make clear the complex interactions taking place between disciplines. The keynote of his theory is that if "separation without equality is suicide, so is integration without difference."[45] The vitality of interdisciplinary work is that it holds in uneasy

alliance two different and equally powerful disciplines. The dynamism of interdisciplinarity does not come from the similarities of disciplines or from their power over the other but from their differences and their struggle to dominate the discourses of culture. Limon's highlighting of the qualities that make interdisciplinary research challenging and rewarding also shows the weaknesses in other methodologies. Rothfield's privileging of the literary text does not allow for an equivalent investigation of scientific culture, while Beer and Levine's attempt to make both literature and science into a series of texts denies them the range of differences upon which interdisciplinarity thrives.

Nevertheless, Rothfield, Beer, and Levine make valuable contributions to interdisciplinary study. Their work makes clear the importance of returning to disciplinary boundaries when seeking to find how knowledge has been constructed. They also illuminate the importance of balance, of considering both disciplines with equal rigor. Together with Limon, these three critics offer the best examples of interdisciplinary work on literature and science. They recognize that the benefit of interdisciplinary work is the challenge of moving outside boundaries—both of disciplines and of their own expertise—which can be constraining. More than this, they know that in the collision of disciplines can arise new formations of knowledge. As Beer states, there is "always the possibility of a vacillation of meaning . . . that will break through generic constraints" and lead to a fresh comprehension of literary and scientific culture.[46]

How might science fiction criticism learn from the interdisciplinary work outlined here? First, it will be clear that no single discipline can claim the investigative rights to science fiction. Neither the literary critic nor the historian nor the philosopher of science can argue that they are better placed to offer contextual analysis of the science fiction text. In conducting interdisciplinary work—whether literature and political history or literature and science—every one of these critics has to work outside his or her own areas of expertise. This, after all, is the nature of interdisciplinarity. Equally, no critic must feel that a lack of competence is an automatic denial of the right to investigate. Interdisciplinary scholars point out the necessity of acquiring new skills and

new knowledge in order to properly conduct interdisciplinary research. Science fiction scholarship cannot, then, continue to elide the scientific content of SF texts by stating an ignorance of scientific fact. It has been clearly shown that science is far more than mere facts. Even if literary scholars find the chemical theories that combine to create smallpox vaccinations extraordinarily complex, they can certainly investigate the cultural significance of vaccination and immunization. They can do this not because it is *easier* to do so but because the skills required to do so are comparable to their own and therefore, one would assume, less complex because more familiar.

Second, the analysis of the science must be given equal status with the analysis of the literature. In science fiction criticism that does attempt to deal with the scientific content of SF, there is often a tendency to make the science secondary to the literature. This leads to a very superficial investigation of science that does not extend either our understanding of the scientific culture within which the literature was conceived or our knowledge of the literary text's use of that science. Providing some equality of analysis will quantitatively increase the focus on the science while quantitatively decreasing the focus on the literary text. However, the qualitative benefits for both the fiction and the science—and therefore for both parts of science/fiction—will make this reconfigurement worthwhile. It is from a balanced consideration of both the culture of science and the culture of fiction, argue interdisciplinary critics, that new knowledge can arise.

Third, science fiction criticism should embrace the disruptions and discontinuities that interdisciplinary work on SF will undoubtedly cast up. John Limon's concern that comfortable correspondence between science and literature belies a misrepresentation of the complexity of the interaction should strike a cautionary note here. SF criticism accepts too readily the easy alliance of scientific progress and the rise of the SF genre. The plethora of chronological lists of scientific developments set alongside concurrent SF publications are examples of the implicit acceptance of uninterrupted progress and continuity between the sciences and the fictions that comment upon them. Interdisciplinary research will not only illuminate the discordant elements erased by such an

approach but also make them the focus of interpretation. As both Beer and Limon have argued, it is in disciplinary difference and contrasting meanings that existing knowledge paradigms can be questioned and genres revitalized.

The chapters that follow exemplify an interdisciplinary model for science fiction criticism that takes account of the status of, and the differences between, the disciplines of science and literature. I have chosen nineteenth-century science fiction because it offers an opportunity for the rediscovery of the genre in a period that criticism has neglected. I have chosen both canonical and noncanonical science fiction texts to show that there is still room for criticism to explore the new and the familiar in innovative ways. The texts chosen are meant to be exemplary rather than comprehensive. Although the ordering of the texts is chronological, the chapters do not assume a sense of progress from the earlier to the later. Rather, they are ordered around a series of themes that both the fictions and the sciences under discussion return to again and again. These themes are articulated in the title of the book: mesmerists, monsters, and machines.

Mesmerism plays a key role in the short stories of E. T. A. Hoffmann early in the nineteenth century. It also recurs in the short fiction of Edgar Allan Poe and in Villiers de L'Isle-Adam's late-nineteenth-century novel. Monstrosity is pivotal to the work of Mary Shelley, is reconfigured by Jules Verne in the 1870s, and is made the central impetus of H. G. Wells's novel in the final decade of the century. Machines play a vital part in the science fictions of Hoffmann, Verne, and Villiers de L'Isle-Adam. However, scientific philosophies of mechanization also inform the work of Shelley and Poe; mesmerism's connections with electricity are inculcated in Shelley's novel; and the monstrosity of science is an underlying theme in both Poe and Villiers de L'Isle-Adam. Focusing on themes that are, in different ways, common to all six science fiction writers discussed here guards against a simplification of the interaction between science and literature. It is impossible, for example, to accept that there is an easy progressivism to science and science fiction if both Hoffmann and Villiers de L'Isle-Adam can discuss the science of mesmerism and the technology of machine making some eight decades apart. It is also

impossible to deny the importance of the cultures in which science and literature take their place when the same themes receive such different treatment at the beginning and end of the century. Most importantly, the focus on mesmerists, monsters, and machines allows the following chapters to show that an interdisciplinary analysis of science and science fiction uncovers the potential of science fiction criticism to offer new insights into the cultural significance of an important genre of literary and popular fiction.

E. T. A. Hoffmann and the Magic of Mesmerism

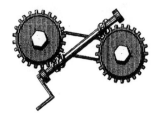

THE SHORT FICTION OF E. T. A. Hoffmann is rarely considered important by critics of science fiction. Yet Hoffmann's place in European literary history is no marginal one. He is widely regarded as a leading late Romantic writer, a subtle fantasist, and precise characterizer. His musical work has also been seen as influential on the major Romantic composers and musicologists. Nevertheless, he remains a minor footnote in the majority of science fiction criticism that deals with the early nineteenth century. Even Brian Aldiss, in his otherwise excellent *Billion Year Spree: The True History of Science Fiction*, relegates Hoffmann to a single sentence in a chapter that surveys the contribution of a range of writers.[1] That Hoffmann has been so neglected is unfortunate, for his work reveals a writer dynamically involved in the important scientific debates of the late eighteenth and early nineteenth centuries.

Hoffmann, born in 1776, continued writing until his death in 1822. His fictions began to appear in the first decade of the nineteenth century. His work is therefore contemporary, with the publication of the first science fiction novel, *Frankenstein* (1818), and with the heated debates on the relationship between the new empirical science and the older forms of natural philosophy that held sway throughout the eighteenth century. Hoffmann's interest in the machine culture of his time is well represented in his short stories, of which the critically renowned "The Sandman" (1816) and "Automata" (1814) are the best examples. But it is not just that Hoffmann reflects contemporary scientific concerns. Rather, his fictional narratives explore the relationship between mechanical science, mesmerism, and the magical traditions from which "knowledge" is gained in more esoteric form.[2] In bringing together the preternatural and the scientific in this way, Hoffmann's work makes a considerable contribution to our understanding of the emergence of scientific knowledge in the early years of the nineteenth century and to the conflict between science and magic, centered mainly on the "truths" available to the advocates of either practice.

Neither science fiction criticism nor other scholarly works, however, acknowledge Hoffmann's important role in the history of science. While his use of mesmerism is cited by Maria Tatar in her *Spellbound: Studies on Mesmerism and Literature,* no connection is drawn between this aspect of his fiction and the materialist sciences to which he gives equal consideration. Other scholarship tends to favor alternative approaches. "The Sandman" in particular—which sets out Hoffmann's vision of the connections between science, magic, and mesmerism—has been dominated by psychoanalytic critics working from Freud's important reading of the story as a prime example of the uncanny. Yet when historicizing Hoffmann's short fiction, it is important to keep in mind that both orthodox and unorthodox science, as well as magic and the occult, remain plausible fields of inquiry, and that one should not be privileged over another. In many respects, Hoffmann's balancing of mesmerism, mechanics, and magic reflects the difficulty in categorizing scientific knowledge in the early nineteenth century.

Of all critics, E. F. Bleiler comes closest to recognizing Hoffmann's equivocal reading of science and magic. In his introduction to the short

stories, he argues that Hoffmann "channelled the Romantic impulse, particularly the supernaturalism which was its heart [into] science."[3] Bleiler's recognition of the blending of the supernatural and the scientific, most especially in "Automata" and "The Sandman," arises from a commitment to position Hoffmann as a leading figure of Romanticism. This is achievable by invoking the scientific supernatural as a form of mystical or imaginative "fancy" rather than the tropes that had been central to the poetic project for earlier Romantic writers such as Novalis or Coleridge. Aligning Hoffmann with science, therefore, retrospectively places his work alongside new forms of knowledge, gaining currency at the beginning of the nineteenth century. While Bleiler is certainly correct to highlight Hoffmann's interest in both science and magic, his reading of Hoffmann as a proponent of new science over older esotericism is inaccurate.

Hoffmann is far less certain of science's primacy than the majority of his critics. The two stories on which this chapter will concentrate— "Automata" and "The Sandman"—deal directly with the power held by science and magic in partnership with each other. Indeed, Hoffmann's fictions question the definitions of science that were becoming more commonplace in the first two decades of the nineteenth century.[4] His reading of the cultural associations of mechanical automata, or androids, highlights the lack of delineation between magical phenomena and scientific possibility. The automata with which he deals in these two stories are mechanical figures vitalized by apparently supernatural means. Their position on the boundary between mechanical excellence and magical animation is maintained throughout and extended to include their scientific inventors, Professors X and Spalanzani. In turn, these scientists, luminaries of the scientific world Hoffmann portrays, reveal themselves to be as bound up in the rhetoric and experimentation of occult practices as they are in the mechanical sciences. In positioning the scientist in this way, Hoffmann is not creating a hybrid out of two opposing philosophical positions. Rather, he is reflecting and investigating the self-representation of mechanical scientists such as Jacques de Vaucanson and Wolfgang von Kempelen, two of the foremost creators

and exhibitors of androids in the late eighteenth century. Their performances of the generic figure of the scientist incorporated both magical and scientific language and symbols.

Such a combination of magic and science was common in mechanical science, even in the early nineteenth century. The *Edinburgh Encyclopedia*, one of the foremost producers of accumulated knowledge and a publication renowned for its attention to materialist science, defined the android as "the most perfect or difficult of the *automata* or self-moving machines; because the motions of the human body are more complicated than those of any other living creature. Hence the construction of an *Androides* [*sic*], in such a manner as to imitate any of these motions with exactness, is justly considered as one of the highest efforts of mechanical skill."[5] Yet alongside this celebration of science is set a history of mechanical production dating back to Albertus Magnus, the thirteenth-century natural philosopher and pupil of Thomas Aquinas. Magnus, the *Encyclopedia* states, was believed to have "formed an artificial man, in the construction of which he spent thirty years of his life [and] which appeared so wonderful to the ignorant multitude, as to draw upon the inventor the dangerous imputation of being addicted to magic."[6]

The *Encyclopedia* here registers its enlightenment perception of mechanical science as a field of inquiry now divested of occult or supernatural implications. Indeed, the insistence on an "ignorant multitude" highlights how far the general public has come in its understanding of science. Nevertheless, by including occult scientists such as Albertus Magnus in the genesis of mechanical science, the *Encyclopedia* also recognizes that scientific developments have come from magical foundations. Although apparently confident that ignorance has given way to rational understanding, the *Encyclopedia* hints at the possibility of a continued adherence to magic amongst those for whom mechanical science remains an opaque and esoteric subject. These brief examples reveal the degree to which public perception had altered in the light of scientific advance. Yet this degree of separation is disingenuous, the product of an 1830s sensibility swept along by the cultural current of scientific centrality and governance. The simplistic difference that the

Encyclopedia draws between an ignorant public with no understanding of scientific skill and the appreciative nineteenth-century public with their ready supplication to the scientist-genius is a caricature of the far more complex movement between the magical and the mechanical that the automata makers reflect in their public pronouncements.

Jacques de Vaucanson, perhaps the greatest automata maker of the later eighteenth century, was undoubtedly conscious of his role as scientist-seer. A member of the *Academie Royale des Sciences*, Vaucanson skillfully constructed many automata throughout his scientific career.[7] Yet Vaucanson was not the thoroughgoing materialist his mechanistic expertise suggests. Instead, he spoke of his mechanical prowess as occult knowledge, a decision that made him seem as much magician as empirical scientist. As historian of mechanics Christian Bailly reports, Vaucanson believed himself to be a modern Prometheus who "dared to investigate the secrets of creation which . . . had been considered beyond the reach of mankind."[8] In employing such phrases, Vaucanson, prefiguring Victor Frankenstein, exploits a supernatural vision of his scientific knowledge. As a Promethean magician, Vaucanson is part of an elect group who enjoy the privilege of secret knowledge, rather than a scientist whose skills are attributable to visible gifts. While his automata reveal scientific skill, Vaucanson's esoteric descriptions makes them magical. Tangibly and visibly mechanistic, the automata are made occult through language. Their context becomes as vital a part of their meaning as their production. The androids may be scientific, but their linguistic descriptors are magical.

Wolfgang von Kempelen, Vaucanson's rival in the exhibition of skillful automata, delivers a similarly balanced performance of science and magic. Most famously, Kempelen exhibited an automaton in the form of a chess-playing Turk whose success at a game requiring intellectual rigor had the nineteenth-century public flocking to see him. Kempelen, like Vaucanson, attracted his audience by alluding to the great mechanical skill with which his automaton had been constructed. However, his exhibits relied on a theatrical occultism designed to stimulate a supernatural response. Otto Mayr, a historian of automatic machinery, notes that while "mechanical . . . was the opposite of magical,"[9] Kempelen's

automata were "purposely kept at a distance . . . with the circumstances of the display carefully stage-managed to produce a mood of mystery and magic."[10] The outcome of this effect was that the public regarded the automata as "mediators between the worlds of magic and rationality."[11] In part, the theatrical performance of science seems not to bolster scientific authority but to undermine it. Yet this view is reached only if science and the occult are seen as detrimental to each other, as Mayr suggests. Kempelen's exhibitions throughout Europe did not detract from the popularity and respect given to mechanical scientists. Indeed, the aura of magic that surrounded his various automata, and his Turkish chess player in particular, only added to the public perception of the mechanical scientist as a skilled professional with knowledge beyond even the imagination of the layperson.

While Vaucanson and Kempelen were very much aware of the power that arcane knowledge gave to their scientific enterprises, the scientific community was less comfortable with the connections being drawn between their practices and those of magicians or occultists. Once again, the *Edinburgh Encyclopedia* captures their position well:

The construction of machines capable of imitating even the mechanical actions of the human body, display exquisite skill; what then shall we say of one capable, not only of imitating actions of this kind, but of acting as external circumstances require, as if it were endowed with life and reason? This, however, was to all appearances accomplished by M. de Kempelen [*sic*], a gentleman of Presburg, in Hungary, who, excited to rival the mechanical performances of M. Vaucanson, was supposed at length to have greatly excelled them. We allude here to the Androides which that gentleman not long ago exhibited at Paris, Vienna, London, and other places, and which was capable of playing skilfully at the game of chess. Every one in any degree acquainted with the principles of this game, must be well aware, that it is so far from being mechanically performed, that it requires a greater effort of judgement than is sufficient to accomplish many matters of greater importance. An attempt, therefore, to make a mechanical chess-player must appear nearly as ridiculous as to make a mechanical counsellor of state.[12]

The scepticism in this description of Kempelen's Turkish chess player illuminates the disquiet with which scientific authority approached the subject of supernatural automata. The supposed magical foundations of mechanical craftsmanship are, in this instance, denigrated as unfounded and ridiculous. The *Encyclopedia* may stop short of accusing Kempelen of fraud, but it does intimate that the scientific reader should draw the conclusion that Kempelen was performing a stage trick rather than skillfully employing the mechanical arts. Here, the boundary between science and magic is clearly defined once more: experimentally verifiable science does not lead to magical effects, or if it does it is built on the falsehoods and trickery of a devious charlatan.

If Hoffmann was only interested in pursuing the antagonism between magic and science, his short fiction would be rather less worthy of investigation than this chapter suggests. What recommends "Automata" and "The Sandman" so forcefully is Hoffmann's recognition that the magical and the scientific are little more than labels attached to various forms of knowledge by different groups with different agendas. In the early nineteenth century, to label a form of knowledge "scientific" was to see it as distinct from the magic and occultism of the preceding centuries. To label knowledge "magical" was to suggest it was archaic and without relevance to the contemporary world. In depicting the cultural formation of mechanical science and its links to magic and occult traditions, Hoffmann is interested in examining the creation of forms of knowledge or disciplines calling themselves sciences in the early nineteenth century.

Of great significance, therefore, in "Automata" and "The Sandman" is the role played by mesmerism. Almost always construed by contemporary science fiction critics as a marginal pseudoscience, mesmerism is vital in Hoffmann's depiction of the early nineteenth century as a time of scientific instability.[13] Labels and categories were weapons used in the fight to obtain scientific authority, and the vigorous and antagonistic debates on the subject of mesmerism well exemplify this combat. While champions of mesmerism, beginning in the 1780s with Mesmer himself, argued for its scientific status, many of those involved in already-established sciences denied that this new practice was anything other

than quackery. Mesmerism was therefore categorized both as a break-through in scientific medicine and as an occult charlatanism preying on the psychology of weak-minded individuals.

What is at stake here is a definition of science as it was to be prac-ticed throughout the nineteenth century. Although it is impossible to argue that science is reducible to a singular type of investigation, there was an attempt in the first decades of the nineteenth century to provide science with some criteria by which it could be recognized and other forms of knowledge could be discredited. This could not be done by simply opposing the new scientific methods with the magical traditions of occult science and alchemy. After all, mesmerism was a new medi-cal practice that appeared to maintain a connection to an occult and magical past. Instead, the mainstream scientific community attempted to construct a definition of science based on materialist criteria: empiri-cal evidence, experimental verifiability, and inductive reasoning. This led, by the mid-nineteenth century, to the demise of occult science and the disaggregation of science from magical traditions. This shift can be exemplified by drawing together the work of two scientifically minded intellectuals: Friedrich Schelling and Thomas Carlyle. In 1799 Schelling produced a new work of scientific philosophy, *First Outline of a System of the Philosophy of Nature,* in which he set out his thesis of *naturphi-losophie,* a romantic vision of the world constructed by polar powers in constant, cosmic flux out of which the individual human spirit also took its life force.[14] Thirty years later, Carlyle, still greatly interested by German enlightenment philosophy and an admirer of Schelling, stated that "the science of the age . . . is physical, chemical, physiological, and, in all shapes, mechanical."[15] The difference between two men of similar sympathies is marked. Carlyle's perception of science as ultimately me-chanical is a long way from the cosmic spirits that Schelling describes, highlighting the move toward the center ground that the empirical sci-ences had made in the fight for scientific and cultural respectability.

For Hoffmann, however, the creation of a scientific hegemony was some time ahead. "Automata" and "The Sandman" appear in the midst of this embittered shift from occultist natural philosophy to materialist sci-ence. Both narratives capture the complexity of scientific categorization

and definition. In detailing the triumvirate of magic, mechanics, and mesmerism, "Automata" and "The Sandman" become works of science fiction that critique the imbroglio of early-nineteenth-century science. By maintaining a balance between new science and magical traditions, Hoffmann characterizes the fluid public perceptions of science and illuminates the kaleidoscopic landscape of the sciences in the early nineteenth century.

Both "Automata" and "The Sandman" describe the relationship between a young male protagonist and an automaton, or android. In both stories the android possesses human characteristics far in excess of those usually found in mechanical figures. This supernatural aspect is attributed to the skill of the mechanical inventors: in "Automata" Professor X and in "The Sandman" Professor Spalanzani. Both men are nationally renowned scientists holding a place of some eminence within their scientific culture. "Automata" depicts an automaton—the Talking Turk—that provides answers to questions posed by the general public. Ferdinand, a young college student, is astonished to discover that this automaton appears to know of his secret, romantic connection to a young woman and is able to give an indication of how it will conclude. Together with his close friend Lewis, Ferdinand visits the automaton's creator, Professor X, in the hope of discovering how the automaton had access to secret knowledge. Professor X does not divulge the secrets of the automaton's telepathy, and the story appears to conclude by bringing to fruition the prophecy of the Talking Turk. This central narrative is framed by another depicting a group of friends who conduct an experiment to move a gold ring by mental power alone. Upon the conclusion of the experiment, these friends tell each other various supernatural tales, of which the story of the Talking Turk is the second. The first is a ghost story relating the history of Adelgunda, a young woman of nervous temperament who is visited nightly by an apparition. Adelgunda's family believes this to be a mental deficiency until she provides them with external proof of the existence of the ghost. This story, and the others, should be taken as a whole in reconstructing Hoffmann's project of bringing together the supernatural and the scientific in order to investigate the relationship between the two different philosophies of knowledge production.

"The Sandman" is of a simpler structure than "Automata" and relates, through a series of letters and personal narration, the deepening mental crisis of Nathaniel, yet another college student, who becomes infatuated by Olympia, another automaton. Beginning with Nathaniel's childhood recollection of his father's alchemical experiments with the hideous Coppelius—whom Nathaniel equates with the mythological Sandman—the story moves to his absurd love for Olympia, the "daughter" of famous mechanist Professor Spalanzani. Nathaniel's relationship with Olympia begins when he first looks at her through a pocket telescope sold to him by the horologist Coppola, an ambiguous doppelganger of Coppelius. Unable to see what appears perfectly obvious to everyone around him—that Olympia is an android—Nathaniel rejects his fiancée and becomes obsessed by the automaton. His mental breakdown occurs when he discovers that she is no more than a mechanical contrivance, which leads ultimately to his suicide.

As is obvious from these brief plot summaries, there are considerable connections between "The Sandman" and "Automata." Both stories center on a young man of some intelligence, steeped in the literature and music of the period. Nathaniel and Ferdinand are products of enlightenment and Romantic learning—they are capable of rational thought, yet they accept that there may be forms of knowledge other than those taught within the boundaries of educational institutions. The androids they become involved with are sophisticated mechanical creations, simulacra of human form that require the utmost skill in creation. These androids, in different ways, are much more than mere mechanisms. For Nathaniel and Ferdinand, they betray an intelligence that sets them apart from other artificially created humans. One of the central questions raised by both stories is where this intelligence stems from, and Hoffmann's answer is unique. Unlike the automotive machines of Charles Babbage, which, as Simon Schaffer has shown, revealed an intelligence within the system of their mechanical construction, the site of intelligence of Hoffmann's automata is removed from the mechanism and placed with the inventor.[16] These inventors—Professors Spalanzani and X—are the central foci of the two stories. Guardians of the secrets that the fictions only subtly reveal, the scientist-inventors are crucial in

Hoffmann's depiction of a scientific world in conflict. Although their reputations are built on their expertise in mechanics, both are characterized as scientist-seers whose power resides in their manipulative mesmerism. Alluded to rather than directly referenced, mesmerism is the foundation upon which each story is constructed, and it is through an understanding of mesmerism that the ambiguities of the text can be reconciled to Hoffmann's larger project.

Hoffmann is clearly influenced by the histories of mechanism and mesmerism in shaping his scientific protagonists and their automata. The public perception of scientists like Vaucanson, Kempelen, and Mesmer make their way into the narratives in various guises and are transformed by Hoffmann into Professors Spalanzani and X. In rewriting important figures in the history of science, Hoffmann contributes to a reconsideration of their place in the scientific culture of the early nineteenth century.

"Automata" opens with a gold ring turning in midair above a table around which sit four keenly concentrating figures. This "experiment," as one of the party calls it, appears more like a séance than the activity of a scientific laboratory. It is into this experimental space that the narrator bursts, to hear the story of Adelgunda and to then read his own narrative of the Talking Turk. What place does the séance hold in the story as a whole? Certainly, as a strikingly atmospheric location for a series of ghost stories, it performs an important function. Scholars of Hoffmann's work go further, reading this frame narrative in the context of a sequence of tales that Hoffmann constructed around the meetings of the Serapion Brothers, represented by the figures around the table.[17] It would be profitable in some ways to reach the same conclusion, especially as one member of the Serapion Brothers was Ferdinand Koreff, a mesmerist and medical doctor whose acquaintance Hoffmann had made in Berlin.

There is, however, a more specific historical context for this opening narrative that places "Automata" very firmly in the scientific practices of the 1800s and 1810s. In Munich, early in 1805, Johann Wilhelm Ritter, a scientist and researcher in the field of electromagnetism, became intrigued by Francesco Campetti's claims of water divination. Ritter's wish

to subject Campetti's talents to scientific investigation arose from his philosophical interest in the connection between the human and the natural world. As Walter D. Wetzels notes, "the idea of man's having such an intimate relationship with inanimate nature had a great appeal to Ritter."[18] The experiments that Ritter and Campetti designed failed to work as they had hoped, but they did provide the impetus for a series of séances conducted around Campetti's mediumship. These séances, attended by Ritter, Campetti, Friedrich Schelling, and Franz von Baader, soon became famous throughout Germany and were much discussed in periodical papers and popular conversation at a time when Hoffmann— now thirty years of age—was a resident in Berlin and Bamberg. The most controversial of the claims made by this group was that Campetti had proved his telekinetic power by making a pendulum "perform mysterious motions."[19] The comparisons with Hoffmann's frame narrative are striking: a group of four male individuals involved in an experiment to discover the source of the strange motions of an inanimate object. Here is how Hoffmann's narrator describes it: "Vincent, opposite me, with the others, around a little table; and they were all staring, stiff and motionless like so many statues, in the profoundest silence up at the ceiling. The lights were on a table at some distance, and nobody took any notice of me. I went nearer, full of amazement, and saw a glittering gold ring suspended from the ceiling, swinging back and forth in the air, and presently beginning to move in circles" (71). Vincent, as Hoffmann's fictional Ritter, confirms his Romantic credentials by calling the narrator a materialist when he admits to some scepticism over the source of the gold ring's motions. Theodore, who claims to have sat "for hours at a time making the ring go swinging in the most varied of directions," enacts a fictionalized Campetti (71).[20] Most interesting in this recreation of an important moment in European scientific history is Hoffmann's immediate introduction of mechanistic and mesmeric imagery.

The location and construction of what Vincent calls an experiment is laden with the symbolism of the séance: the small circular table, the silent concentration of the participants, and the subdued and diffuse lighting all hint at the domestic salon of the medium. Yet at the same time the initial impression of the four men around the table is of their

inanimate nature. The narrator describes them as stiff and statuesque in language that prefigures both the later descriptions of the Talking Turk and of Olympia in "The Sandman." While there is no suggestion here that the narrator's gathered friends are anything less than human, it is intriguing that the descriptive language of the narrator evokes the mechanical theme of the central narrative as well as the marginalized practice of telekinesis, a power often associated with mesmeric phenomena. This initial scene, then, brings into focus the two strands of scientific research that Hoffmann will proceed to discuss in the remainder of the story: new mechanical technologies and the psychic effects of mesmerism. However, the narrator's description goes further than simply introducing these themes. In bringing together a specific experiment in animal magnetism, the supernatural theatrics of the séance, and the rhetoric of automata construction, Hoffmann's frame narrative integrates the three antagonistic methods by which science is inscribed in early-nineteenth-century culture: heterodox, magical, and mainstream.

It is important to stress the integrated aspect of Hoffmann's project. "Automata" does not simply place side by side the various imaginative methods by which scientific practices were characterized and disseminated. Rather, the narrative fruitfully combines them in order to allow for a fluidity that more comprehensively reflects the protean hierarchy of the sciences in the period. Doing this in the frame narrative, which initiates the manner in which the reader approaches the rest of the text, colors the stories of Adelgunda and the Talking Turk and allows these tales to build further layers of meaning and resonance without the need for further reinforcement of the narrative methodology.

The story of Adelgunda looks to be somewhat of a non sequitor in the proceedings of the narrative. An apparently thoroughgoing gothic tale of supernatural visitation, it is difficult to see either its scientific basis or its relevance to the narratives that frame it. Disturbed by the daily visitation of a ghostly apparition, Adelgunda becomes increasingly mentally unstable. Believing that this disturbance is a product of Adelgunda's abnormal psyche, her family employs various physicians

whose expertise lie in the cure of psychological disease to bring about some improvement in her condition. As the narrative reaches a crisis, Adelgunda disproves their hypotheses in an unsettlingly theatrical exhibition of the ghost's apparent existence:

> "Oh God!" cried Adelgunda, "they think I am out of my mind. See! it is stretching out its long arm, it is making signs to me!"
>
> And, as though she were acting under the influence of another, without exercise of her own will, with eyes fixed and staring, she put her hand back behind her, took up a plate which chanced to be on the table, held it out before her into vacancy, and let it go.
>
> The plate did not drop, but floated about among the persons present, and then settled gently on the table. (76)

There is an understandably hysterical reaction to this remarkable floating plate. Adelgunda's family either faint or fall victim to nervous disorders, and the tale concludes in tragic fashion with a brief history of ongoing mental illness and death. Macabre, certainly, but not without a certain pointed indication of a potential mesmeric basis for the supernatural activities. Indeed, in the passage above, Hoffmann comes closest to spelling out the hidden forces at work on Adelgunda's mind. She appears to be under a foreign influence that has denied her the power of volition. This influence is closely linked to an alteration in her vision: Adelgunda's eyes are fixed and staring, devoid of personality.

These psychological and physical changes are common in descriptions of the mesmeric trance. Yet in this instance there is no obvious mesmerizer present, unless it is Adelgunda herself. There is, of course, a precedent for reading the narrative in this way. After all, Adelgunda's floating plate is paralleled in the frame narrative by Theodore's telekinetic power over the gold ring. Unless we are expected to view Adelgunda as under the influence of a cosmic mesmerism to which she is an unwitting accomplice, it is more credible to acknowledge that it is Adelgunda's own latent mesmeric abilities that have now been realized. Such a reading does not reduce the supernatural elements of the

story—the ghostly apparitions remain unexplained—but it does place their "proof" within the boundaries of science, albeit the equivocal science of mesmerism.

In the story of Adelgunda, then, we find the supernatural merged with the unorthodox science of mesmerism. In the frame narrative we have found an experiment in unorthodox science performed within a supernatural sphere by participants who symbolize mechanical science. The third and most important story—the story of the Talking Turk—provides a narrative of mainstream scientific research that is infiltrated by scientific unorthodoxy and magic. In combining three stories with three different dynamics of scientific authority, Hoffmann is able to add further complexity to the interrelationship of the sciences and the magical traditions that affected the struggle for power among the scientific community in the early years of the nineteenth century.

The Talking Turk enters "Automata" when Theodore reads a description of the "remarkable automaton" that "was attracting universal attention and setting the town in commotion" (78). The interest caused by this automaton is due less to its skilled mechanical construction than its oracular answers to questions posed by the visiting public. Such human, or at least intelligent, communication disrupts (very positively for the till receipts) the unwritten contract between the exhibitor and the paying public. Throughout the late eighteenth and early nineteenth century, automata impressed the public with their complex and ingenious systems of levers, gears, wheels, and pulleys, all of which effected a fair representation of the physical human frame and its movements. As such, these automata were recognizably limited simulations of the human. What they were not, of course, were simulacra that could not be told apart from the human. After all, how is one to appreciate its automotive qualities if it seems human rather than mechanical? To create a human automaton that has pretensions to human qualities accepted as beyond the scope of the mechanist intervenes in the comfortable exchange of scientific respect from the layperson and modest acknowledgment of mechanical genius from the constructor. Such disruption leads to the kind of notoriety that Hoffmann's Talking Turk achieves in the opening scenes of the story.

There is a resemblance here between the Turk and Kempelen's equally notorious, and equally uncanny, chess-playing automaton that caused such wild reactions among the nineteenth-century public. Edgar Allan Poe, writing in the *Southern Literary Messenger* and stealing wholesale from Richard Willis's earlier article,[21] describes a visit to Kempelen's chess player in the following terms:

> At the hour appointed for exhibition, a curtain is withdrawn, or folding doors are thrown open, and the machine rolled to within about twelve feet of the nearest of the spectators, between whom and it (the machine) a rope is stretched. A figure is seen habited as a Turk, and seated, with its legs crossed, at a large box apparently of maple which serves it as a table. The exhibitor will, if requested, roll the machine to any portion of the room, suffer it to remain altogether on any designated spot, or even shift its location repeatedly during the progress of a game. The bottom of the box is elevated considerably above the floor by means of the castors or brazen rollers on which it moves, a clear view of the surface immediately beneath the Automaton being thus afforded to the spectators. The chair on which the figure sits is affixed permanently to the box. On the top of this latter is a chess-board, also permanently affixed. The right arm of the chess-player is extended at full length before him, at right angles with his body, and lying, in an apparently careless position, by the side of the board.[22]

Detailed and technical, this description suitably illustrates both the theatrical performance that such exhibits attempted to recreate and the culture of transparency that was common practice in exhibitions of this type. Hoffmann's description of the Talking Turk exhibition is no different:

> In the centre of a room of moderate size, containing only a few indispensable articles of furniture, sat this figure, about the size of a human being, handsomely formed, dressed in a rich and tasteful Turkish costume, on a low seat shaped like a tripod. The exhibitor would move this seat if desired, to show that there was no means of communication between it and the ground.

The Turk's left hand was placed in an easy position on its knee, and its right hand rested on a small moveable table. Its appearance, as has been said, was that of a well-proportioned, handsome man, but the most remarkable part was its head. A face expressing a genuine Oriental astuteness gave it an appearance of life rarely seen in wax figures, even when they represent the characteristic countenances of talented men.

A light railing surrounded the figure, to prevent the spectators from crowding too closely about it; and only those who wished to inspect the construction of it (so far as the exhibitor could allow this to be seen without divulging his secret), and the person whose turn it was to put a question to it, were allowed to go inside this railing, and close up to the Turk. (78–79)

Parallels with Poe's description of Kempelen's chess player are obvious: the nationality ascribed to the automaton, the construction of the exhibition space, the role of the exhibitor, and the positioning of the automaton's body parts. As Poe's plagiarized essay argues, Kempelen's mysterious automaton was nothing more than a fraud. The product of neither mechanical genius nor magical operations, the chess player was a spectacular optical illusion operated by a human figure unseen by the watching audience. Although this claim has never been substantiated, Hoffmann's central protagonist, Ferdinand, comes to a similar conclusion in rationalizing the supernatural answers of the Talking Turk. "There cannot be the smallest doubt," he claims, "that some human being is so placed as to be able . . . to see and hear the persons who ask questions, and whisper answers back to them" (82). Fraudulent human intervention is, ironically, the most satisfactory answer at this stage in the story while the precepts of mechanical science hold sway. It is not long, however, before the story begins to offer an alternative explanation for the Turk's ingenuity, initially by undermining Ferdinand's claim:

The figure and its exhibitor were watched and scanned most closely by the eyes of the most expert in mechanical science; but the more close and minute the scrutiny, the more easy and unconstrained were the reactions and proceedings of both. The exhibitor laughed and joked in

the farthest corner of the room with the spectators, leaving the figure to make its gestures and give its replies as a wholly independent thing, having no need of any connection with him. Indeed he could not wholly restrain a slightly ironical smile when the table and the figure and tripod were being overhauled and peered at in every direction, taken as close to the light as possible, and inspected by powerful magnifying glasses. The upshot of it all was, that the mechanical geniuses said the devil himself could make neither head nor tail of the confounded mechanism. (80)

The Talking Turk is subject to rigorous investigation by the experimental and observational techniques of empirical science. Despite bringing to bear instruments that had contributed so much to scientific discovery in the late eighteenth and early nineteenth centuries, the "mechanical geniuses" are unable to discover the source of the Turk's intelligence.

Immediately after the failure of new scientific practice to illuminate the mysterious aspects of the Talking Turk, the narrative shifts perspective to its creator, Professor X. To this point, Professor X's involvement in the construction of the Turk had remained hidden, leaving mechanics as the only object of investigation. By suggesting that answers may be found elsewhere, Hoffmann highlights the flaws in paying attention to only one branch of knowledge. In Professor X we find a scientist "highly skilled" in the mechanical arts whose appearance and demeanor suggest an inclination toward mesmerism. To find a single scientist involved in both orthodox and heterodox sciences was not uncommon in the early nineteenth century. As Alison Winter shows in her excellent reading of mesmerism in early Victorian Britain, practitioners of clinical medicine situated at the center of scientific orthodoxy also indulged in mesmeric experiments. In John Elliotson, the central focus for Winter's discussion, we find a scientist of national reputation whose interest in mesmerism put his career in jeopardy.[23] Throughout the century, likewise, there are numerous examples of scientists working within the scientific establishment whose personal interests run to the most heterodox sciences of the day. Alfred Russell Wallace, to give but one more example, not only contributed significantly to evolutionary theory (itself heterodox

at one time) but took time to defend the principles of spiritualism in a case that became a cause célèbre of the 1870s.[24]

Professor X is an equally polymathic figure, so readily interweaving mechanics and mesmerism that any boundary that may have existed becomes erased as the narrative progresses. It is significant that this should be the case, for Hoffmann draws particularly on three figures whose careers and rhetoric challenge the differentiation between the scientific and the occult and ultimately call into question those definitions of science that mechanists and other mainstream scientific professionals were attempting to validate. Using Vaucanson, Kempelen, and Mesmer as prototypes, Hoffmann parallels their fusion of the magical and the scientific in his fictional professor. Kempelen, as automata impresario, encouraged a mystical representation of mechanics in his European exhibitions. Vaucanson indulged the language of the seer in explaining his scientific purpose. Mesmer, while continually claiming his animal magnetism as a serious scientific discipline, continued to display himself to the general public as a magician. It is to Mesmer that Professor X is most assiduously connected, through the symbolic imagery and descriptive language of the narrative. That Hoffmann weaves mesmerism into the narrative would not have been lost on an early-nineteenth-century audience: "Automata" appeared early in 1815, only a few months after Mesmer's death and the reappraisal of his techniques that followed. Not that mesmerism had lain dormant before this. Mesmer had published his third and final memoir, *Mesmerismus,* in 1814, closely following J. P. F. Deleuze's *A Critical History of Animal Magnetism,* published less than a year before.

With Professor X established as a fictional version of Mesmer, the story proceeds to introduce mesmerism to the central protagonist. When Ferdinand realizes that Professor X is responsible for the Talking Turk's unusually perceptive answers, the narrative turns from an investigation of mechanical skill to the detection of mesmeric agency. That the professor radically altered a mediocre automaton into a mysterious and somewhat supernatural android is reinforced in the description of his first encounter with the exhibition:

"the ... body reacts to the alternate effects of [magnetic force], which by entering the substance of the nerves affects them immediately."[26] Therefore mesmeric influence, beginning as an extension of external healing techniques using magnetism and electricity, becomes a vital weapon in the armory of the mesmerizer. Mesmer particularly enthuses about the curative power of the mesmeric trance that was brought about by mesmeric influence. Those critical of his practice were quick to object: allowing the self to be influenced and controlled by another, they argued, is to submit to the position of the victim and give control to the mesmerizer. Indeed, as several historians of science have detailed, even the physical performance of mesmeric influence revealed the domination of the mesmerizer and the passivity of the mesmerized subject.[27]

Conscious that this type of influence is at work, Ferdinand visits Professor X at his home in the hope of discovering exactly what forces are directed against him. Here the narrative embeds the link between the professor and Mesmer: "They [Ferdinand and his friend Lewis] called on Professor X, in high hopes that he would be able to throw light on many questions relating to occult sympathies and the like, in which they were deeply interested. They found him to be an old man, dressed in an old-fashioned French style, exceedingly keen and lively, with small grey eyes which had an unpleasant way of fixing themselves on one" (93). The professor's vision initially suggests a parallel with Adelgunda's fixed and staring eyes, but it is the contrast rather than the comparison between them that is most striking. While Adelgunda's was a passive "staring," Professor X's gaze is active and menacing. The importance of the gaze in the mesmeric trance is investigated in more detail in "The Sandman," yet it plays an important, primary role here in further strengthening Professor X's natural propensity for mesmerism. The trance, so central to Mesmer's later articulation of the healing power of magnetism, is traditionally initiated by the gaze of the mesmerizer, who captures the eye of the subject and brings the subject to a state of somnolence from which mesmeric suggestions can successfully be made. Ferdinand's reading of the gaze of Professor X as "unpleasant" reflects the master/ slave dialectic that the mesmeric trance embodies; it also hints at the mesmeric power that Professor X may already hold over Ferdinand.

Other details of Professor X's bearing and dress also invite comparisons with Mesmer. He appears dressed "in an old-fashioned French style," perhaps suggestive of Mesmer's lengthy and controversial stay in Paris in the 1780s from where his more combative pronouncements on mesmerism were made. Professor X also reveals a keen interest in music, as noted by Ferdinand, who hears a sound that, "as it swelled and became more distinguishable, seemed to resemble the tone of a glass harmonica" (99). As Vincent Buranelli attests, Mesmer's public reputation "was that of a fashionable Viennese physician with a taste for science and music, his particular forte being the playing of the glass harmonica."[28] If we consider Hoffmann's own musical background and the importance he attaches to music in many of his fictions, it is difficult not to accept that the connection is a pointed one designed to reinforce Professor X's mesmeric credentials.

Combining details of Mesmer's life with the practices of mesmerism in his characterization of Professor X, Hoffmann has moved from depicting a scientist involved solely in mechanical research to one who infuses the mechanical with the mesmeric. Despite this fusion, it is still difficult to follow any logical path from the mechanistic to the mesmeric in the final sections of "Automata," although this does seem to be Hoffmann's plan in drawing the disparate sciences together. Once Professor X has been clearly designated as a mesmerist as well as a mechanist, Ferdinand begins to suspect that there is much more in his own past life that has been under scrutiny from his sinister gaze. Various coincidences follow: Professor X is related to the young woman with whom Ferdinand had fallen in love some years before and who was the subject of his questions to the Talking Turk; Ferdinand's final meeting with this woman is in the presence of Professor X; the Turk's prophecy, no doubt linked to Professor X's work on the automaton, comes true. Ferdinand can find no answer for these peculiar connections between his own life and Professor X's. Logical progression and consistently linked narrative would, after all, reflect only the methods of mechanistic science with which the story began. The machine, working on principles of cohesion and vital connections between levers, gears, and wheels, defines this mode of writing. In undermining this by disrupting narrative causality, Hoffmann

pushes the reader to view the tale from a very different perspective. In the concluding scenes, which lead to an ambiguous denouement, the narrative takes on a mesmeric form of storytelling: parallels are struck that have no temporal, spatial, or causal link to one another, and forces appear to be at work that are invisible and without category.

In bringing the narrative to its conclusion on this basis, Hoffmann introduces what Ferdinand has already defined as the "occult sympathies" of mesmeric science. Mesmerism's cultural currency was greatly hindered by its apparently magical or occultist connections, which had been unhelpfully promoted by Mesmer's penchant for donning a magician's robe during his clinical sessions. In a period when science was becoming increasingly defined as a practice that could show experimentally verifiable phenomena, the secret and necromantic associations of the occult did not recommend themselves to those at the cultural center. Academies of science, often attached to the great universities or to the major hospitals or even to the state itself, found mesmerism a dubious practice precisely on the grounds that it was too closely related to the occult than was comfortable.[29] Hoffmann's position was as equivocal as those institutions, and he remained, as Maria Tatar suggests, "in two minds about mesmerism" throughout his life.[30] "Automata" reflects his uncertainty: not content to allow mesmerism to *explain* the apparent incongruities of the story and thereby gain ultimate authority within a scientific hierarchy, Hoffmann incorporates a critique of mesmerism that parallels the normative view of the scientific orthodoxy. This is largely achieved in the placement of Ferdinand as a mesmeric detective whose final discoveries implicate mesmerism's role in maintaining the supernatural within science.

Of the evening after his first meeting with the young woman who plays such a major role in his life, Ferdinand relates how his "sleep was scarcely more than a kind of dreamy, half-conscious condition, in which [he] was cognizant of all that was going on" (84). This description of a bout of insomnia is very close to Mesmer's own description of the mesmeric trance, during which "the subject appeared to be asleep [although] his thought processes may be more acute than ever."[31] If, indeed, Ferdinand has unwittingly submitted to mesmeric influence at this point,

it is conceivable that he remains in its grasp for some time afterward. Mesmer was clear on the power held by the mesmerizer even after the mesmeric trance had been broken: "Most astonishing, [the patient] became susceptible to post-hypnotic suggestion, carrying out when awake orders given to him during hypnosis, in total ignorance of the causes or meaning of his behaviour."[32] Although Ferdinand remains ignorant of the mesmeric method that allows Professor X to gain control of his life, his articulation of his suspicions uncannily reflects the language of that method: "I feel, too clearly, some hostile foreign influence at work upon my whole existence, smiting upon all its hidden strings, and making them resound at its pleasure. I am helpless to ʌ‸ᵉⁱst it, though it should drive me to my destruction! Can that diabolical, sneering irony, with which Professor X received us at his house, have been anything other than the expression of this hostile principle?" (100). This statement provides a powerful summation of the mesmeric forces working in the narrative. The diabolic hostility of the unscrupulous mesmerizer, the unseen influences pervading the existence of the central protagonist, and the connections that can be tentatively drawn between the two very accurately describes Ferdinand's experience at the mercy of a powerful mesmerism.

Ferdinand's final judgment, acting as a conclusion for the narrative as a whole, still elides any definitive statement about scientific authority. By regarding Professor X as the "hostile principle" rather than the sciences of mesmerism or mechanics, Ferdinand is ultimately unable to decide on the relative value of orthodox and heterodox practice. In fact, Professor X is at once mesmerist, mechanist, and also both together, the scientist-seer whose genius is derived from sources unknown. To attempt to unweave these three representations is to miss Hoffmann's purpose. Their combination is integral in reading the text as an analysis of the cultural position that science held in the first decades of the nineteenth century. On the boundary between a new empiricism and an older occultism, science was still subject to magical infection. With inventors like Vaucanson, who depicted himself and his work as supernatural, or mechanistic popularizers such as Kempelen, who cast a gloss of secrecy and mystery over his automata, even the discipline

of mechanics was tainted by these more ancient traditions. Orthodox science was also guilty of blurring the boundary between science and magic. While some scientists depicted mesmerism as an occult practice, others championed it as a credible form of medicinal treatment. "Automata" captures this complex and fluid negotiation between the magical and the scientific, just as Hoffmann's later and more highly regarded short story "The Sandman" attempts to do. However, "The Sandman" approaches this mapping of the mechanistic, mesmeric, and magical landscapes from a slightly different angle, concentrating on the changing visual perceptions of an individual as he becomes influenced by mechanical and mesmeric science.

"The Sandman" brings to the fore the power of vision, central to the mesmeric trance and the healing power of the mesmerizer. In this story, however, it is the many facets of science and vision that Hoffmann wishes to explore. What one sees, how one sees it, and the extent to which science is a visionary discipline are all questions that "The Sandman" considers. The opening of the narrative reveals just how important the power of vision will be. Nathaniel, telling a story of his childhood, remembers the nights that his father was visited by a mysterious stranger. To rush him to bed before this stranger arrives, his mother equates the stranger with the mythological Sandman, come to sprinkle sand in Nathaniel's eyes and pluck them out. As Nathaniel grows older he becomes less frightened and more fascinated by the Sandman's visits to his father. He decides to hide himself in his father's study in order to catch a glimpse of this supernatural figure for himself. The Sandman turns out to be the "loathsome and repellent" (89–90) Coppelius, a friend of his father's whom he dislikes and fears. Much to Nathaniel's surprise Coppelius and his father "clad themselves in long black smocks" (91) and uncover "a small hearth" (91) containing "all kinds of strange implements." (91) As they begin their alchemical experiments, Nathaniel, "gripped by wild terror," (91) falls from his hiding place:

> "Little beast! Little beast!" [Coppelius] bleated, showing his teeth. Then he pulled me up and threw me onto the hearth, so that the flames began to singe my hair.

That Hoffmann was writing in a period when this revision of scientific history had not yet been fully undertaken by orthodox science is clear. He places the mechanist and the alchemist within the same frame, connecting them through their similar interest in human anatomy and physiology, which Paracelsus, for example, had studied at the University of Basle, where he later became a professor. By characterizing Coppelius as both a mechanical scientist and an alchemical cabalist, "The Sandman" collapses the distinction between the magical and the scientific that was beginning to take hold in the 1810s. It also allows for a more credible rendering of mesmerism later in the narrative, when magic, science, and the power of vision are combined and circulating in the central plot.

The central narrative of the story focuses on a female automaton known as Olympia. Ostensibly Professor Spalanzani's daughter but actually an android he and Coppola have created, Olympia draws the attention of Spalanzani's students. Nathaniel, who by some strange coincidence reminiscent of the unseen connections in "Automata" finds himself renting rooms opposite Spalanzani's home, is one of the few to catch a glimpse of her. His description of her reiterates the importance of vision: "A tall, very slender, beautifully dressed, beautifully proportioned young lady was sitting in the room in front of a small table, on which she had placed her outstretched arms, with hands clasped. She was sitting opposite the door, so I could see her divinely beautiful face. She did not seem to notice me; indeed her eyes seemed fixed. I might almost say without vision. It seemed to me as if she were sleeping with her eyes open" (99). The final sentence hints at a mesmeric trance, with the subject having fallen into a somnolent state yet remaining actively linked to the powerful gaze of the mesmerizer. Olympia's fixed eyes and lack of vision all point to the same mesmeric forces brought to bear on Adelgunda in Hoffmann's earlier tale. At the same time, Hoffmann is paralleling the lack of active vision with automation: to be unable to see is to be an automaton. Nathaniel, here and elsewhere, constantly draws attention to Olympia's ocular deficiency, describing her eyes as "peculiarly fixed and lifeless" and her entire appearance as "stiff [and] rigid" as a "beautiful statue" (109). Lifeless eyes suggests a lack of humanity.

As Nathaniel's close friend Sigmund concisely argues, "she seems to be playing the part of a human being" while actually she is no more than "some kind of clockwork" (116).

Vision plays a greater role here than it did in "Automata," not only registering the importance of the eyes in mesmeric practice but also linking active vision with human life and passive vision with automation. Fixity of vision as the loss of humanity was a notion already common in the debates surrounding the techniques of mesmerism. As discussed, the subject in a mesmeric trance gave over his or her personality and conscious self to the mesmerizer. The subject's actions, both physical and psychological, could be controlled entirely by another, as though he or she were a clockwork automaton set in motion by the mechanical inventor. William Stone, writing in 1837 and capturing the dynamics of mesmerism that had been prevalent throughout the early nineteenth century, relates to a friend a mesmeric experiment performed on a young woman: "When in a state of magnetic slumber, she had been sent to a fancy dry goods store to select various articles of merchandise, . . . [and], by the will of the magnetizer, she would go into a flower-garden, when asleep, and cull various flowers of various hues."[35] The mastery of the mesmerizer over the mesmeric subject turns the young woman into an unthinking machine, entirely at the mercy of the experimenter. The language clearly reflects her inability to resist his orders or even to register any opposition. For the magnetizer, the young woman can be manipulated as easily as if she were a clockwork doll.

Olympia, another female victim of a mesmeric experimenter, represents not only the power dynamic of mesmerism but also the inhumanity and selflessness of the mechanical construct. In fact, to be either the mesmerized subject or the automaton would mean the same fate for Olympia: a loss of self-expression and control, not to mention the fixity of vision that everyone else finds "rather weird" (116). In part, the public dislike of Olympia that Hoffmann details undoubtedly stems from her inhumanity. Sigmund, voicing public opinion, does admit that "she might be considered beautiful" but states also that she is somehow "unpleasantly perfect" and that the majority of the students "wanted to have nothing to do with her" (116). Thomas Beddoes, acclaimed scientist and

prolific writer on scientific subjects, wrote of the uncanny gap between external appearance and internal mechanics in his memoir of 1811. Railing against the manufacture of automata as children's toys he argued that "the flush of delight, arising from the first impression, cannot be but transitory; and no sooner does the little possessor examine into the structure of his new acquisition, than he flings it aside, or breaks it to pieces and tramples it under foot, as if to revenge himself upon it for belying the promise of its exterior."[36] Sigmund's uncanny dislike of Olympia is of the same order as Beddoes's "little possessor." He can somehow see beneath the perfect exterior to the void beneath. Ironically, Olympia is to suffer the same fate as the toy described here when Spalanzani and Coppola break her to pieces in their struggle for her eyes. This, however, is later in the narrative. In the meantime, Nathaniel becomes increasingly obsessed with Olympia, an infatuation that is brought about by an alteration in his vision. As Beddoes intimates, the more penetrative one's vision, the greater the power one has over any object that is subject to that vision. This is as true for the possessor of the children's toy as it is for the mesmerizer well practiced in the mesmeric trance. It is to be expected, then, that when Nathaniel purchases a pocket telescope from the spectacle maker Coppola, enabling him to gaze on Olympia more intimately, his power over her will increase. Hoffmann, however, turns this logic on its head: as his gaze becomes more powerful, Nathaniel loses control of himself and submits to Olympia's will. What causes such a reduction in the power of vision that the narrative had been at pains to construct? The answer lies with Coppola and the "beautifully finished" pocket telescope he sells to Nathaniel (110).

When Nathaniel first meets Coppola, he is shocked to see the similarity between him and Coppelius, the family friend whom he describes as his father's alchemical master and whom he had always associated with the Sandman. Coppola's profession compounds this shock; it is very easy for Nathaniel to associate a spectacle maker with a collector of eyes. Although persuaded by his close friends that there is very little chance of Coppola and Coppelius being the same person, Nathaniel continues to fear him (this fear is never explicitly disclaimed in the narrative, which remains ambiguous about the Coppola/Coppelius figure).

When Coppola visits Nathaniel for a second time, exclaiming "lovely eyes! lovely eyes!" as he enters the room, the unnerved Nathaniel purchases a pocket telescope in order permanently to rid himself of the spectacle maker (109). As he puts the pocket telescope to his eye and looks at Olympia, he discovers the "clarity and distinctness" his vision has previously lacked: "For the first time now he saw her exquisitely formed face. Only her eyes seemed peculiarly fixed and lifeless. But as he continued to look more and more intently through the glass, it seemed as though moonbeams were beginning to shine in Olympia's eyes. It seemed as if the power of vision were only now starting to be kindled; her glances were inflamed with ever-increasing life" (110). The glass transforms the lifeless automaton into a living human being and emasculates Nathaniel's romantic disinterest. From this moment forward he is imprisoned by an obsessive desire for Olympia's love.

It is telling that it should be an instrument of vision that brings about such a change. Nathaniel's gaze is not only made more powerful by the pocket telescope, it is dramatically altered. His vision is not now the personal and romantic perception afforded by his own eyes but the gaze of a scientific instrument bolstered by mechanical and mesmeric skill. There is a humorous irony here of which Hoffmann was certainly aware. The creation of ever more powerful lenses for scientific microscopes was one of the most engaging scientific quests of the late eighteenth and early nineteenth century—so engaging that it became the focus for another science fiction story written later in the century. In "The Diamond Lens," Fitz-James O'Brien details the ever-increasing power of the microscopic lens and the greater capacity for viewing organisms unseen by earlier lenses.[37] The instrument makers are intent on making a full range of (microscopic) life available to the gaze of the scientist. Hoffmann shows Nathaniel's gaze achieving the same penetration: his powerful pocket telescope reveals the life in Olympia that has until then been invisible.

Through the astonishingly powerful pocket telescope, Hoffmann takes the concept of vision beyond the simple ability to see. Vision becomes a state of perception that affects both the physical eye and the psychological mind. This is both a Romantic notion of vision and a

peculiarly mesmeric attitude toward the power of the eye. The pocket telescope, in fact, acts as a medium for mesmeric control, and its scientifically created "eye" (the glass lens) subjects him to the mesmeric will of the scientists at the center of the narrative: Professor Spalanzani and Coppola. In mesmeric practice, to capture the eye of another is to subject him or her to your will, to take over his or her mental cognition and make it your own. In putting the pocket telescope to his eye, Nathaniel perceives Olympia while under the influence of a mesmerizer. As that mesmerizer is also an automaton maker, Nathaniel therefore sees Olympia as an example of scientific skill. His vision of Olympia becomes influenced by a mechanistic appreciation for the well-crafted automaton.

Hoffmann is at pains to highlight that Nathaniel's personal vision is altered when he purchases the pocket telescope, a purchase, incidentally, that "strangely distressed" him although he can see "no reason for it" (111). When Olympia is next revealed to us, the narrative clearly positions her as an automaton, leaving no doubt that the alteration is to Nathaniel's vision alone. Indeed, when he attempts to court her in traditional romantic fashion, Olympia's reactions are exactly what we would expect of an android rather than a human being:

She neither embroidered nor knitted; she did not look out of the window nor feed a bird nor play with a lapdog or kitten; she did not twist slips of paper or anything else around her fingers; she had no need to disguise a yawn by forcing a cough. In brief, she sat for hours on end without moving, staring directly into his eyes, and her gaze grew ever more ardent and animated. Only when Nathaniel at last stood up and kissed her hand and then her lips did she say, "Ah, ah!" and then add, "Goodnight my dearest."

He sat beside Olympia, her hand in his, and with fervour and passion spoke of his love in words that no one could understand, neither he nor Olympia. But perhaps she did, for she sat with her eyes fixed upon his, sighing again and again, "Ah, ah, ah!" Whereupon Nathaniel answered: "Oh, you magnificent and heavenly woman! You ray shining from the

promised land of love! You deep soul, in which my whole being is re-
flected," and more of the same. But Olympia did nothing but continue
to sigh, "Ah, ah!" (117–18)

Olympia's rigid and fixed attitude, her inability to reveal the fatigue
or the animation of the physical human body, and her lack of involve-
ment in the conversation with Nathaniel, all illuminate her artificial sta-
tus. Otto Mayr, mechanical historian, points out that such failings were
common in the automata of the late eighteenth and early nineteenth
centuries. In particular, automata "were not capable of participating in
dialogue or answering questions."[38] How Nathaniel is unable to see that
Olympia is an android when she blatantly betrays all those characteris-
tics would be difficult to understand were it not for the influence of the
pocket telescope on his capacity for self-controlled perception.

Such scenes humorously acknowledge the love of mechanics that the
pocket telescope has instilled in Nathaniel, but they do not fully answer
his blindness to Olympia's artificiality. A delight in mechanical arts does
not, after all, infer an inability to distinguish the mechanical from the
organic. For a fuller explanation of Nathaniel's altered vision, we have to
look beyond the mechanical to the mesmeric, for it is the power of the
mesmeric gaze that has taken hold of Nathaniel's conscious and think-
ing self and that denies him an opportunity to view Olympia appropri-
ately. The principal player in all of this is Professor Spalanzani, aided
by his accomplice, Coppola. It is Coppola who brings Nathaniel under
the influence of mesmerism by selling him the pocket telescope, but it
is Professor Spalanzani who is the site of mesmeric power in the narra-
tive. While this is stated less explicitly than in "Automata," it is still clear
that Hoffmann wishes to place Spalanzani within the same mesmeric
frame as Professor X. Spalanzani has the characteristic optical power
that Hoffmann always associates with mesmerism. In the narrative's
single description of Spalanzani, he is carefully given a physiognomy
similar to Mesmer himself, the most vital aspect of which is his "pierc-
ing eyes." The penetrative quality of Spalanzani's sight is indicative of his
mesmeric potential to influence others. More crucial than this, however,
is the comparison that Nathaniel draws with Cagliostro in order to fully

describe Spalanzani to his friends: "But better than from any description, you can get a picture of him if you look at a picture of Cagliostro as painted by Chodowiecki in any Berlin pocket almanac. Spalanzani looks just like that" (98). The relevance of this description is two-fold: first, Spalanzani is equated with Cagliostro, infamous for his fraudulent alchemical claims and scientific charlatanism, with which Spalanzani's duping of Nathaniel can readily be compared. Second, this equation draws Mesmer into the frame, for the founder of mesmerism was himself often compared with Cagliostro. Mesmer's biographer, Vincent Buranelli, talks of the points of comparison in some detail, concluding that it was because both Mesmer and Cagliostro were believed to "call spirits from the nether world" that the comparison stuck.[39] With Spalanzani later called "sinister and ghostly," the comparative triumvirate is further reinforced.

The introduction of a certain supernatural gloss on Spalanzani's character, if only by allusion to Cagliostro, dovetails rather neatly with Nathaniel's altered perception. The life that suddenly infuses Olympia, and that is brought about by the mesmeric and mechanistic power of the pocket telescope, is a preternatural occurrence. Animation takes place as Olympia is exposed to Nathaniel's gaze, a gaze that magically transforms her from lifeless automaton to living human being. The moment in the narrative when Nathaniel puts the pocket telescope to his eye and finds life blossoming in Olympia becomes the crux of the story. The power of vision takes on a central role here, for it is through the gaze, and the control of that gaze, that the narrative either authorizes or denies scientific ascendancy.

The act of seeing was vital to the new science, with its authority partly constructed on the importance of empirical-experimental processes. The power of the eye is also important to the science of mesmerism in its claims to bodily control through the impact of the mesmerist's gaze. Magical or occult traditions were equally validated by the power of vision, but for them it was vision as a penetrative force that took the participant beyond the veil of the natural world. Each of these readings is possible in Hoffmann's ambiguous pocket-telescope transformation scene, and that is indeed his intention. Just as "Automata" did not al-

low for either the scientific (in various forms) or the supernatural to hold sway over the narrative, neither does "The Sandman" provide an unequivocally hierarchized text. It is possible to argue that Nathaniel is subject to a mechanical state of mind when he picks up the beautifully crafted scientific instrument and holds it to his eye. It is also possible to argue that Nathaniel becomes an unknowing victim of the mesmeric gaze through his use of the pocket telescope. It is equally plausible that the tale depends on a supernatural change in Olympia and that the pocket telescope, functioning as an occult object, allows Nathaniel to witness her increasing spectrality. Ultimately, all three positions are available equally and simultaneously. Hoffmann obfuscates any hierarchy of early-nineteenth-century science by centering his discussion on the power of vision rather than on the power relations between the marginal science of mesmerism, the mainstream science of mechanics, and the magical basis of the occult.

In "Automata" and "The Sandman," Hoffmann dramatizes the complex interplay of scientific and magical forms of knowledge in the early nineteenth century. He does this not only by reinforcing their connectedness to each other but also by revealing the public perceptions of their status and authority. Greatly influenced by the rhetoric employed by mechanics and mesmerism, as well as by their links to magical traditions, Hoffmann contributes a science fiction that substantially adds to our comprehension of the dynamics of science and magic. By reflecting this dynamism and participating in the ongoing debates that defined the first two decades of the nineteenth century, both "Automata" and "The Sandman" deserve to be better placed in the critical history of science fiction.

In a number of critical works, these stories have either been disregarded as fantasies or mentioned only as early examples of the robot fictions that were to become a standard of the popular science fiction tradition. Both these positions betray a lack of knowledge of the cultural significance of those sciences that were most influentially participating in the definition of science as it was being formed at the beginning of the nineteenth century. This lack of knowledge is due in part to the influence of contemporary science fiction criticism, in which mesmerism is viewed as a pseudoscientific practice without current authenticity.

Recent histories of science have shown that science cannot be seen as monolithic or unproblematic in the nineteenth century and that attention needs to be paid to those areas of scientific practice that have as yet received scant attention. In revealing Hoffmann's important contribution both to science fiction and to the early-nineteenth-century debates on mesmerism, mechanics, and magic, I hope to have gone some way toward instituting a reappraisal of his position.

While Hoffmann can, of course, stand individual scrutiny as one of the most important of the nineteenth-century science fiction writers, his contextual position within a range of nineteenth-century science fiction is also important. His short fiction is contemporaneous with the work of Mary Shelley, whose novel *Frankenstein* holds a far less equivocal position in current science fiction scholarship. In certain respects, Shelley's science fiction tackles those aspects of science that Hoffmann overlooks: the internal conflicts of one scientific discipline and the ethics of scientific practice in a culture where the scientist was becoming a central figure of authority. Yet there are enough similarities in their work to suggest that they should be viewed as the starting point for nineteenth-century science fiction as a whole. Their use of the gothic, an interest in both the Romantic and the materialist scientific philosophies, and their fascination with the animation of lifeless bodies links them together in the formulation of a set of criteria that provide the basis of much of the science fiction of the later nineteenth century. Hoffmann's influence as a science fiction writer should therefore be regarded as important as Mary Shelley's. It is to her novel *Frankenstein* that the next chapter turns to uncover the sciences that form its foundation as well as to consider their cultural implications in the continuing debate over scientific authority.

Mary Shelley's
Electric Imagination

MARY SHELLEY'S *FRANKENSTEIN; or, The Modern Prometheus* (1818) is often interpreted as a cautionary tale of scientific hubris. It is undeniable that the novel critiques the role of science in the early nineteenth century, but there is a great deal more to its critique than a condemnation of the overreaching scientist. Beginning with an interest in the debates surrounding electrical research, Shelley builds a considered reading of the opposition between Romantic and materialist science as they confront each other over the possibilities and properties of electricity. Despite her own position at the heart of a Romantic movement at times suspicious of the influence of science, Shelley shows a commitment to science as it is theorized, practiced, and disseminated to the popular imagination. In fact, *Frankenstein* stands as a significant intervention in the cultural understanding of the power of electricity as maintained by various groups of scientists from the later eighteenth to the early

nineteenth century.[1] The novel highlights the equivocal position of the scientist undertaking electrical research by drawing together the various positions held by the Romantic and the materialist camps in their struggle for scientific authority.

As a commentary on the internal wrestling of one scientific discipline, *Frankenstein* is an exemplary text. Shelley's carefully woven narrative blends the evangelism of new science with the transcendentalism of Romantic science and dresses both in a gothic occultism that undermines any attempt to read the novel as a simple extrapolation of one version of events in the history of science. Allowing different scientific histories to influence the actions of Victor Frankenstein and his monstrous creation maintains a narrative dynamic that holds in suspension the peculiar controversies of the time. Neither materialist theories of electricity as a natural yet unremarkable force nor Romantic belief in the life-giving properties of electrical fluid are given primacy in the text. Such a balancing act reflects, and indeed takes part in, the popular ruminations on the potential of electricity that were ongoing at the time of the novel's publication.[2]

That *Frankenstein* is completely immersed in the scientific culture of the time is evident when comparing the critical opinion in the first year following the novel's publication and the broad sweep of contemporary scholarship. The greater the temporal gap between publication and critique, it seems, the more opaque becomes Shelley's purpose. Early commentators understood that *Frankenstein* was a "science" fiction and wrote purposefully of the innovation of such an imaginative construction. Sir Walter Scott, reviewing the novel for *Blackwood's Edinburgh Magazine* in 1818, noted that "this is a novel, or more properly a romantic fiction, of a nature so peculiar that we ought to describe the species before attempting any account of the individual production."[3] That Scott mixes the lexes of mechanized industrial output with that of natural history is apt in one of the first critiques of the science fiction genre. In assessing Mary Shelley's fiction in this way, he recognizes that *Frankenstein* uniquely captures both the rhetoric and cultural practice of science while still transforming science with the "extraordinary postulates"[4] on which the narrative is based.

Although Muriel Spark agrees with Scott that Shelley was creating a "new and hybrid species,"[5] most contemporary criticism allows the extraordinary elements of the novel to overshadow the scientific detail. Edith Birkhead, writing a century after Scott, claimed that "by resting her terrors on a pseudo-scientific basis . . . Mrs. Shelley waives her right to entire suspension of disbelief."[6] Such criticism favors the supernatural over the scientific and denies *Frankenstein* its role as investigator of the cultures of science. As the temporal aporia between critical opinion and the novel's publication widens further, readings of the text further reinforce Birkhead's accusations. Radu Florescu argues that "Mary's monster is more the child of the alchemists and occultists than of the scientists,"[7] while Robert Kiely notes that "though Frankenstein himself scorns the notion, his scientific method has a large dose of hocus-pocus in it and comes a good deal closer to alchemy than it does to physiology."[8] James E. Rieger sums up this onslaught in the most direct denial of the novel's science fiction status: "It would be a mistake to call *Frankenstein* a pioneer work of science fiction. Its author knew something of Humphry Davy's chemistry, Erasmus Darwin's botany, and perhaps Galvani's physics, but little of this got into her book. Frankenstein's chemistry is switched-on magic, souped-up alchemy, the electrification of Agrippa and Paracelsus."[9]

These critics are indicative of the contextual misinterpretation that constantly belittles Shelley's contribution to the scientific culture of the early nineteenth century. They fail to recognize the significance of the novel's genesis, which was begun the day after Shelley had listened, if not contributed, to a well-informed debate on the merits of electricity between a practicing amateur scientist and a qualified physician. They fail also to register that the new sciences of the nineteenth century did not bloom in virgin pastures but were the evolutionary creation of older traditions that encapsulate magic and the occult. Rieger is therefore correct to call chemistry "souped-up alchemy," even though it was his intention to illustrate Victor Frankenstein's occultism rather than highlight the continuity often forgotten in the history of science.

To place the blame for these limited readings wholly at the feet of particular critics is a little disingenuous. In part, it is the canonical acceptance

of *Frankenstein* as a gothic text that draws a veil over the scientific world that Shelley was investigating. The gothic appeared to suggest to many critics an antirational, supernatural ethos that did not sit comfortably with science. Gothic fictions explored occult sensibilities, rationalized their events on preternatural beliefs, and maintained that magical, secret forces were a central dynamic in the workings of the world. To be gothic was to be entirely antagonistic to the scientific. Literary history tells us that Mary Shelley was intensely interested in gothic fiction and that her reading of gothic narrative immeasurably influenced *Frankenstein*.[10] This seems a strong argument against those theses (of which this is one) that view her novel as science fiction. Yet the gothic only superficially opposed a scientific worldview. Indeed, in placing sources of power within the natural world, gothic fiction was an asset to the writer of science fiction, as Linda Bayer-Berenbaum asserts: "Gothicism insists that what is customarily hallowed as real by society and its language is but a small portion of a greater reality of monstrous proportion and immeasurable power. The peculiarly gothic quality of this extended reality is its immanence, its integral, inescapable connection to the world around us. The spirit does not dwell in another world; it has invaded an ordinary chair, a mirror, or a picture. The soul has not gone to heaven; the ghost lingers among the living."[11]

In the confusing and chaotic first decades of the nineteenth century, when science was altering the way in which knowledge gained authority, the "immeasurable power" that the gothic insisted on introducing to "the world around us" reinforced the new sciences as greatly as it did the occult and mysterious. As Bayer-Berenbaum goes on to argue, "the aim of the supernatural in Gothic literature is to become as natural as possible, an extension of nature."[12] The sensibilities of gothic fiction were therefore in tune with the experimental practices of science, which constantly upheld a methodology of natural investigation. Add to this the traces of a magical and occultist worldview that continued to infect those sciences that were coming to the fore in the early nineteenth century, and the gothic becomes a genre capable of interpreting the complex interplay of the mystical and the scientific.

More specifically, Victor Frankenstein's personal scientific interests neatly parallel such potent symbols of the gothic as the tomb interior, the diseased body, and the moonlit quest. In pursuing his investigations into the physiology of the human body, Victor finds himself paying visits to crypts and mortuaries, attending to the decomposition of the dead, and seeking experimental materials in the dead of night.[13] These episodes highlight the close proximity of the gothic narrative and the story of science. As Hoffmann had done before her, Shelley dovetails the conventions of gothic fiction with the principles of scientific investigation. Unlike those critics who assume that science fiction and the gothic are mutually exclusive narrative categories, Shelley saw the potential for fruitful juxtaposition. This is borne not only from a desire to experiment with fictional forms but also from an understanding that science, especially in the public sphere, appeared as a very gothic form of knowledge: a powerful, penetrative, and natural branch of investigation.

Of the newly discovered forces under scientific consideration in the early nineteenth century, electricity was one that embodied such a definition of the gothic and scientific. It was also one of those controversial areas of research that opened a vast chasm between different scientific philosophies. In choosing electricity, Shelley found a theme from which she was able to present an examination of the conflicting attitudes toward new discoveries that beset the scientific community at this time. Romantic and materialist scientists both believed that ongoing investigations into the origins and constituent parts of electricity would reinforce their own keenly held beliefs about the natural world. This, in turn, would bolster their own definition of science and give greater credence to their scientific philosophy at the expense of the other. The battle to secure and record the principles of electricity was in part a battle for scientific supremacy. The search for the substance of electrical power was a project intended to legitimize one set of beliefs. For the Romantic scientists, proving that electricity was a universal force that had some bearing on human spiritual existence would greatly enhance their continued insistence on the importance of natural forces as cosmic and transcendent and of science as a pragmatic tool for reading the

Benjamin Franklin extended the range of electrical power by drawing a comparison between the Leyden Jar and storm clouds. This led Franklin to suggest that lightning was an overflow of atmospheric electricity. Franklin's discovery was important in exciting scientific researchers to assert that electricity had greater natural significance than previously believed. Philip C. Ritterbush details the logic of this assumption in noting that "this discovery of atmospheric electricity inspired speculation that all kinds of natural phenomena were caused by electricity."[16] Invigorated by these discoveries, many inexplicable effects began to be defined as the product of electrical force. The medical profession was particularly enthusiastic in embracing the power of electricity. Its experiments with electrical force led to a series of electrical treatments that were viewed as an important development of late eighteenth century clinical practice. While there is a growing belief amongst historians of science that electrical cures were as much a product of psychological as somatic effects, it was from the successes of electricity in medicine that the idea of internal electricity gained currency. Immanence—the belief that subtle and invisible fluids caused all physical phenomena—had long circulated in marginal scientific practices, and the numerous discoveries in electrical research seemed to suggest that electricity may well be one of these fluids. This hypothesis only served to reinforce electricity's position as one of the most important forces in modern science. Again, Ritterbush provides some contextual commentary: "The inheritance of a harmonious system of forces was made to order for electrical speculation. This relationship between the speculative framework and the newly discovered cosmic force accounts for the extravagance of belief."[17]

The excessive claims made on behalf of electricity found voice once more in the experimental discoveries of Luigi Galvani, whom Mary Shelley refers to in her 1831 introduction to *Frankenstein*. Galvani's assertion that "all animals stored electricity on their tissues"[18] was the result of a series of experiments in which he agitated the limbs of small animals with electricity. The physical movement of the animals' limbs when charged with electric force suggested to Galvani that muscular animation was a product of electrical charge.

For the Romantic scientists, Galvani's discovery was undeniable proof of their philosophical belief in universal forces that affect the natural and animal worlds equally. Electricity was the subtle fluid they had long theorized as the life-giving principle of human existence. Electricity, some claimed, was the basis of the human soul, and science had now discovered one of the basic building blocks of God's own inventions. It is, however, at the height of electricity's Romantic status that empirical scientific practice undermines these claims. Alessandro Volta, a physicist with expertise in electrostatics and meteorology (two of the fields in which the nature of electricity had been widely debated), claimed to have proved Galvani incorrect in his assumptions about the animating force of electricity.

Volta had copied Galvani's experiments on small animals, but his results led him to very different conclusions: "By November 1792, after countless trials on diverse unlucky creatures, . . . Volta had concluded that all Galvanic excitations arose from external electrical stimulus."[19] The effect of Volta's experiments was immediate and revolutionary: "At a stroke electricity was dethroned from its position as master of the cosmos and shown to be a property of common matter. This difference of emphasis, as much as the specific errors disclosed in the theory of life, destroyed the idea of immanence upon which speculations on electricity had been based."[20] Romantic electricity may have been ousted from a position of eminence, but it was not defeated. Galvani in particular would not admit that his experimental errors denied the overall validity of his thesis. As claim and counter-claim were exchanged, the scientific community became embroiled in a confrontation that lasted long after Galvani's death in 1798. As one of his biographers argues, "When Galvani died, prospects for the survival of his theory were very uncertain. Nevertheless, support for the concept of animal electricity survived into the nineteenth century."[21]

It is within the context of these nineteenth-century debates that *Frankenstein* should be placed. Although pressure was growing on the Romantic conception of electricity in the first two decades of the nineteenth century, there remained a great deal of equivocation over its material construction. Electricity was still widely accepted as a fluid, although

opinion differed as to its exact makeup. As a typical scientific treatise of 1815 reveals, electricity was best explained by "the hypothesis of one, or two such fluids."[22] Where the Romantic collided with the materialist, scientists tended to tread more carefully. The same writer tentatively acknowledges that electricity has a "tendency to unite with and in inert matter"[23] but does not go so far as to defend Galvani's animation principle. Later in the same thesis, the author does note that "electricity pervades all nature,"[24] a comment more sympathetic to the Romantic position than the previously skeptical assessment of its role in "matter." How to negotiate between Romantic and materialist discourses was, as we can see, a very difficult task. The heterogeneity of electrical theory made it almost impossible to categorize it adequately, especially in the obscure middle ground between the more occultist Romantics and the vigorously antitranscendental materialists.

Of the two poles, German *naturphilosophie* is exemplary of the occult philosophies that took electricity to be one of the fluids that constitute an invisible life force or soul. Led by Friedrich Schelling,[25] German Romantic science viewed electricity as the pinnacle of all the natural forces (which included magnetism, heat, light, hydrogen, and oxygen). Schelling and his followers disseminated their view that electricity was an *urphanomene* (primal force) that would unlock many of the natural mysteries of the world. In opposition to this stood scientists whose empiricism held such occult notions as anathema to "real" scientific research. Alessandro Volta and Hans Christian Oersted exemplified this position in their total rejection of any *spiritus animus* in electricity. For them, electricity was another property of common matter that in no way suggested itself as a life-giving fluid.

It is easier to differentiate between such opposing philosophical positions when they are the extremes in a broad spectrum of debate. However, it was far more common to find scientists who positioned themselves on the boundary between these opposing ideas. Humphry Davy is a good example of a scientist unwilling to take up one position or another. A staunch defender of Romantic principles of nature, Davy advocated a less extravagant approach to electrical force and called for detailed scientific experiments and observations that might prove the

validity or otherwise of multifarious theories. Erasmus Darwin, likewise, spoke for many eighteenth-century naturalists when he argued that electricity may prove to be the animating principle in common matter but it could not possibly be the source of the human soul.

Darwin and Davy's positions highlight the complexity of belief over the nature of electricity in the early nineteenth century. Yet almost all *Frankenstein* scholarship fails to recognize the intriguing dynamics of electrical theory that the novel attempts to encompass. Even Maurice Hindle, in an otherwise brilliant reading of the text, misses the subtle differences of opinion that characterize the period. Arguing that the received view of the monster without a soul is a response to the Frankenstein myth rather than the novel itself, Hindle concludes that "the 1818 edition of *Frankenstein* has a passage explicitly referring to electricity as a 'fluid.' This suggests that Frankenstein's cosmology does originally contain the notion of an immaterial, but 'sensing' human soul, one that shares its life-nature with electricity."[26] Hindle too readily accepts that if electricity is viewed as a fluid, it must also be part of a wider belief system that is thoroughly Romantic and occultist. This is not the case. Even those scientists who aligned themselves with the materialists did not always deny that the fluid theory was the most acceptable paradigm of electrical composition. As E. T. Whittaker notes in discussing the work of an electrostatics researcher and materialist scientist, "electrostatic theory . . . suddenly advanced to quite a mature stage of development by Simeon Denis Poisson in a memoir which was read to the French Academy in 1812. As the opening sentences show, he accepted the conceptions of a two-fluid theory."[27]

While Hindle is one of the few critics to recognize Mary Shelley's contribution to electrical research in the novel, his simplification of the paradigms of electricity tend to reduce the novel's complex reading of it to a single belief system. In fact, Shelley is never specific in detailing which electrical theory Victor Frankenstein accepts when animating his reconstructed human. Forever shifting his principles from materialist to Romantic, Victor cannot be limited to one scientific philosophy. Nor can the monster be said to exist on the basis of a single reading of elec-

tricity. Without being able to categorize electricity, it is an impossible task to "read" the monster's spiritual existence solely from the techniques used to vitalize him. In fact, the novel invites a simultaneous reading of the monster (and of Victor) as both Romantic and materialist. These two positions do, of course, provide alternative and conflicting points of view, but it is important to recognize that both of them are available to the reader and critic throughout the novel. For it is in the lack of a singular scientific foundation for the novel's extrapolation of electrical power that the narrative intervenes in the problematic status of the sciences in the early nineteenth century.

Similarities can be found here with Hoffmann's construction of the scientific world in the short fictions "Automata" and "The Sandman." Hoffmann, like Shelley, combines opposing scientific philosophies in order to highlight the battle for scientific authority that characterized the first two decades of the nineteenth century. However, *Frankenstein* is decidedly different from Hoffmann's work in important ways. Shelley does not set up the same triangulation of new science, marginal science, and the occult that Hoffmann employs. Rather, she gives voice to two separate philosophical positions, both of which laid claim to scientific truth. Hoffmann revolves his narrative around different types of science while Shelley is interested only in electricity. Indeed, Hoffmann leaves his narratives more open than does Shelley on the question of scientific authority. While Shelley never places one branch of electrical research above the other, she does view the links to an occult and alchemical past as associated more with the Romantic position than the materialist. In doing this, the novel becomes more prophetic than Hoffmann's short stories can claim to be, for *Frankenstein* does prefigure the removal of the occult connections in the new materialist sciences that were to gain greater authority as the nineteenth century progressed. Shelley's science fiction is also more extrapolative than Hoffmann's: her novel looks to the future both in terms of scientific ascendancy and the effects of certain scientific beliefs on the individual and society. Hoffmann's fictions worked more readily on a present understanding of the power dynamics of various scientific disciplines. His short stories and Shelley's novel are an excellent

pairing in the early history of science fiction. They function as exemplary texts in the reading of scientific culture, showing an understanding of the complexity of that culture as it undergoes significant change.

Frankenstein allows us to observe this change through the shifting dominance of Romantic and materialist conceptions of electricity. Although there are several moments when it seems that Victor has become a convert to either Romanticism or materialism, the narrative never allows one to capture the foreground for long. Nevertheless, it is possible to trace the formation of these opposing philosophies, beginning with the powerful influence of materialism that Victor is subject to in his formal education.

While Victor's boyhood experiences are predominantly occultist and Romantic, by the time he becomes involved in his academic studies at the University of Ingolstadt, materialist conceptions of science have made him aware that there is a scientific community that denies the importance of those occultist figures that he had previously found so inspiring. Scientific pragmatism begins for Victor when he encounters the two professional scientists, Krempe and Waldman. Still impressed by alchemists and occult scientists, Victor initially finds Krempe "a squat little man, with a gruff voice and repulsive countenance [who] did not prepossess me in favor of his pursuits" (45). Waldman, however, makes a very different impression. Not as dismissive of the occultists as his colleague, he persuades Victor that the new science builds remarkably on their work:

> The modern masters promise very little; they know that metals cannot be transmuted, and that the elixir of life is a chimera. But these philosophers, whose hands seem only made to dabble in dirt, and their eyes to pore over the microscope or crucible, have indeed performed miracles. They penetrate into the recesses of nature, and show how she works in her hiding-places. They ascend into the heavens. . . . they have acquired new and almost unlimited powers; they can command the thunders of heaven, mimic the earthquake, and even mock the invisible world with its own shadows. (47)

Beginning modestly, Professor Waldman's oration soon reaches the hubristic championing of empirical science that many critics have attributed to Victor. His "panegyric" reveals the penetrative and masculine aspects of materialist science as well as the godlike status awarded to the scientist (46). Yet this is tainted by the practice of such science, which scrabbles dirtily and peers voyeuristically into the natural world. Shelley never allows materialism to talk entirely on its own terms, and even here, in the battle cry of the great materialist scientist, there is a hint of disease and malformation. Ironically, Victor—who will very soon be dabbling in dirt himself—is inspired by the claims of Waldman, who has previously warned him against following only "the ancient teachers [who] promised impossibilities" (46). Indeed, Victor's change of perspective is so pronounced that he even admits that Professor Krempe imparts "a great deal of sound sense and real information" (49).

The materialist philosophy with which Victor now pursues his scientific studies is reflected in the account of his research into "the cause of generation and life" (51). Victor's methodology is based on the principles of scientific experimentation set down primarily by Oersted in the late eighteenth and early nineteenth century. Oersted's procedures, designed to give new science a definitive method of observation and analysis, were also a strategic attack on the Romantic sciences and their lack of experimental integrity. For Victor, to follow Oersted's practices is to further reinforce his position as the thoroughgoing materialist. Oersted's methodology was based on the scientific experiment being "the test of a hypothesis under controlled conditions"[28] that "must be clearly defined in terms of questions to be answered, hypotheses to be tested, specifications to be met, or effects to be estimated."[29] Every properly conducted experiment should "describe the following five aspects ... treatments ... experimental material ... size of experiment ... experimental techniques ... [and] related variables."[30] Victor follows the first of these four experimental rules assiduously. His failure to comply with the fifth raises an ambiguity in the novel over the appropriateness of Oersted's materialist methodology and thereby questions Victor's decision to forego Romantic science in favor of a rigorous materialism.

The treatments—those objects to be placed under scientific scru-tiny—make up the most gothic section of his experimental research. Spending "days and nights in vaults," Victor determines "the corruption and death" of organic matter and the inheritance of the worm over "the wonders of the eye and brain" (50–51). Having acutely observed these processes, Victor then begins to collect the materials for his experiment from "the unhallowed damps of the grave" (53). At this point, he de-scribes the size of his experiment, altering his original plans to take ac-count of the problems that the materials gave rise to: "As the minuteness of the parts formed a great hindrance to my speed, I resolved, contrary to my first intention, to make the being of a gigantic stature; that is to say, about eight feet in height, and proportionably large" (52). Victor's experimental technique is more difficult to define, for it is around that contentious issue that the novel circulates its reading of Romantic and materialist aspects of electrical hypotheses. Nevertheless, Victor does still reveal that it is electricity that provides the animating principle. "I collected the instruments of life around me," he ambiguously states, "that I might infuse a spark of being into the lifeless thing that lay at my feet" (56). There can be no question that the rhetoric of electricity informs this description, and it gives the lie to those critics who believe that there is no scientific basis for Victor's experiment. To "spark" is to be electric. Galvani, Franklin, Oersted, and the many other scientists (whether Romantic or materialist in their convictions) who were work-ing with electricity in the late eighteenth and early nineteenth century employ this vocabulary to describe electrical action. If we place this alongside Shelley's discursive commentary in the 1831 introduction, there is a body of evidence that demands the text be read as an investigation into electrical power.[31]

It is with the related variables of his experiment that Victor's mate-rialism becomes problematic. Having begun his work on the basis of materialist methodology, he fails to complete his experiment satisfacto-rily. Rather than taking account of the variables that may infect his at-tempts to animate a lifeless body, Victor becomes "unable to endure" his research and completes the experiment without due care for the proce-dures that he had set in motion (56). Whether Shelley is suggesting that

the failure is the fault of materialist method itself or of Victor's inability to comply with that method remains ambiguous. Indeed, this ambiguity is part of the novel's sophisticated analysis of conflicting scientific philosophies. That it retains a tension between a failure of materialism and a failure to implement materialism maintains a balanced, if fragile, construction of scientific authority. Materialism is neither privileged nor condemned by Victor's actions; its position remains equivalent to that of Romantic science.

What can be accepted is that Victor's experimental method is materialist in origin. *Frankenstein* clearly duplicates Oersted's prescribed stages of hypothesis, observation, and testing, with human body parts taking the symbolic place of the chemical substances that Oersted had used in his own examples. This attention to empirical practice is brought forcefully to the surface when Victor pauses to describe the creature he has assembled. Materialism is writ large on the body of the creature, whose foul and sepulchral image reiterates the dirt in which Professor Waldman envisioned the new scientist dabbling:

> I collected bones from charnel-houses and disturbed, with profane fingers, the tremendous secrets of the human frame. In a solitary chamber, or rather cell, at the top of the house, and separated from all other apartments by a gallery and a staircase, I kept my workshop of filthy creation. The dissecting room and the slaughter-house furnished many of my materials. . . . His limbs were in proportion, and I had selected his features as beautiful. Beautiful!—Great God! His yellow skin scarcely covered the work of muscles and arteries beneath; his hair was of a lustrous black, and flowing; his teeth of pearly whiteness; but these luxuriances only formed a more horrid contrast with his watery eyes, that seemed almost of the same colour as the dun-white sockets in which they were set, his shrivelled complexion and straight black lips. (53–56)

The creature's appearance personifies the materialism that has come to be the major force in Victor Frankenstein's scientific thinking at this point. With a certain dry humor, Shelley turns materialist philosophy into actual, physical material. As though to reinforce this, Victor is visited by

a nightmare in which he and Elizabeth (his fiancée) embrace, only for her to die as their lips touch:

> I thought I saw Elizabeth, in the bloom of health, walking in the streets of Ingolstadt. Delighted and surprised, I embraced her, but as I imprinted the first kiss on her lips, they became livid with the hue of death; her features appeared to change, and I thought that I held the corpse of my dead mother in my arms; a shroud enveloped her form, and I saw the grave-worms crawling in the folds of flannel. I started from my sleep with horror; a cold dew covered my forehead, my teeth chattered, and every limb became convulsed: when, by the dim and yellow light of the moon, as it forced its way through the window shutters, I beheld the wretch—the miserable monster whom I had created. (57)

Victor associates his own body with the corpses from which he had constructed his creature, and the dream extends this comparison by painting a picture of Victor's physical touch as a harbinger of death and decomposition. There is then a shift from Elizabeth to Victor's mother, highlighting the guilt Victor feels at having betrayed her hopes for his future. The nightmare then turns to Victor's own body once again, comparing its movements to the convulsive animation of the monster. To make clear this connection, Victor awakens to the sight of the monster and the reality of his materialist experiment. Overall, the dream illuminates Victor's unconscious perception of the effects of his scientific practices on the wider community: his desire for family (both maternal and sexual) is obstructed by a science whose uncontrolled investigations lead to the death of the objects of desire.

Building an image of the monster as a physical incarnation of scientific method, Shelley plays on Victor Frankenstein's own claims of godlike status. Earlier in the narrative, Victor had immodestly challenged the creative authority of God. During the early stages of his work he had argued that "a new species would bless me as its creator and source; many happy and excellent natures would owe their being to me. No father could claim the gratitude of his child so completely as I should deserve theirs" (52–53). Rather than the image of God, Victor's "children" should

take on his image, the image of the materialist scientist, and indeed the creature does become a physical representation of the materialist methodology that led Victor to his electrical discoveries.

The monster's classification as a creature of materialist science is most decidedly reinforced by the reactions of human society. While his appearance is certainly unusual and, if Victor's own descriptions are to be taken at face value, also hideous and frightening, there is something out of the ordinary in the very extreme reactions that the monster encounters. His first attempt at cultural intercourse is met with fear, hatred, and violence. Even when the monster more carefully chooses his moments to engage with society, he is met with "horror and consternation" (131). In the section of the novel given over to the creature's own description of his life, he details his meeting with a blind old man whose family he has watched for some time from a secure hiding place. The old man, disabled and disfigured and therefore somewhat of a human parallel to the creature, talks with the creature for some time, assuring him that even if he were "a detestable monster" or a "criminal," he would not judge him (130). However, when the family inadvertently returns to break up this meeting, the old man discovers the very different genesis of the creature. In exclaiming, "Great God . . . who are you?" he clearly dissociates himself from the monster and calls into question the human lineage that he had originally taken for granted (131).

That the old man, sympathetic to the creature from the start and able to accept a variety of deviancy, should suddenly find him totally alien tells us of the demonic essence of the creature. Yet even if the creature is gigantic, he is physically human. There must therefore be something integral to the creature's total constitution that is inhuman and other. Again, a comparison with Hoffmann is useful in illuminating the creature's preternatural origins. Both the Talking Turk and Olympia (like the creature, representations of an artificial human) are manifestly imitation. Their physical characteristics are mechanical rather than organic. It is for this reason that Olympia in particular is disliked by the community. While the Talking Turk can be said to simulate human intelligence, his status as a human is never accepted and the origin of his intellect is believed to be magical. Victor Frankenstein's creature is

a more sophisticated form of automaton. He is organic rather than mechanical and moves by internal electrical power rather than a network of gears and wheels. The creature is a far more skilled simulacrum of the human form than those imagined by Hoffmann, but he is a simulacrum nonetheless. To that extent, then, he remains as unnatural a being as either the Talking Turk or Olympia. Their inner vacuum, that cavity that reveals nothing but the constant whirring of mechanical parts, is still to be found in the organic monster. However, his void is not material but spiritual. The materialist science that has given him life has stripped him of a soul.

Constructed according to a strict process of empirical observation and experiment, and by a scientist whose youthful interest in Romantic science is backgrounded in favor of a strict adherence to materialism, the monster is inextricably a soulless creature. As a personification of materialist science, the monster has to be denied any spirit or soul. He is nothing but an aberration of the mechanical automaton, a clockwork toy made monstrous by his organic body. In offering this as a possibility, Shelley adheres to the position of materialist science in the early nineteenth century. The physiologist Charles Bonnet argued that "it is not to be denied that Supreme Power could create an automaton which should exactly imitate all the *external* actions of man" [my italics].[32] It is external actions that are important here. Bonnet denies that any supreme power (to which electricity could lay some claim) could offer more than a basic animation of the physical body. Prevailing opinion had already supported Bonnet's view. Materialist scientists from Descartes to La Mettrie had previously argued for the separation of the body from an inner intelligence.

Samuel Holmes Vasbinder says more about dualism in his intriguing reading of the monster as a child of materialist science. Arguing that the creature progresses through several stages of enlightenment, learning, and experience, Vasbinder relates these stages to the work of empirical materialist David Hartley. Hartley's philosophy, set down in *Observations on Man, His Frame, His Duty and His Expectations* (1791), is based on a dualism that denies the existence of a human soul and

opposes the cosmic harmony so central to Romantic scientific thought.[33] In Vasbinder's convincing reading, it is not only in the reactions of society that we see the monster's soullessness but also in his own narrative of learning and progress. The evidence of the creature's own testimony weighs heavily in favor of the pervasive influence of materialism. Yet as the creature tells us, the blame for his construction has to be fixed firmly with his scientific creator, Victor Frankenstein. Certainly, it is on Victor that the focus should fix. It is his methodology and electrical beliefs that influence the creature's animation. While Victor Frankenstein certainly became increasingly materialist throughout his course of study at the University of Ingolstadt, there are suggestions earlier in the novel that his character leans toward materialism, regardless of the inspiring rhetoric of his professors.

The two central figures in Victor Frankenstein's childhood are Henry Clerval and Elizabeth. Clerval acts as a foil to Victor's nature while Elizabeth's influence on them marks their different characters. In Victor's own narrative of his childhood years, we see a reluctance to give in to the Romantic inspiration that Clerval enjoys. Victor is always to be found in "intense application" and "investigation" of the natural world, looking for "a secret which [he] desired to divine" (36). By contrast, Clerval became "deeply read in books of chivalry and romance" and "composed heroic songs, and began to write many a tale of enchantment and knightly adventure" (36–37). Polarized as the scientific investigator and the Romantic author, Victor and Clerval also react differently to Elizabeth's promptings. Victor has a temper that "might have become sullen" were it not that Elizabeth could "subdue" him (37). In opposition, Clerval is inspired by Elizabeth, who "unfolded to him the real loveliness of beneficence" (38).

Clerval's Romantic excess, poured out in fictions of medievalism and magic, is set against Victor's pragmatic observations and dour empiricism. Stereotypical as these characterizations may be, they highlight a penchant for the material world that exists in Frankenstein's character long before his university career begins. Late in the novel we see their differences exacerbated further by Victor's immersion in materialist science:

After some days spent in listless indolence, during which I traversed many leagues, I arrived at Strasbourg where I waited two days for Clerval. He came. Alas, how great was the contrast between us! He was alive to every new scene; joyful when he saw the beauties of the setting sun, and more happy when he saw it rise and recommence a new day. He pointed out to me the shifting colours of the landscape, and the appearance of the sky, "This is what it is to live," he cried; "now I enjoy existence! But you, my dear Frankenstein, wherefore are you desponding and sorrowful?" In truth I was occupied by gloomy thoughts, and neither saw the descent of the evening star, nor the golden sunrise reflected in the Rhine. (149)

Giving further dramatic emphasis to the differences between Victor and Clerval, Shelley allows the latter to explicitly articulate the chasm that has opened between them. Although Victor's position remains opaque, he is placed entirely in opposition to Clerval's Romantic delight in nature and his transcendental belief in the connectedness of human life and the natural world. Victor is not only "listless" and "gloomy" but also unable to take pleasure in the effects of nature. Victor unweaves Keats's rainbow in this extract. His observations into the minutiae of nature through the practice of materialist science appear to undermine his ability to appreciate the sublime grandeur of the natural world.[34]

Susceptibility to materialist principles is therefore revealed in Victor's personality early in the text and is brought vividly home in his later meeting with Clerval. Now a lineage of materialist science can be traced through *Frankenstein*. Victor, occupied by occultists and alchemists in his youth, is unable to give his materialist impulses free reign until he arrives at Ingolstadt. Once there, his acceptance of the occult is challenged and his interest in new science fostered. Victor concurs with Professor Waldman's rhetoric and allows his latent materialism to rush to the surface, overwhelming him and directing his research toward the re-creation of life. Overcome by the apparent power of materialist procedures, Victor creates a monster in his own image, a soulless creature that performs the role of a hideous harbinger of materialist science throughout the remainder of the narrative. Blame, if there is blame to be

attached, is directed toward Victor rather than his scientific philosophy and methodology. The scientist rather than the science is laid bare to criticism. Victor's inability to temper the rhetorical power of the new materialist science is the central impetus for the murderous reign of his creature.

Nevertheless, materialism is only one half of the scientific foundation of *Frankenstein*, and a corrective is required to give proper balance to the debate between materialism and Romanticism that Shelley attempts to elucidate in her novel. While materialist belief was on its way to becoming the received orthodoxy at this time, Romantic notions of electricity as a cosmic and spiritual force were still current. Indeed, to the interested layperson or scientific amateur, Romantic electricity captured the imagination more than materialist theories. Partly because the excited responses to Galvani's claims predated Volta's diminution of electrical power, materialist science was often perceived as reductive and unimaginative in the minds of the popular scientific audience. In the gothic frisson of the animation scene, *Frankenstein* plays on that willingness in society to aggrandize electricity. The "spark of being" that animates the monster becomes a teasing signification of an electrical force that may just be able to provide spiritual regeneration:

It was on a dreary night of November, that I beheld the accomplishment of my toils. With an anxiety that almost amounted to agony, I collected the instruments of life around me, that I might infuse a spark of being into the lifeless thing that lay at my feet. It was already one in the morning; the rain pattered dismally against the panes, and my candle was nearly burnt out, when, by the glimmer of the half-extinguished light, I saw the dull yellow eyes of the creature open; it breathed hard, and a convulsive motion agitated its limbs. (56)

This passage is a classic example of the early science fiction form. It appears to provide a rational scientific explanation for the animation of the creature but does in fact elide any specific reference to scientific technique. The instruments of life remain uncataloged and the infusion of a spark is left vague and unrealized. Between these discrepancies and

the moment of life is a grand caesura that hides any methodology or specific scientific detail. Shelley's technique is to be elusive rather than concrete. We register the scene as scientific, but any actual science has been erased by an intervening censor.

There is not only merit in this technique—which science fiction throughout the nineteenth century uses and adapts—but also an essential function that is demanded by the scientific story Shelley is telling. In leaving the creation of the monster equivocal, the vital turning point between inertia and animation can be appropriated by either materialist or Romantic science. Moreover, without either of these opposing philosophies able to defend their position from textual evidence, they both exist simultaneously, caught in a moment of equivalence at the very center of the novel.

Shelley is clever with the form of the novel at this moment. Although no credence is given to electricity as a Romantic form of energy, the symbolic imagery of Victor Frankenstein's narrative is allied more closely with Romantic science. Using the gothic talismans of a secret interior space, the hours of darkness, the stormy weather, and the partial lighting, Victor's laboratory experiment takes on the occult tone more often associated with Romantic science. Shelley depends on the popular associations between Romantic science and earlier forms of knowledge in bringing Romanticism to the fore in this creation scene. With the rise of the new science in the later eighteenth and early nineteenth century, Romantic science—which had always been distinct from the occult sciences—was marginalized as an anachronistic practice that was about to be superceded by a new methodology more accurate in divining natural truths. As a materialist empiricism made headway in the scientific community, Romantic scientists found themselves characterized as unorthodox practitioners in much the same way as occult sciences had been chastised in their turn. Of course differences between these two remained clear, yet in the popular imagination Romantic science was allied with the occult as a form of knowledge that was less orthodox and less attentive to scientific procedure. This impression is certainly unreasonable, especially in light of the contributions made by the occult and Romantic sciences to the larger body of scientific knowledge, but

the grand claims that each made for the natural world, and the necro-mantic attitude they struck with regard to investigative practice, made them easy targets for the attacks of the new science.

In 1816, however, there was as yet no clear delineation between ma-terialist science and its Romantic counterpart. In the field of electrical research, the boundaries between them were extremely difficult to find. For *Frankenstein* to pursue an analysis of electricity based in Romantic science was to develop a series of theoretical positions that already ex-isted in the scientific community, and Shelley would undoubtedly have gleaned some knowledge of these from both Percy Shelley and John Polidori. Conscious of the combinations that were possible in pursu-ing an investigation of the hypotheses of electrical force, Shelley is at pains in the early sections of the novel to highlight Victor's interest in the occult and Romantic traditions. This is very important preliminary work, for it provides a counterbalance to the materialism that is more explicit in Victor's later studies. Equally, to introduce Romantic science early in the novel makes more plausible a reading of the creation scene as predominantly Romantic.

Early in his own narrative, Victor describes his interest in "natural philosophy" and states "those facts which led to my predilection for that science" (38). His first scientific encounter is with the work of those re-searchers now marginalized as alchemists and occultists:

> When I returned home my first care was to procure the whole works of [Cornelius Agrippa], and afterwards of Paracelsus and Albertus Mag-nus. I read and studied the wild fancies of these writers with delight; they appeared to me treasures known to few besides myself. I have de-scribed myself as always having been imbued with a fervent longing to penetrate the secrets of nature. In spite of the intense labour and wonderful discoveries of modern philosophers, I always came from my studies discontented and unsatisfied. Sir Isaac Newton is said to have avowed that he felt like a child picking up shells beside the great and unexplored ocean of truth. Those of his successors in each branch of natural philosophy with whom I was acquainted appeared even to my boy's apprehensions, as tyros engaged in the same pursuit. (39)

The majority of critics who view *Frankenstein* as a gothic novel use these autobiographical revelations to argue that Victor is more a seer than a scientist and that it is necromancy that informs the animation of the creature. However, here and in later rhetorical passages, Victor promulgates a far more complex scientific lineage than they give credit to. As visionary promoters of scientific knowledge, Paracelsus, Agrippa, and Magnus are placed alongside Sir Isaac Newton as vital figures in a scientific education. Although Victor's narrative voice is skeptical of the profit he gained from reading the works of the occultists, it is important to recall that this narrative is retrospective and has as its audience Walton, whom Victor is warning of the influence of science on the hubris of mankind.

More revealing than the bibliographical details of Victor's scientific studies is his first observation of electrical power when he witnesses the explosion of a tree that is hit by lightning. As Victor describes it, the oak was nothing "but a blasted stump" that had been "shattered in a singular manner" (40). Watching this display of electricity with Victor is a man of new science:

> Before this I was not unacquainted with the more obvious laws of electricity. On this occasion a man of great research in natural philosophy was with us, and, excited by this catastrophe, he entered on the explanation of a theory which he had formed on the subject of electricity and galvanism, which was at once new and astonishing to me. All that he said threw greatly into the shade Cornelius Agrippa, Albertus Magnus, and Paracelsus, the lords of my imagination; but by some fatality the overthrow of these men disinclined me to pursue my accustomed studies. (40)

Again, the "theory" of electricity is left vague, although it seems likely that a new theory that talks to galvanism would be in line with Volta's dramatic overthrow of Galvani's hypotheses. It is certainly true that any representative of the new science would undoubtedly undermine Victor's faith in the occult sciences that have until now been the mainstay of his scientific research. Indeed, parallels between the unnamed

"man of great research" and Oersted are compounded only moments later when Victor—influenced by the tutorial he has received—vows to direct his attention to the "secure foundations" of scientific knowledge rather than the chimerical occult theories he has admitted to previously (41). What is intriguing here is that the overthrow of the occult sciences does not turn Victor toward materialism. In fact, it is exactly the opposite: his studies in natural history are made mundane by the loss of the occult, and he determines to give it up altogether.[35]

Why is it, then, that Victor suddenly decides to revive this interest at Ingolstadt? The answer is to be found in the rhetoric of Professor Waldman. Waldman alone inspires Victor to return to the studies that he had set aside. Waldman's lecture, which I have previously categorized as an homage to materialism, also possesses the rhetorical stance of the Romantics and occultists. Waldman may deny the importance of these branches of scientific knowledge, but he does so in language appropriated from them. It is in this combination of occult, Romantic, and materialist discourse that Victor finds himself "grappling with a palpable enemy" that must surely be read as the materialist science that has been anathema to all his previous scientific experiences (47). Nevertheless, Waldman's lecture belongs in both the Romantic and materialist traditions: he may be referring to new science, but in his rhetoric he appeals to the divine and iterates the cosmic and universal power of science. In exclaiming for science such control and power, he is as effusive and ambitious as the Romantic scientists and occultists that others (particularly Krempe and the natural philosopher) denigrate. Yet it is exactly this expansive discourse that Victor finds so appealing. Therefore, while we perceive Victor as a convert to materialism in the aftermath of Waldman's lecture, he still remains bound to the Romantic and occultist tendencies of his youth. Ultimately, Victor's scientific practice is a synthesis of materialist method and Romantic imagination.

Vasbinder has highlighted the significance of Waldman in uniting the Romantic with the materialist by drawing parallels between Waldman and Humphry Davy.[36] In a persuasive reading of Waldman's monologues, Vasbinder reveals the influence on Shelley of Davy's discourse in *Elements of Chemistry*. Arguing that Davy's interest in vitalism and

his experiments into the connections between base chemicals and the construction of molecular electricity prove his Romantic inclinations, Vasbinder suggests that Shelley was conscious of the belief in electrical force that Romantic science upheld and was concerned to introduce this into the novel's scientific foundations. While it is probably going too far to suggest, as David Ketterer does, that "Frankenstein might be said to represent Romanticism in a nutshell,"[37] it is certainly the case that the spirit of Romanticism still inhabits Victor Frankenstein long after his scientific experiments have become entirely materialist.

If Victor maintains a certain Romanticism (even if it is as thought experiments rather than empirical observation and investigation), then we should expect to find this reflected in the creature, who is, after all, an image of himself. Despite the surface of the creature's body, which inscribes a dominant and unrestrained materialism, there are aspects to his character and actions that signify a lasting relationship with the Romanticism that informed Victor's theories of life creation. Morse Peckham highlights one way in which the monster may be viewed as a Romantic victim turned aggressor: "To impose one's will upon others . . . is to treat them as mere instruments for realizing the will, to treat them as objects, to treat them, in short, as society treats the alienated Romantic."[38] In light of Mary Shelley's own biography and the genesis of *Frankenstein,* it would be unsurprising for her to think of the creature as an alienated Romantic. Living in exile, with the publicly reviled Byron as host, and married to Percy Shelley, whose reputation had been sullied by his elopement with Mary, a feeling of alienation would be strong in the weeks that saw the novel begun and the creature created. The monster, however, only imposes his will on others after his disastrous attempts to ingratiate himself into human society. "Othered" by this society, the creature makes the relatives of Victor his instruments of revenge, turn-ing each of them into the alienated Romantic that he felt himself to be. To see the monster in this way also demands that Victor Frankenstein be seen as a Romantic rebel.[39] It is Victor that the monster wishes to re-venge himself on and whom he alienates and objectifies throughout the second half of the novel when the narrative turns from one of scientific investigation into the more traditional gothic quest. It is in these later

sections that Romantic hypotheses on the nature of the human mind and the place of humanity in the natural world are most clearly influencing the relationship between Victor and his monstrous creation.

Victor's decision to swap his place as the hunted for that of the hunter is determined by his realization that the creature poses a threat not only to his immediate family but also to humanity as a whole. As Victor toils in yet another laboratory to create a mate for his original monster, he is struck by a preevolutionary fear of the species he is helping to propagate: "Had I a right, for my own benefit, to inflict this curse upon everlasting generations? I had before been moved by the sophisms of the being I had created; I had been struck senseless by his fiendish threats: but now, for the first time, the wickedness of my promise burst upon me; I shuddered to think that future ages might curse me as their pest, whose selfishness had not hesitated to buy its own peace at the price, perhaps, of the existence of the whole human race" (160–61). Victor's sudden fear is the product of a scientific realization that had previously eluded him. He had always considered his creature the demonic personification of a materialist impulse in his scientific thinking. Yet now he considers him (and the mate he is about to animate) as a new species of animal life, one whose power is further reaching than that of humanity.

Using a common trope of science fiction, Shelley characterizes the monster as a powerful alien whose malign purpose is the destruction of the human race. While the majority of nineteenth-century science fiction extrapolates on Darwinian theory in order to imagine the evolutionary superior of man, here Shelley works from a different scientific paradigm, one that is central to Romantic conceptions of natural order. The law of parallelism, defined and described by Friedrich Schelling and others, imagines a hierarchy of animals that is always progressive. Each new species takes up a position of superiority over its predecessors, with present authority in the hands of the human race. Victor, by ascribing to this scientific model, sees his monster as part of "a race of devils" that "might make the very existence of man a condition precarious and full of terror" (160). Automatically categorizing the creature as an individual example of a new human race, Victor's knowledge and acceptance of Romantic scientific law leads him to conclude that this

species will assume a position of eminence in the animal kingdom. The creature becomes less symbolic of errant materialism and more a manifestation of a Romantic reading of natural progression.

As Victor turns his attention to the possible Romantic principles upon which the monster may be said to exist, he begins to loosen the shackles of materialist science that had gripped him since his arrival in Ingolstadt. His decision to actively pursue the creature rather than remain a passive victim of its revenge coincides with his realization that it is his own bastardization of opposing scientific philosophies that has led him to his present predicament. Shelley introduces a scene of some importance here in order to fully articulate Victor's enlightenment: the erasure of his scientific space and equipment. Victor describes this process as "odious" (164). His instruments are "sickening," his chemical apparatus require "cleaning," and the second creature is scattered around the laboratory, making Victor feel "as if I had mangled the living flesh of a human being" (164, 165). This symbolic cleansing of his experimental life illuminates the improper scientific practices that Victor had indulged. Revealing an unconscious belief in the creature's humanity (and therefore its implicit possession of a soul) while associating with this the tarnished instruments of materialist methodology, Shelley highlights Victor's peddling of both Romantic and materialist principles of electricity.

Soon after Romanticism returns to take its place in the narrative alongside the materialism that has dominated the construction and creation of the monster, we witness the only explicit reference to the creature's possession of a soul. In contemplating his own death, the monster talks of his continued existence in an afterlife: "But soon," he cried, with sad and solemn enthusiasm, "I shall die, and what I now feel be no longer felt. Soon these burning miseries will be extinct. I shall ascend my funeral pile triumphantly, and exult in the agony of the torturing flames. The light of that conflagration will fade away; my ashes will be swept into the sea by the winds. My spirit will sleep in peace; or if it thinks, it will not surely think thus" (215). In concluding his life, and in concluding the narrative, the monster foretells of the destruction of his material self and the transcendence of his soul. Nowhere else in

the novel is a Romantic conception of the power of electricity so clearly documented. Yet there remains an ambiguity to this commentary that is dependent on its positioning as the denouement of the narrative. First, it is only on the monster's terms that we read of his belief in the everlasting spirit; no external evidence is presented as confirmation. Second, the monster's discourse may be seen as a product of his learning while hidden at the house of the de Lacey family. There, he had read Plutarch, Milton, and Goethe and had his mind informed by, among other things, Werther's "disquisitions upon death and suicide" (125).[40] The Romantic and Christian rhetoric to be found not only in Goethe but also in Milton significantly influences the monster's personal eulogy. Indeed, it can be argued that the monster's vocabulary is constructed only from the de Lacey family and from these texts, making it all the more likely that they color his attempts to articulate his final moments of life. While it may be that the Romantic claims for electrical force are brought to the fore in this monologue, their validity remains equivocal and more easily attributable to other fictions than to scientific fact.

It is interesting, nevertheless, to see that Romantic science has returned to a position of prominence in the third and final volume of *Frankenstein*. Indeed, it is illuminating to follow the changing authority of the sciences as we move from one volume to another. The first—which concludes with the deaths of William and Justine—moves from Victor's early interest in the occult and Romantic sciences to his materialist education at Ingolstadt. The second—which leads us through the monster's early life and ends with Victor agreeing to create a second creature—develops the monster's Romantic education whilst maintaining Victor's fascination with materialist method. The third volume—which concludes the novel—shows Victor's coming to terms with his scientific influences alongside the monster's explicit recognition of a Romantic spirituality. Forever moving between the Romantic and the materialist, Shelley constructs her text as a constant dialogue between two opposing philosophies within the single scientific field of electrical research.

This is the ultimate intention of *Frankenstein*: to portray the complexity of scientific discourses and authorities as they affect early-nineteenth-century culture. In her introduction to the novel, Shelley alludes to this

method of reading science through the cultural imagination: "Many and long were the conversations between Lord Byron and [Percy] Shelley, to which I was a devout but nearly silent listener. During one of these, various philosophical doctrines were discussed, and among other things the nature of the principle of life, and whether there was any probability of its ever being discovered and communicated. They talked of Dr. Darwin (I speak not of what the Doctor really did, or said that he did, but, as more to my purpose, of what was then spoken of as having been done by him)" (8). Also involved in these conversations was the physician John Polidori, who completes a triumvirate of scientific professional, practiced amateur, and interested intellectual. Most interesting in this short piece of biographical detail, however, is the place Shelley reserves for Erasmus Darwin. In detailing Darwin's apocryphal experiment, Shelley makes clear that it is neither the technical scientific detail of Darwin's work nor even his own discourse on that work that interests her, but rather the dissemination of science into the public sphere.

Shelley is interested in portraying the workings of science in culture as well as in scientific theses. To some extent, this was the same thing; science was often promulgated through non-scientific channels, such as the popular press or the public lecture. Shelley's science is predicated on this mediation through the fabric of cultural life. Her project in *Frankenstein* is to produce a reading of science that plays a part in detailing the amalgamated discourses of a science in conflict and playing out that conflict on the landscape of society.

Just as Hoffmann was determined to highlight the complex dynamics of the occult, the mesmeric, and the mechanical in his short stories, so too does Shelley evoke the transgressive nature of scientific practice as the philosophies of electricity battle with one another for cultural authority. In clearly situating the novel within the domain of electrical research, Shelley offers a critique that recognizes the heterogeneity of scientific thought and its application in cultural contexts. That there are no fundamental conclusions in *Frankenstein* only serves to underline the problematic nature of scientific truth in an age where science was becoming the central depository of knowledge but was still riven with internal conflict over the nature of that knowledge.

Shelley's concluding words on scientific conflict and its role in the broader culture of the early nineteenth century come at the very end of the narrative, when the creature has outlived Victor long enough to claim narrative authority over his creator. His final task is to highlight the hubris of the scientist, an arrogance born not of the attempt to do the work of God but of the belief that science was true to its own popular rhetoric. The monster does not wish for death for any other reason than to deny Victor's powerful if mistaken perception of science: "I think on the heart in which the imagination of it was conceived, and long for the moment . . . when that imagination will haunt my thoughts no longer" (214). It is not science per se that is responsible for the creature but the process by which the scientist comes to conceptualize science. Victor's scientific work—made manifest in the creature—has utilized the philosophies of Romantic and materialist science as they were realized by the popular imagination. To paraphrase Shelley's introductory comments, Victor's re-creation of life reveals not only what science can do or what it says it can do but also what an audience outside the scientific community believed to be possible. Victor Frankenstein gains inspiration from scientific discourse as much as from scientific method. His imagination is excited by narrative more often than by any other form of knowledge, beginning with his books of occult science and ending with the lectures of Professor Waldman.

Mary Shelley's final critique is neither of Romantic nor materialist science but of the claims to ultimate authority and power that science, regardless of doctrinal differences, makes on its own behalf. The discourses of science are made real in the monstrous demon that Victor creates on a wave of rhetorical inspiration. That the monster is vast in size, powerful of body, misinterpreted by society, and unchecked by his scientist-creator gives evidence enough of Shelley's impression of the scientific imagination. In writing the language of science on the body of "the filthy daemon," Shelley makes a profound intervention in the scientific world of the early nineteenth century (73). This chapter began by discarding the notion that *Frankenstein* is a cautionary narrative, yet in one sense it is exactly that: a caution against narrative, against those stories science tells of itself and that it begins to believe.

The Human Experiments of Edgar Allan Poe

By the late 1830s and early 1840s, as Poe was writing his most important science fiction, the United States was experiencing a revolution in both mechanical science and animal magnetism. Indeed, mesmerists and machines were the focal point of public interest, each characterized by a potent symbol of power: the medical doctor and the steam locomotive. The impact of these two apparently different fields of scientific inquiry cannot be understated; they altered the landscape of science in nineteenth-century North America irreversibly and profoundly.

The advances in mechanical science begun around 1830 make a marked difference in the American landscape and psyche. For example, in 1830 73 miles of rail track had been laid throughout the country. In contrast, by the beginning of 1840, there were 3,328 miles of track across America.[1] Despite the fact that Britain was supposedly the leader in industrialization, the American experience of change was very much

more significant as the middle of the nineteenth century approached. By this time, the "American railroad mileage was almost double the British; stupendous engineering feats had been accomplished. . . . New York City was well on its way to commercial dominance [and] . . . the idea that machinery might lead to the economic use of the limited supplies of capital and labour was rapidly gaining ground and the love of gadgetry had taken hold."[2]

To be involved in mechanical science was to be at the forefront of scientific and technological development as well as a part of the vital social and cultural debates concerning the impact of science on human society. The science of mechanics was a science at the boundary of human knowledge and on the outer edge of scientific expertise. As with all scientific disciplines that do not belong to the mainstream, mechanics was not wholeheartedly accepted. Many cultural commentators were wary of the impact of the machine on human culture and their critique of mechanics continued the traditions of their Luddite predecessors.

Ultimately unsuccessful, and forever daubed as enemies of progress, the Luddites were only the first in a long line of dissenters who opposed the evangelical optimists who are more often cast as the only interrogators of mechanics in the mid-nineteenth century. Those at mid-century concerned by the speed at which mechanical science was coming to define contemporary life place less emphasis on the workplace and more on the role of the human in an increasingly mechanical environment. They question the involvement of the human in a society controlled by machines and the working methods of machines. They ask whether the definition of the human can remain the same in the face of mechanical developments. They ask what power the human retains when much of it appears to have been abrogated by superior machines.

Mesmerism parallels some of these concerns. Like the science of mechanics, mesmerism was widely seen as a developing area of science that pushed the boundaries of human capability. Although it had come a long way from the necromantic gatherings of Mesmer in his Paris salon, the science of applied animal magnetism had not yet achieved a recognizable status or authority amongst the scientific orthodoxy. Where mesmerism had made some headway was in the medical sphere. In the

United States and in Britain the restorative and curative techniques of mesmeric influence were commonly practiced by medical doctors in positions of senior authority. This in turn led to further experimental practices and to a volume of published work comparable with the output of any other scientific discipline. Led by vibrant figures such as John Elliotson, Chauncey Hare Townshend, and Thomas Capern, mesmerism reached a huge audience, its apogee achieved in the "mesmeric mania" of 1850–51.[3] Intriguingly, this follows closely on the heels of what cultural historians of industrialization have called the "railway mania" of 1845.[4]

Mesmerism as it was being conducted in the large teaching hospitals and infirmaries coalesced around a triangular relationship between patient, trance state, and doctor. Some incredible results were reported, not only of the cure of the patient but also of the visions afforded by the trance, especially in support of the doctor's diagnosis of illness. As pamphlets, letters, books, lectures, practical public experiments, public testimony, and media reports began to detail the findings of medical mesmerism, those same questions as were asked of the machine began to be asked of this more marginal scientific field. If it was a scientifically verified fact that a patient could envision illness either in herself or in others, what did this mean for human vision or consciousness? How human did one remain if a mesmerizer was able to control one's physical motions and mental capabilities? Did the results of mesmerism mean that we had to redefine the limits of humanity? Was animal magnetism a control on human subjectivity or an aid to its development?

In mechanics and mesmerism, the relationship between science and the human was being cast in the same light. Neither wholly positive nor entirely negative, the role of science in expanding or reducing human power and capability was being afforded a focus through the rise of the machine and the mesmeric experiment. Ultimately, the question of the position of science itself was at stake, for in asking where the boundaries of the self lay, society was also considering the boundaries of science. Both the machine and mesmerism were about the breaking down of boundaries: the limits of speed, the zenith of production, the gap between the organic and the inorganic, and the veil covering the material from the spiritual world.

For Edgar Allan Poe, these boundaries were a central concern through-
out his science fiction. While this chapter will concentrate on four
short stories ("The Man That Was Used Up," "The Facts in the Case of
M. Valdemar," "The Tale of the Ragged Mountains," and "Mesmeric
Revelation"), there are many other tales that exemplify his abiding in-
terest in the contestation between the science and the human, as well
as his fascination with the borderlands of scientific achievement, both
in terms of their advancement to new states of knowledge and their
place within the scientific pantheon.[5] In "The Unparalleled Adventure
of One Hans Pfaall" (1835), Poe devises a story that introduces one of
his favorite themes: the fantastic voyage. Hans Pfaall's balloon journey
takes him through one boundary—the atmosphere of the earth—and
thereby constitutes the first example of the hoax tale, felt by many con-
temporary commentators to be a boundary unreasonably crossed by
Poe himself. "The Balloon Hoax" (1844) continues this tradition of the
faked scientific expedition, the hoax this time resting on the crossing
of the Atlantic by a large airborne balloon. Again Poe combines fraud-
ulent science with the physical boundaries of exploration. "A Descent
into the Maelstrom" (1841) works to some extent in the same tradition
as "The Unparalleled Adventure of One Hans Pfaall," for it too is an
extraordinary travel narrative, although this time on the ocean rather
than in the air. The central symbol of "A Descent into the Maelstrom,"
however, is another boundary—the very edge of a whirlpool on which
the narrator hangs perilously for a lengthy section of the story. That he
survives by applying the scientific principles of motion, acceleration,
and resistance makes him a unique individual, for no other sailor has
ever survived the centrifugal force of such a vortex.

Several other examples of Poe's science fiction reveal his concerns
with metamorphosis through scientific achievement: the alteration of
material substances or the change from physical presence to spiritual
incorporeality. These tales dovetail neatly with the previous marvelous
narratives in expressing a range of imaginative readings of liminal space
entered and traversed. While the first grouping delivers characters un-
harmed from their adventures in the borderlands of science, this second
collection illustrates difference and transfiguration. "Some Words With

a Mummy" (1845), for example, humorously enacts a scientific conversation between an Egyptian king and several nineteenth-century professors, brought about by the galvanic reanimation of a mummy. The collision of the ancient with the modern is the central motif of this tale and the transitory nature of scientific belief the butt of most of Poe's comic narrative. That Poe decides to use a mummy to highlight the poverty of contemporary science is important, as it again marks his investment in the erosion of boundaries of space, time, and the material body. "Von Kempelen and His Discovery" (1849) is likewise concerned with material objects, in this instance the classic gothic trope of the transmutation of base metals into gold. Again Poe constructs this tale as a scientific hoax that plays against the recent Californian gold rush. More supernaturally, "The Conversation of Eiros and Charmion" (1839) and "The Colloquy of Monos and Una" (1841) continue the theme of materiality that had been a secondary concern in "Some Words With a Mummy" but very much in focus in the "The Man That Was Used Up" (1839). In both these rather eclectic and intellectual fictions, Poe dramatizes a dialogue between two spirits, occupying a spiritual realm that remains unlocated and nonspecific. The conversations particularly concern the memory of each spirit's transformation from material to spiritual. This attempt to articulate the transition from life to death becomes the sole focus of both tales and further reinforces Poe's continued attention not only to the crossing of boundaries but to the development of a narrative method that allows for the crossing to be linguistically registered and scientifically investigated.

While these science fictions add up to a credible amount of circumstantial evidence, it is in the four stories I detailed earlier that Poe firmly addresses the issues of mechanics and mesmerism in relation to the boundaries of the human. In his earliest SF work that talks to these themes—"The Man That Was Used Up"—Poe investigates the replacement of the human body with a mechanical substitute. Through the central figure of General John A. B. C. Smith, Poe places in dialogue the Romantic imagination, mechanical power, the human form, and class privilege. The tale exemplifies and assesses public fear over the increasingly vital role played by machine culture in the mid-nineteenth cen-

tury. Writing some time before Marx's dicta on the reification of factory workers, Poe's interest lies less in the dehumanizing effects of contemporary labor and more in the cultural significance of a society that is allowing the machine to act as a substitute for the human without this surrogacy ever being visible.

Contemporary commentators had already begun to register the encroachment of mechanics on human activities. Carlyle had amalgamated the mechanical and the human in his image of the "iron fingers"[6] of the machine as early as 1829, while Andrew Ure gave details of the "iron man," a spinning machine "with the thought, feeling, and tact of the experienced workman."[7] In the same year that Poe published "The Man That Was Used Up," *Chamber's Edinburgh Journal* published a lengthy article entitled "Machinery: A Dialogue," which enacts the fears and enthusiasms of a mechanical society:

> *A Cotton Spinner:* My friends, I tell you that all machines are abominable things. If we do not bring *them* to an end, they will soon bring *us*. The spinning machine which I manage does more work by itself than a hundred persons could.

> *Bonhomme Richard:* No, my friends, I am of quite an opposite opinion. I think the machines are productive of very great good to the country.[8]

Richard then recounts with evangelical zeal the increased prosperity that man will enjoy because of the machine's power. This argument wins the day and the dialogue ends with a unanimous cheer of "machines for ever!"[9]

Despite such widespread propaganda attempting to smooth the transition from human labor to machine production, the opposition to mechanization continued. For many the replacement of the human with the machine meant a loss of individuality, creativity, and human control. John Ruskin, an outspoken opponent of machine culture, argued that artistry and aestheticism were threatened by mechanization. Discussing the Crystal Palace in 1851, he noted that "we may cover the German Ocean with frigates, and bridge the Bristol Channel

with iron, and roof the county of Middlesex with crystal, and yet not possess one Milton, or Michael Angelo."[10] To be human, Ruskin attests, is to be individually creative, to produce work from the subjective self that cannot be repeated. Repetition and regulation are the forte of the machine and the core of its power. By setting human creativity against a regulatory framework, Ruskin formulates a definition of the human that has been forced on him by the machine culture of the mid-nineteenth century. Despite Ruskin's attempts to differentiate between the human and the machine, defining the human was becoming increasingly difficult in this period. A distinct cultural shift was underway that began to turn the strengths of the machine into the strengths of the human. To be regular in one's moral and professional life, consistent in one's behavior, and like clockwork in one's timekeeping and habits all became positive signifiers of proper human behavior. These metaphors suggest that society was increasingly defining itself according to mechanical rules, yet at the same time the machine was consistently being described in human terms.

Just as human culture was accepting the mechanical procedures of steadiness, regularity, and proficiency as positive attributes, it was at the same time trying to bring about the humanizing of the machine. Carlyle and Ure's imaginative rendering of the machine as human are good examples of this process. Such amalgamations of the human and the machine were rather disingenuous. Mechanical science may have begun to alter definitions of the human, but human intervention had little effect on the machine. Despite the rhetorical stance of those who defended mechanization, the machine did not take on human characteristics or move into a more symbiotic relationship with the human. The reality was that the machine transformed the human, but the human could not transform the machine. Rather, the machine subsumed and annihilated the human whenever they came into conflict with one another.

A revealing instance of this collision between the human and the machine occurred in 1830, when a train on a new railway line in the North West of England killed William Huskisson. Not only does this case highlight the disparate power of the human and the machine but it also signifies the lack of importance of other structures of power in the

face of mechanization. At the opening of the Liverpool to Manchester Railway on September 15, 1830, Huskisson, a member of Parliament for Manchester, wrote himself into the record books by becoming the first person to be killed by a moving locomotive engine. Huskisson's death was widely reported, especially as several holders of important public offices, including Sir Robert Peel and the Duke of Wellington, were present at the event. The facts of the case appear to show that Huskisson, traveling in a carriage attached to one of the leading locomotives, had alighted some way along the railway line when the train had stopped to take on water. Strolling across the tracks and attired in the frock coat and tall hat that symbolized his position as English gentleman, Huskisson was unaware of the approach of the Stevenson Rocket coming toward him at the heady speed of twenty-four miles an hour. Surprised by its velocity, Huskisson was unable to remove himself from the track in time for the Rocket to pass. Although, as the *Mechanics' Magazine* stated ten days later, the engineer "endeavoured to arrest its progress,"[11] the Stevenson Rocket hit Huskisson, throwing him under the wheels of the locomotive as it continued on its given trajectory. Huskisson suffered severe injuries and died a few hours later. The Rocket continued its journey from Liverpool to Manchester.

There are several factors that make this infamous case relevant to Poe's intervention in the human/machine debate in "The Man That Was Used Up": mechanical power, human powerlessness, the humanized machine, and the public and political status of the victim. William Huskisson was a member of Parliament who, seconds before the collision, had been in conversation with the Duke of Wellington. Moreover, he was wearing all the trappings of the powerful figure of authority. Yet these signifiers of class status and cultural centrality meant nothing to the machine that was to take his life. Likewise, the engineer aboard the Rocket was unable to exert any control over the outcome, as despite his attempts to bring the locomotive to a halt, the machine dictated its own movements. Perhaps realizing this, Huskisson "lost his presence of mind, seeming like a man bewildered."[12] At the very moment when the machine loosened the shackles of human control, Huskisson experienced fear. The power of the machine proved itself greater than

the power of its human creators: the mechanical scientist submitted his power to the mechanism itself.

As the report in the London *Times* suggests, the moment of collision between the Rocket and Huskisson verified that direct physical conflict between the human and machine will end inevitably in the destruction of humanity: "He contrived to move himself a little out of its path before it came in contact with him, otherwise it must have gone directly over his head and breast. As it was, the wheel went over his left thigh, squeezing it almost to a jelly, broke the leg, it is said, in two places, laid the muscles from the ankle, nearly to the hip, and tore a large piece of flesh, as it left him."[13]

Fictional representations of the collision between the human and the machine paint a similarly stark portrait. Charles Dickens, in *Dombey and Son,* imagines that confrontation in the following terms: "He heard a shout . . . felt the earth tremble—knew in a moment that the rush was come—uttered a shriek—looked round—saw the red eyes, bleared and dim, in the daylight, close upon him—was beaten down, caught up, and whirled away upon a jagged mill, that spun him round and round, and struck him limb from limb, and licked his stream of life up with its fiery heat, and cast his mutilated fragments in the air."[14] Carker, the victim of the onrushing locomotive, is not destroyed by the machine as much as consumed by it. Dickens' imagery is of ingestion and decomposition—the breaking up of the organic body and the active consuming of that body by the inorganic train. The locomotive's heated engine and the human "stream of life" are brought together in a single image that collides and bonds the machine with the human. In the same way, the *Times* describes Huskisson's physical body—if only for a brief moment—as attached to the machine, seared together in a union of flesh and metal. Of course, the disentangling of these moments of fusion results in painful annihilation of the human body for both Carker and Huskisson. The end result of confrontation with the machine is an involuntary amalgamation followed quickly by destruction and dissolution.

The case of Huskisson's unfortunate accident (and Dickens' fictional representation) is to show in miniature the effects of a formidable me-

chanical science on the human body. Huskisson's death beneath the wheels of the Stevenson Rocket not only exemplifies the lack of control that the human has over the machine (or even the loss of status in the face of mechanical power) but also reveals the cultural slide toward a mechanized society where the human first seeks to control the machine, then attempts to become like the machine, and then is finally destroyed or replaced by the machine. Of course the parading of this eventuality in the press or popular fiction did not entirely alter the perceptions of those who defended machine culture. Despite the obvious warnings of the Huskisson case, it was only a few days before another set of voices found their way onto the pages of the *Times*. On this occasion, the scientists responsible for the Stevenson Rocket and the financial owners of the railway were at pains to counter public opprobrium of mechanical power. In a lengthy open letter to the readers of the newspaper, they were "as sorry as men could be that any accident should have occurred; but as it was evident to all who had seen it that it was not occasioned by any fault of the machinery, it was requisite that they should do all in their power to prevent such a notion from getting into circulation."[15] While notional profit and the fear of lost income is certainly the initial impetus for such sentiments, it is significant that the rhetoric of the letter should turn so strongly to moral defense when the machine is brought under the microscope. For those institutionally connected to mechanics, through either scientific or corporate motivation (which, in the case of technological developments such as the rail system, is very often the same thing), the machine requires the full force of courtroom argument. In a paragraph that enacts the opening statement of a jury trial, those involved in the production of machine culture deny the liability of the machine as though it were on trial for murder. Their language relies heavily on subtle metaphors of moral personification: blame, fault, and public personae. Indeed, by default they attach blame to the victim, Huskisson, and deny that the human has any more moral authority than the machine. By transgressing into human territory, the defenders of mechanical science begin to break down the boundary between the human and the machine. Moral and cognitive understanding had

always been the reserve of humanity, yet by inscribing the machine with similar abilities in order to defend its position against the human, the difference between them becomes increasingly difficult to pinpoint.

For Dickens, however, the gap between machine culture and human culture remained. Early in *Dombey and Son,* before Carker's Huskisson-like demise, Dickens constructs an apocalyptic vision of mechanical interference in human communities by detailing the effect of the railway on the London borough of Camden:

> Everywhere were bridges that led nowhere, thoroughfares that were wholly impassable. Babel towers of chimneys, wanting half their height; temporary wooden houses and enclosures, in the most unlikely situations; carcasses of ragged tenements, and fragments of unfinished walls and arches, and piles of scaffolding, and wilderness of bricks, and giant forms of cranes, and tripods straddling above nothing. There were a hundred thousand shapes and substances of incompleteness, wildly mingled out of their places, upside down, burrowing in the earth, aspiring in the air, mouldering in the water, and unintelligible as any dream. Hot springs and fiery eruptions, the usual attendants upon earthquakes, lent their contributions of confusion to the scene. Boiling water hissed and heaved within dilapidated walls; whence also the glare and roar of flames came issuing forth; and mounds of ashes blocked up rights of way, and wholly changed the law and custom of the neighbourhood.[16]

The coming of the machine may well turn the landscape of London upside down, but it is the destruction of the human geography that so engages Dickens's ire. The space of human life is depicted as a rotting cadaver, the environment as a polluted and uninhabitable region that suffers as much from moral as physical decay. The legal and cultural alterations are as significant. Human movement and interaction are disaggregated and cauterized by the appendages of mechanization as Camden becomes a laboratory to mechanical science.

Such opposition to machine culture was not uncommon and served as a counterweight to such staunch defenders of mechanization as the scientists and managers of the Liverpool to Manchester Railway. Nevertheless,

even powerful imaginative visions of mechanical destruction rely on the same dynamic of intervention in human culture as did those who accentuated the positive influences of mechanics on nineteenth-century culture and society. Ruskin, Dickens, the factory worker, the mechanical scientist, and the corporate businessman all envision the human and the machine occupying the same space. Whatever their stance on the conflation of the human with the machine, they are in agreement that such conflation is an inevitable outcome of mechanization.

Edgar Allan Poe begins his short story "The Man That Was Used Up" from an ambivalent position between the expressions of harmony and the monstrous visions of annihilation that were the extremes of the human/machine debate. In this tale, he investigates the mechanization of the human in intimate terms, depicting a single individual whose military career demands that parts of his organic human body be replaced by mechanical substitutes. In writing a science fiction narrative that centers on the mechanization of the human, Poe obviously draws on the work of E. T. A. Hoffmann. Indeed, with his interest in mesmeric phenomena, Poe can be seen as directly influenced by Hoffmann's short fiction. Yet there are distinct differences between their attitudes and reactions to scientific developments that make comparison both complex and instructive. While Hoffmann was fascinated by the relationship between automata (the human machine), mesmerism, and magico-occult practices, Poe is more keenly interested by the cyborg (the mechanized human), medical mesmerism, and the role of science as fraudulent activity. Both writers comment on the boundaries implicit and explicit in the culture of science in the nineteenth century, but while Hoffmann concentrates on scientific boundaries, Poe investigates the boundaries of the human in different scientific disciplines. Hoffmann and Poe, therefore, are complementary figures in the history of science fiction who reveal some of the important changes in science's relationship with culture and society as the nineteenth century progresses.

Critics of Poe's work have not often cited "The Man That Was Used Up" among his more celebrated works, yet Poe himself appears to have thought rather more of it than his commentators. He chose it to accompany "Murders in the Rue Morgue" in a two-story edition of his work

that appeared in 1843. Reviewers of that volume believed that it "did in no way equal its predecessor,"[17] an opinion borne out both by earlier and later reviews. One of the first notices commented that the tale was nothing more than "a specimen of the author's power of humour."[18] Twentieth-century views have been more caustic in their criticism. Edward H. Davidson thought it to be a "piece of uncomely fooling"[19] and A. H. Quinn sarcastically noted that if there was "some profound meaning in this satire . . . it escapes the present writer."[20] These early judgments have led to a lack of critical attention on "The Man That Was Used Up," leaving only one essay on Poe's work that makes this tale its focus.[21] Nevertheless, the tale does address the profound influence of mechanical science on aspects of the human, as well as highlighting a shift in the philosophy of science from a set of values that were predominantly Romantic to those that are predominantly materialist.

This cultural relocation of science is rather complexly articulated through both the narrator and General Smith's relationship to Romantic mythology. During his investigation of General Smith's "secret," the narrator is drawn into a debate about the exact title of a Byron play: "'Man-*Fred*, I tell you!' here bawled out Miss Bas-Bleu, as I led Mrs. Pirouette to a seat. 'Did ever anybody hear the like? It's Man-*Fred*, I say, and not by any means Man-*Friday*.' Here Miss Bas-Bleu beckoned to me in a very peremptory manner; and I was obliged, will I nill I, to leave Mrs. P. for the purpose of deciding a dispute touching the title of a certain poetical drama of Lord Byron's. . . . I pronounced, with great promptness, that the true title was Man-*Friday*, and not by any means Man-*Fred*."[22] By introducing Byron's Faustian drama of thaumaturgical excess, and revealing the narrator's ignorance of Romantic literature, Poe advances his vision of scientific culture by stressing the powerlessness of Romantic occultism. The narrator, Joan Tyler Mead has argued, is more "used up" than General Smith, and if we accept that the narrator is placed so as to represent a dissolute Romanticism, then her argument has some force.[23] Certainly, the narrator's inability to correctly name Byron's play discredits him as a Romantic symbol and obversely reinforces his obsessive materialism, apparent in his curiosity of General Smith's appearance. Furthermore, that it is Byron's *Manfred* that the

narrator misrepresents is no coincidence. The eponymous antihero of this drama is brought into focus to provide a point of comparison with General Smith.

Manfred is superficially similar to the general; both seek some form of immortality through the preservation of the physical body. Yet it is their different positions within a culture of scientific experimentation that Poe wishes to stress. Manfred's assertion of necromantic power is treated with disdain and disgust by his peers. His refusal to admit culpability for his occult excesses or to cease to indulge them sees him disenfranchised from society and human fellowship. General Smith's experience is very different indeed. Although the bourgeois society within which he takes his place knows all the details of his prosthetic appendages, they hold him up as a symbol of a great age rather than condemn him for meddling with the natural world. This aggrandizement of machine culture is in direct contrast to Manfred's marginalization by a skeptical and fearful public. General Smith's science is to be celebrated while Manfred's is condemned. Manfred's world is a Romantic one, more amenable to occult sciences and less infatuated by the machine. Yet even in a society where Manfred would be likely to receive the most sympathetic of hearings his work is discredited. In "The Man That Was Used Up," however, what is significant is not only that the materialism of society places General Smith at its center but that it has entirely forgotten even the title of Byron's play. Manfred is confused with man Friday, the primitive and prescientific companion of Robinson Crusoe. That Manfred is so easily erased by the culture of the machine highlights the impotence of Romanticism in the face of a robust mechanization. Manfred and the occult systems with which he worked have become irrelevant to a materialist culture that considers science in terms of machine power and mechanical creativity.

For Poe to record the relationship between Romanticism and materialism so carefully reveals the importance of the shift in power relations between the two. In Mary Shelley's *Frankenstein* the conflict between a Romantic and materialist electricity was bitterly fought and had an outcome that suggested a certain equality of authority. As Poe argues in "The Man That was Used Up," this balanced coexistence is no longer

the case. Power has moved so significantly to the materialist camp that Romanticism—here symbolized by a literary text concerned with the state of advanced human knowledge—is no longer properly recognized. Manfred has become irrelevant to a society mesmerized by the machine and is replaced by a new hero: the mechanized General Smith. Where Shelley and Poe arrive at similar conclusions is in seeing the effect of materialist science on the human. While Frankenstein's creature revealed the influence of materialism in his hideous physical appearance, General Smith is treated satirically as an absurd promoter of mechanical science.

General Smith's first speech on the wonder of the machine age illuminates Poe's belief in the vacuousness of scientific rhetoric. As the narrator, in conversation with General Smith, reports, "'There is nothing at all like it,' he would say. . . . 'There is really no end to the march of invention. The most wonderful—the most ingenious—and let me add, Mr.—Mr.—Thompson, I believe, is your name—let me add, I say the most *useful*—the most truly *useful*—mechanical contrivances are daily springing up like mushrooms, if I may so express myself, or, more figuratively, like—ah—grasshoppers—like grasshoppers, Mr. Thompson—about us and ah—ah—ah—around us!'" (263). This promotion of machine culture displays a dialogic rhetoric that combines the poor articulative skill of Hoffmann's Olympia with the pedantic call for "usefulness" that characterized the writing of mid-nineteenth-century defenders of mechanization. The constant jarring pauses and repetition of verbal sounds is uncannily close to the speech of Olympia in Hoffmann's "The Sandman," a tale that critics of Poe believe to have been influential on his work. To hint at General Smith's status as an automaton is an intriguing reversal of his true position. General Smith is a mechanized man rather than automaton, yet to suggest that his mechanical parts influence his expression more than his human consciousness develops the argument that he is becoming increasingly subject to mechanical power. In giving General Smith a voice that seems to be the product of the machine while at the same time articulates the propaganda of the mechanists, Poe is generating a rhetoric that deconstructs the difference between the human and the machine and ultimately calls into question

the power structure of human master and machine slave that mechanists offered to the public. Simultaneously, this commingling of different communication registers (of mechanists and automata) suggests a bleeding of one into the other—a mechanization of the human that elides the difference between the human and the machine and thereby hides the effects of mechanical culture on human society.

Certainly, the bourgeois society within which General Smith and the narrator circulate appears not to notice the mechanization of his language. Despite several examples of his degraded linguistic ability, General Smith remains a highly valued figure. Throughout the tale he is variously described as "quite a hero" (266) and "a *remarkable* man—a *very* remarkable man—indeed one of the *most* remarkable men of the age" (261–62). The narrator, who absurdly states that he has "never heard a more fluent talker, or a man of greater general information" (262), moves into hyperbole when he comes to mention General Smith's physical qualities: "He was, perhaps, six feet in height, and of a presence singularly commanding. There was an *air distingue* pervading the whole man, which spoke of high breeding, and hinted at high birth. . . . His head of hair would have done honour to a Brutus. . . . The bust of the General was unquestionably the finest bust I ever saw. . . . The arms altogether were admirably modelled. Nor were the lower limbs less superb. These were, indeed, the *ne plus ultra* of good legs (259–60)."

Joan Tyler Mead has suggested that this "ludicrous excess" should be regarded with some suspicion. She believes that the narrator's words "are subversive, for beneath the flattery he is actually presenting the hero as an artificial construct."[24] While the narrator is undoubtedly subversive in these comments, his subversion is of a different order to that identified by Mead. In connecting General Smith's appearance with the physical symbols of aristocracy, Poe is highlighting the shift from a biological and cultural imperative to a mechanistic worldview. In conflating mechanics with class status, Poe very carefully places the machine within existing cultural structures. Substituting mechanical science for the aristocracy makes a very bold statement about the cultural primacy of mechanics in the mid-nineteenth century. This not only effaces biological inheritance in favor of the promotion of inorganic matter but also gives over

the trappings of power to the machine while at the same time secreting this transference in the language of human (organic) reproduction. Breeding and birth—the two markers that the narrator picks out—depend on human biology and cultural hierarchy. In General Smith, it is the products of mechanical science that stand as their symbols. By encroaching on the territory of the social and biological, mechanical science has crossed a significant boundary between the machine and the human. It has commandeered the territory of biology and replaced it with a machine: the basis of human life has succumbed to mechanical expertise.

Of course, the narrator's comments are uniquely influenced by a lack of knowledge, as he has not yet realized the prosthetic nature of General Smith's physical body. To fully understand Poe's reading of the human/machine dichotomy, to grasp the complexity of the relationship between the human and the machine, as well as to see the shifting of the boundary between them, it is necessary to confront the narrator at the point of his discovery of the mechanical nature of General Smith. This occurs very near the end of the narrative, when all other avenues of information appear to have been shut off. Upset and frustrated by his inability to discover what is remarkable about the general, the narrator decides on a phenomenological study rather than one that is purely theoretical. He makes a visit to the general at home. Unannounced and unexpected, he advances toward the general's room:

As I entered the chamber, I looked about, of course, for the occupant, but did not immediately perceive him. There was a large and exceedingly odd looking bundle of something which lay close by my feet on the floor, and, as I was not in the best humour in the world, I gave it a kick out of the way.

"Hem! ahem! rather civil that, I should say!" said the bundle, in one of the smallest, and altogether the funniest little voices, between a squeak and a whistle, that ever I heard in all the days of my existence.

"Ahem! rather civil that, I should observe."

I fairly shouted with terror, and made off, at a tangent, into the farthest extremity of the room.

THE HUMAN EXPERIMENTS OF EDGAR ALLAN POE

"God bless me! my dear fellow!" here again whistled the bundle,
"what—what—what—why, what *is* the matter? I really believe you don't
know me at all." (269)

This complex passage merges the gothic with the burlesque, almost slap-
stick humor that has been the common register of the story from the
beginning. Nevertheless, this is the most vital section in understand-
ing Poe's construction of the machine culture of the mid-nineteenth
century. Surprisingly, what is so striking about this section is that the
power of the scene depends on a lack of mechanical material. The gen-
eral's unique appearance as a "bundle" is dependent on the removal of
all his mechanical aids. Yet it is the natural form of the general and not
his prosthetic aids that inspires terror. His shapeless human form is an
amorphous and somewhat spectral presence. Yet this spectrality comes
from the absence of prosthetics and not the discovery of them. Ironi-
cally, the narrator is unable to see General Smith as human when all
his artificial limbs have been removed. If the recognizable symbols of
humanity are actually mechanical, what use is the system of recognition
that defines the human in such a way? This, ultimately, is the central is-
sue of the story. What, then, are the conclusions to be drawn from this
final episode of "The Man That Was Used Up"?

For the narrator, to bear witness to the self-reassembly of General
Smith further influences his perception of the human. Providing a run-
ning commentary consisting of mechanical facts, figures, and personali-
ties, the general attaches his inorganic body parts to the original head
and torso that made up the bundle. Having put in place a leg, an arm,
a set of shoulders, a bosom, a wig, a set of teeth, two eyes, and a larynx,
the narrator begins to comprehend the mechanical manipulation that
makes General Smith such a remarkable man:

> I now began very clearly to perceive that the object before me was noth-
> ing more nor less than my new acquaintance, Brevet Brigadier General
> John A. B. C. Smith. The manipulations . . . had made, I must confess,
> a very striking difference in the appearance of the personal man. . . . I
> acknowledged his kindness in my best manner, and took leave of him

at once, with a perfect understanding of the true state of affairs—with a full comprehension of the mystery which had troubled me so long. It was evident. It was a clear case. Brevet Brigadier General John A. B. C. Smith was the man—*was the man that was used up.* (271–272)

Once the general has affixed his various mechanical devices, the narrator again acknowledges him as human. However, it has not been possible even to recognize the general as human until the introduction of his mechanical prosthetics. The bundle becomes the man only when the machine has intervened. This suggests that the mechanical constitutes General Smith's humanity. Yet the conclusion drawn by the narrator suggests something different. General Smith may be a man again, but he is a "man that was used up." Whether it is the mechanical prosthetics that have used up General Smith or his well-known military career remains ambiguous. The narrator's position is a complex one: he seems to suggest that the machine both improves and degrades the human, making the general a man but also using up his humanity.

These views are not as incompatible as they first appear. It has been Poe's project to reflect the complex relationship between human society and mechanical science, and "The Man That Was Used Up" does attempt to reflect the difficulties inherent in the boundaries between the machine and society. The apparent contrariety of the narrator's position at the conclusion of the story parallels the rhetorical position of many commentators on mechanization in the 1830s. For mechanists and their supporters, the machine was the one product of mechanical science that would alter the workings of human culture and society. They argued that, rather than replace the human, the machine would augment already existing human characteristics. In putting forward this case, the promoters of mechanical science began to advance a mechanical philosophy that placed the characteristics of the machine at the top of a social hierarchy of self-performance, manner, and bearing. At the same time, they began to talk about the machine in terms usually reserved for the human: responsibility, morality, and consciousness. Together, these ways of thinking began to bring the human and the machine far closer to each other, with human society mechanizing the emotional

life of the self, for example, while the machine became increasingly described in terms of its human animation. The narrator, in playing the part of the mechanical promoter, reinforces this position by showing mechanical prosthetics as though they were human body parts. At the same time, he also considers the other side of the debate. By revealing that the general's bodily degradation may be due to his use of mechanical parts, the narrator confirms the fears of those commentators who bemoaned the constant privileging of mechanics over the human.

In playing out a tale of hidden mechanization, Poe asks questions of the limits of the human self: Where can the boundary of the human be said to fall? Does science extend or disrupt that boundary? While there is optimism in seeing General Smith as an example of a benevolent mechanical science, there is also pessimism in wondering whether mechanical science creates automata in the place of the human. The dilemmas brought about by new scientific practices, especially in defining the boundaries and limits of the human, provide the central focus for Poe's work. In the remaining three stories, the limits of the human are investigated through the science of mesmerism.

There are several reasons for Poe's move from the mechanical to the mesmeric. First, mesmerism became a topic of great debate in the 1840s, reaching an apogee around the middle of that decade, and could not have failed to interest Poe, setting out, as it did, a dynamic of power relations that reflected his own views of the effects of science on the human subject. Second, mesmerism was a scientific discipline that very clearly demanded attention to boundaries. For one thing, it was on the boundary of mainstream scientific practice, performed in the major medical hospitals of Europe and the United States yet widely criticized by central figures of the scientific establishment. For another, the practice of mesmerism appeared to question the distinctions between the material and the spiritual world, as well as between life and death, two boundaries that appeared as culturally unequivocal as that between the human and the machine. Third and finally, the relationship between the mesmerizer and his or her subject appeared to parallel, in some ways, the relationship between the machine and the human that Poe believed was the defining characteristic of scientific development in the late 1830s.

Together, these characteristics of mesmerism provided Poe with valuable material for an imaginative treatment of science's effects on the human, and his experiments in mesmeric science fiction were calculated to expand his vision of the place of the human subject in contemporary scientific culture.

To consider mesmeric debates in the realm of fiction rather than that of science was no great difficulty. By the mid-1840s mesmerism was already achieving results that demanded an imaginative leap on the part of a fascinated public. Its effects in the treatment of disease, the diagnosis of illness, the reading of minds, and the seeing of the past, present, and future appeared fantastic, yet they were largely undertaken by accomplished and respected scientific practitioners whose opinions could not be easily discarded as the ravings of a misguided fanatic (as Mesmer had been daubed). Indeed, mesmerism had significantly progressed since the first two decades of the nineteenth century, when Franz Mesmer's techniques had gained a reputation as occultist or magical practices far removed from the regular pattern of scientific investigation. Hoffmann's science fiction, detailed in the chapter 2, reads the phenomena of mesmerism according to this view of mesmerism, a view widely held early in the century, but Poe treats the subject very differently, reflecting the changing perceptions and practices of mesmerism as it works its way to a more central position in midcentury United States and Europe as well as Victorian Britain.

Many different authorities contributed to the new mesmerism of the 1830s and 1840s, amongst them the writer Harriet Martineau, the medium and mesmeric popularizer Chauncey Hare Townshend, and the clinical doctor John Elliotson. The range of professional and personal activity that even these three represent illuminates the breadth of mesmeric belief and practice. Even in this small cross section we find a professional scientist, an amateur investigator, and a writer of imaginative literature, three of the professions central to the dissemination of mesmeric method. Equally important are the vast audiences that such different individuals found amongst the general population. In the United States (and across Europe), Townshend's general study of mesmerism, *Facts in Mesmerism* (1840), was the central text for anyone interested in the subject. John

Elliotson's public lectures and performances of mesmerism were always eagerly attended, and Harriet Martineau's *Letters on Mesmerism* became one of the most widely discussed publications of the 1840s, significantly appearing in the same year as Poe's three science fiction stories concerned with mesmerism—"The Facts in the Case of M. Valdemar," "A Tale of the Ragged Mountains," and "Mesmeric Revelation."

Mesmerism had also gone through many changes in its relationship with society, the scientific establishment, and the popular imagination. While in the late eighteenth and early nineteenth century it had been viewed with skepticism by scientific authorities and seemed supernatural or diabolic to the general public, by the time we reach the 1830s, this had manifestly altered. Mesmerism became common practice in diagnostic treatments in the most traditional hospitals and, as Alison Winter expertly proves, entered the practices of central scientific figures.[25] No longer was mesmerism confined to the salon of the adept; it was instead distributed in scientific, theatrical, and personal spaces such as the lecture theater, the stage, and the parlor. Phenomena associated with mesmerism became familiar to the public and the various tropes associated with the mesmerizer, the mesmeric subject, and the mesmeric experience as a whole were common parlance. There were still those who continued to question both the morality and scientific authority of mesmerism. Its status—while decidedly different from its earlier days—still remained firmly on the boundaries of the scientific mainstream and was always shadowed by faint suggestions of malpractice.

In the discussions of Hoffmann's science fiction that precede the present chapter, the gender politics of mesmerism were shown to be central to the mesmeric debates of the earlier nineteenth century. While these certainly continued throughout the 1840s, there was also a growing interest in the effects mesmeric trances had on the human mind and consciousness. Activities such as clairvoyance and telepathic communication became more and more central to the growing range of experiences associated with mesmerism. For Poe, reading of such episodes in texts such as Townshend's *Facts in Mesmerism*, as Sidney E. Lind has revealed he undoubtedly did,[26] the recognition that the limits of the human were being tested would have been fascinating. Allied to this was

the role played by the mesmerized subject, who seemed increasingly at the mercy of the mesmerizer, especially as the range of mesmeric techniques expanded. The mesmerized subject became detached from his or her personality and turned over bodily and mental authority to the mesmerizer. This process of automatization can be clearly connected to the mechanization of the human that was influencing the definition of the human in Poe's earlier science fiction. There is a concrete link between mechanical and mesmeric science, with each playing a part in reifying the human by making it subject to the processes of a powerfully manipulative scientific practice.

To view mesmerism in this light is to accept that it was inextricably tied to the cultural politics at the center of a debate over the effects of science on the human subject. For Poe, this was a debate centering on the boundaries of human consciousness and physicality. For several commentators, this was also a central concern of the various mesmeric practices. As one contributor to the mesmeric canon suggests, clairvoyance (as found in mesmerized patients) allowed the human subject to "drop beneath the floors of the outer world, and come up, as it were, upon the other side. We often see what we take to be sparks or flashes of light before us in the night; but they are not really what they seem, but are instantaneous penetrations of the veil that, pall-like, hang between this outer world of Dark and Cold, and the inner realm of Light and Fire, in the midst of which it is embosomed, or, as it were, enshrouded; and true clairvoyance is the lengthened uplifting of that heavy pall."[27] Paschal Randolph, writing on the subject of seership in Boston in the mid-nineteenth century, symbolizes the boundary of the human as a wall between the temporal, physical world around us and the spiritual realm that exists beyond our reach. Using the common image of the veil, Randolph slowly makes this boundary slimmer and weaker until he is able to suggest that it can be broken altogether by the clairvoyant.

Poe investigates similar penetrations of the boundary between matter and spirit (or life and death) in all three of his mesmeric science fictions, but most significantly in the most successful of these three stories, "The Facts in the Case of M. Valdemar." It has already been widely argued, most keenly by Sidney E. Lind and Doris V. Falk,[28] that Poe is working

as closely as possible with the actual truths of mesmerism, using various textual sources to support his reading of the diverse operations of mesmerism. Lind and Falk write very convincingly of the influence of Townshend and others on Poe's mesmeric tales, yet they limit their discussions to the facts of that influence rather than investigating Poe's own thesis on the role of mesmerism within a wider cultural sphere. This is surprising, for there is a great deal within all three tales that can be brought to bear in an examination of Poe's position in the mesmeric debate.

"The Facts in the Case of M. Valdemar" gives us the first insight into Poe's understanding of the significance of mesmerism as a scientific practice, even if early reviewers of the story were less concerned by what Poe actually says in the tale than by the nature of its factual or fictional genesis.[29] One of the first concerns for Poe appears to have been the position of mesmeric experiments within the culture and society of the United States in the 1840s. Although interest in mesmerism grew at about the same rate in Europe and the United States and was equally popular, say, in Britain and the United States in the middle of the 1840s, the attitude toward the implementation of mesmeric phenomena differed somewhat. One of the main reasons for this difference was the rather swifter professionalization of science in the United States, where by midcentury "the trained specialist—the professional whose sole source of support was his scientific employment—had come to be the new type."[30] One would believe that this turn toward the dedicated scientific professional gave mesmerism either a place within the scientific pantheon or made certain it stayed outside, depending on the view taken by the majority of the professional scientists. However, Jacksonian America also benefited from its dedication to the principles of free speech and democracy, which allowed all citizens to speak out on the issues of the day with something approaching equal authority. Mesmerism, always tinged by charlatanism, suffered greatly at the hands of amateurs who made all sorts of claims for its power, as George Daniels suggests: "It was not simply that a few erroneous opinions had gained currency. The roots were deeper. American democracy was extremely antiauthoritarianist. In fact it had gone so far as to hate all authority. Hence all the quacks were assured of a sympathetic hearing when they

appealed to the democratic process."[31] Despite the professional scientific establishments of the United States, new and controversial sciences such as mesmerism never did obtain the rubber stamp of authority. Instead, they were assailed and undermined by the claims of individuals and groups whose credentials were questionable yet who demanded a voice on the principles of democracy. This mélange of voices, all claiming authority, meant that even the most respected of commentators on mesmeric experiences—such as the Reverend Townshend—were always associated in the popular (and scientific) imagination with the "quacks."

Poe's comprehension of this complex interweaving of cultural registers is revealed in the initial exchanges of "The Facts in the Case of M. Valdemar."[32] His mesmerizer, who also narrates the tale, has no clear scientific position, yet there are several subtle indications to suggest he is not a medical professional. First, the narrator, named only as P——, differentiates between his own involvement with Valdemar and the careful administrations of his physicians. P——'s relationship with Valdemar appears to be one of friendly acquaintance rather than professional care. Second, the colleague he calls on to provide external validation for his mesmeric experiment is only "a medical student with whom [he] had some acquaintance" rather than a practicing physician whose testimony would carry far greater authority (197). Add to this P——'s comment that Valdemar "had no relatives in America who would be likely to interfere" (195) and a picture is built of a mesmerist without any institutional authority who fears both public and private intervention in his amateur experiments.

Doris V. Falk has argued that the narrator's trepidation at the beginning of the tale is due to his concerns for the mesmeric sympathy that flows between him and Valdemar.[33] However, the narrator has always found Valdemar to be an excellent mesmeric subject, despite his lack of "sympathy" for mesmerism as a science (195). The narrator's concerned introductory comments are demonstrative of his dubious place as scientific authority in the medical arena that is Valdemar's bedroom. Having introduced a certain unsettling element into the narrative in this way, Poe proceeds to document the actual mesmeric experiment that

P—— undertakes. In doing this the register moves from the compromising hesitation of an investigator unsure of his status to a decidedly scientific language: measured, exacting, and minutely descriptive. This change is brought about by the note sent to the narrator from Valdemar in which he hands over authority from the medical experts to his mesmerizing friend. Taking on board the power given to him by the patient, P—— now claims scientific preeminence. His relationship with Valdemar's doctors becomes one of mastery. As the narrator explains, they agree to return "at [his] request" (196) and listen without interruption or disagreement to "what [he] designed." (197). Despite the close attention of these two medical experts (and two nurses), the narrator brings in his own recorder of events, thereby demoting the scientific professionals to the position of impotent observers.

Claiming textual, evidentiary, and scientific authority, it is difficult to see the narrator as anything other than the primary scientific figure in the tale. Yet all the evidence points to his amateur status. Poe cleverly reflects the ambiguous position of mesmerism in the way he constructs the relations of power in this story. To move the narrator from a marginal to a central position so quickly is quite astonishing, yet this is exemplary of his constant questioning of boundaries. Here, the boundary under the microscope is a scientific one: it is the position of mesmerism within the culture of science. Poe's shifting of the narrator to the center of the text demands that the reader pay attention to the oscillation of mesmerism between the instability of its "garbled and exaggerated accounts" (194) in popular culture and those medical capabilities that saw it infiltrate the most traditional scientific ground—the teaching hospital.

However, Poe is interested not only in the boundary-breaking that mesmerism effected in the 1840s but also in the boundaries of human capability it called into question. Sidney Lind has provided some useful textual contexts for Valdemar's incredible reaction to mesmerism, and there is therefore no need to detail them here.[34] Nevertheless, it is vital to examine closely the exact nature of Valdemar's condition, as the narrator describes it: "It was evident that, so far, death (or what is usually termed death) had been arrested by the mesmeric process. It seemed clear to us that to awaken M. Valdemar would be merely to insure his instant, or

at least his speedy dissolution. From this period until the close of last week—*an interval of nearly seven months*—we continued to make daily calls at M. Valdemar's house, accompanied, now and then, by medical and other friends. All this time the sleep-waker remained *exactly* as I have last described him" (202). Most important here is the suspension of natural organic activity that mesmerism brings about. Valdemar does not hang between life and death so much as halt the degradation of the human body that happens once death has occurred. The narrator admits that by removing the mesmeric trance, Valdemar would immediately embark on the common process of decay that affects all living tissue. He is already dead, certainly, for death has been "arrested" rather than evaded. Valdemar points this out, of course, during several conversations with the narrator. One such interchange explicitly details his loss of life: "I *have been* sleeping—and now—now—*I am dead*" (201). There can be no clearer pronouncement of Valdemar's state than this, and it is the very fact of Valdemar's death that is so intriguing.

Poe is not following the writings of mesmerists in maintaining Valdemar in this suspended mode. Mesmerism was far more clear-cut about the role of magnetic forces within the human body. Thomas Capern, a central figure in British mesmerism and superintendent of the London Mesmeric Infirmary in the 1840s, gives details of the general consensus in a pamphlet entitled *Pain of Body and Mind Relieved by Mesmerism:* "The possession of this principle, whatever it may be, is essential to the very existence of animal life. By some it has been called vital magnetism, and various other appellations; but no matter how it be designated, it is a real thing. A due proportion of it preserves its possessor in the condition of health; a deficiency of it produces sickness; the entire withdrawal of it occasions death."[35] Poe's vision of Valdemar is that of neither rude health nor ready death that Capern demands. Rather, Valdemar falls somewhere between these poles: he is neither brought back to a state of health by the mesmeric force nor allowed to die naturally and completely. If Poe does base many of his mesmeric claims on the published writings of various mesmeric authorities, as Lind and Falk maintain, why does he not comply with opinion here? The central reason is that Poe is more interested in the effects of new scientific practices on the

human body and mind than on the precise details of mesmerism. He feels able to alter the effects in order to illuminate, and give primacy to, the human at the center of his experiments. Valdemar's state may not entirely fit Capern's review of mesmeric phenomena, but it does suit Poe's design. He is concerned to visit the borderlands of human experience in order to discover how these boundaries are made malleable by science. Mesmerism, in this instance, appears to delay natural organic processes, yet the forces that achieve this are already present in the human body. Therefore, the potential to stave off organic decomposition is a human potential, one that would extend the capabilities of the human beyond present knowledge.

Valdemar's position as both physically dead and mentally alive certainly gives new meaning to human capability. The boundary that human culture draws between life and death denies the possibility of conscious thought. Yet Valdemar very obviously disrupts that boundary. To articulate that oneself is dead is an impossibility if the definition of the human remains intact. The fact that Valdemar is able to do this, and more than this to repeat it (*"I say to you that I am dead!"*) after a period of seven months (203), is to entirely discard the boundaries of human volition in place in the 1840s. By investigating the properties of science, Poe has contested the very nature of humanity. General Smith challenged the boundary between the organic and the inorganic, and here, in "The Facts in the Case of M. Valdemar," another experimental human subject takes Poe's project a step further. Valdemar not only throws down a gauntlet to mechanical science by proving that mesmerism can alter the nature of organisms but also illuminates another boundary that science has broken through: that of matter from spirit, and even life from death.

Both the narrator and Valdemar prove to be more than human within this context. The narrator has the ability to control the forces of mesmerism to such an extent that he can suspend natural decay. Valdemar's physical body no longer acts as the human body should. His receptivity to mesmerism has allowed his material body to become so powerful as to halt its own decay. In both instances the limitations of the human body are undermined. Death is no longer the boundary it once was. Moreover,

it is science that has brought about this alteration in the human. Just as mechanics extended the physical life of General Smith, so too does mesmerism augment the physical body of the willing experimental subject. Poe leaves no doubt that it is mesmerism that performs this feat. When the mesmeric trance is rescinded, Valdemar returns instantaneously to his original organic nature: "His whole frame at once—within the space of a single minute, or even less, shrunk—crumbled—absolutely *rotted* away beneath my hands. Upon the bed, before that whole company, there lay a nearly liquid mass of loathsome—of detestable putridity" (203). Horrifically fecund and viscous, Valdemar's body almost instantaneously passes through the seven months of decay that had been suspended by mesmeric force.

Of course, we should not forget that the mechanics that gave General Smith an improved physical body also brought about a mechanization of his humanity that seemed to be paralleled by an increasing mechanization of the human in society. Mesmerism, too, plays its part in reducing the human to a subsidiary role in a culture that was handing over power to science. The practice of mesmerism constructs a relationship between the provider of mesmeric force (the mesmerizer) and the recipient of that force (the patient) that is detrimental to individual human consciousness. Poe draws this aspect of mesmerism into his tale alongside the others. The narrator, P—— (who could well be Poe himself), may well highlight the possibilities that mesmerism affords the human, but in doing so he takes possession of Valdemar's physical self, leaving him as little more than a puppet to the vagaries of experimental practice. First, Valdemar's motor functions transfer their power to the mesmerizer: "As I approached M. Valdemar I made a kind of half effort to influence his right arm into pursuit of my own, [and] as I passed the latter gently to and fro above his person . . . his arm very readily, although feebly, followed every direction I assigned it with mine" (198–99).

This brief experiment (which proves Valdemar is entirely physically bound to the will of the narrator) is followed by a number of conversations between mesmerizer and patient that suggest Valdemar's loss of control of his physical body, if not of his mental faculties. He pleads with the mesmerizer to allow him to die, knowing that the will to do so

THE HUMAN EXPERIMENTS OF EDGAR ALLAN POE

is no longer his own. Valdemar's life has been gifted to the mesmerizer, to whose mind he must now appeal in order to regain possession of his own. This pattern of human control lost to external forces clearly parallels the issues Poe was determined to discuss in "The Man That Was Used Up." There, he argued that 1830s machine culture had put control of the human in the hands of the machine. As mechanization increased, so the human became more mechanical and the machine more human. As General Smith revealed, the human and the machine become so similar that it is difficult even to notice the difference between mechanical and human bodies. Mesmerism brings about the same dynamic of power with respect to the mesmerizer and the subject. While mesmerism argues that it is sympathy and influence that allow mesmeric force to take effect, it is also true that the close alliance this necessitates between mesmerizer and patient hides the real outcome of a mesmeric trance. That outcome is the placing of the human subject entirely within the power of the mesmerizer, thereby removing from that subject all mental and physical capability. To place a human patient within a mesmeric trance, then, is to turn that patient into a mechanical object.

Thomas Capern, in a passage from one of his many popular pamphlets on mesmerism, draws on the image of mechanical transference to describe the practice of the mesmerizer. "It is well known that electric fluid is readily conveyed by mechanical means; and the experience of many may be adduced to prove that this vital principle, whether analogous to electricity or not, can be conveyed or imparted by one individual to another, by passes made with the hand, accompanied by a strong will or intention of the operator to do it."[36] Capern's insistence on the mesmeric trance as a mechanical transfer dependent on the strength of the mesmerizer is an important touchstone in considering the mechanizing effects of mesmeric forces. Mesmeric commentators, no doubt influenced by the language of mechanics that was circulating in mid-nineteenth-century culture, recognize the congruity between the mechanization of human society and the effect of the mesmeric trance. While Hoffmann never quite saw the unique convergence of the two in this way, Poe, working within a different scientific culture, could not ignore the similarity between the mechanized human and the mesmeric

subject. The trance state turns the human into an automaton under the guidance of an operator who controls the subject in the same way that the machineworker controls mechanical apparatus.

There is a problem in so simplifying the relationship between the human and the machine in order to make it fit the roles of the mesmerizer and the entranced subject. As we have already seen, the machine did not remain subject to human control for long. As William Huskisson had found to his detriment, mechanical inventions did not always conform to the role assigned for them by their human creators. Nor, of course, did the mesmeric subject remain entirely bound by the mesmerizer. Instead, the dialogues between mesmerizer and patient are characterized by a struggle for supremacy and control of the mesmeric space.

In "A Tale of the Ragged Mountains,"[37] Poe continues his reading of mesmeric phenomena by describing a more distant and contested relationship between the mesmerizer and the patient that allows for a very different set of boundaries to be challenged. In this tale, Mr. Augustus Bedloe plays the part of the patient mesmerically influenced by Dr. Templeton, ostensibly as a cure for his "neuralgic attacks" (100). Sidney Lind has convincingly shown that Poe uses several mesmeric textbooks to construct a credible picture of mesmerism at a distance. He concludes that "Bedloe's strange experience is revealed in its true light as being a mesmeric trance transmitted from Templeton's mind."[38] Even Doris Falk, who disagrees considerably with Lind, does not question this summation. Falk does, however, have a great deal to say about Poe's interpretation of mesmeric phenomena:

> For, Poe, however, it is an amoral force operating within the mind and body, linking consciousness and "physique," animating both. Within the body, magnetism is the unifying force which prevents dissolution; within the mind it is a unifying and illuminating force, comparable to "imagination" within a poem. The will of the magnetist himself is only a mechanical stimulus like drugs or sensory deprivation, and its power upon the mind of the patient is "psychedelic" rather than psychological or moral. The widened consciousness or the preserved body becomes

the theater of the action rather than a motivating force with metaphorical or moral significance.[39]

Ascribing such a reading to Poe is largely correct, although it does hint at a rather Romantic conception of mesmerism that is not apparent in Poe's scientific writing. Moreover, Falk's assertion that there is no metaphorical or moral significance in Poe's science fiction does tend to elide the serious concerns that his work reveals for the state of the human within an increasingly scientific culture. Indeed, "A Tale of the Ragged Mountains" is a largely metaphorical tale, relying on mesmerism to provide metaphors of human mechanization and accomplishment that question the definition of the human in light of new scientific practices.

Our unnamed narrator describes Augustus Bedloe and Dr. Templeton's mesmeric relationship in detail. From the very beginning, it is one of contested power. Templeton's initial attempts to induce "magnetic somnolency ... entirely failed," though by "the fifth or sixth he succeeded very partially," and only by "the twelfth was the triumph complete" (100). These early struggles are registered in the language of conquest, with Templeton as the aggressor and Bedloe the defender. By the time the narrative opens, however, Templeton has exerted his mesmeric power to such an extent that "the will of the patient succumbed rapidly to that of the physician, so that . . . sleep was brought about almost instantaneously, by the mere volition of the operator, even when the invalid was unaware of his presence" (100–101).

The tele-mesmeric power of Templeton, hinted at in the final phrase of this quote, has been victorious in the struggle for Bedloe's conscious self. Bedloe, automatically acting on Templeton's commands, has been automated by mesmeric force and is utterly without self-control. This is unsurprising, as his character seems primed for a sympathetic reception of mesmerism. As various mesmerists describe, the ideal mesmeric subject is often sensitive, nervously excited, and suffering from "disordered nerves."[40] Bedloe, as Poe describes him, suffers from neuralgia, and is "sensitive, excitable, [and] enthusiastic," the perfect mesmeric foil (101). That Templeton not only mesmerizes but also completely

dominates Bedloe's personality is dependent on the susceptibility that Bedloe's character reveals. However fine a conduit for mesmerism Bedloe appears to be, he does, like Valdemar, attempt to resist its automating power. Having been mechanized by mesmerism, Bedloe now acts like the machine, testing the limits of control by which he is bound to follow his master's orders. As he crosses the Ragged Mountains, Bedloe begins to suffer from unusual visions that inspire "nervous hesitation" (102). Unwilling to admit that he is being forced to comply with Templeton's will, Bedloe characterizes the mesmeric force as, variously, a "dream" (104), a "thousand vague fancies" (102), and finally the "possession of [his] soul" (105). At the same time he attempts to stave off the trance state by physical activity and "a series of tests" (104). Unsuccessful in these defensive maneuvers, Bedloe finally submits to the mesmeric state and is forced to witness a succession of strange events in an ancient city: "Volition I had none, but appeared impelled into motion, and flitted buoyantly out of the city, retracing the circuitous path by which I had entered it. When I had attained that point of the ravine in the mountains . . . I again experienced a shock as of a galvanic battery; the sense of weight, of volition, of substance, returned. I became my original self" (106). This description brings together, in another dialogic partnership, the language of mechanics and mesmerism. Sidney Lind has suggested that the galvanic battery is the strongest scientific force that Templeton can imagine, while Doris Falk connects galvanism with animal magnetism in her assertion that it is entirely consistent with mesmeric experience for an electrical impulse to restore identity.[41] These opinions have their place in this context, but it is more to the point that Bedloe's loss of self-control is brought to an abrupt end by a force usually associated with the machine. His status as an automaton ends with the onset of an electrical shock and, in a clever parody of *Frankenstein,* Bedloe's organic human self comes to life.

Despite this episode, Templeton seems unaware of the power he exerts over his patient. This is not simply, as the narrator suggests, that the power was unknown to mesmerists in the 1840s.[42] As William Edwards discusses at the end of that decade, Chauncey Hare Townshend commonly mesmerized his patients at a distance, just as Templeton does

with Bedloe: "After frequent mesmerizings, a person may become so susceptible as to be influenced at a distance, across the table, in another room, or even at a distance of several miles. Townshend, in his 'Facts in Mesmerism' relates several successful cases in which he mesmerized one of his patients at a distance."[43]

As various critics have asserted, Poe had certainly read and digested Townshend's work before embarking on his mesmeric fictions. He would certainly, therefore, have read at least one case study of mesmerism occurring over a distance. Of all the various mesmeric phenomena discussed by Townshend and others, why should he be so interested in this aspect of it? For Poe, the tele-mesmerism described by different commentators provides a valuable context for his continual fictional experiments on the human body and mind. Mesmerism not only provides an interesting corollary to mechanical science in its apparent mechanization of the human subject but also appears to extend human capability beyond certain boundaries. Mechanics extended the life of the human body in "The Man That Was Used Up" and mesmeric trance arrested organic decay in "The Facts in the Case of M. Valdemar," yet in "A Tale of the Ragged Mountains," Poe delves deeper into the boundary between matter and spirit than he had done in those previous tales. As William Edwards comments, "The fact of being able to magnetize a person at a distance, evidently proves that some medium must exist by which mind is enabled to act upon matter. Future experiments may determine the nature of this medium, but at present there is little or nothing known respecting it."[44]

How the human mind is able to occupy and alter both material and immaterial space fascinates Poe, yet it is not a subject that he can supplement with external scientific knowledge. As Edwards suggests, there is little evidence of the phenomena of distance mesmerism from which Poe can work. At the same time, of course, Poe's science fiction is only an imaginative investigation, not a scientific one. His experiments are conducted on the culture of science rather than the evidence of science. The story of Bedloe and Templeton is a critique of new mesmeric phenomena as it affects human individuals. Poe's conclusion is indicative of the way in which he perceived his own inquiries into scientific culture.

In that conclusion, the narrator begins by describing Bedloe's death and moves on to present the subsequent obituary notice that misspells his name. As well as providing a gothic frisson in the story's final paragraphs, this description articulates the position of Poe's fiction within the scientific culture of the mid-nineteenth century:

> I was speaking with the editor of the paper . . . when it occurred to me to ask how it happened that the name of the deceased had been given as Bedlo.
> "I presume," said I, "you have authority for this spelling . . ."
> "Authority?—no," he replied. "It is a mere typographical error."
> (108–9)

Here, Poe highlights the gap between authority and language and in doing so is rather self-deprecating of his own science fictions. The difference between writing and authority hinted at here can be taken as a commentary on Poe's own diminution of the impact of his mesmeric tales on the culture of the United States. Yet it is undoubtedly the case that as Poe questions scientific authority in his fiction, so too do those fictions impact on the cultural authority of science. Whether taken as authoritative or otherwise, Poe's fictions of science become part of the circulation of ideas that have a role in defining science and its practices in midcentury America.

"A Tale of the Ragged Mountains," then, performs several functions, all of which could be encapsulated under the topic closest to Poe's science fiction interests: the perimeters of science and the human. Working at the very fringes of mesmeric competence, Poe utilizes the limitrophic nature of this science to comment on the collisions, conflations, and contradictions that appear when human society and scientific culture meet. Bedloe's incredible clairvoyant talent—teased out by Templeton's powerful mesmerism—is both optimistically rendered as an extension of human performance and rather more pessimistically viewed as a dangerous game of power politics between science and the human. It is, perhaps, this pessimism that wins through, for all of Poe's fictions end with the usurpation and destruction of the human. General Smith

becomes a shapeless mass, Valdemar decays, and Bedloe dies. Indeed, in Poe's only other mesmeric story, "Mesmeric Revelation," the very point of the narrative is the final boundary between what Heidegger called being and nothingness.

"Mesmeric Revelation" is one of the least plot driven of Poe's science fictions.[45] It details the deathbed dialogue of a mesmerizer and his patient, Mr. Vankirk. Vankirk's revelatory disclosures are iterated, so the mesmerizer suggests, from beyond the grave. Poe attempts here, in the most philosophical of his mesmeric investigations, to construct a theory of mesmerism that places it on a more spiritual plane than his previous fictions had done. According to Vankirk, mesmerism is akin to death: "When I say that it resembles death, I mean that it resembles the ultimate life; for when I am entranced the senses of my rudimental life are in abeyance, and I perceive external things directly, without organs, through a medium which I shall employ in the ultimate, unorganized life" (131).

While Poe's previous readings of mesmerism had hinted at its contestation of the boundary between matter and spirit, Vankirk is the only character to directly argue this position. Mesmerism takes the organic human body and the conscious human mind into a space normally designated for the dead. This is the ultimate border territory of both science and science fiction in the nineteenth century and one that we have already seen investigated by Hoffmann and Shelley. However, it would be disingenuous to suggest that this is a wild flight of fancy on Poe's part. Serious consideration was being given in the 1840s to mesmerism's spiritual dimension. George Bush, for example, writing in 1847, argues that "nothing is more idle than the attempt to refer the Mesmeric effects, in the light in which I consider them, to physical or natural causes. They inevitably conduct us to a higher sphere."[46] Arriving at such a conclusion via the writings of Swedenborg, Bush is very close to Vankirk in seeing mesmerism as a divine principle rather than a scientifically verifiable natural phenomenon. Vankirk, indeed, gives an explanation of the connection between the mesmeric and the divine: "There are gradations of matter of which man knows nothing; the grosser impelling the finer, the finer pervading the grosser. The atmosphere, for example, impels the

electric principle, while the electric principle permeates the atmosphere. These gradations of matter increase in rarity or fineness, until we arrive at a matter *unparticled*—without particles—indivisible—*one*. . . . This matter is God. What men attempt to embody in the word 'thought,' is this matter in motion" (127). Vankirk's image of matter could well stand as a metaphor for Poe's entire project: the intersecting grades of material representing the complex interweaving of the human and the scientific on the boundary between the physical and immaterial worlds. Certainly, this passage does provide a speculative hypothesis for what Dr. Templeton called "some stupendous psychal discoveries" (107). That there is an attempt to arrive at a philosophical understanding of the basis for new scientific practices illuminates the different angle of attack that Poe tries out in "Mesmeric Revelation." Rather than show the practical implementation of mesmeric force and the subsequent impression it makes on the human body and mind, Poe gives preference to a theoretical reading of mesmerism's impact on humanity. Having detailed the extended capacity for physical and mental capabilities that mesmeric science provides, Poe tries to theorize the contestation of boundaries that mesmerism makes possible.

Ultimately, as his conclusion to this tale suggests, Poe postulates that the boundaries we believe define what it means to be human are being significantly altered by the scientific developments of the mid-nineteenth century. This is not always to be applauded, however, as these developments are often as inhibiting of human capability as they are complementary. New scientific knowledge gifts the human with new vision, but only if that science is allowed to invade and inhabit the human body. General Smith, M. Valdemar, Bedloe, and Vankirk are all connected by their ability to cross boundaries that were previously impenetrable. Yet to do so they must give up control of themselves to science—Smith to mechanics and the others to mesmerism. This emasculation reifies each of them, making them automata under the control of the scientist who has granted them more than human power.

To the popular imagination, any scientific practice that appeared to come "from out of the region of shadows" was treated with suspicion (134). This did not spring solely from the dynamics of power that Poe

sees as a necessary result of the new scientific culture. Rather, it was a skepticism based on a sometimes commonsensical and a sometimes more informed scientific distrust of the nonevidentiary nature of new scientific claims. For the nineteenth-century public, the invisibility of science was problematic. In many mesmeric documents, for example, professed skeptics defended their position by arguing that they had never seen a mesmeric display and were therefore unconvinced of its validity. As Dr. Brigham, a New York physician in the late 1830s, writes to his colleague Mr. Stone, "Understanding that you have *recently witnessed* many experiments, and even performed some yourself, illustrative of the powers of animal magnetism, and have become a believer in this new art, science, or imposture, I am exceedingly desirous of knowing what phenomena, *seen by yourself,* have served to convince you" (my italics).[47]

Scientific authenticity and authority comes from being able to witness it with one's own eyes, or perhaps, at a remove, to read an eyewitness account. While Poe is certainly involved in reading scientific culture in terms of the boundaries between science and the human, he is also interested in another boundary—that between actual science and charlatanism. Each of the four science fiction tales discussed in this chapter are, in one way or another, hoaxes. They appear and were disseminated as true accounts of science but are actually fraudulent fictions. In designing them in this way, Poe is replicating cultural engagements with the claims of science. The authenticity and authority of science in the 1830s and 1840s depended on acceptance. Mechanical science—with its tremendous marketing tool, the machine—was able to convince society that it alone would bring progress and the enhancement of human culture. The rhetoric of mechanists continually reinforces this message. Mesmerists, likewise, used a language of persuasion to gain popular authority. Harriet Martineau's popular *Letters on Mesmerism* begins, "The great majority who [*sic*] know nothing of the matter, and are so little aware of its seriousness as to call it a 'bore,' or to laugh at it as a nonsense or a cheat. If nonsense it is remarkable that those who have most patiently and deeply examined it, should be the most firmly and invariably convinced of its truth."[48] Martineau may not directly invite her audience to accept mesmeric phenomena, but she does suggest that those who have

had the most opportunity to "see" it are convinced of its veracity. Her powers of persuasion rely on knowledge of the power of vision.

For Poe, setting up his science fiction as hoax narrative (even "The Man That Was Used Up" appears to be a practical joke played on its narrator) is a strategy calculated to mirror the most common method employed by one scientific discipline to undermine the claims of another. While earlier nineteenth-century science (as we have seen in the work of Hoffmann and Shelley) was denied authority on the basis that it was associated with magico-occult traditions, by the mid-nineteenth century this was no longer the case. As Poe realizes, the method of attack in the 1830s and 1840s was to charge scientific practices with fraudulence, trickery, or charlatanism. Undercutting these thrusts against authenticity by producing trickery of his own, Poe clearly reveals his comprehensive understanding of the scientific culture of the mid-nineteenth century. Moreover, a distinct irony develops when the stories are placed within a framework that includes their critical reception. As the reviewers debate the truth or fiction of his tales, they replicate the popular reaction to sciences such as mechanics and mesmerism. Poe's stories, therefore, at the very moment when they are debated by critics, become uncannily similar to the sciences they are depicting: they are controversial documents that are discussed as though they were questionably authentic scientific theses. For Poe, this would have been one of his greatest achievements—in revealing his writing as fiction rather than fact, it becomes even more scientific.

CHAPTER 5

Verne's Deep-Sea Investigations
on Dry Land

On April 28, 1870, almost exactly at the time Jules Verne's *Twenty Thousand Leagues Under the Sea* was receiving its first reviews in the French press, T. H. Huxley published two letters in the columns of *Nature* under the heading "The Deep-Sea Soundings and Geology." The first letter briefly detailed Huxley's interest in the geology of the ocean floor and told of a quantity of "North Atlantic Mud" that he had posted to the "eminent geologist Professor Gümbel of Munich." The second letter is Professor Gümbel's reply to Huxley, designed not, as we might expect, to express astonishment and chagrin at receiving mud through the mail but to offer profuse thanks for such an important specimen. While the major focus of the letter is a list of the organic material found in the mud, generously littered with Linnaean classifications, Gümbel does raise his head from his specimens long enough to dwell on the marvelous facility of the microscope to "disclose . . . new worlds" and lay them

open to scientific examination. Excited by such developments and the new materials afforded him by improved deep-sea dredging technology, Gümbel admits to Huxley that he has begun a series of new experiments, which he labels "deep-sea investigations on the dry land."[1]

It is not the results of these experiments that are of significant interest, for, as Gümbel admits, his letter details only the "the first commencement of researches," but rather that the correspondence between Huxley and Gümbel perfectly characterizes what we might broadly call natural history in the mid-nineteenth century.[2] From the 1850s, natural history (in one form or another) was easily the most practiced of the nineteenth-century sciences. Research in the field of natural history was undertaken by the population of Europe on a grand scale. Crossing class and gender boundaries and seemingly unaffected by degrees of knowledge, specialization, or even competence, natural history was performed daily on the meadows, forests, farmlands, and seashores of every European country with a scientific culture. The unchallenged leaders in these endeavors were Germany, France, and Britain. Such was the vitality of natural history in the middle decades of the nineteenth century that, in Britain alone, authors of natural history primers found themselves at the top of the bestseller lists and courted as men of substance and learning. At the height of the craze for natural history, for example, amateur natural historian Philip Gosse could not stroll along the seashore with a glass bottle and a net without being followed reverentially by a crowd of spectators eager to learn from such a famous "scientific" authority.[3]

Natural history was one of the most popular leisure pursuits of the mid-nineteenth century, uniquely suited to the Victorian belief in the efficacy of an improving and educational pastime. Indeed, it is precisely its wide appeal to the general public that makes it the most revealing cultural scientific phenomenon of the nineteenth century. Huxley and Gümbel, of course, can hardly be considered amateurs. Huxley in particular was a man at the very forefront of experimental science in the Victorian age. Yet their correspondence on the matter of a box of mud reveals a fascination with the objects of natural history study that is held by professional and amateur alike. The very fact that a quantity of

mud can make the pages of *Nature,* and at the behest of a scientist of Huxley's standing, highlights the astonishing popularity of natural history at this time. However, it is not the intensity of interest that Huxley's letters most ably demonstrates. Oceanology (as the professional scientist would have categorized Huxley's field of interest), or studies of the seashore (as the amateur might have articulated it), was one of the more dynamic branches of natural history. Huxley's letters show that the discourse of oceanology worked within the broader discourses of Victorian science and society to illuminate the synthesis between the study of marine life and the cultural concerns of the period.

What is immediately striking about the correspondence between Huxley and Gümbel is the difference between the material object of their study and the rhetoric surrounding their investigation of it. Mud is opaque, a signifier of the unseen or the hidden. Mud does not reveal; it conceals. It is never the object of interest but merely the guardian of secrets found behind it or beneath it. Gosse washes mud from shells and seaweed as he traverses the seashore, but the specimen is always the shell or the seaweed, never the mud. However, in Gümbel's investigations, the mud is not extraneous to scientific study; it is the object of that study. It is indicative of the ocean's place as the great unknown landscape of science that even its mud (in this case from the North Atlantic) is worthy of intense speculation and experimentation. That Huxley and Gümbel are so fascinated by mud points to the mystery that the ocean still holds and the excitement that the opportunity to advance oceanology affords. Of course, Gümbel's rhetoric also dovetails with the symbolic traces of concealment that mud signifies: his microscopic investigations allow him to see further, to penetrate the turbid material with powerful scientific vision. The muddy correspondence, then, plays both on the characterization of the sea as a place of hidden scientific value and on the phallic power of science to penetrate the most obscure materials and give them up to the gaze of the investigator.

The two letters also neatly encapsulate the conflict and cooperation of natural history investigations characterized by the binary oppositions between field and closet that forever unsettled its many practitioners. Who takes credit for the mud? The investigator who "discovered"

the mud and dredged it from the ocean floor, or the laboratory worker whose experiments tell us the qualities of the mud? In the correspondence between Huxley and Gümbel, there is a sense of shared pride in the activities of science, with Huxley in the field and Gümbel in the closet. Gümbel, indeed, is at pains to recognize Huxley's role in his investigations, although this is hardly necessary, as Huxley makes sure that his own part is illustrated before Gümbel's experiments are introduced. Such careful declarations of roles are not always common. The link between the natural world (the field) and the laboratory (the closet) was often a weak one, made unsteadier by the hierarchical nature of Victorian science. Natural historians working in the field were very often amateurs, while those in the closet were more likely to hold professional positions. Distrust of each other's practices was commonplace: the professional viewed the amateur as an ignorant member of the general public, while the amateur saw the professional as an elitist and narrow-minded individual lacking a holistic vision of the natural world. Gümbel's title for his investigations bears this out. "Deep-sea investigations on the dry land" is something of an oxymoron, hinting both at his inability to visualize scientific specimens in their natural habitat and his belief that the context of ocean materials has no bearing on the work he intends to pursue.

The distrustful lacuna between the field and the closet also brings into sharp focus the nature of the natural history specimen, for it was these objects that most often bridged the gap between those working on the seashore and those ensconced within the laboratory. In the letters written by Huxley and Gümbel, there is no recognition that mud may be a rather odd object to be discussing quite so effusively. Yet their tone is appropriate to the status taken on by the mud in the context of natural history. For the natural historian, the specimen is a great deal more than an object of scientific interest. It is, in the first instance, a testament to rigorous field work. The discovery of a specimen suggests a certain accomplishment in the necessary qualities of the natural historian: keen vision, knowledge of the subject, and appropriate employment of techniques. However, it is after the collection of the specimen that its status alters significantly. Huxley's mud is, to state the obvious, much more

than a box of sea sludge. It has become an object of economic signifi-
cance, put into play in a system of exchange that classifies specimens
according to values both scientific and cultural. For Gümbel, the mud
is not a gift from Huxley as much as the beginning of a transaction. The
mud he receives through the mail is exchanged for scientific informa-
tion to which Huxley's name is attached. In essence, Huxley swaps the
mud for an accreditation of discovery.

This type of transaction is typical of natural history in the mid-
nineteenth century: the amateur field worker passes a specimen to a
laboratory professional who in turn classifies and registers the speci-
men with reference to the field worker from which he received it. The
amateur is given scientific recognition, and the scientist has a specimen
that advances his knowledge and career. At times, the first part of the
transaction may include payment, the only moment where monetary
economics plays a role in the exchange. Essentially, the natural history
specimen very quickly becomes a commodity with scientific and cul-
tural value. In the transaction of the mud, both Huxley and Gümbel
reinforce their roles as leading scientists and raise their profile by ap-
pearing in a popular periodical. Huxley, indeed, seems to have gained
a great deal—for the cost of a postage stamp he takes on the status of a
geological investigator.

Natural history, and in particular oceanology, reflects and informs
the scientific and societal dynamics of the second half of the nineteenth
century. It operates on the principles of commodity capitalism that were
coming to dominate Victorian economics, highlights the increasing
tensions between professional and amateur science, and articulates the
powerfully masculine rhetoric of vision and penetration that had always
categorized science in the nineteenth century. Moreover, oceanology
captures the imaginative and even mythical dimensions of scientific dis-
covery that resonate throughout the mid-Victorian period. To step into
the sea was to begin an investigation of a landscape as yet unclassified
by science. This disclosing of new worlds, to use Gümbel's phraseology,
brought to science the quality of imaginative fiction and the fascination
with exploration and adventure often found in the rhetoric of scientists
in the early decades of the nineteenth century.

It is this scientific environment that Jules Verne entered in 1870 with the publication of *Twenty Thousand Leagues Under the Sea*. This novel, Verne's finest contribution to the genre of science fiction, intervenes significantly in the scientific culture of the nineteenth century. Widely regarded as an optimistic technological journey penned predominantly for the juvenile market, *Twenty Thousand Leagues Under the Sea* has been undervalued and misinterpreted in the very arena that it so importantly critiques: public attitudes to mid-nineteenth-century science. Verne's novel is an extended vision of the dynamics of natural history as they were being played out in Europe in the decade that preceded the writing and publication of his text. Just as the correspondence between Huxley and Gümbel can be read as an articulation of the central foci of natural history practice, so too can Verne's novel illuminate the cultural politics of the natural history craze and, more than this, provide us with a detailed rendering of its place within a wider society of science that was as concerned with technology as with the natural world. This combination is Verne's ultimate success in *Twenty Thousand Leagues Under the Sea*. He places the fascination of the machine in dialogue with the excitement of the naturalist. In doing this, Verne does not simply reiterate the quotidian belief that the organic and inorganic are utterly opposed to each other and that the work of the technologist and the researches of the natural historian are incompatible. Rather, the novel investigates the common ground of these disparate scientific fields by constructing a narrative that places them in situations where they are able to interact. Nowhere is this more obvious than in the stark image of the protagonists making their way in breathing apparatus through the forests of the ocean floor—technology surrounded by the landscape of natural history—or in the false belief that the Nautilus is some form of sea serpent—the conflation of the organic and inorganic in a single object.

Literary criticism often directs attention to the technological feats of Verne's narratives, yet there is rarely any mention of the importance of natural history in discussions of *Twenty Thousand Leagues Under the Sea*. This is surprising given the space the narrative affords to the specifics of classification, collecting, and museum cataloging, never mind Aronnax's position as a leading oceanologist and Nemo's rewriting of

natural history textbooks. Indeed, in many of the English translations of the novel, several conversations between the protagonists on the subject of marine zoology are excised altogether. There is a definite disregard for the important part played by natural history in the novel, in elision, one could argue, of its scientific status. Such a standpoint hints at the reason for natural history's disappearance from contemporary readings of Verne. Cynically disregarded by geologists or paleontologists as the domicile of butterfly collectors, natural history often saw its place in the scientific pantheon under threat from more established fields of investigation. Its popularity amongst amateurs did not help maintain its scientific credibility in the face of its detractors. Literary critics, whose focus is the fictional achievement of Jules Verne, are less interested in the position of natural history in the history of science than they are in Verne's imaginative rendering of science. The very fact that natural history occupies a less central position in a hierarchy of sciences suggests that it is a topic likely to receive less critical attention than the more mainstream fields of, say, mechanical engineering or geology. However, it is the purpose of the present study to challenge orthodox views of scientific authority.

Some grounding in the critical reception of Verne's *Twenty Thousand Leagues Under the Sea* will provide a valuable foundation for an interrogation of natural history and technology in the novel. Readings of the novel are characterized by their variety. There is no single line of interpretation that can be said to provide a canonical scholarly position. To different critics, Verne is a modernist, the last optimistic nineteenth-century novelist, the father of science fiction, a forerunner of Wells or a complement to Poe, a Romantic, a realist, or a writer of didactic juvenile adventure stories. As far as his position in the literary and theoretical history of science fiction is concerned, Verne is variously a scientific pragmatist, a fantasist, or a utopianist. In the *Encyclopedia of Science Fiction,* John Clute suggests that Verne was "a pragmatic, middle-class entrepreneur of letters, and at least during the first part of his career wholeheartedly espoused the clear-eyed optimism about progress and European Man's central role in the world typical of high 19th-century culture."[4] Verne as the pragmatic, conservative, nineteenth-century novelist is continued

in other works of criticism. Edmund Smyth sees his pragmatism as, in part, defined by the positivism of science during his writing career: "It is undoubtedly true that Verne must initially be approached with due regard to the prevailing ideology of positivism which characterized his epoch. Roland Barthes is correct to point to the 'encyclopedic' aspect of Vernian discourse, with its reliance on documentation, catalogues and inventories. . . . The positivist context is apparent from the emphasis which seems to be placed on the role of science and technological prog-ress generally—the product therefore of an era of determinism, scientific methodology and taxonomy."[5]

Although these are general comments about Verne's place in a mod-ern science fiction tradition, Smyth could as easily be discussing his depiction of natural history in *Twenty Thousand Leagues Under the Sea*. Catalogs, lists, and documents play a major role in defining the practice of the oceanologist as well as in illuminating the type of sci-entific methodology that Verne accepts and reflects. Sarah Capitanio takes Smyth's critique further, arguing that Verne not only relies on scientific positivism but also uses its methodology to reinforce a real-ist register:

> The amount of detail in Verne's descriptions, and their internal organi-
> zation, follow the Realist model; they are ordered in a particular way.
> . . . They contain statistics, repetition, *feuilletonesque* "rappels" and re-
> formulations; above all, they contain enumeration, frequently of tech-
> nical substantives, thus reinforcing the importance at the textual level
> of the "naming" process just noted. The result is that the often fantastic
> nature of the elements that form the subject matter of the descriptions
> is eclipsed by modes of narration which follow Realist conventions of
> writing (and thus call on parallel modes of reading), lending these ele-
> ments a particular type of credibility.[6]

While Capitanio's reading of Verne goes little further than reinforcing Wells's formulation of the domestication of the impossible hypothesis, it is again striking that what critics appear to be treating as exclusively Vernian narrative methodology is very clearly also the narrative meth-

od of natural history writing, as exemplified by, among others, Philip Gosse, Charles Kingsley, and George Lewes. In the work of these amateur naturalists, enumerations, statistical information, naming, and classification form the basis for narratives that attempt to maintain both readerly interest and a high standard of scientific integrity. Although arriving at similar subject matter from different points of departure, there is a singular resemblance between the techniques they employ. Indeed, Capitanio suggests this, although her attention is directed toward literary realism rather than scientific writing: "Verne's texts take to an extreme the nineteenth-century Realist tendency to represent a world that is *a priori* circumscribable, causal and explicable in a way that frequently blurs the boundaries between the novel and scientific or technical manual."[7]

Timothy Unwin, in an extended discussion of the boundary between fiction and science in Verne's work, agrees that such overlap exists, but he does not allow that it is as a result of Verne's realist manifesto. Arguing that Verne uses the imagination of science itself to create his narrative drive, Unwin posits a linguistic base for much of Verne's mystery and fantasy. Verne "restates, rewrites or recycles knowledge gleaned in the scientific, geographical and historical reviews of the day," states Unwin, whereupon science fiction "becomes not the creation of new and barely recognizable worlds inhabited by strange beings, but the larger-than-life fictions of science itself. Verne stages and dramatizes the scientific, giving it power and mystery through the cumulative impact of his language. Even as natural phenomena are tamed, understood and classified by language, they are endowed with a compelling otherness."[8] Once again, the use of the word "classification" provides a trace of the natural history that plays such a major role in *Twenty Thousand Leagues Under the Sea*. Yet Unwin does not situate Verne's liberal use of scientific material within any tradition of verisimilitude. Indeed, Unwin argues that Verne's language—the language of science—defamiliarizes the natural world and reconstitutes it as a site of fascinating mystery.

This is certainly part of the role that natural history is allocated in *Twenty Thousand Leagues Under the Sea*. Its place at the center of the novel generates a complex narrative that oscillates between a sublime

alienation and a pragmatic cataloging of fact. Verne does not need to construct a narrative that moves between these two poles, for the writings on natural history that so influence the novel already feature such a dynamic opposition. For the natural historian—in *Twenty Thousand Leagues Under the Sea* the oceanologists Aronnax, Nemo, and Conseil— the world of nature is both a classifiable system, reducible to a limited series of linguistic signifiers, and an object of artistic creativity to which the viewer must show due reverence. The movement between science and art is a common one for the naturalist, if not for either the scientist or the artist. While literary critics attempt to decipher Verne's narrative methodology in order to take account of his binary modes of operation, it is easier to accept that the role of natural history was as important in formulating his various registers as his loyalty to either realism or fantasy. The critic that comes closest to arguing this case is Arthur B. Evans, one of the most astute Verne scholars in the science fiction field: "Nature is portrayed as an object not only of scientific conquest but also of esthetic contemplation. Its methodical 'decoding' by science does not destroy its intrinsic grandeur or its power to captivate the affective imagination."[9] Although natural history is again elided in Evans' discussion, what he terms Verne's Romanticism is a product of the scientific writing that most influenced him in compiling *Twenty Thousand Leagues Under the Sea*. If Verne, in Evans' view, combines elements of both Romance and realism in his science fiction, then we need look no further than popular science writing for his model. It is a characteristic of all nineteenth-century popular science—of which natural history is the most common and most highly regarded example—to characterize science as simultaneously rigorous in methodology and exciting of the imagination.

Natural history is such a central element in this complex relationship between pragmatism and imagination, it is almost inevitable that, at the end of the 1860s, Verne makes it the focus of one of his fictions. *Twenty Thousand Leagues Under the Sea* is the most important of Verne's science fiction novels, as it directly enters the scientific domain that had been so important to his SF method. As the culmination of a decade's work, it also acts as a summation of his achievement in the first years of

his career, during which he completed his most important novels. More than this, *Twenty Thousand Leagues Under the Sea* interacts with natural history (and technology) to influence its cultural significance throughout Europe. As Arthur B. Evans argues, "because of their pedagogical character, they [the novels] functioned not only as a passive reflection of their historical milieu but rather as a part of their dynamic mediation with it, in other words, as having affected their society as much as having been an effect of it."[10] Verne's imaginative reading of oceanology does not simply mirror the performance of such research. Instead, his narrative questions the validity of certain positions in natural history and parodies other areas of investigation that had obsessed oceanologists in the previous three decades. In doing this, Verne actively intervenes in the ongoing cultural practice of natural history, reinforcing for a general public both the equivocal nature of scientific theories and the excitement that natural history engendered.

The opening section of *Twenty Thousand Leagues Under the Sea* brings both these attributes together in setting the scene for the portrayal of oceanology in the rest of the narrative. The novel begins, "The year 1866 was marked by a strange incident, a mysterious and inexplicable phenomenon," before detailing how, "for some time past, vessels had been met by 'an enormous thing,' a long object, spindle-shaped, occasionally phosphorescent, and infinitely larger and more rapid in its movements than a whale."[11] The sea serpent that occupies the first chapters may be unknowable, but its appearance in the narrative does allow Verne to define his approach to natural history. In particular, it opens for discussion a number of issues that are to be vital in Verne's reading of the function and practice of oceanology. Keenly stressed at this stage of the narrative is the importance of scientific interpretation. While Verne tells his reader that "the facts relating to this apparition (entered in various logbooks) agreed in most respects" or even "that it *did* exist was an undeniable fact" there remains an inability to either classify it satisfactorily or rule out its mythical status (3). Despite these significant problems, or indeed because of them, the sea serpent becomes the main talking point of learned society: "In every place of great resort the monster was the fashion. They sang of it in the cafes,

ridiculed it in the papers, and represented it on the stage. All kinds of stories were circulated regarding it. There appeared in the papers caricatures of every gigantic and imaginary creature, from the white whale, the terrible 'Moby Dick' of hyperborean regions, to the immense kraken whose tentacles could entangle a ship of five hundred tons, and hurry it into the abyss of the ocean" (4–5).

The sea serpent enters the world of the imagination before it reaches science, becoming a song, a piece of prose, a sketch, and a myth before any scientific system is brought to bear on its enigmatic status. Yet Verne is not solely providing an intertextual example of his own imaginative fiction. Rather, the entire rendering of the sea serpent controversy very clearly parodies natural history debates over the existence of unknown creatures in the world's oceans. Bringing together a range of discourses and communications—from newspaper reports to popular conversation, from ship's logbooks to mythical literature—the first chapter of *Twenty Thousand Leagues Under the Sea* depicts the craze for the sea serpent that swept across Europe in the late 1840s and was still on the natural history agenda in the 1860s. Reading documentary evidence of this craze alongside Verne's narrative suggests two themes that should form a cultural interpretation both of the novel and of oceanology: authority and vision. Of all the variant conceptualizations of the sea serpent, one thing remains constant: it is vital to know how the sea serpent was seen and who saw it. *The Zoologist* of 1847 "contained one of the many accounts"[12] of sea serpent sightings during the years of the craze. The following letter deserves quoting at length:

H.M.S. *Daedalus,* Hamoaze, Oct. 11th. SIR,—In reply to your letter of this day's date, requiring information as to the truth of a statement, published in the *Times* newspaper, of a sea-serpent of extraordinary dimensions having been seen from Her Majesty's ship *Daedalus,* under my command, in her passage from the East Indies, I have the honour to acquaint you, for the information of my Lords Commissioners of the Admiralty, that at 5 o'clock p.m., on the 6th of August last, in latitude 24° 44' S and longitude 9° 22' E., the weather dark and cloudy, wind fresh from the N.W., with a long ocean swell from the S.W., the ship on the port tack,

heading N.E. by N., something very unusual was seen by Mr. Sartoris, midshipman, rapidly approaching the ship from before the beam. . . . On our attention being called to the object, it was discovered to be an enormous serpent, with head and shoulders kept about 4ft. constantly above the surface of the sea; and, as nearly as we could approximate by comparing it with the length of what our maintopsail yard would show in the water, there was at the very least 60ft. of the animal. . . . Your obedient servant, Peter McQuhae, Capt. [13]

Accompanied by a sketch "taken immediately after it was seen,"[14] this type of sensational narrative (coupled with pictorial evidence) was common in the newspapers and scientific periodicals of the 1840s and 1850s. Set against Verne's own narrative deployment of ship sightings, positions, movements, and the dates and times of logbooks, the similarity between certain moments in the cultural history of oceanology and the novel is striking. Yet it is important to recognize that such letters in the columns of scientific periodicals formed only part of a larger debate that occupied both the scientific community and the public. Despite the authoritative voice of the ship's captain, the corroboration of his crew, and the view of *The Zoologist*'s commentator that this is "unassailable evidence from the best source possible,"[15] there remained a powerful forum of scientific professionals who were skeptical of the veracity of the sighting. The men who had been witness to it, they suggest, were victims of a cultural mythology made current once again in the recent spate of sightings. Yet many scientists also recognized that the ocean remained one of the largest areas yet to be penetrated by the scientific gaze. There was an understanding in the natural history community that the depths of the sea may yet hold objects that science either had not postulated or, as in the cases of sea serpents, had flatly denied. The *Illustrated London News*, often the first to publish stories of sea serpents, gives us a hint of the scientific view of the wonders of the ocean depths. In an article dedicated to explicating some of the latest technological items that aided deep-sea discovery, the writer discusses new and "ingenious contrivances" for ocean exploration and speculates on the probability of finding answers to "the disputed question as to the existence

or non-existence of animal life at the bottom of the sea": "This is the great natural history fact of the expedition, and one which shows us that the depths of the ocean, their conditions and their temperatures, become more and more subjects of interest as we gradually approximate towards accurate knowledge of them, and as their requirements oblige us to investigate their mysteries."[16]

By the time Verne writes the first chapters of *Twenty Thousand Leagues Under the Sea* in 1869, the debate over the existence of sea serpents is, as these newspaper accounts attest, once more on the scientific agenda. Verne takes advantage of this position to introduce his narrator, the eminent naturalist Pierre Aronnax. Aronnax's qualifications are redoubtable: he is a professor at one of the greatest nineteenth-century natural history museums and has published *Mysteries of the Great Ocean Depths,* a book "highly approved of in the learned world" that has gained "a special reputation in this rather obscure branch of Natural History" (9). First called upon as a scientific expert, Aronnax very precisely enacts the position of the oceanologist in the debate surrounding the existence of the sea serpent. He offers neither denial nor acceptance but a teasing betrayal of possibility: "The great depths of the ocean are entirely unknown to us. Soundings cannot reach them. What passes in those remote depths—what beings live, or can live, twelve or fifteen miles beneath the surface of the waters—what is the organization of these animals, we can scarcely conjecture" (9).

Again, Verne's employment of the rhetoric found in the periodicals is obvious. Aronnax performs his role according to expectation. Yet the scientific commentary he provides subtly reveals his position as closet natural historian, more comfortable in the museum than on the ocean. His summary of the sea serpent controversy relies not on the evidence of sight but on theoretical assumptions. He makes vision secondary to scientific knowledge, however removed that knowledge is from the site of contestation. As he lines up fact alongside fact in a logical and studied development of scientific possibility, Aronnax makes not a single concession to the gaze of the seaman, whose original claims had set the entire debate in motion. Instead, he includes only those possibilities available to scientific fact, grading them in a hierarchy of plausibility

that is positivist in origin. The sea serpent, however, is highly resistant to such a monocular vision, and, indeed, Verne allows Aronnax to undermine his own theoretical position very quickly. "My article was warmly discussed, which procured it a high reputation. It rallied around it a certain number of partisans. The solution it proposed gave, at least, full liberty to the imagination. The human mind delights in grand conceptions of supernatural beings. And the sea is precisely their best vehicle, the only medium through which these giants . . . can be produced or developed" (11).

While Aronnax has based his prediction only on the theoretical possibilities afforded by oceanological fact, the result of his article has been to enhance the mythology of the sea serpent. Once again this appears out of step with the intentions of sober, scientific calculation. The conflict between the classifiable natural history object and the mythological or supernatural object continues unabated. This has a far-reaching effect for Aronnax. Set up as the narrative authority, his judgment is called into question immediately when he enters the text. This seems an unusual tactic for a work of science fiction. Indeed, it is more often the case that the authority of the narrator is used to drive the narrative forward, bolstering scientific plausibility and imaginative extrapolation.

This is a skewed view to take in Verne's case. Rather than sabotaging Aronnax's status, Verne constructs his role to coincide with the cultural view of natural history current in the mid-nineteenth century. By allowing Aronnax to register the imaginative impact of his oceanological findings, and by suggesting that he is pleased by such public excitement, Verne cleverly places his narrator as the archetypal natural historian. It is the role taken on by the naturalist to mediate between the Romantic imagination and the pragmatic detailing of fact. Natural history is both an investigative science and a practice designed to elicit sublime wonder. Philip Gosse, for example, opens his oceanological monograph *The Aquarium* by noting how "pleasant it is to start on such an excursion. The day all before us; hope dominant; fancy busy with what treasures of the deep the dredge may pour at our feet."[17] In more sober prose, George Lewes exacts the same pleasure from his natural history studies: "There are two aspects in which natural history may be regarded—as

an amusement, and as a science; the one being simply delight in natural objects, the other a philosophic inquiry into the complex facts of life."[18] Natural history is characterized by its equal attention to "fancy," "delight," and philosophical investigation. As Lynn Merrill has argued, it is both science and art: "Because it depends on facts, natural history writing is allied to science; because it deals with human responses and emotions, it is allied to literature. As a result, the discourse of Victorian natural history falls squarely in the middle of a major argument about the respective qualities and aims of science and the humanities."[19]

For Verne, oceanology's battle with the sea serpent should be read as a prime example of this discourse. Aronnax's scientific appraisal of the "phenomenon in question" (9) and his subsequent acknowledgment that the public used this document to reinforce their own imaginative reconstruction of the sea serpent illuminates the multivocality of oceanological language. Moreover, it demonstrates that there is a significant cultural shift in the reception and transmission of natural history when it is transferred from the professional to the amateur, or moved from the closet to the field. Aronnax, whose role is that of the professional oceanologist most comfortable in the closet, is therefore immediately set up in opposition to the field worker, who will be given a voice later in the text through Captain Nemo.

Although Verne's reading of oceanology in *Twenty Thousand Leagues Under the Sea* is an intriguing reflection of the dynamics of nineteenth-century natural history, it describes only one aspect of his interest in contemporary scientific communities. As important is his attention to the technological or mechanical nature of culture. The sea serpent that Verne imagines, we must remember, is not a sea serpent at all but a piece of technology. Verne reveals this by drawing a contrast between the organic and the inorganic as the Nautilus comes into view:

> I wriggled myself quickly to the top of the being, or object, half out of the water, which served us for a refuge. I kicked it. It was evidently a hard impenetrable body, and not the soft substance that forms the bodies of the great marine mammalia. But this hard body might be a

bony carapace, like that of the antediluvian animals; and I should be free to class this monster among amphibious reptiles, such as tortoises or alligators.

Well no! the blackish back that supported me was smooth, polished, without scales. The blow produced a metallic sound; and incredible though it may be, it seemed, I might say, as if it was made of riveted plates.

There was no doubt about it! This monster, this natural phenomenon that had puzzled the learned world, and overthrown and misled the imagination of seamen of both hemispheres, was, it must be owned, a still more astonishing phenomenon, inasmuch as it was a simply human construction. (35)

As Aronnax's investigation of the object swings from an attempt to classify it according to genus and species toward an understanding of its technological construction, he neatly sidesteps any mention of his own mistaken hypothesis of its origins. Although he too had described the Nautilus as "a gigantic narwhal" (10), it is to the seamen he turns to cast blame for any misinterpretation. Their vision, rather than his theory, had been at fault.

Vernian critics often begin their readings of the Nautilus from the fact that it is not a sea serpent but a mechanical device. Peter Costello, introducing the Everyman English translation of the novel, exemplifies this position by arguing that "underlying all of Verne's books is a grasp of new and progressive facts, whether of geography, science, or technology. . . . Take the Nautilus submarine, for example."[20] Science means technology to Costello (and others), although the sea serpent story receives mention only as "some topical note" in a narrative with other concerns.[21] Yet this is to miss Verne's point altogether. The importance of the Nautilus is established because it *is* a sea serpent—a submarine that defies classification because it occupies a liminal space between the inorganic machine and the organic marine creature. There is enough substantial evidence to claim that this is a conscious decision on Verne's part. Even after Aronnax's lengthy oceanological essay on the Nautilus/narwhal,

there is a curious symbiosis of organic and inorganic in the various descriptions of the Nautilus in action. "The peculiar life with which it seemed endowed" (3) is extended at times to encapsulate the highest animal species, the human. "The Nautilus defended itself like a human being. Its steel muscles cracked. Sometimes it seemed to stand upright" (272). Even when not the subject of organic metamorphosis, it maintains a certain quality that is not at all mechanical. Nemo admits that he sees the Nautilus "as a part of [himself]" (63) and Aronnax recognizes that it is "associated with the body and soul of the Captain" (249).

Anthropomorphized from sea serpent to human, the Nautilus cannot be said to play a part only in the mechanical fantasy of the novel. Rather, it should be interpreted as a vehicle for a continued critique of natural history. Having been the primary symbol of natural history's interplay between scientific pragmatism and aesthetic mythologizing, the Nautilus is reconstituted as a technological tool that allows Verne to extend his reading of oceanology's cultural implications, as well as to investigate the use of mechanical devices to penetrate the natural world. This is not to suggest that there is an implicit ecocriticism in Verne's work. He may consistently highlight the wonder of nature, but he is just as happy to destroy if it will enhance the excitement of his narrative. Of course nineteenth-century natural historians, whether amateur or professional, were hardly overconcerned by the damage they may have been doing to the world around them. To be in awe of the marvels of nature did not in any way dampen their desire to capture natural objects, remove them from their normal habitats, exhibit them, and, often, dissect them. The Nautilus allows this pattern to develop throughout *Twenty Thousand Leagues Under the Sea*. Its penetration of the ocean depths presents Aronnax—along with Conseil and Nemo—ample opportunity for oceanological work in the field, but also, surprisingly, in the closet and the museum.

That the submarine enables its inhabitants to experience every avenue of natural history is one of Verne's great imaginative achievements. The Nautilus is both in the field of oceanology and the enclosed space of the closet. As Andrew Martin has argued, "The Nautilus is, in effect, a fragment of land which has slipped its moorings and floated

off. . . . Part of the *raison d'être* of the Nautilus is precisely to oppose and resist the water, to keep the feet of its passengers resolutely dry."[22] In providing a machine that performs the function of both laboratory and expeditionary vehicle, Verne accomplishes exactly that method of natural history research favored by Professor Gümbel in his letter to T. H. Huxley—"deep-sea investigations on the dry land."

Deep-sea investigations, from the surface of the ocean rather than beneath it, were commonplace by the 1860s. Expeditions under the banner of oceanology had been increasing in number and ambition from the late 1840s and were avidly followed by the public. *Nature*, which first began publication in 1869, included an extended serialization of one expedition in its early editions, no doubt aiming to hook a readership on the expeditions' adventures and discoveries.

Beginning on November 25, 1869, the explorations of HMS *Porcupine* were communicated first to the Royal Society and then to the readers of *Nature*. The excitement this engendered makes up the first details of a number of lengthy reports: "The opening meeting of the Royal Society on Thursday last was attended by a numerous assemblage of men of science, especially attracted by the announcement that Dr. Carpenter, representing a committee consisting of Professor Wyville Thomson, Mr. Gwyn Jeffreys, and himself, would communicate the results of the deep-sea dredging explorations, carried out in the course of the past summer and autumn in the *Porcupine,* a vessel expressly fitted out and placed by the Government at the disposal of the committee for this purpose."[23] The reports from the *Porcupine* exacted a fascination on the readership of *Nature* from the end of 1869 until April 1870. However, by late January of 1870, it had been relegated to second place in favor of another expedition—the Arctic passage of a group of Swedish and German adventurers. This was distasteful to the *Nature* reporters for several reasons:

England seems ready to resign the position she once held as chief of all the competitors in Arctic exploration. Our flag has been carried within 7 ½ degrees of the North Pole; our seamen have forced from the ice-bound straits which lie to the North of America the secret of the North-Western passage; and from the days of Scoresby until those of Franklin

we have been foremost in scientific researches within the dreary arctic wastes. But now the answer to all who would emulate the deeds of a Parry or a Ross, a Beecher or a Franklin, is the stereotyped cui bono. A business account of the probable gains of an Arctic journey must be rendered before England will send men or ships to the Polar seas.[24]

Scientific expeditions—most commonly made to further the investiga-tions of natural history—performed a function far beyond the idealistic search for knowledge that was most often the rhetorical stance taken by those involved. As the above reports reveal, the cultural politics of natural history exploration revolved around notions of competition: scientific, economic, and national. The great European countries were involved in a constant battle for supremacy on the field of oceanology. In the above quote, *Nature* regrets England's inability to match its Eu-ropean counterparts in Arctic adventure. By comparison, the *Porcupine* expedition seems little more than dabbling at the seashore.

This pattern of competitive natural history investigation was a tem-plate not only for nation states but also for individuals. Oceanology in particular was marked by a determination to discover better objects than one's fellow naturalists, to design more practical and more useful equipment, to classify more molluscs and rarer celaphopods, to compile larger and more valuable collections, and ultimately to "know" more, to be acknowledged as an expert by the wider community. Everywhere in the work of Philip Gosse and George Lewes are instances of this com-petitive imperative. Gosse advances his own work on the aquarium by stating, "The inhabitants of the deep sea have hitherto been almost in-accessible. . . . The Marine Aquarium, however, bids fair to supply the required opportunities."[25] Lewes, in the preface to his *Sea-Side Studies at Ilfracombe, Tenby, the Scilly Isles, and Jersey,* advances "new facts and new physiological interpretations" that have "received striking confirmation in the admirable researches of Professor Huxley."[26] Even Charles King-sley cannot resist highlighting his own expertise in a lecture on natural history to the Royal Institution: "Believe me you need not go so far to find more than you will ever understand. An hour's summer walk, in the company of some one who knows what to look for and how to look

for it . . . would furnish you with subjects for a month's investigation."[27] From improved equipment through new scientific facts to expert vision, these three writers of popular natural history exemplify the arenas in which natural historians fought their field battles.

In *Twenty Thousand Leagues Under the Sea*, entry to the Nautilus is the beginning of this conflict for Professor Aronnax. Already characterized as a closet oceanologist, Aronnax finds himself challenged by Nemo, the champion of field exploration. Taking a tour of the submarine, Nemo introduces Aronnax to his natural history collection: "Under elegant glass cases, fixed by copper rivets, were classed and labeled the most precious productions of the sea which had ever been presented to the eye of a naturalist. My delight as a professor may be conceived. . . . To estimate the value of this collection was simply impossible" (53–54).

Confronted by an amateur collection far exceeding the quality of his own institution's holdings, Aronnax resorts to a reinforcement of his own professional status, unconsciously moving the terms of the conflict from the collection to the expertise of the individual. Nemo, however, will not allow such a shift to occur. Instead, he calls on the most powerful tool of the field naturalist—self-collection: "You are examining my shells, Professor? Unquestionably they may be interesting to a naturalist; but for me they have far greater charm, for I have collected them all with my own hand, and there is not a sea on the face of the globe which has escaped my researches" (54). Aronnax, obviously placed on the defensive, rather churlishly admits to "the delight in wandering about amidst such riches" and attempts once again to elide the combative stance Nemo has adopted: "No museum in Europe possesses such a collection. . . . But if I exhaust all my admiration upon it, I shall have none left for the vessel that carries it" (54–55). This dialogue, in which the professional closet naturalist is confronted by a man who claims to be "an amateur, nothing more" (52), clearly demonstrates the conflict and competition that existed in natural history at this time.

Despite his position as a public authority on oceanology, Aronnax is on alien territory aboard the Nautilus. This is not only due to Nemo's captaincy of the machine; it is also a product of the difference between their places in the oceanological hierarchy. As Lynn Barber has shown,

the professional and the amateur inhabited very disparate spaces in the study of the ocean: "Broadly speaking, the field belonged to the amateur, and the closet to the professional. Closet naturalists held all the top scientific posts and dominated the learned societies and journals."[28] Within the confines of the Nautilus, however, Aronnax's professional position is nullified. The submarine has become the entire world of oceanology, leaving no recourse to a wider scientific community in which Aronnax's qualifications and position count in his favor and reduce Nemo to the amateur status he himself admitted. Indeed, Nemo's amateurism is disingenuous on board the Nautilus, for there is no avenue for professionalization outside the metal walls of the machine. This, ultimately, is Aronnax's unsolvable problem. Although he is the titular professional of the Nautilus, he now exists within an oceanological world that gives primacy to the field. His professional status demands professional activity and recognition of the type Verne has shown us at the beginning of the narrative. Here, he is imprisoned in an amateur environment in which the tables of expertise have been turned. Nemo plays heavily on this reversal, highlighting his amateur status and amateur pursuits (his own collecting), all the time aware that his apparently lowly status in oceanological terms has no meaning in the microcosmic world of the machine.

Aronnax's impotent professional stature is further reinforced by his assistant Conseil, who not only performs more capably in the field when saving Aronnax from drowning but also steals the role of classificatory expert from his superior. As the wonders of marine life are revealed to the inhabitants of the Nautilus, it is Conseil who categorizes the specimens he and Aronnax discover: "For two whole hours an aquatic army escorted the Nautilus. . . . Our imagination was kept at its height, interjections followed quickly on each other. Ned named the fish, and Conseil classed them. I was in ecstasies with the vivacity of their movements and the beauty of their forms. Never had it been given to me to surprise these animals, alive and at liberty, in their natural element" (68). The heavy irony of the positions taken by the amateur and professional is clear. Conseil, the consummate amateur, lists, categorizes, and classifies species while Aronnax looks on in wonder. A career spent in the closet

has not prepared him for the experience of the field. Yet his response to the ocean life is very much that of the field amateur. He romanticizes natural history, using language most often found in popular accounts of natural history fieldwork. Witness Philip Gosse's opening account of natural history investigation in *Evenings at the Microscope; Or, Researches among the Minuter Organs and Forms of Animal Life*—"the author has swept rapidly across the vast field of marvels, snatching up a gem here and there, and culling one and another of the brilliant blossoms of this flowery region"[29]—or George Lewes's introductory remarks in *Sea-Side Studies:* "Who will revive me with *that* flutter which deprived me of all coolness and presence of mind[?] . . . Who will restore the enthusiasm of that moment when my eye first rested on a clump of *Clavelinae*[?]"[30] Aronnax divests himself of professional etiquette very quickly and in doing so takes on the role of field naturalist forever marveling at the heterogeneity of the marine world.

As Aronnax shrugs off his status as closet oceanologist and begins to play the part of the field explorer, he completes the portrait of field investigation that Verne has been painting. Taken together, Nemo, Conseil, and Aronnax are the archetypal field amateur: they are competitive and brusque in their defense of field study, classifiers par excellence, and romanticizers of the natural world. Lynn Merrill, in her otherwise excellent cultural study of natural history, has attempted to read these three characters in their respective scientific roles: "One is the familiar mad scientist, with an Ahab-like propensity for vengeance: Captain Nemo. The other hero is a quintessential nineteenth-century scientist-collector, off on expeditions to find specimens to collect, categorize and send back for exhibit: Aronnax. . . . The assistant to Professor Aronnax, his servant Conseil, is a walking compendium of taxonomy."[31] Such a reading of the three central figures of Verne's novel does not recognize the significance of the oceanological roles played by each, nor does it grasp Verne's depiction of fieldwork in all its manifestations. Merrill's reading is a common one, but one that does not grant Verne the understanding of natural history's popular significance that he undoubtedly possessed. Of course, to regard Nemo, Aronnax, and Conseil as a cooperative group that performs a singular role goes against the popular reading of these

characters as continually in conflict. Yet there is certainly a cohesion in their oceanological personalities that suggests such a cooperative is one available reading of the narrative. Moreover, the Nautilus—as the site in which this is played out—must be viewed as a more complex symbol than that of technological fetishism.

What the Nautilus actually allows Verne (and his characters) to *do* is of central importance. While many critics take the position, articulated by Roslynn Haynes, that Verne's "particular focus on various novel means of transport . . . becomes a metaphor for the assertion of individual freedom," the Nautilus also functions as a coda for "environmental domination."[32] Within the oceanological focus of the novel, this subjection of nature to the power of technology turns the Nautilus into a piece of equipment equivalent to the deep-sea dredge or the aquarium that extends the ability of oceanologists to investigate the marine life hidden in the depths of the sea. Having placed his field workers on board the submarine, Verne begins to explore the technological importance of the Nautilus as an oceanological tool.

Natural historians almost always hail discoveries in technology as advantageous to their ongoing research. The *Illustrated London News*, in an article of 1861, discusses the necessity of an improved dredging machine: "Although the deep-sea sounding machines hitherto commonly used have brought up a sufficiency of the ocean bed for microscopic examinations, yet during the recent exploring voyage of H.M.S. Bulldog it became evident that means for bringing up a much larger quantity from vast depths was necessary, not only for the requirements of the projectors of submarine cable routes, but also for the purpose of settling the disputed question as to the existence or non-existence of animal life at the bottom of the deep sea."[33] Technological improvements to natural history equipment mean more specimens from previously inaccessible locations, leading to additional knowledge. An extension of range, an increase in quantity, and the succession of new scientific facts is the end product of mechanical advancement. This is precisely what is achieved by Nemo's submarine. The Nautilus reveals an "endless variety" of marine life (88) that Aronnax has never before witnessed and that leads him to entertain the idea of improving greatly his own research of the

ocean depths: "I had now the power to write the true book of the sea; and this book, sooner or later, I wished to see daylight. Then again, in the water by the Antilles, ten yards below the surface of the waters, by the open panels, what interesting products I had to enter on my daily notes!" (243). Vision is the key to Aronnax's superior oceanological knowledge. Through the windows of the Nautilus, he has been able to see further, deeper, and more particularly than his closet had ever allowed. This ability to "penetrate the awful mysteries of the ocean" (88) is brought about by the view afforded from the transparent walls of the submarine. These glass panels turn the ocean into a vast aquarium and allow Verne to intervene in one of the most interesting moments in the history of nineteenth-century oceanology.

The aquarium was designed by Robert Warrington and first disseminated in the early 1850s through the Chemical Society of London. It was, however, Philip Gosse who popularized its use by naturalists. Having constructed an aquarium for the London Zoo in 1853, Gosse then published *The Aquarium: An Unveiling of the Wonders of the Deep Sea* in 1854, which set down his own amendments to Warrington's original design.[34] Gosse's detailing of the methods of aquarium construction and upkeep disingenuously suggest that its design is his alone, despite a brief acknowledgment of Warrington's discovery. But it is the symbolic significance of the aquarium, rather than claims to its discovery, that makes Gosse's work so interesting. The aquarium is an oceanological version of the fern case, immensely popular in the homes of amateur naturalists in the 1840s. The case of marine life brings the ocean indoors; it allows the oceanologist to study the field within the confines of the closet. In a sense, the aquarium is the single piece of equipment that illustrates Gümbel's "deep-sea investigations on dry land." As Lynn Merrill has shown, the case, or cabinet, articulates into the practice of natural history:

A cabinet was a small-scale museum, a collocation of curios, and a personal archive. It might be a humble little box with drawers, or a beautifully crafted wood-and-glass display case.... Whatever its shape, the cabinet was the physical analogue of the activity of collecting. It

served as a repository for all manner of collected natural objects, which, stimulating to the mind and eye, lent themselves to contemplation and sheer aesthetic pleasure. Stocked with curious minerals or plants or shells, the cabinet invited careful scrutiny of its contents. As such, the natural history cabinet was firmly grounded not only in the collecting urge, but also in the ingrained belief that meticulous observation was important.[35]

The aquarium is the oceanological equivalent of the naturalist's cabinet, and the entrapment of the diversity of marine life within the cabinet is a corollary of the prowess of the oceanologist: the more diverse the genus and species collected together, the greater the oceanological skill of the collector. The aquarium functions not only to highlight observation and collection but to set apart exemplary observing and collecting. The aquarium is a site of competition—as Gosse made clear in attempting to claim credit for its design—that allows for the deployment and illumination of oceanological practice at its best.

As the aquarium became more sophisticated and knowledge of its finest uses more widely known, amateur oceanologists went to great lengths to maintain their own aquariums at home. Many shipped seawater from the coast each morning to replenish their tanks or paid vast sums for specimens of marine plants. The competitive drive of natural history is nowhere more clearly depicted than in the sacrifices (monetary and otherwise) made by the amateur oceanologist in pursuit of a superior aquarium. Performance and skill in oceanological investigation was graded according to distance and vision: How far had one gone to collect samples? How much more had one seen on these expeditions? For the competitive oceanologist, to go "to points a little beyond the reach of the amateur" was a necessity.[36] Even more vital was to bring back evidence of this prowess. The aquarium, therefore, became the miniature laboratory in which oceanological penetration was measured. Each rare specimen was further corroboration of the oceanologist's skill. The "meticulous observation" that Merrill argues was the central learning experience of the aquarium is also the means by which expertise and accomplishment was viewed by others.

The basic equipment of competition, of course, was the aquarium itself. Gosse, indeed, attempts to reinforce his own reputation for oceanological facility via the construction of the aquarium rather than the specimens with which he fills it. Technical competence, from knowing the best type of jar to use for collecting on the seashore to the improvements in the deep-sea dredge, is the foundation of proper field investigation. Nemo, as designer, owner, and captain of the Nautilus, has no equal when competition turns to technology. Unlike Gosse, who tinkers with the basic design of the aquarium, Nemo takes control of the largest aquarium of all: the ocean. In a reversal of the usual formula, Verne transports his amateur oceanologist to the sea rather than bringing the sea to the oceanologist. In this turnaround of normal procedure, the Nautilus plays a major role. Its complex technology, detailed at length by Nemo in conversation with Aronnax, allows it to take on the function of a myriad of oceanological devices, of which the aquarium is one of the most distinctive: "Suddenly light broke at each side of the saloon, through two oblong openings. The liquid mass appeared vividly lit up by the electric gleam. Two crystal plates separated us from the sea. . . . The obscurity of the saloon showed to advantage the brightness outside, and we looked out as if this pure crystal had been the glass of an immense aquarium" (67–68).

The Nautilus transforms the ocean into an aquarium before the eyes of Aronnax, and it is to the eyes that he constantly makes reference. Increased vision characterizes the defamiliarized sight of the ocean depths. In the context of the symbolic resonances emanating from the aquarium, this is one further example of Nemo's oceanological superiority over his professional colleague. Having already revealed himself as a collector without equal, Nemo now proves himself adept at harnessing technology. His sublime aquarium positions him as *the* oceanological force of the novel, relegating Aronnax to the stuffy confines of the closet. Yet there is a problem in viewing Nemo and Aronnax in a too simple binary relationship of amateur to professional, field investigator to closet scientist. This is particularly the case in the development of the ocean as an advanced aquarium, for if the Nautilus provides its inhabitants with a window onto the ocean aquarium, then it must be read as a closet

within which the aquarium rests. However, to see the Nautilus as the closet rather than the field is to problematize the critical stance taken throughout the present chapter. Verne intends for this problematizing to occur. His ambivalent construction of the Nautilus has been in evidence since the opening chapter of *Twenty Thousand Leagues Under the Sea* and is always utilized in order to critique nineteenth-century natural history in its various cultural manifestations. In placing the submarine on the boundary between the field and the closet, indeed to turn it into a closet within the field, is only another method by which the politics of oceanological research can be demonstrated and investigated.

There is little doubt that one of the central foci of Verne's continued assessment of natural history is the purpose of the closet as a denotative site of theoretical science. Aronnax's initial invitation to peruse the Nautilus highlights both the atmosphere of closet study and the importance of textual knowledge:

I entered a room equal in dimension to that which I had just quitted. It was a library. High pieces of furniture, of black violet ebony inlaid with brass, supported upon their shelves a great number of books, uniformly bound. . . . Light moveable desks, made to slide in and out at will, allowed one to rest one's books while reading. In the center stood an immense table, covered with pamphlets. . . .

"Captain Nemo," said I to my host . . . "this is a library which would do honour to more than one of the continental palaces, and I am absolutely astounded when I consider it can follow you to the bottom of the seas."

"Where could one find greater solitude or silence, Professor?" replied Captain Nemo. "Did your study in the Museum afford you such perfect quiet?" (50–51)

Verne provides the Nautilus with the quintessential library of the closet oceanologist. Nemo draws particular parallels with Aronnax's own professional institution, inferring that the submarine is superior to many other sites of professional oceanological activity. Not only is the Nautilus an exemplary field craft, it is also a first-rate research institution.

The "twelve thousand" volumes (51) of scientific works that line the walls of the library are Nemo's "favourite study" (48). Amongst them is Aronnax's own monograph, annotated by Nemo: "In the library I often found his books left open, especially those on Natural History. My work on submarine depths, conned over by him, was covered with marginal notes, often contradicting my theories and systems" (198). Nemo's intense study of the work of Aronnax and other professional natural historians must be placed alongside his modest claims of amateur status and his championing of the observable phenomena of the field. Just as the Nautilus can be seen to reside in a borderland between the field and the closet, so too does Nemo's rhetoric betray the dialogic mingling of the language of both the field and closet oceanologist. Interested in textual knowledge and field observation, Nemo can certainly lay claim to expertise in both the field and closet, and it is Verne's intention to make clear that this combination best serves the advancement of natural history as a subject of serious scientific study.

The Nautilus, which has continually rebuffed attempts to adequately classify it, reveals itself as the space of the dedicated amateur naturalist but also as a professional site of oceanological knowledge. While it is relatively simple to categorize it as Nemo's private study, sealed off from public admission, Aronnax's reaction to its museum collections and library holdings undermines any reading that takes only this line. Aronnax forever places the Nautilus in dialogue with professional institutions, reading Nemo's collection of oceanological specimens against the great museums of the world and the library against the palaces of Europe. Nemo enters this debate himself, highlighting the superiority of his own library by comparing it to Aronnax's home institution. How, then, should the Nautilus be classified? Undoubtedly, it performs a dual role as a private collection of the supreme amateur and as a hidden site of professional oceanological expertise. The ultimate technological weapon in the fight to extend an understanding of the ocean's marine life, the Nautilus has the skills of the field and the closet, of the amateur and the professional. It is no surprise, if we accept this formulation, that passage on the Nautilus leads to an expedition that sees Nemo create one of the

greatest private collections of oceanological specimens while allowing
Aronnax to complete the research necessary to write a book of the sea
that surpasses "terrestrial science" (48).

Moreover, Nemo's museum collection is Verne's depiction of the
cultural dynamic engendered by the natural history arena—that of the
public pursuit that improves the intellectual character as well as sat-
isfying a yearning for interesting and engaging leisure activities. This
was exactly the role played by amateur natural historians throughout
the middle decades of the nineteenth century, and it was also the role
taken on by the natural history museums later in the century. As Lynn
Barber, talking particularly of the British Museum, points out, the mu-
seums of natural history "represented that fusion of scientific vitality and
popular entertainment that characterized Victorian natural history at its
best."[37] Such a fusing of science and leisure is apparent from Aronnax's
perusal of Nemo's drawing-room curiosities, where he notes both the
classificatory precision of the collection and the aesthetic pleasure of
its arrangement: "Amongst those specimens, I will quote from memory
only the elegant royal hammer-fish of the Indian Ocean, whose regular
white spots stood out brightly on a red and brown ground, an imperial
spondyle, bright-coloured, bristling with spines. . . . A common ham-
merfish of the seas of New Holland, which is only procured with dif-
ficulty; exotic buccardia of Senegal; fragile white bivalve shells, which
a breath might shatter like a soap-bubble" (53–54).

Synthesizing artistic appreciation with scientific accuracy, Aron-
nax reacts to Nemo's museum as both the amateur naturalist and the
professional oceanologist. Here, on the site of classificatory authority
(the natural history museum), Aronnax reveals the best of natural his-
tory—its combination of field work and closet study in creating an ex-
hibition of supreme scientific merit. By noting the difficulty with which
such specimens are retrieved, as well as constantly referring to these
objects by their correct scientific nomenclature, Aronnax highlights
those strengths of the field and the closet that Verne has merged in the
Nautilus and its captain. Nemo's museum makes concrete the discrete
activities of oceanology (discovery, retrieval, recognition, classifica-
tion) that together form a powerful alliance in the progress of science.
This symbolic site of partnership between the amateur and professional

captures Verne's reversal of the more common pattern of conflict that characterizes nineteenth-century views on natural history. Instead of disunity, *Twenty Thousand Leagues Under the Sea* iterates a totality of scientific practice that brings the field and the closet together in useful and constructive cooperation. Arthur Evans posits a similar view of the individual scientist in Verne's work: "The Vernian scientist also personifies mobility. His scientific accomplishments (themselves the result of a 'voyage') are depicted as progressive motion towards the total codification of Nature."[38]

By portraying the Nautilus and Nemo as symbiotic organisms that marry together field and closet, amateur pursuit, and professional investigation, Verne envisions oceanology as a progressive science that can see nature in the round. As the Nautilus circles the oceans of the world, Aronnax compiles a "true" picture of the depths of the seas, and Nemo continues his rewriting of natural history textbooks. Oceanology is brought closer to a position of scientific omniscience. Rather than dwell on the glory of natural variety supplied by divine imagination, natural history takes on the mantle of the visionary, occupying the place of divine power as opposed to reflecting it.

Verne's vision of the cultural politics of natural history in nineteenth-century Europe, then, is one that champions harmony over dissent and cooperation over competition yet manages critically to assess the difficulties of achieving such a utopian state. Critics of Verne almost always focus on the idealism inherent in such a project rather than addressing the complexity and ambiguity of scientific culture that always acts as a counter to outright evangelism. Peter Costello, for example, claims that Verne "tried to present the possibilities of scientific development in a romantic light,"[39] while Sarah Capitanio argues that "many of the codes of utopian writing . . . are present in the novels of Verne."[40] However, this tells only one side of the story: Verne always mediates his work through the specific historical lens of the scientific field that is the focus of his novel.

Moreover, the science that provides the impetus for Verne's work is never discussed only within its scientific context. In *Twenty Thousand Leagues Under the Sea,* oceanology is placed within a scientific milieu that is primarily engaged in debating the oppositions between the

amateur and the professional. But this debate is also framed by wider concerns, concerns that develop the place of oceanology in society and culture as a whole. Nowhere is this more apparent than in the thread of economic competition that runs throughout the text. This chapter has already addressed the notion of competition within oceanological research, yet the connection Verne makes between science and society in this context has yet to be fully investigated.

Lynn Barber reveals one of the central indicators of the influence of nineteenth-century society on natural history. "In order to be rational," she argues, "a study had to be either useful or morally uplifting. Useful, in Victorian terms, meant applicable to the wants of man, which ultimately meant convertible into shillings and pence."[41] Natural history is undoubtedly a "useful" science. Aronnax, for one, certainly recognizes the economic nature of oceanological study and understands that marine specimens play a part, not only by adding to the stock of scientific knowledge but also in the circulation of capital. There are several instances throughout *Twenty Thousand Leagues Under the Sea* where he gauges the value of certain objects. A "magnificent sea-otter" so "sought after in the Russian and Chinese markets" would "certainly fetch £80" (83) and a shell with a left spiral would find "amateurs . . . ready to pay their weight in gold" (112). Likewise, Nemo has a collection of objects of "inestimable value" (53), including an imperial spondyle worth "not less than £1000" and a pearl of equal dimensions to the one "Tavernier sold to the Shah of Persia for three millions" (54). Add to this the many other examples of wealth accumulation or exchange that the narrative details—the discovery and plunder of sunken ships, the monetary gift given by Nemo to the pearl fisherman, the cost of the various mechanical parts of the Nautilus, the discussions of Nemo's private fortune—and there is an increasing body of evidence to suggest that the processes of economics are a vital factor in Verne's reading of oceanology.

As Huxley's correspondence with Professor Gümbel revealed, the nineteenth-century natural history community was involved in a system of exchange that parallels the rise of a capitalist commodity culture. Marine specimens took on value above and beyond the monetary recompense set by market forces. Aronnax seems rather anachronistic

in this regard: his attendance to the cost of certain specimens takes no account of their value as a commodity. Yet as the narrative proceeds, he begins to view the objects obtained on this oceanological expedition as valuable in more current terms. The marine specimen becomes an object that signifies knowledge rather than cash and a particular form of knowledge that Verne sees as of greater value than the traditional oceanological specimen. For Aronnax, the objects accumulated on the Nautilus voyage can be commodified as both field and closet knowledge. This increases their exchange value in the natural history marketplace, as they symbolize (at least in Verne's view) the ultimate achievement in oceanological research. While the early sections of the novel articulate Aronnax's desire to obtain wealth on his return to Paris, the conclusion of the novel finds him more inclined to exchange oceanological speci-mens for professional advancement, turning knowledge into power. This is the essence of mid-nineteenth-century commodity culture: to commute possessions (wealth) into status.

Mark Angenot has asserted that all of Verne's fictional texts "are nar-ratives of circulation" and that this could "easily refer to Marx's concept of the commodity circuit."[42] For Angenot, "Science opposes fixed capi-tal: they are the positive and negative aspects of modernity. . . . Verne portrays expense, not accumulation; circulation, not surplus value."[43] This is true, however, only toward the conclusion of *Twenty Thousand Leagues Under the Sea*. For at least the first half of the novel, Aronnax does not so much oppose capital with science as use scientific knowledge to gauge capital accumulation. However, the circulatory pressure of the text does bear fruit: as the Nautilus circles and circles (finally circling frantically in the maelstrom that ends the novel), so too does Aronnax come to regard his marine specimens and oceanological observations not as surplus value that he will sell in the cultural marketplace but as part of a circulation of scientific knowledge. While the first part of the novel is marked by strident competition between Aronnax and Nemo, this has dissipated by the time we reach the final chapters. Indeed, even when Aronnax discovers that Nemo has scribbled a number of mar-ginal corrections in his (Aronnax's) oceanological monograph, he notes only that "the Captain contented himself with thus purging my work;

it was very rare for him to discuss it with me" (198). It is astonishing to witness the calm with which Aronnax narrates this episode. With his professional reputation called into question, we would expect him to retaliate far more tenaciously. Yet his concern is only for dialogue, for an exchange of ideas between oceanological colleagues. These marginal notes, and Aronnax's disappointment at a lack of discussion, mark the change that has occurred. No longer does the professional natural historian view oceanological knowledge as a valuable slice of capital. Rather he now sees it as a commodity that needs to be put into circulation in order for its dynamism to continue.

It is perhaps Nemo himself who has brought about this alteration in Aronnax's scientific character. Although Nemo never indulges Aronnax's oceanological queries in any meaningful way, he does show him an alternative to the competitive jealousies and accumulative capitalism that Aronnax brings on board the Nautilus. Again, Mark Angenot makes reference to this alternative methodology in his discussion of Verne's critique of capitalist values: "Nemo intervenes politically by financing the Cretans' liberation movement against the English imperialists, but he draws the money from the unproductive treasure of the Spanish galleons sunk in the Bay of Vigo. In other words, he places in circulation 'sedentary' capital."[44]

Nemo reveals a way to circulate capital that works against the system of capitalist accumulation. In the instance above, his design is political, but it is a design that Aronnax makes scientific. Reacting to Nemo's social conscience, Aronnax develops a scientific conscience that sees him forego competition in favor of cooperative circulation of knowledge. It is exactly this method of cooperation that Huxley and Gümbel's epistolary conversation signifies, and it is also the method that allows the narrative of *Twenty Thousand Leagues Under the Sea* to be written. As Aronnax tells us on the very final page of the novel, when the Nautilus has been swamped by the maelstrom and he, Conseil, and Ned Land are taken in by the inhabitants of the Loffoden Isles, "Among the worthy people who have so kindly received us, I revise my record of these adventures once more. Not a fact has been omitted, not a detail exaggerated. It is a faithful narrative of this incredible expedition" (273).

As a narrative that contains extensive conchological and zoological evidence, Aronnax's dissemination of it is an exemplary indication of his belief in knowledge circulation. The publication of the text should not been seen, however, as a benevolent gesture. Aronnax's final words attest to that: "And to the question asked by Ecclesiastes 3000 years ago, 'That which is far off and exceeding deep, who can find it out?' two men alone of all now living have the right to give an answer—CAPTAIN NEMO AND MYSELF" (273). Knowledge may be passed on, but its value as a commodity of science is still demanded as payment. With Nemo lost at sea, Aronnax claims scientific knowledge for himself, disregarding Conseil and Ned Land, whose right to share in the capital value of that knowledge is as prescient as Aronnax's own. They, however, are not part of the scientific community (as Nemo was), and therefore their ability to place oceanological knowledge in circulation, or to benefit from its value as a commodity, is null. Aronnax may seem to move toward Verne's vision of cooperative scientific investigation and accomplishment, but this cooperation extends only to the boundary of the scientific community and no further. Who enjoys that status is debatable: Does the amateur naturalist form part of the scientific establishment? Or is he or she relegated to the role of hobbyist? Verne never manages to answer such questions directly, but all the evidence points toward a fairly elitist notion of science. Our touchstone here may be Ned Land, whose encyclopedic knowledge of the sea is caricatured either as scientific ignorance or as violent ecoterrorism. Even Conseil—the classifier par excellence of the novel—is never allowed to look beyond his status as servant to the oceanological master.

Ultimately, Verne's aggrandizement of a collaborative oceanology, which sees amateur and professional working side by side in both the field and the closet, is tempered by the regulatory power of a scientific elite who control access to the benefits of science and to the value of scientific knowledge. In one way, this is a prophetic reading of the history of nineteenth-century natural history, for it was not long before natural history museums, as Lynn Barber tells us, "were so specialized, so highly organized, and so vast that they could no longer expose all their treasures to the public, and the layman had to be barred from the

Villiers de L'Isle-Adam's Invention of Psychical Research

Villiers de L'Isle-Adam contributed to the popularity of French science fiction begun by Baudelaire's translations of the work of Poe and continued by Jules Verne's *Voyages extraordinaire.* Villiers de L'Isle-Adam's novel *L'Eve Future,* translated both as *The Future Eve* or *Tomorrow's Eve,* first appeared in a single edition in 1886, having previously gone through periodical publication in 1885.[1] Continuing the traditions of nineteenth-century science fiction, Villiers de L'Isle-Adam's novel pays homage to Hoffmann, Shelley, and Poe. Indeed, Hoffmann and Poe receive the honor of being immortalized in Villiers de L'Isle-Adam's numerous epigraphs. Villiers de L'Isle-Adam produces a text that talks directly to the scientific cultures of his time, addressing the complex interaction of central and marginal practices through the image of the artificial human (or cyborg) named Hadaly. Taking the creation of a human figure by scientific experiment as a central theme of the narrative,

Villiers de L'Isle-Adam invites comparison with the works of his prede-
cessors, and there are certainly resemblances between Hadaly and Poe's
General Smith or Hoffmann's Olympia. Likewise the development of
electricity as a fundamental tool for mechanical production betrays the
influence of Shelley and Verne.

Villiers de L'Isle-Adam also follows all of these writers in viewing
science as a contested space frequently transgressed by various prac-
tices claiming authority—for Hoffmann, this was the conflict between
mechanics and mesmerism; for Shelley, the Romantic and materialist
differences over electrical force; for Poe, the effect on the human of
mechanical and mesmeric influence; and for Verne, the battle between
the professional and the amateur for the realm of natural history. In
Tomorrow's Eve, Villiers de L'Isle-Adam explores spiritualism and its
experimental partner, psychical research. Together these formed a new
discipline that was attempting to gain entry into the scientific pantheon.
In pursuing the cultural significance of spiritualism, most especially
through its formulation in psychical research, Villiers de L'Isle-Adam
brings spiritual power and electrical force into dialogue with one another
and sets both in the context of the conflict between the public and the
scientist. Having these markers in place allows Villiers de L'Isle-Adam
to investigate the popular and scientific attitudes toward psychical re-
search while at the same time revealing the shifts of power and control
between the orthodox science of electricity and the subordinate and
heterodox spiritualism.

Despite the centralilty of this construction to Villiers de L'Isle-Adam's
project, critical opinion has tended to minimize his contribution to sci-
ence fiction. Although John Clute and Peter Nicholls argue that Tomor-
row's Eve is "seen as an important contribution to the Symbolist move-
ment," they believe it is interesting only because "a fictional character
named Thomas Alva Edison comes to the rescue with an impeccable
robot duplicate."[2] For Brian Aldiss, another important critic of science
fiction in the nineteenth century, the novel deserves no more than a few
sentences in his history of SF. This is not surprising, since Aldiss views
the text as nothing more than the story "of an inventor who creates a
beautiful automaton."[3] Even scholars who focus on the work of Villiers

de L'Isle-Adam fail to recognize the importance of scientific culture in his novel. John Anzalone, for example, argues that the supernatural is most prominent when reading across Villiers de L'Isle-Adam's canon: "He was specially drawn to the strains of romanticism that implied revolt and rejection. He found the appropriate vehicle for his lifelong indictment of bourgeois ideology in that complex fusion of occult doctrine, ritual and magic commonly referred to as, simply, the *Tradition*. His works abound in portrayals of supernatural experiences, and his prestige in the secret sciences was such that for the symbolist generation he was reputed and even revered as an occultist master."[4] Again critical commentary focuses on the importance of Villiers de L'Isle-Adam's symbolist career, which gives us an important clue in solving the mystery of his missing science. For the majority of critics, Villiers de L'Isle-Adam's work forms part of a late-nineteenth-century oeuvre that is variously defined as symbolist, decadent, or fin de siècle. Traditional readings of the literature associated with these movements posit a thematic construction based on a neoromantic philosophy of transcendent and supernatural individuality. As Jennifer Birkett has shown, decadence "flowed—or festered—throughout Western Europe, but by common consent its centre was France, where it reached its apogee in the eighties and nineties."[5] Villiers de L'Isle-Adam became a central figure in this new movement, yet analyses of his fiction have been rather limited by his position as a symbolist. As subsequent critical opinion accepted this as his sole contribution to fiction, it became increasingly difficult to extricate his work from such a confined context. However, a broader reading of decadence allows us to see that Villiers de L'Isle-Adam responded to science and the occult from within a decadent philosophy and that an understanding of decadent views of science will provide a vital new context within which *Tomorrow's Eve* can be read.

The materialist philosophy of the mid-nineteenth century was anathema to those writers, philosophers, and scientists that criticism marks as symbolist. Much of their work is directed toward a critique of empiricism and the promotion of a new Romanticism that recalls the ideologies of the earlier nineteenth century. It is in this context that Murray Pittock characterizes symbolists as a collective group of "artists and

ideologues [who] opposed the idea of a materialist account of creation ordered and understood by scientific and empirical thought."⁶ For Pittock, this meant a return to "basic early mythic beliefs, such as the idea of an animative universe, with an animating 'force' which could be 'controlled through sympathy and contagion in various kinds of ritual and discipline."⁷ However much this appears to slide back to the occult sciences of the late eighteenth and early nineteenth centuries, it is important to comprehend that the 1880s was a very different world, one significantly altered by half a century of scientific discovery. John R. Reed is perhaps closer to the mark when he argues that the late return of a repressed supernaturalism "represented a metaphysical craving for the liberation of the mind from the statistical and measurable habits of the late nineteenth century . . . [and] indicat[ed] a powerful desire during the nineteenth century for some means of escape from a depressingly materialistic existence."⁸ Reed's insistence on returning supernaturalism to the foreground of cultural thought is important. It is certainly true that, in the sciences, there had never been an unequivocal acceptance of materialism or the complete denial of those arenas of knowledge less central to scientific method. J. A. V. Chapple makes this point in discussing the scientific culture of the 1870s: "It is very inadequate to speak of the 'limited and definite character' of science in an age when, for example, John Tyndall kept returning to the absolute need for a ranging, boldly speculative imagination in scientific research, fully romantic in its dissatisfaction with the constraints imposed by the sensible material world in which we live."⁹

The dissenting voices of materialist science can be heard, but only when one looks beyond the accepted orthodoxy. For the most part it was the scientific mainstream that received attention, and this meant a focus on materialism. Stephen G. Brush, in an excellent study of Victorian biology, shows that mainstream science was affected by a general shift away from materialism, and that this shift influenced science as well as culture more broadly: "The disgust for *crass* materialism was due partly to the mechanization of work and life in general that accompanied the rise of industrialization in the nineteenth century, together with the loss of faith in traditional religion. Some of this disgust was transferred to *scientific* materialism."¹⁰

Science as a whole suffered from the homogenizing effect of cultural insecurity. Despite the obvious challenges to empirical science that were coming from within the assemblage of discrete subjects known collectively as "science," it was still popularly believed that science was dominated by a materialist philosophy. To revolt against materialism was to revolt against the totality of science. Seen in this light, it is unsurprising that critics of *Tomorrow's Eve* have failed to recognize the critique of scientific materialism that Villiers de L'Isle-Adam attempts. After all, if *Tomorrow's Eve* concentrates on a nonmaterialist practice, it cannot be a novel concerned with science. Or if it is concerned with materialist science, then it cannot also be concerned with other forms of science, as these do not exist within the limited range of scientific orthodoxy. Yet Villiers de L'Isle-Adam's critique has its foundation in alternative scientific practices that many culture commentators of the 1880s branded as pseudosciences. When they acknowledge the novel as one that deals with the ideologies of mechanics, they do not recognize the other sciences in conflict with this central doctrine, because they do not accept that science has a multiplicity of voices.

Conversely, critics who accept that the novel should be placed within the traditions of 1880s decadence and symbolism read the narrative as Romantic rather than scientific. This is due largely to the manner in which science in the 1880s and 1890s began to look very much like science at the start of the century. While the mid-nineteenth century had witnessed a shift from the magico-occult scientist described by Shelley and Hoffmann to the cult of the scientist as serious harbinger of future progress, the 1880s and 1890s enact a return to a situation approaching that of the 1810s and 1820s. Although the sciences were still regarded as largely materialistic in philosophy and empirical in methodology (and had been since at least the 1850s), there was more room in these last two decades for alternative scientific practices to subtly influence scientific culture. The rise of spiritualism, the discovery of atomic particles, and the theories of forces unavailable to the human eye all cast a more supernatural light on the contemporary sciences. The scientist added to this increased paranormality; professionalization was creating a scientific culture that was more and more unintelligible for a lay audience, and with a lack of understanding comes a sense of mystery and occult.

In considering the culture of this period, it is all too easy to regard Villiers de L'Isle-Adam's work as occult or supernatural and therefore not scientific. To do this, however, is to fail to recognize that science was once again involved in change and was no longer as homogenously materialist as it had been in the mid-nineteenth century.

The 1880s was, therefore, a period of some upheaval in the way that scientific culture appeared to the public. Remaining materialistic, yet on the cusp of the necromantic, the sciences and those who worked within them could shift away from the mainstream pragmatism that had been the norm for some thirty years and the more opaque and mysterious magical traditions that had dominated the first decades of the century. Villiers de L'Isle-Adam attempts to highlight this complexity in the choice of his central scientific character. Unlike Hoffmann, Shelley, Poe, and Verne, L'Isle-Adam decides against the creation of a purely fictional scientist in favor of a fictionalized version of an actual scientist, one whose life and work was known throughout the world. This tactic was not merely for the verisimilitude that a semifactual characterization might add to the narrative. Rather, the use of Thomas Edison allows for a very particular interrogation of scientific culture in the late nineteenth century, since Edison was undoubtedly one of the most recognizable scientists in the Western world, renowned for his engineering talent and technological expertise but also popularly cast as a magician or necromancer. For Villiers de L'Isle-Adam, Edison was marked by both the materialist and Romantic notions that characterized the sciences in the 1880s.

Tomorrow's Eve opens with a direct address to the reader that requires some critical attention. In this brief preface, Villiers de L'Isle-Adam calls to the reader's attention his use of Thomas Edison as a central character:

> Everyone knows nowadays that a most distinguished American inventor, Mr. Edison, has discovered over the last fifteen years a prodigious number of things, as strange as they are ingenious. . . . In America and in Europe a LEGEND has thus sprung up in the popular mind regarding this great citizen of the United States. He has become the recipient

of thousands of nicknames, such as "The Magician of the Century," "The Sorcerer of Menlo Park," the "Papa of the Phonograph," and so forth and so on. A perfectly natural enthusiasm in his own country and elsewhere has conferred on him a kind of mystique, or something like it, in many minds. . . . Thus, the EDISON of the present work, his character, his dwelling, his language, and his theories, are and ought to be at least somewhat distinct from anything existing in reality. Let it be understood, then, that I interpret a modern legend to the best advantage of the work of Art—metaphysics that I have conceived, and that, in a word, the hero of this book is above all "The Sorcerer of Menlo Park," and so forth—and not the engineer, Mr. Edison, our contemporary. (3)

This is a complex statement that plays with definitions of reality and myth, despite the fact that Villiers de L'Isle-Adam implicitly accepts their stability. He calls Edison's magical persona legendary, yet this is part of the reality of his public character. The difference between the "real" scientist and the legendary sorcerer is unclear, especially in the popular mind to which Villiers de L'Isle-Adam refers. Although clearly stating that he wishes to segregate the reality from the myth, L'Isle-Adam is surely aware that such easy separation is far from simple. Thomas Edison is both engineer and necromancer, and both of these are necessary constituents of one character that cannot stand without the other—one of them cannot so simply be left behind on the basis of a short instructive paragraph. Indeed, this opening argument seems so ineffectual that it is hard to believe that Villiers de L'Isle-Adam does not have another purpose in choosing to confront the reader at the beginning of the text. What this preface does do is draw the attention of the reader to the complex dynamics that will be at work in the novel as a whole. It makes clear that Thomas Edison is both scientist and sorcerer, and that, despite claims to the contrary, both of these must be kept in mind in reading the novel. Of course, this is exactly as Villiers de L'Isle-Adam intends it: his decision to place Thomas Edison in the novel makes the most of his equivocal public character and comments on the increasingly mobile categories in which the sciences and scientists were finding themselves.

W. T. Conroy unwittingly makes this point in his consideration of Edison as a central character. He believes that Villiers de L'Isle-Adam's choice "is another attempt to confuse the reader. Edison was of course a historical person (1847–1931), still living and working at the time of the novel's publication. Thus, despite Villiers' avowal that his character is 'at least passably distinct from reality,' one may well confuse him with the person and take as true the most extraordinary actions of the character."[11] Conroy appears, rather perversely, to be arguing that this confusion is a negative connotation of the use of Edison. It is, on the contrary, one of the strengths of Villiers de L'Isle-Adam's technique: the confusion that makes Conroy so uncomfortable is the unsettling effect that invigorates the critical attention paid by Villiers de L'Isle-Adam and the reader to the nature of scientific culture. Other scholarly voices reinforce this. Carol de Dobay Rifelj, for example, argues that both "science and the occult . . . are necessary to the novel" and are brought into focus by "Edison the great inventor" on the one hand, and Edison as "the sorcier [sic], the wizard"[12] on the other.

Certainly, the Thomas Edison we know from historians of science was caught firmly between those poles of invention and sorcery that Villiers de L'Isle-Adam identifies. This parallel with the real Edison would not have been lost on any of the first readers of *Tomorrow's Eve*. As Ronald W. Clark notes, "Between 1880 and 1890 Edison crossed that real but unidentifiable frontier which divides the famous from the celebrities."[13] With *Tomorrow's Eve,* written and published in the second half of the 1880s, the reader's familiarity with Thomas Edison would have been assured. These same readers would also have been familiar with Edison's famous Menlo Park laboratory, where the action of the novel takes place. The interest that surrounded Edison's scientific workspace was intense. Not only were the media—and the general public—caught up in the excitement of Edison's research, they also fell prey to Edison's skill at self-publicity. In one instance, as Thomas P. Hughes relates, Edison almost brought about the downfall of *Scientific American* with his sensational tactics: "Edison sketched his concept of a recording and reproducing device in the Summer of 1877. His skilled mechanist, John Kreusi, built the first model. When Edison took it to the offices of the widely read

technical journal, the *Scientific American,* his friend the editor had to stop the demonstration because the size of the crowd that had assembled threatened to collapse the office floor."[14]

Edison's showmanship continued throughout his career, never more incredibly than when he lit up the Menlo Park laboratory with his recently invented electric light bulbs. The incredulity of the public even led to "special trains from New York and elsewhere [that] brought the prominent and the plain to view four houses illuminated, streets lit, and the laboratory glowing."[15] Edison's drive to success was borne of a rigorously materialist view of scientific invention. Clark tells us that "preoccupation with development of a specific invention to meet a specific need was a feature of Edison's entire working life, and with it there went a contempt, barely concealed at times, for the man who dealt in theories rather than their practical application."[16] Empirical method was the foundation of Edison's scientific achievements, and it is only logical that he became known as "a plain-speaking man of inventive genius" who solved "practical problems of substance and intrinsic interest."[17] Edison makes science useful, worldly, and comprehendible.

At the same time, however, he cast an altogether different shadow over the public, especially the public with whom he had the closest contact, his fellow citizens of Menlo Park, New Jersey. As Clark suggests, "By the simple inhabitants of the region . . . he was regarded with a kind of uncanny fascination, somewhat similar to that inspired by Dr. Faustus of old, and no feat, however startling, would have been considered too great for his occult attainments."[18] Characterized privately as the pragmatic technologist, Edison's public face was necromantic and even diabolic. His sorcerous nickname and rather fearful persona were given impetus by his own penchant for theatrical entertainment and extravagant show. In a sense, Edison's own publicity machine worked to make him more mysterious, even as it made his work more accessible. If there is an irony in this, it is one that Villiers de L'Isle-Adam is more than aware of. In the novel, after all, a media frenzy begins at the very point that Edison calls for complete secrecy.

Certainly, Villiers de L'Isle-Adam uses the full range of phenomena associated with Edison—from the sensational visual experiments to the

mystical, supernatural otherness of his Menlo Park laboratory—in *Tomorrow's Eve*. Edison is, in fact, the only scientific character in the novel. Unlike Hoffmann and Shelley, who spread their scientific philosophy amongst several characters, or Poe and Verne, who give us both amateurs and professionals, Villiers de L'Isle-Adam has only the figure of Edison to disseminate his reading of the scientific culture of the 1880s that the novel depicts. Likewise, while Hoffmann, Shelley, Poe, and Verne allow their scientists to exist amongst, and contend with, the world at large, Edison never leaves his own laboratory space and never encounters any public reaction to his scientific experiments beyond that of his patron, Lord Ewald.

It is to Edison alone, then, that Villiers de L'Isle-Adam looks for his symbols of scientific organization. The fictionalized scientist must not only play the part of the scientific individual but also represent the conflict of the sciences as Villiers de L'Isle-Adam perceives them. In this context, the choice of Edison as the fictional scientist is even more apt, for Edison's thaumaturgical facade and empirical ideology make him an eminently able character in the movement between the orthodox and heterodox sciences that *Tomorrow's Eve* relies on. Likewise, Edison's range of scientific interests also allow him to manage a greater number of different practices without, as it were, falling out of character. In short, Edison is a metamorphic character whose suppleness makes him the most obvious candidate for a role that requires the fluidity that Villiers de L'Isle-Adam sees in the scientific culture of the 1880s.

Fluidity is a central component of the novel's vocabulary. *Tomorrow's Eve* argues for a fluid boundary between various scientific phenomena, despite these phenomena being characterized very differently in late-nineteenth-century culture. Concerned, as all our science fiction writers have been, with sciences that are both central and marginal, and by the significance of the boundaries between authoritative and dissident practices, Villiers de L'Isle-Adam makes a case for the inclusion of psychical research as a credible scientific doctrine within a framework of science that takes electrical research as its central and most powerful practice. By placing a prestigious science and a subordinate "pseudoscience" in the same context, and in the work of the same scientist, Villiers

de L'Isle-Adam is able to draw connections that usually remain hidden or unrecognized. Indeed, the ultimate aim of *Tomorrow's Eve* is to reveal how the varied avenues of scientific investigation, while apparently in positions of very different authority and power, are actually striving for the same intellectual, ideological, and philosophical ends. That they do not, in that case, acknowledge their commonalities is something Villiers de L'Isle-Adam interrogates, arguing that it is the context and dissemination of those ideas and ideals that determine the perception of science in the 1880s.

With Thomas Edison as our lead character, it is no surprise to find that electricity plays a significant role. In fact, the role of electricity receives greater attention in *Tomorrow's Eve* than it ever did in *Frankenstein*. Part of this is due to the gregarious nature of the real Edison's electrical experiments. Thomas Edison's invention of the electric light bulb may be less significant in this history of science than Galvani's frog experiments, but Edison turned it into a feat of technological though arrogant self-publicity. The electric light bulbs that Edison strung around his laboratory gained fame far beyond their scientific status. The electric glow was ethereal, almost magical for those who came to see it, and it allowed the inventor to take on the role of electrical magician.

Lord Ewald—for whom Edison makes the cyborg Hadaly to replace his senseless lover Miss Alicia Clary—captures the supernatural or mythical aura of Edison's electrical research very early in the novel. Taken to the most secret of Edison's laboratories, Ewald notes that "Edison was like an inhabitant of the distant kingdom of electricity" (53), a comment that hints at a fairytale mythology of electrical research. The supernatural is reinforced as Ewald tells Edison, "It seems to me that I've come into the world of Flamel, Paracelsus, or Raymond Lull, the magicians and alchemists of the Middle Ages" (62). That Villiers de L'Isle-Adam should so explicitly give to electricity an occultist temper seems to simplify the far more complex relationship of materialism and magic that he has set up in his fictionalized Edison. Indeed, it is soon apparent that Ewald's comments are about to be undercut by a scientific pragmatism that draws on electricity both as a vital force in mechanics and as a tool without supernatural origin or power.

Indisputably, electricity is central to the construction of Edison's artificial human: the novel's first sentence places Menlo Park "at the heart of a network of electric lines" (7). Although Robert Martin Adams argues that Villiers de L'Isle-Adam "knew practically nothing"[19] of contemporary science, it is clear that the significance and direction of electrical research in the late nineteenth century was well within his understanding. Hadaly, the machine in question, is a "magneto-electric entity" (59) of a type commonly associated with the electrical experiments of the last two decades of the nineteenth century. A report from the London Physical Society in 1886 (the year *Tomorrow's Eve* was published) details the cutting edge of electrical research: "Dr. Frohlich gave a short report on the results of his investigations, lasting for years, into the theory of the dynamo-electric machines, which he had developed with special reference to the practical requirements of technics, and had quite recently published in a separate work. He communicated and explained the concluding formulae he had found for the various systems of machines, in respect of their magnetism, as also of their intensity and polar tensions. He likewise gave the formulae for the performance of the dynamo machine as transmitters of energy."[20] The practical application of electromagnetism in mechanics was high on the agenda of electricians at this time and would undoubtedly have appealed to Thomas Edison's inventive pragmatism. Indeed, references to the use of electricity in powering machines seemed to be numerous in the periodicals that dealt with scientific subjects. The *Athenaeum,* in the same year as the Physical Society report, included a book review of Gisbert Kapp's popular *Electrical Transmission of Energy* that contained "a full investigation of the theory of electromotors, and abundant particulars as to the machines and methods in actual use."[21] Even those amateurs whose knowledge of electrical applications in mechanics was severely limited were tempted to contact the periodicals with the most banal of questions. A short letter to *Nature* gives a flavor of these correspondences: "Would any of your readers aid me in carrying out this idea: To make the works of a small striking clock strike the hours on a large bell by an electrical connection."[22] Such a frivolous example does highlight the intense interest in electrified machinery that was characteristic of

the 1880s, and that is central to Villiers de L'Isle-Adam's vision of the machine in *Tomorrow's Eve*.

Electricity is not only the force célèbre of mechanical science but the inheritor of the authority and power once held by mechanics. Edison's laboratory, as Lord Ewald sees it, is a place of sparks and connections rather than steam and pistons. Speed, communication, knowledge, and information are now under the management of electricity, and power is articulated not by heat and noise but by "an imperceptible shiver" of electrical action (16). The subtlety of electricity is not lost on Edison, who condemns previous automata builders for their lack of fluidity:

> Poor fellows, for lack of the proper technical skills, they produced nothing but ridiculous monsters. Vaucanson . . . and all that crowd were barely competent makers of scarecrows, Their automata deserve to be exhibited in the most hideous of wax museums. . . . Just call to mind the succession of jerky extravagant movements, reminiscent of Nuremberg dolls! The absurdity of their shapes and colours! Their animation, as of wigmaker's dummies! That noise of the key in the mechanism! The sensation of vacancy! In a word, everything in these abominable masquerades produces in us a sense of horror and shame. (61)

Here, Villiers de L'Isle-Adam's suggests that Edison's use of electricity so alters the machine as to make earlier incarnations of automata clumsy and lifeless. In showing Lord Ewald around his laboratory, Edison refers several times to the improvements made by electricity: "This is the arm of an Android of my making, animated for the first time by this vital, surprising agent that we call Electricity, which gives it, as you see, all the soft and melting qualities, all the illusion of life!" (61). Electricity's ability to perfect the human machine, or android, arises from the very different constituents of electrical force that make more primitive machines seem crude. Central to these differences is visibility. The machines that dominate the mid-nineteenth century are impressive because their sources of energy can be seen. Electricity, by contrast, is powerful because it is invisible. It is a force that cannot be easily brought within the identifying power of the gaze. That electricity remains a spark or an

unseen current makes it more incredible to the popular imagination. Just as Maelzel's chess player was notorious because the audience could not see how it was able to play chess, so too electricity receives its plaudits for the inconspicuous energy it produces.

It is the invisible nature of electricity that also leads to its being tainted by suggestions of occult or supernatural power, as Lord Ewald immediately claimed. Electricity cannot easily be viewed in the process of its work, which leaves it open to interpretation as a force outside the rules and systems of the natural world. That Edison eloquently defends the supreme talent of electricity to improve machine building both challenges and reinforces this view. In seeing electricity as "the spark of life" (79) or "a murmur of spirits" (7), Edison gives an occult context for his own appreciation of electricity. Yet at the same time, he undermines a supernatural reading of electrical force by noting that "the electrical apparatus of Hadaly is no more her *self* than the skeleton of your friend is her personality" (78). Throughout the narrative, Edison continues to oscillate between magus and mechanist. He explains electricity as though it were a power source for an early computer, perhaps influenced by Babbage's work in the 1840s[23]: "The current distributed through the electrical network is modulated, so that motion can be communicated or inhibited in any one of the limbs or in the entire person. This is the basic electro-magnetic motor. . . . All the interactions of these steel wires are controlled, each one of them is under the influence of the central electrical current which prescribes their individual flexions according to the pattern printed on the central Cylinder" (130, 139). This description of electric motors and steel wires is an example of mechanical and electrical science within a pragmatic, empirical framework. Nevertheless, the conclusion of this explanation finds Edison moving beyond the practical technology to more questionable and unidentifiable territory: "You will be surprised at the *identity* of the charm which these programs can diffuse" (139). Such a distinct change of rhetoric—which hints at electricity's involvement in the creation of personal identity—posits a very different attitude to electrical power that strikes against the materialism of wires and circuits. In a decade where the sciences were being increasingly invaded by occultist traditions of hidden forces channeled by individual adepts, this language is particularly resonant.

Tomorrow's Eve consciously shifts between the various registers that produce alternative readings of electrical power. Villiers de L'Isle-Adam sets in motion a conflicting set of scientific parameters that he will later use to conflate different scientific practices in order to investigate the connections between them. In essence, he invents a particular brand of electrical investigation that will allow him to theorize the connectivity of orthodox and heterodox scientific beliefs. Before this occurs, however, the novel makes even more complex the question of identity that Edison has raised in his explanations of electricity.

Just as Poe's science fiction questioned the nature and definition of the human in a society dominated by mechanics, so too does Villiers de L'Isle-Adam investigate the artificiality of human culture. More vociferous and direct than Poe's work, *Tomorrow's Eve* places the "artificial" human form above the "natural" physical body of the human. Edison argues that the human body is as much a tissue of artificial or illusory aids as the electromagnetic machine. In a blatantly misogynist reading of the female body, Edison highlights the many extraskeletal effects used to transform the organic base into an object of "beauty": "Here now is the lily complexion, the rosy modesty of the virgin; here is the seductive power of passionate lips, moist and warm with desire, all eager with love! And he set forth a make-up box filled with half-empty jars of rouge, pots of greasepaint, creams and pastes of every sort, patches, mascara, and so forth. . . . Here are the gleaming white teeth . . . and he played like a pair of castanets, with the upper and lower dentures . . . here now are the lovely breasts of our siren . . . and he waved aloft some scraps of grey wadding" (119–20). In an uncanny similarity with Poe's "The Man That Was Used Up," the human form is here revealed as so many artificial contrivances brought together to create a "natural" body. Edison calls into question the very idea of the natural, thereby raising the status of the electromechanical body alongside, if not above, that of the original human form. In fact, the electrical body is claimed as a more moral form, for it does not attempt to hide its artificiality behind a "natural" facade.

There are several points to be made here that add significantly to Villiers de L'Isle-Adam's reading of electricity. The electrical machine (in this instance an automaton) is sophisticated because the mode of

its operation, the electricity itself, is invisible. Yet at the same time the "machineness" of its constituency is not in question: the electricity that powers the machine is not secret. How, though, can electricity be both invisible and not hidden, as Villiers de L'Isle-Adam seems to be suggesting? The simple answer is that electricity is not simultaneously visible and invisible. However, Edison's scientific authority allows him to claim that it is. As the single source of scientific perspective, Edison's position is one of unchallenged authority. His knowledge of electricity—as well as his belief in its integrity—allows him to disregard its capacity for illusion while despising other forms of chimerical activity. For scientific disciplines to be regarded as acceptable, verifiable, and irreproachable, they require the support of scientific authority, an articulation of faith from the center of the scientific hegemony. This is exactly what electricity has achieved. Its position as the focal point of Edison's experiments gives it superiority over other cultural activities that are unfortunate in lacking such prestigious patronage.

The power of electricity also contributes to Edison's maintenance of his authoritative position. The technological developments that Edison has overseen—and in which electricity have played no small part—are all designed to place him at the center of a vast network of scientific communication. Although the novel opens by explicitly telling us that Edison is the center of an electrical network, the following chapters leave us in no doubt that the scientist is the controller of a vast system of electrical communication that extends far beyond the boundaries of his laboratory. Electricity allows Edison to talk with his employees at a distance via a "small polyhedral ball suspended from the ceiling by an electric wire" (16) and to receive written communication through a perfected telegraphy unit. A similar construction also allows him to discharge his domestic responsibilities with some ease: "Edison stepped quickly to a tapestry and laid his finger on a electric button . . . almost at once the voice of a merry infant rang out. . . . What is it, father?" (16–17). Much later in the novel, other electrical devices allow for a keen surveillance of Lord Ewald's discussion with Hadaly: "He stepped briskly to a table on which rested a pair of marine binoculars, a microphone of a new design, and an electrical rheostat. The wires of these last two instruments

passed through the walls and stretched away to lose themselves in an electrical network which covered every part of the avenue" (189).

Edison's complete control of his immediate environment is paralleled by an extended superintendence of a wider world that includes not only his scientific contacts but also the other characters of the novel. His electrical expertise is used to manipulate Miss Alicia Clary's movements and draw her into the laboratory; his telegraphic skill means he is able to maintain a mastery over information and thereby confuse the media representatives who attempt to uncover his latest experiments; and his surveillance equipment creates a space in which no knowledge is exchanged without his being a silent partner in the transaction. Edison's use of electricity buttresses his position as the single source of authority in the text. There is an intriguing circularity to this dynamic that symbolically reenacts the circular movements of an electrical current, as well as the network of information just described. Edison's scientific authority, and his position at the prestigious center of scientific culture, allows him to foreground the power of electricity and to argue convincingly for the place of electrical research within society. At the same time, of course, it is electricity—by the power its currents and connections afford for a communication network—that has given him that privileged position. A loop of reciprocity is constructed whereby electrical force gives Edison the building blocks of cultural superiority and, in turn, Edison gives prime place to electrical research within that culture.

The position of Edison, ably supported both by his knowledge of electricity and his practical prowess in constructing electric machinery, seems unassailable. However, Villiers de L'Isle-Adam cleverly undercuts this superiority at the very moment where it seems most assured. He does this by introducing an alternative network of communication, one that does not require electricity to function and that thereby subverts Edison's central position. Ironically, this alternative source of scientific authority is introduced by Edison himself. Drawing his lecture on the construction of the android to a close, Edison says to Ewald,

Note if you will, my Lord . . . that hitherto I've only given you explanations, more or less conducive, for certain preliminary physical

problems presented by Hadaly. But I warned you that various other phenomena of an altogether different and superior order would manifest themselves in her—and it was there and only there that she became EXTRAORDINARY!

—You're not speaking of electric current, are you?

—No, my Lord; it is another sort of current which is now acting on the android at this very moment. One experiences its actions without being able to analyze it. (157)

The alternative current is psychic force, the root of which can be found in Sowana, a spirit medium materialized by the influence of Mrs. Anderson, whose somnambulistic body rests in the labyrinthine caves beneath Edison's laboratory. Psychic force becomes, to some extent, the opponent of electricity in the later stages of the novel, and Sowana/Mrs. Anderson directly challenges Edison's position as scientific authority.

Spiritualism and psychical research were well on their way to prominence by the middle of the 1880s, having been first introduced to Europe from the United States in the late 1840s. The central claim of spiritualism was that certain individuals with strong psychic ability were able to make contact with the dead. Evidence of this took many forms but invariably included the materialization of spirits, table rapping, the movement of furniture or people, and slate writing. Spiritualist phenomena were disseminated to the popular imagination in the writing of various religious, scientific, and occultist documents but more often through the practice of the séance. Séances ranged from large public gatherings to intimate family affairs but almost always took the same form: a medium renowned for his or her psychic ability would bring forth the spirits of the dead (either vocally or materially) for a fascinated audience who were then allowed to interact with the spirit and thereby confirm the apparent authenticity of their experience. However supernatural this account may appear, it was a practice that captured the interest and intellectual curiosity of a wide range of individuals. As Janet Oppenheim argues,

spiritualism and psychical research loomed as very serious business to some very serious and eminent people, such as the Fellows of the Royal

Society, university professors, and Nobel prize-winning scientists who supported the Society for Psychical Research. Together with the industrious middle-class professionals and self-educated artisans who joined spiritualist clubs in London and the provinces, these intellectuals turned to psychic phenomena as courageous pioneers hoping to discover the most profound secrets of the human condition and of man's place in the universe. With psychology in its infancy, it still seemed in the late nineteenth century that psychical research, if not spiritualism, might play a legitimate and important role in the growth of a new science.[24]

Aspects of the scientific investigation of spiritualist phenomena were conducted by the Society for Psychical Research (SPR), founded in Cambridge in 1882, only a few years before Villiers de L'Isle-Adam's serialization of *Tomorrow's Eve*. Led by Cambridge University academics Henry Sidgwick and Frederick Myers, and supported by many leading scientists, the SPR set out to use scientific methodology to prove (or disprove) the veracity of the claims of spiritualism. W. H. Salter, in a history of the Society, quotes from an early proceeding that sets out the SPR's system of investigation: "The aim of the Society will be to approach these various problems without prejudice or prepossession of any kind, and in the same spirit of exact and unimpassioned enquiry which has enabled science to solve so many problems, once not less obscure nor less hotly debated."[25]

For the psychical researchers, spiritualism was a natural phenomenon open to interrogation by scientific method and thereby placed within a history of science that values the discovery of knowledge through proper investigative practice. Yet the very fact that the SPR so vociferously defended the scientific basis for spiritualism reveals that it was under severe attack by some members of the scientific community, who argued that it was nothing but illusion or stage magic and not at all deserving of the investment of scientific expertise. Certainly there were grounds for being cynical about the scientific status of spiritualism. There were many examples of fraudulent behavior among mediums, whose psychic ability was sometimes no more than expertise in slight of hand and trickery.[26] At the same time, there were those whose ability could not be attributed to conscious fakery, and it was these examples that the SPR

used to defend the scientific nature of their investigations. The journal *Science,* for example, commented on the seriousness of a paper given by Mrs. Sidgwick in the same year as the publication of *Tomorrow's Eve:* "Mrs. Sidgwick's paper was candid and able, and dealt with evidence, not theories. It is one more example of the good work being done by the Society for Psychical Research in determining just what basis there is for the multitude of current beliefs concerning certain classes of psychical and semi-psychical phenomena."[27]

Gaining acceptance from an authoritative journal such as *Science* was cause for celebration amongst the members of the SPR; it was also necessary for the progression of their new scientific discipline. The contexts in which spiritualism was discussed and the sites from which it was praised were vital to the ongoing success of the SPR's experiments. Scientific status comes not only from the method of investigation but also from a huge panoply of authorized voices, each adding to the acculturation of a particular discipline into the scientific pantheon. One of the most important and influential examples of this predates the inauguration of the SPR. This was the 1876 trial of the medium Henry Slade, who was accused of fraudulent practice by the scientist Edwin Ray Lankester and defended by leading botanist Alfred Russell Wallace. Several historians of science have discussed this case in terms of its media interest and the conflict it created between two major scientists of the period, but none have considered the rhetoric of either the spiritualists, the scientists, or the popular press who made the case such a cause célèbre.[28] A detailed study of the letters, testimonies, and press reports from the *Times* reveals a fascinating struggle for the safe ground of scientific method and illuminates a professional dispute that had very little to do with the apparent fraudulence of Slade's mediumship.

Before Henry Slade was brought in front of Bow Street Magistrates Court on October 2, 1876, there had been several skirmishes in the pages of the *Times* between leading defenders of spiritualism and those skeptical of its claims. The sequence of letters to the editor, all of which appeared between September 16 to September 23, reveal the great furor amongst the scientific community about the place of spiritualism within scientific culture. The range of correspondents, and the vigor with which

they approach the subject, highlights that this was a significant struggle for power and authority. Over seven days, twelve different writers appeared in the pages of the *Times*. The first to put pen to paper was Edwin Ray Lankester, professor of zoology at University College London. He was supported in his assessment of Slade by Horatio Donkin, a physician at Westminster Hospital. At the same time, A. Lane Fox, president of the Royal Anthropological Institute, gave his own impression of the study of psychical phenomena. Thereafter, contributors to the debate consisted of lecturers in comparative anatomy, an inventor of mechanical automata, a professor of physics, and leading members of several scientific societies. Alfred Russell Wallace, the eminent natural historian, defended the place of spiritualism as well as his role in the present debate, and Henry Slade contributed two letters contesting Lankester's accusations of fraud.

The central debate in these letters appeared to be of the honesty of Henry Slade, who claimed that the slate writing he produced was performed by spirits called on by his own dead wife, Allie. Lankester argued that Slade wrote on the slates himself, without spiritual involvement, and fraudulently took money from his clients; several of the letters give details of the séances at which Slade produced the slate writing. Lankester's letter, for example, describes the performance as follows:

The witness and Slade being alone in an ordinary well-lit sitting room, Slade produces a common slate and a small piece of slate pencil, which are laid on the simple four-legged table, at one corner of which the witness and Slade are seated. Slade then shows the witness that there is no writing on either side of the slate. He then places the slate horizontally against the table and below it, pressing the slate against the table, the little piece of slate pencil being supposed to be between the slate and the flat under surface of the table. The slate is so closely applied to the table that that no hand or finger could possibly get between them in order to write. A noise as of writing is now heard proceeding from the slate, which is held by Slade or by the witness—the spirit is supposed to be at work. The slate is then removed and a message is found written.[29]

As Lankester continues his description and critique of Slade's séance, he becomes more vehement in his determination to prove Slade's slight-of-hand imposture. For the most part, those who responded to Lankester's thesis concentrated on this aspect of the spiritual phenomena supposedly at work. A. Joy and George Joad, writing at the same time as Alfred Russell Wallace, disagree with Lankester's interpretation, while C. Carter-Blake, a comparative anatomist, calls into question Lankester's scientific method. The journal *Science* also concentrated on the performance of spiritualism rather than on the more subtle power politics at play between the various *Times* correspondents. In their articles on the Slade prosecution, they quote the opinion of leading chemist Alexander Duffield, who thought that "there could be established a sort of post office in connection with the other place,"[30] as well as Alfred Russell Wallace's belief that Slade was "an honest gentleman . . . as incapable of an imposture . . . as any earnest inquirer after truth in the department of Natural Science."[31]

However, the real focus of the Slade prosecution was neither the integrity of Slade himself nor the possibility of a spiritual presence at his private séances. Rather, the letters and subsequent trial are very public examples of the conflict over the acceptance of spiritualism and psychical research as an appropriate area of investigation for the mainstream scientific community. Richard Milner gives some insight into this while detailing the minor role played by Charles Darwin. "The Slade trial was to become one of the strangest courtroom cases in Victorian England. Some saw it as a public arena where science could score a devastating triumph over superstition . . . but what made the trial unique was that the two greatest naturalists of the century ranged themselves on opposite sides. The "arch-materialist" Darwin gave aid and comfort to the prosecution, and his old friend Wallace, a sincere spiritualist, was to be the defense's star witness—making it one of the most bizarre and dramatic episodes in the history of science.[32] Milner is correct in identifying the trial as a battleground for scientific authority, but he overplays Darwin's intervention in the process. The main protagonists were Lankester and Wallace, whose fight was less about the collision of science and superstition and more about the boundaries of traditional science.

Lankester's first letter to the *Times* is revealing. He does not begin by stating his opinion of Slade's mediumship but by abusing Wallace's role in allowing spiritualism onto the agenda of the British Association for the Advancement of Science:

> Sir,—I trust that you will find space for a brief account of an interview with "Dr." Slade from which I have just returned. In consequence of the more than questionable action of Mr. Alfred Wallace, the discussions of the British Association have been degraded by the introduction of the subject of spiritualism, and the public has learnt—perhaps it is time they should—that "men of science" are not exempt as a body from the astounding credulity which prevails in this country and in America. It is, therefore, incumbent upon those who consider such credulity deplorable to do all in their power to arrest its development.[33]

Lankester's anger is directed not at Slade but at Wallace. The outsider's charlatanism is far less important than the apparent betrayal of a close colleague and fellow member of one of the most important institutions of orthodox science in Europe. Wallace, he believed, had betrayed science by allowing psychical research a voice within the corridors of scientific power. That a discipline so marginalized had exercised an authority within an institution with the BAAS's standing was, for Lankester, an outrage that could not be allowed to pass. Spiritualism, in its infancy as a subject of scientific debate, and cut off from those areas of scientific culture that possessed a hegemony on power and influence, had suddenly breached the walls of the privileged scientific community. Lankester, defending what he saw as the moral authority of science within the public sphere, could not stand by while the occultist stain of communication with the dead tainted his own discipline.

A. Lane Fox, president of the Anthropological Institute whose committee had allowed the article on spiritualism to be heard at the BAAS meeting in Glasgow, was quick to leap to the defense of his own members and to staunch the wound that Lankester believed had been opened: "I am stated to have said that I had witnessed the manifestations of spiritualism. I should be sorry that as President of the Anthropological

Institute I should be supposed to have jumped at any such conclusions, from the *data* that are now before us."[34] Fearing that a public argument would not best represent the interests of the various scientific societies, Fox suggested that it would be better if it was "by a committee of inquiry that this investigation should be conducted than by public discussion."[35] Desperate to remove the subject of spiritualism from public view, Fox took a conservative course in demanding that science works out its policy in-house. Once again the boundary was being redrawn and breached walls immediately repaired.

Unfortunately for Fox and his associates, Alfred Russell Wallace was not about to let Lankester's attack go unanswered. Three days after the first letter appeared in the *Times,* Wallace's reply was printed. He rejects Lankester's assessment of Slade's practice, as well as his claim that Wallace was responsible for the reading of a paper on spiritualism at the BAAS meeting. Most interesting, though, is Wallace's defense of psychical research: "As to Professor Lankester's opinion as to what branches of inquiry are to be tabooed as 'degrading,' we have, on the other side, the practical evidence of such men as Lord Rayleigh, Mr. Crookes, Dr. Carpenter, and Colonel Lane Fox—none of them inferiors in scientific eminence to Professor Lankester, yet all taking part in the discussion, and all maintaining that discussion and inquiry were necessary; while the close attention of a late President of the Association and of a crowded audience showed the great interest the subject excited."[36] Again, the focus of debate is not Slade's guilt or innocence but the place of psychical research within the institutions of the scientific elite. Both Wallace and Lankester use their scientific colleagues as weapons in this battle—the more eminent the scientist, the more powerful weapon he becomes. In this quote Wallace unleashes a barrage against Lankester that he hoped would conclude the matter in his favor. Of course nothing was further from the truth, and the conflict continued throughout Slade's prosecution and conviction. The correspondence in the *Times,* however, reveals that of the eighteen letters published between September 16 to September 23, two were from Slade himself, and of the other sixteen, no less than nine talk directly to the paper on psychical research presented at the BAAS meeting. That a series of letters purporting to discuss the

fraudulent activities of one medium should spend much of their time discussing which committee allowed the reading of a spiritualist paper illuminates the real anxieties of the scientific community: on the one hand, that psychical research would move to the center of scientific orthodoxy if societies continued to condone it officially, while on the other hand, that it would be reduced to the status of witchcraft or folklore if the argument for its inclusion in scientific institutions was lost here.

In all of this, the question of the possibility of communication with the dead was somewhat sidelined. All that can be said for the Slade prosecution was that it did place psychical research even more firmly on the agenda for the late-nineteenth-century public. Indeed, the criminal trial articulated one very important aspect of psychic phenomena: evidence. How was it possible to produce evidence of psychic phenomena that would be acceptable to all parties involved? This, of course, could work both ways. How was it possible to deny the existence of psychic phenomena when it had no particular physical mark of its appearance? For Villiers de L'Isle-Adam, the related questions of evidence and scientific authority were the most interesting aspects of spiritualism. As *Tomorrow's Eve* moves from a discussion of electricity to a consideration of psychical phenomena, these aspects of spiritualist research are vigorously investigated.

As the novel progresses, the complex electrical robot created by Edison is taken over by the spirit called Sowana. This does not occur surreptitiously. Edison knows of the existence of this spirit and is able to communicate with her through the medium Mrs. Anderson, with whom he has a strong mesmeric affinity. That Sowana is materialized by Mrs. Anderson's powerful psychic ability is explained by the spirit herself in conversation with Lord Ewald:

This living ether is a region without limits or restrictions within which the privileged traveler, as long as he remains there, feels able to project within the intimacy of his temporal being the shadowy harbingers and dark anticipations of the creature he will someday become. An affinity is thus established between his soul and those beings, still in the future for him, of the occult regions bordering on that of the senses. The path

joining these two kingdoms leads through that domain of the Spirit which Reason—laughing and exulting in those heavy chains of hers, which triumph here but for an hour—calls, in hollow disdain, MERE IMAGINATION. (195)

Sowana reads psychic phenomena as a natural law discarded by science for its lack of evidence. Material science, she argues, views the existence of psychic force as a product of the imagination of spiritualists rather than as a verifiable fact. The domain of the Spirit—within which psychical research conducts its experiments—is denigrated by Reason (empirical science) for its insubstantial and nonmaterial nature. The weight of psychical research is firmly behind Sowana's interpretation of psychic phenomena as closely related to the spirit or soul. Villiers de L'Isle-Adam's pursuit of a credible spiritualism in *Tomorrow's Eve* takes him directly to the work of the various individuals and societies active in investigating psychic phenomena throughout Europe and the United States. Henry Myers, one of the founders of the Society for Psychical Research in Britain, was, according to historian Alan Gauld, "inclined to regard cases of [psychical phenomena] as evidence that our bodies are animated by a separable spiritual principle or soul."[37] Likewise William James, the founder of the American Society for Psychical Research, sees the spirit as an animated and active force that is the foundation of psychic ability: "The thoughts of one Soul must unite into one self, it was supposed, and must be eternally insulated from those of every other Soul. But we have already begun to see that, although unity is the rule of each man's consciousness, yet in some individuals, at least, thoughts may split away from the others and form separate selves. As for insulation, it would be rash, in view of the phenomena of thought-transference, mesmeric influence, and spirit-control, which are being alleged nowadays on better authority than ever before, to be too sure about that point either."[38] Clearly, the relationship between Edison, Mrs. Anderson, Sowana, and even Hadaly and Lord Ewald, reflects the central beliefs of late-nineteenth-century spiritualists.

There is, however, a great deal more to the novel's rendering of scientific culture than a simple paralleling of expert opinion. Villiers de

L'Isle-Adam is interested not only in revealing the practices and beliefs of psychical research but in placing them in a scientific culture that will allow him to comment more fully on the role of spiritualism in late-nineteenth-century society. Edison, as already argued, plays the part of the scientific establishment in this performance. The introduction of psychic phenomena in Hadaly is designed to show how the center of scientific authority deals with the onslaught of heterodox science. Just as the Slade prosecution was a trial of orthodox science rather than of an individual's questionable practice, so too is *Tomorrow's Eve* an interrogation of the conflict between the empirical sciences, with their stranglehold on scientific power, and of psychical research, whose defenders wish to see it given access to the scientific mainstream.

The opposing players in this conflict are Edison (on the side of empirical science) and Mrs. Anderson (on the side of psychical research). Villiers de L'Isle-Adam makes this battle clear by utilizing mesmerism as a potent symbol of the struggle for domination over the will of another. Mrs. Anderson, weakened by neurological disease, very easily capitulates to Edison's mesmeric skill: "I was soon able to exercise one of my abilities which is perhaps innate, that of projecting my will into another. With practice, this gift developed, until now, given certain natures, I feel able to exert enough nervous energy to dominate another person almost completely" (209). Entirely in control, Edison appears to be the dominating partner, using his knowledge of medical science to both aid and exert influence on his patient. Yet there is an irony in his use of mesmerism of which Villiers de L'Isle-Adam is well aware. The mesmeric trance was often used by mediums as a steppingstone to the materialization of spiritual phenomena. Unwittingly, Edison's initial mastery, gained through heterodox practice, releases Mrs. Anderson's psychic abilities: "Instant, occult communication was possible. She not only received, instantaneously, impulses from my will, but found herself mentally, sympathetically, actually in my presence, to the point of hearing my voice and obeying my orders—even though, physically, her body might be twenty leagues away and apparently fast asleep.... As you can see, she's a pretty sensitive spiritual receiver" (210). Although Mrs. Anderson's psychic capacity comes to the fore without Edison's consent

or foreknowledge, he is still, at this time, able to exert control over it. It is not until the creation of the electromechanical robot, Hadaly, that the reigns of power are taken by Mrs. Anderson. Edison, concentrating only on the power with which electricity furnishes his experiments, and convinced that the combination of electricity and mechanics will produce the most perfect automata ever witnessed by science, does not notice that Mrs. Anderson's materialized spirit, Sowana, has taken control of the automaton. Only at the completion of his project does Edison realize that a very different force, one that his empirical science cannot explain, has superseded his electrical power: "*Not everything about this creature is an illusion!* It is really an unknown creature . . . behind those veils of electrical machinery, beneath this silver armour which imitates a human woman. You must always recall that, though I know Mrs. Anderson, *I swear to you on my soul* THAT I DO NOT KNOW SOWANA" (211). Not only is this new force unknown to Edison, it is also a force with the power to alter his electrical robot from a proficient example of the automaton to one of real aesthetic beauty: "I have furnished the physical basis for her illusions, a Soul which is unknown to me has passed over my work and, incorporating itself there forever, has laid her hand on the slightest details of those superb and inspiring scenes, imposing on them, believe me, an art so subtle that it surpasses, in all truth, the reach of human imagination. Within this new work of art a creature from beyond the reach of humanity has insinuated herself and now lurks there at the heart of the mystery, a power unimagined before our time" (216). Mrs. Anderson's victory over Edison is completed here, as Edison admits that his application of the principles of materialist science have been transcended by psychical force.

To read the novel only in this way, however, is to accept only one aspect of Villiers de L'Isle-Adam's critique of central and marginal sciences. Although psychical phenomena are seen to exist here, they are still viewed as occult, unknown forces that are more magical than scientific. If Villiers de L'Isle-Adam is attempting to prove that psychical research has a place within the scientific pantheon, he has not persuaded his reader of that here. What needs to occur is for Edison to accept psychical research on an equal basis with his electrical investigations and

to experiment with it in the same way as he would with those areas of science already accepted as orthodox.

Is there any evidence in the novel to support this position? From the very beginning of the narrative, it is clear that Edison's rhetoric makes him a prime candidate for psychical research. As the novel opens, he is musing on his invention of the phonograph, cursing the luck that allowed for it to be discovered only in the late nineteenth century. What "dead voices" had been lost forever that could now be recorded, Edison asks, if only "this little spark" of electricity could "give the sounds a start of fifty centuries and yet chase them down" (10). Edison's "lamentations" are similar to the desires of the spiritualist (9). What he is wishing for here is communication with the dead. His electrical research is nothing more than an attempt to bring the voices of spirits into the material world.

Yet this is only a starting point. Strewn throughout the novel is the same type of rhetoric, becoming explicitly spiritualist as the novel reaches its conclusions. Of the recorded song of a nightingale, Edison says, "I evoke it by means of electricity; that's spiritualism put in really practical terms, right?" (95). Frivolously spoken, perhaps, but this is a significant moment in the text, as it is the first time that Edison conflates electricity with spiritualism, seeing in them a common cause or purpose, as well as a similar application of their force. Indeed, as Edison reveals more and more of his scientific operation to Lord Ewald, it becomes apparent that, despite his continual eulogizing of electromechanical power, he is as affected by psychical phenomena as he is by more material science. He even admits that his construction of Hadaly, for example, could not have been completed without the aid "of a sort of prophetess named Sowana" (123). Even when challenged by Lord Ewald on the existence of spirits, Edison remains less committed to his empiricism than might be expected: "Still, Doctor William Crookes, who has discovered a fourth state of matter, the radiant state (in addition to the three we knew before, the solid, liquid, and gaseous), gives us many accounts of spiritualist experiences; they are supported by serious scholars in England, America, and Germany who have seen, touched, and hear the same things that he has seen, touched and heard: I find his stories worthy of serious consideration" (157). Remarkably similar to Alfred

Russell Wallace's letter to the *Times,* where he also invokes the name of Sir William Crookes, Edison here acknowledges that some members of the scientific community have an interest and faith in psychical research as a subject worthy of scientific investigation.

Yet even this is only a preliminary to the utter reversal that we find in the final paragraphs of the novel. Having begun by showing Edison persuading Lord Ewald of the unrivalled power of that substantial and material substance electricity, Villiers de L'Isle-Adam now promotes spiritualism. In the conclusion of the novel Ewald denies the existence of any force greater than electricity, while an increasingly excited Edison demands that he accept the immaterial forces of psychical research: "To conclude, from the moment when the hidden sensibility of Sowana showed itself susceptible of secret influence from electric current . . . I sensed that the two sorts of current were linked by some sort of affinity. In other respects there was no sort of connection . . . but the connection of electric current with psychic current was evidently a fact, and consequently I began to suppose that to some extent various of their properties might be synthesized to create a third power of unknown nature and characteristics" (214). Edison's speech manifestly details the conflation of orthodox and heterodox science. The synthesis and affinity of currents, electric and psychical, go toward the creation of a third source of power, as yet unknown and untapped. That both electrical and psychical research can be placed within the same experimental hierarchy and exist there on an equal footing proves Edison's acceptance of spiritualism as a fitting subject for scientific analysis. Language plays a major part in that acceptance: the rhetoric associated with electrical power can also be applied to psychical force. Edison's telegraph is described as communication at a distance, as is the clairvoyant or telepathic ability manifested by many with psychic ability. The phonograph brings the dead or the distant into the present, as does the manifestation of spirits. The linguistic articulation of scientific "ideas" connects the electrical with the psychical throughout the novel, even to the "murmur as of spirits" (16) that describes the working of the telegraphy system.

As Alison Winter has argued, whether a science was seen as orthodox or heterodox was often connected to the context in which ideas were

"received and understood."[39] Since it was not always "obvious when, where and to whom" one made claims for scientific status, there was a "significant degree of ambiguity that could surround the status of a new claim."[40] In light of this, *Tomorrow's Eve* can be seen as a novel that accepts the differing status often afforded to different practices on the basis of their system of delivery. Yet it also goes beyond that, arguing that the language of science can act as a balance between orthodox and heterodox disciplines. Villiers de L'Isle-Adam certainly argues that case: the language of electrical research is no different from that of the supposedly subordinated psychical research. This significantly alters public acceptance of each practice, making it more difficult to readily place one above the other. If, as *Tomorrow's Eve* seems to suggest, the language used to give voice to scientific theory and experiment, regardless of the position of that scientific discipline in the public imagination, is much the same in several different fields of inquiry, then the possibility of one being set apart from another becomes more remote.

Certainly Edison's grand articulation of electricity at the beginning of the novel is difficult to distinguish from his defense of psychical forces at the end. As the single scientific authority present in the text, his consideration of psychical phenomena can be given the same status as his pronouncements on electricity. In the same way, Wallace's sturdy vindication of spiritualism in the Slade prosecution has a status equal to his botanical research. For a more general public audience, one not equipped to deal with the complexities of scientific argument, the prestige is attached not only to the individual who delivers "science" but also to the language of that delivery. For the nonspecialist, scientific discourse is placed according to its similarity to previous discourses whose status is without question. If it reads like science, it is more likely to be accepted as science.

For Villiers de L'Isle-Adam, this is the key to understanding the vagaries of scientific credibility. Psychical research, according to his reading of scientific culture, gained at least partial access to the scientific establishment because its language and its ideas were so "scientific" as to be indistinguishable from the more materialist disciplines, such as mechanical or electrical science. Villiers de L'Isle-Adam's use of Thomas

Edison as his central character reinforces the importance of discourse in scientific culture. While Edison was not the magical figure that a broad section of the public thought him to be, his language often suggested that his scientific skill was rooted in the traditions of the magic and occult practices of his forbears. Psychical research consciously performs a similar linguistic transformation. Its dubious place at the margins of scientific credibility was challenged by its forceful use of scientific discourse. Allied to a research methodology complementary to orthodox scientific disciplines, this allowed psychical research to become recognized as a serious subject for scientific investigation.

Villiers de L'Isle-Adam's positioning of a marginal practice within the established group of sciences in the later nineteenth century is based on a very definite belief in the power of language to articulate scientific plausibility. It also demands of a scientifically fascinated public that they accept the words of science without too close an examination. The next chapter details how the professionalization and institutionalization of science led to challenges to scientific authority from the general public rather than, as has been seen until now, that challenge appearing from either heterodox sciences or the scientific amateur. That change is a very significant one in the cultures of science in the nineteenth century and marks the final major shift in the relationship between science and its audiences.

and reinforced his reputation in the following years with the publication of *The Island of Dr. Moreau, The Invisible Man,* and *The War of the Worlds.* Together these four romances, appearing in a burst of creativity between 1895 and 1898, form the foundation of Wells's science fiction.

While it is possible to draw comparisons between Wells's position at the head of a new genre and the position of science as new cultural authority, a more vital question is whether Wells himself was aware of the changes taking place in science in the 1890s and whether he incorporates and critiques them in his fictions. To conclude with Wells is appropriate—as the (largely) undisputed major figure of the science fiction genre in the nineteenth century (at least in the English-speaking world), it is important to investigate his contribution to scientific debates, especially as his scientific expertise has been both lauded by critics and advertised by Wells himself. Nevertheless, this chapter will be less interested in Wells's own scientific skill and more interested in the interventions he makes in the important scientific questions of his day. Revealing Wells's social, cultural, and political constructions of scientific culture places him within the framework upheld throughout the previous chapters, rather than relying on his reputation within the science fiction canon.

This final chapter will go further than any of those that precede it by providing equal space to both the scientific and the literary. The influence of scientific culture will be brought to the forefront to an even greater extent, allowing not only for a critique of the literary text but also for sustained interpretation of the cultural implications of science *in and for themselves.* To that end, this chapter will bring together Wells's *The Island of Dr. Moreau* and the creation of the British Institute of Preventive Medicine as two moments in which the institutions of science were rigorously examined both as scientific and cultural edifices.

Wells's critics have, of course, had a great deal to say about his scientific romances, and if *The Island of Dr. Moreau* is not their chief interest, it remains a text that has received some intense scrutiny. It has not, however, ever been read as a document that speaks directly to the rise of laboratory science in the 1890s. The early reviewers, perhaps best placed to comment on Wells's contribution to that "moment" of science, make little explicit reference to laboratory culture. The consensus was

that Wells had stooped to a degree of gothic horror that went beyond the bounds of Victorian propriety. These commentators denigrated *The Island of Dr. Moreau* as "cheap horrors,"[1] "still lower depths of nastiness," "cruder manifestations of fantastic imbecility," and even an "artistic failure."[2] Later critics, able to place Wells's work in a historical and literary context unavailable to his contemporaries, are less stinging in their criticism but continue to elide the laboratory as an important image for the integrity of the novel's critique of science. Bernard Bergonzi, for example, in his important work *The Early H. G. Wells,* argues that the novel is "a version of the 'island myth' which conveys a powerful and wholly imaginative response to the implications of Evolution. . . . One of the effects of Darwinism, conceived in terms of the traditional world-picture, had been precisely to abolish 'the chasm which divides man from brute.'"[3] For Bergonzi, the scientific discipline Wells was most concerned with was evolutionary biology, an arena of science that was decidedly lacking in a laboratory tradition.

Patrick Parrinder, like Bergonzi a leading Wellsian scholar, prefaces a reading of *The Island of Dr. Moreau* with a lengthy discussion of Darwinism, natural history, and paleontology. He goes on to look more closely at the novel in these contexts, suggesting that "the reversion of the Beast Folk, which Prendick observes in the span of a few months, parallels the process of future human degeneration discovered by the Time Traveller; it is effectively a speeded-up version of the devolutionary process. . . . Wells presents both the theory and the experience of zoological retrogression and human dethronement."[4] Just as Bergonzi had characterized Wells's novel as a tale of cautionary evolution, Parrinder conceives it as a narrative of degeneration or devolution. Such leading critics are representative of the critical perception of *The Island of Dr. Moreau* in contemporary science fiction scholarship. There are two contextual reasons for this monocular reading of Wells's novel. First, Wells has been cast as a significant writer of the fin de siècle, and the major thematic concerns of that period are evident in his fiction—degeneration and bestiality certainly figure strongly in many of the critical works of that period. Second, readings of nineteenth-century science have been dominated by Darwin and evolutionary debates to such an

extent (certainly in literary criticism) that the mere hint of a Darwinian context immediately sets critics on an evolutionary track.

Yet there are enough suggestive voices, especially in the first commentaries, to point toward another area of scientific investigation that interested Wells and that was intensely debated in the 1890s. Several reviewers from that period highlight vivisection, one of the most controversial techniques of experimental science in the late nineteenth century, as the target of Wells's criticism. An anonymous review in the *Manchester Guardian* calls the novel "a curious fantasy, with its quasi-scientific foundation, in which a doctor upon a remote island practices vivisection in the spirit of a modern and unsentimental Frankenstein."[5] Another reviewer, this time in the *Speaker*, similarly summarizes the plot in terms of "a remote islet in the pacific where a notorious professor of vivisection . . . is engaged in a series of hideous experiments."[6] Even the *Guardian* review that Wells is said to have respected above all other notices remarks that "Dr. Moreau is a vivisectionist."[7] Most important in this context, however, is the critical appraisal of R. H. Hutton, the writer of one of the few positive reviews of *The Island of Dr. Moreau* and an active antivivisection campaigner. His periodical paper, the *Spectator,* was at the forefront of vivisection debates in the 1890s, and it was there that the review of Wells's novel appeared on April 11, 1896:

> It is, of course, a very ingenious caricature of what has been done in certain exceptional efforts of human surgery,—a caricature inspired by the fanaticism of a foul ambition to remake God's creatures by confusing and transfusing and remoulding human and animal organs so as to extinguish so far as possible the chasm which divides man from brute. Mr. Wells has had the prudence, too, not to dwell on the impossibilities of his subject too long. He gives us a very slight, though a very powerful and ghastly, picture, and may, we hope, have done more to render vivisection unpopular, and that contempt for animal pain, which enthusiastic physiologists seem to feel, hideous, than all the efforts of the societies which have been organized for that wholesome and beneficent end.[8]

Hutton is under no illusion that Wells's novel is anything other than a direct critique of vivisection techniques. Whether it can so easily be

seen as an attack on vivisection itself remains to be discussed in this chapter, but Hutton's review highlights the certainty with which Wells's contemporaries read his work in the light of animal testing. Moreover, Hutton explicitly argues for Wells's important interventions in this area of scientific culture, claiming that *The Island of Dr. Moreau* may well play as important a part in the vivisection controversy as the societies created to oppose its practice in laboratories. It has become a theoretical norm in literary studies that the fictional text is as much a part of the creation of culture as it is a reflector of that culture, but it is often difficult to provide evidence for this in a science fiction context. Here, though, we find a commentator clearly stating that the imaginative rendering of science acts directly on those engaged in debating that science. Hutton's claim that Wells's work is equivalent to the lobbying and popular protest of the antivivisection campaigners provides a clear and unadulterated example of the power of science fiction to intervene in the cultures of science and affect their place within human society.

What, though, of the culture of science that Hutton believes is so vividly represented by *The Island of Dr. Moreau?* Is there any evidence to suggest that Wells's novel is any more than a lucky hit on a topical theme? And if so, what was the position of vivisection in the scientific laboratory in the 1890s? Although Wells, in his nonfiction writings, says little about the genesis of *The Island of Dr. Moreau,* its difference from his previous scientific romance, *The Time Machine,* does suggest that he is more inclined to reflect the increasing institutionalization of science in the 1890s. Both *The Time Machine* and *The Island of Dr. Moreau* present individual scientific figures who conduct their research in private laboratories. However, there are several differences between these laboratories that highlights a shift in emphasis from one novel to the other. In *The Time Machine* we find the Time Traveller as a solitary laboratory worker, planning his research from a private laboratory attached to his domestic space. Wells pictures the laboratory in the following ways:

> Taking the lamp in his hand, he led the way down the long, draughty corridor to his laboratory. I remember vividly the flickering light, his queer, broad head in silhouette, the dance of the shadows, how we all followed him, puzzled but incredulous, and how there in the laboratory we

beheld a larger edition of the little mechanism. . . . The thing was gener-
ally complete, but the twisted crystalline bars lay unfinished upon the
bench beside some sheets of drawings.[9] . . .

The Time Machine had gone. Save for a subsiding stir of dust, the
further end of the laboratory was empty. A pane of the skylight had, ap-
parently, just been blown in.[10]

Making allowances for the gothic atmosphere that Wells wishes to
evoke, this remains a portrait of an early-nineteenth-century labora-
tory rather than the new spaces of science that are characteristic of the
1890s. As a private space for a single investigator, the Time Traveller's
laboratory has more in common with a pre-Victorian notion of scien-
tific experimentation: solitary, hidden, and self-funded. With the sober
lighting, the dust-covered workspaces, and the small skylight, Wells
writes more to the traditions of scientific work found in Mary Shelley's
Frankenstein than to the laboratory culture that defines the final de-
cade of the century.

By comparison, *The Island of Dr. Moreau* details two laboratories
more in step with the 1890s. Moreau's London workspace is a secure
space in the metropolitan center, where it is not unusual to see a "labo-
ratory assistant" (22). [11] It is also a laboratory that is in the public eye to
such an extent that "a journalist" disguises himself in order to gain ac-
cess (22). The second site of science is the laboratory built by Moreau
on the unnamed island, where the main action of the narrative takes
place. Wells's focus here is on the symbolism of the laboratory as it
is spatially constructed and accessed by certain individuals. There is
a "locked" enclosure, heavily gated and accessed or secured only by
Moreau through an "elaborate locking-up" (20). There are also a num-
ber of sealed and separate areas for different research activities that are
accessible to Moreau's laboratory assistant Montgomery. Both these ex-
amples show Moreau's laboratories as decidedly different from the Time
Traveller's. The first, while connected once again to domestic space, is
populated by several investigators rather than one. It is also placed geo-
graphically in the metropolitan center, while the Time Traveller's is on
the margins of London at Richmond, and well enough known by the
public for it to become the subject of media attention. Moreau's second

laboratory, while a little closer to that possessed by the Time Traveller, is still more in tune with a methodology of scientific research only fully developed toward the end of the nineteenth century. Moreau, again, is not the solitary scientist but assisted by a technician, Montgomery. The laboratory space itself is larger than any domestic arena, separated into specialist areas, and bound by tight security. Of course the narrator has no access to the laboratory, but this too is indicative of the suspicious attitude toward the general public taken by many late-nineteenth-century laboratories.

Overall, the impression gained from a close comparison of *The Time Machine* and *The Island of Dr. Moreau*, completed only a few months apart, is the anachronistic vision of the former and the far more contemporary imagination of the latter. Taken together, these two texts raise a question over Wells's purpose in constructing such diverse scientific spaces. While it is undoubtedly his method in *The Time Machine* to both domesticate and make gothic his science, this approach was deemed unsuitable for *The Island of Dr. Moreau*. For a novel that looked directly to contemporary scientific concerns, Wells required contemporary scientific apparatus. The gothic elements of the novel are restricted to the natural environment and to the character of Moreau himself. The scientific space is rigorously maintained according to the culture of the 1890s. To intervene forcefully in the scientific debates surrounding the rise of laboratory science (and the uses of those laboratories for the purposes of vivisection), Wells could not risk diluting his critique by dulling the contemporary edge of his fiction. For this reason, *The Island of Dr. Moreau* is consciously imagined within the culture of laboratory science in the late nineteenth century. What that culture was, and how it arose, requires further investigation.

According to historian of science Peter Alter, science began to institutionalize on a large scale only in the second half of the nineteenth century. Not even an event as important as the Great Exhibition, which explicitly applauded the sciences as the great achievers of the mid-nineteenth century, had the effect of bringing about a change in the structure of science in Britain. Rather, it was in the decades after this that the sciences began to specialize and to segregate themselves into enclaves of power: "Only 18 of the 453 societies in the UK at the end of

the nineteenth century had been founded before 1800. According to available (but incomplete) statistics, the vast majority, numbering 149 societies, was founded between 1865 and 1888."[12] This quantitative data suggests an increasingly structured scientific society, especially in the last three decades of the nineteenth century, where Alter's robust figures indicate a new culture of scientific institutionalization. However, numerical evidence hides the important facts of personnel and membership. Many of the scientific societies were populated by nonscientific members whose subscription to institutions like the Royal Society or the British Association for the Advancement of Science was a necessary part of the social life of the fashionable aristocrat. Indeed, Alter notes that "research and an interest in science were for a long time seen as a hobby of the aristocracy and the wealthy upper classes" rather than the domain of professional scientific workers.[13] While this public perception of science as a leisure pursuit for the privileged may not have been in the best interest of scientists keen to pursue a career in scientific investigation, it was nevertheless a reality that scientists were reticent to oppose. After all, science had never provided a solid livelihood for those without the benefit of personal finance, and the patronage of wealthy enthusiasts could not be so easily discarded. Caught between the possibility of endowments for future research and the nonprofessional hobbyism that harmed its reputation, science was in no position to reject the latter and risk cutting off its income. So it remained—even in the 1860s and 1870s—that scientific institutions were far from being purist enclaves of research and development and were actually much closer to the gentleman's clubs frequented by many of their members.

At the same time, the ideology of scientific research interpolated an amateurism that defended the principle of the wealthy hobbyist. This is never more clearly outlined than by A. W. Williamson in his presidential address to the British Association for the Advancement of Science (BAAS) in 1874. For Williamson, the fact that so many of his members were amateurs of independent means proved "how true and pure a love of science must exist in this country and how Englishmen will cultivate it when it is in their power to do so. . . . The truth-loving Englishman . . . had to make his own way in the world and had no shielding or fos-

tering organization.[14] Williamson evokes the exploratory masculinity of the Renaissance to defend the lack of institutional support for scientific investigation. In his vision of "true" and "pure" science, Williamson uses the powerful symbol of the cultivated English garden to engender science with a nationalistic and patriotic zeal that highlights its greatness in the English system. Science is here associated with imperialism, with gentlemanliness, and with the spirit of the adventurer, all very imposing images in the 1870s. What Williamson denies, of course, is the professional scientist, the scientific community, and the scientific investigator whose position in a rigid class system means he is unable to finance any scientific ventures without the support of the "truth-loving Englishman."

Historians of science are equally culpable, at times, of accepting the dynamics of science proposed by Williamson. Scientific institutions, for example, have been eulogized as the visionary products of the great Englishman. Egon Larsen, in his history of the Cavendish Laboratory in Cambridge, begins with a story of Kelvin: "When, for instance, William Thomson, later Lord Kelvin, taught at the University of Glasgow in the 1840s, he took over an old wine cellar in his predecessor's house; he threw out the bins, installed a water supply and a sink, and called the room a physical laboratory: it was the first of its kind at a British University."[15] Again, we find the exemplary scientist to be an individual with unique foresight and an adventurous spirit, one who discards the polluting alcohol of the vapid professor and replaces it with a pure and, this time, very British, knowledge. Thomson's laboratory, however, is little different from that of Wells's Time Traveller: it is a space closely connected to the individual and domestic arrangements of a single investigator, with limited access and private funds.

There was, therefore, an economic restriction—bolstered by ideological interpretations of "true" science—on the professional scientist and the professional scientific institution in the latter half of the nineteenth century. Scientific societies did little to alter this position, although they did provide a useful point of contact for those scientists who were determined to see science put on a more professional footing. Indeed, the societies can be said to have played a supporting role by increasing and

improving the communication channels between individual scientists determined to break the amateur monopoly.

By the 1870s changes were beginning. The universities of Oxford and Cambridge, who had held out so long against scientific research, founded the Clarendon and Cavendish laboratories in 1872 and 1874. The most important of these, the Cavendish at Cambridge, was a direct product of the first attempts to place laboratory research at the forefront of Victorian science. In 1872 Lord Devonshire (rather ironically a keen amateur scientist and owner of a private laboratory) chaired the Devonshire Commission, which looked anew at the state of science in Britain. Its findings represented a major turn in the fortunes of the science lobby. The Commission recommended both the building of state-funded laboratories and increased research grants for private scientists. The state had always been unwilling to put public money behind scientific projects, relying instead on the wealthy amateur to keep Britain at the forefront of scientific investigation. As the Devonshire Commission proved, however, Britain's European counterparts—most significantly Germany and France—held the same values as the British but also supported their scientists through state funding. Germany, indeed, already had a very sophisticated scientific civil service.[16] This attempt to shame the government into capitulating to the commission's recommendations did have some effect. State funding improved slightly, although not so significantly as to appease the scientists who had been ignored for so long.

The Cavendish laboratory, although inspired by the Devonshire Commission's claims, received no state support. Instead, Lord Devonshire himself paid for the building and equipment, and Cambridge University provided the staff and took on the running costs. The Cavendish is a fine example of the very slow process of change that was taking place in scientific culture. It was remarkable, after all, that a university such as Cambridge, which had for years viewed science in all its forms as a subject unsuitable for serious study, now had the foremost British research laboratory in its midst. Nevertheless, the laboratory remained a restricted space of scientific investigation. Its first manager was the Cambridge professor James Clerk-Maxwell, who spoke in his inaugural address of his hope that the laboratory would fully support both the

Cambridge science curriculum and the scientific method that he himself employed.[17] Already fairly prescriptive, the systems that Maxwell set in place only served to increase the selectivity of the laboratory's research culture. Women were barred entry to the laboratory, and all other research appointments were made on the basis of Maxwell's personal invitation.

The interior architecture of the Cavendish also reveals the vestigial remains of earlier laboratory culture. While there were several "public" rooms for laboratory work, there was also the private laboratory of the professor, situated next to his sitting room. The domestic, private investigation of science still had a foothold. However, the new spirit of transparent opportunity for research, regardless of wealth and position, was not entirely forgotten. Maxwell and his assistants readily admitted interested scientists to the Cavendish to peruse the equipment and witness the methods of research. One anecdote, from a member of the Cavendish team working with Maxwell, clearly illustrates the enthusiasm of the professor in disseminating the laboratory's work to a wide audience: "I remember more especially a young American astronomer expressing in severe terms his disappointment that, after travelling on purpose to Cambridge to make Maxwell's acquaintance and to get some hints on astronomical subjects, the latter would only talk about the Cavendish, and almost compelled him to take his coat off, plunge his hands into basins of water and submit himself to the sensation of a series of electric shocks.[18] Situated uneasily between the elite scientific culture of the early nineteenth century and the more public and professional arena in which science was beginning to take its place, the Cavendish is a good example of the difficult transition to institutionalization that marks the sciences at the close of the nineteenth century.

A decade and a half after the Cavendish first opened its doors, "the old free amateurism was disappearing,"[19] and in its place a professional scientific community, complete with its own institutions, was beginning to dominate. At the center of this community were the laboratories and scientific societies, which, as amateurism waned, had been taken over by professional scientists who now used them to bring about further changes in scientific culture. Their success was partial. Even in the

mid-1890s there was still limited opportunity for a career in science. As R. M. Mcleod points out, at the end of the nineteenth century, "there was undoubtedly an increasing number of posts available for the scientific technologist; for the works chemist and analyst, the electrical engineer and electrotechnologist. But for the 'pure' chemist with research interests there were very few opportunities: the industrial research laboratories were then only in their infancy. For his colleague, the physicist, there were even fewer chances, for the first industrial physics laboratory had not then been founded in England."[20] Although there were limits to the ambitions of budding scientists in the 1890s, the situation had dramatically changed in the twenty years since the Devonshire Commission presented its report. For the scientific community, then, the 1890s must have appeared a period of some optimism, and there was undoubtedly a feeling of success and achievement.

Yet in all the rhetoric of increased opportunity, this new scientific community had forgotten one thing: how would the nonscientific public view them? After all, the increasing opportunities called for by the science lobby had only provided for other scientists. For the general public, science remained a mysterious set of disciplines. With the building of large laboratories and other sites of science, the physical presence of the new scientific culture was more imposing and unapproachable than the much less visible elitism of the midcentury. Therefore, while the scientific community was largely in a self-congratulatory mood through the 1890s, the public perception of science was of a very different temper.

For the British public, late-nineteenth-century science was distancing itself from general society by constructing grand edifices behind whose walls research of a dubious morality took place. Although the scientific community felt itself to be slowly released from the elite practices common until the 1870s, the public saw it as reconstructing an alternative hierarchy that privileged professional scientists rather than the wealthy dilettantes. There was, then, a crisis of representation in the circuits of communication between science and society that led to a degree of opposition from public bodies determined to face off the monolithic scientific structures being built all around them. Those members of the scientific community at the forefront of laboratory expansion failed to

understand that their egalitarianism (in terms of research, at least) was viewed as nothing more than the accumulation of power and influence for science itself.

One of the important historical touchstones for this crisis was the creation of the British Institute of Preventive Medicine. First mooted amongst a select group of scientists at a meeting on July 1, 1889, the institute was opposed from the very beginning. The various reasons for that opposition can be traced to foundations as different as xenophobia, economic instability, animal rights, fears of disease, and persecution of the middle and working classes. For the incredible range of cultural signifiers that the episode represents, it is undoubtedly one of the most important and unique moments in the history of science. It is also, of course, the moment that H. G. Wells chose to investigate in *The Island of Dr. Moreau.*

When Wells came to write *The Island of Dr. Moreau* in 1895, he was living on Mornington Road, in the Euston area of London, no more than a short walk from the new British Institute of Preventive Medicine in Great Russell Street.[21] The vivisection controversy was at its height, and the antivivisection campaigners were putting most of their energies into opposing the creation of a new institute in Chelsea. It would have been impossible to read any of the newspapers and periodicals of the time without encountering the vivisection question, and with scientists like T. H. Huxley defending the British Institute, it is highly unlikely that Wells was ignorant of the debate.[22] Certainly the brief history of Dr. Moreau sketched out by the narrator, Prendick, goes directly to the heart of the claims commonly made in the popular print media:

"The Moreau Horrors!" The phrase drifted loose in my mind for a moment, and then I saw it in red lettering on a little buff-coloured pamphlet, to read which made one shiver and creep. Then I remembered distinctly all about it. That long-forgotten pamphlet came back with startling vividness to my mind. . . . [Moreau] had published some very astonishing facts in connection with the transfusion of blood, and in addition was known to be doing valuable work on morbid growths. Then suddenly his career was closed. He had to leave England. A journalist obtained access

to his laboratory in the capacity of a laboratory-assistant . . . [when] a wretched dog, flayed and otherwise mutilated, escaped from Moreau's house. It was in the silly season, and a prominent editor, a cousin of the temporary laboratory-assistant, appealed to the conscience of the nation. It was not the first time that conscience has turned against the methods of research. The doctor was simply howled out of the country. It may be that he deserved to be; but I still think that the tepid support of his fellow-investigators and his desertion by the great body of scientific workers was a shameful thing. (21–22)

The vague recollections that Wells allows his narrator produce a slightly opaque history that is no more than a series of illuminated fragments. Nevertheless, the overall effect is a powerful one, provoking the reader into rewriting the remainder of that history and imagining for themselves the role of the public, the media, and the scientific community. At the same time, Prendick leads the reader in certain directions, passing judgment on Moreau's fellow scientists and the voyeuristic journalist while leaving Moreau's involvement shrouded in lost memory. Prendick suggests that it is not the practice of vivisection that condemns Moreau but the public perception of him as a cruel experimenter. The flayed dog that runs through the streets of London acts as physical evidence in support of the antivivisection lobby's case against science. Indeed, Moreau's partly vivisected escapee is exactly the scenario foretold by antivivisectionists in their propaganda battle with scientific sympathizers.[23] One writer to the *Star* fears for the safety of those living near a laboratory that practices vivisection "because it was a danger to the neighbourhood, and no precautions would be sufficient to protect them from it. . . . [It would be] an inferno for innocent creatures, a material danger and a moral horror."[24] Moreau's expulsion from London comes not as a direct consequence of his scientific method or even of his moral indifference but from his delivery of ammunition to the enemy. The scientific community turns its back on Moreau for tarnishing the reputation of scientific investigation. For the most part, scientists were firmly in favor of the principles of vivisection, and it was left to those in other professions to oppose it. It is not, therefore, an opposition to Moreau's

experiments that lead to his banishment but his failure to halt the shift in moral authority from science to the popular press and then to the public. Yet it is not Wells's intention to fall back on the staples of "moral horror" for which he is taken to task by so many of his early reviewers. He has another objective altogether in *The Island of Dr. Moreau:* he means to carefully consider the culture of laboratory science within the complex debates around animal experimentation.

In fact, in this incomplete history of an individual experimenter, Wells is able to encapsulate the various competing parties in the vivisection debate: the propagandist antivivisectionists (whom he parodies by providing exactly the situation they so fear), the laboratory scientists (who think callously of their own position of power and exclude Moreau for undermining it), and the individual scientist (working within a community for the first time yet pressured to an even greater extent by public calls for accountability and transparency). Of course, Wells's interest and involvement in the controversies surrounding vivisection do not end with Moreau's exclusion from the metropolitan scientific community. Indeed, the central critique of vivisection in laboratory culture occurs on the Pacific island where Moreau continues his investigations, free from the constraints imposed on him in London. The island laboratory, the experiments that occur there, and the interventions of Prendick are the real core of Wells's reading of scientific culture in the 1890s. The very fact that the site of science is a vague and uncharted piece of territory, that the histories of Moreau, Montgomery, and Prendick are either unknown or known only partially, and that the experiments are captured only in veiled allusion means that Wells has a fresh canvas on which to paint a culture of vivisection that elides specifics in favor of varied imagistic representations. In this respect, *The Island of Dr. Moreau* is a very writerly text. By requiring the vivisection debate to be transplanted from London scientific institutions to an exotic island laboratory, and to three central figures, Wells necessitates the involvement of the reader in placing what Nicolaas Rupke has called "the triangle of science, politics, and public concern"[25] onto the narrative.

The 1890s reader of *The Island of Dr. Moreau* would have had little trouble in recognizing the key aspects of that triangle as it was played

out between the scientific community and the antivivisection societies in the late nineteenth century. Vivisection had been in the public eye ever since the Cruelty to Animals Act of 1876, when the government set down policies for the practice of vivisection in Britain. The laws that the Act ushered in were acceptable to neither the antivivisectionists nor the scientists, and the controversy that it was supposed to bring to an end lingered in the public imagination through the 1880s. It erupted once more at the end of that decade after the announcement that leading British scientists were set to follow Pasteur's example and construct a laboratory of preventive medicine in England.

The history of antivivisection in Britain was entirely bound up in the cultural significance of scientific institutions. The increased professionalism of late-nineteenth-century science, along with the perceived power it now wielded over society, raised fears in the public mind of the future hierarchies that would be set in place. Science was a male-dominated arena that subordinated the role of women; it was a set of disciplines that applauded the practices of other nation-states, and it held a powerful influence over the lives of individual humans. Each of these aspects of scientific culture coalesced in the antivivisection campaigns of the 1890s. Mary Ann Elston, for example, clearly describes the relationship between vivisection and the place of women: "The metaphor of medical science, and medical practice on women, as rape, became a dominant theme in antivivisection literature, especially that written by women, from the 1880s onwards. Women were explicitly invited to identify themselves with the animals, as potential victims of sexual assault by materialistic medical men. This sexual imagery was a key link between antivivisection claims and a much wider public debate about sexual morality in the late nineteenth and early twentieth century."[26]

Connected to the fear of sexual assault was the more xenophobic horror of cultural contamination by foreign powers. The work of Louis Pasteur in his Paris Institute became the focus for jingoistic scaremongering amongst the antivivisection societies. Foreign morality, or rather the lack of it as perceived by the British campaigners, could not be allowed to gain a foothold in British scientific institutions. The Pasteur Institute—which practiced vivisection—became characterized as a place of horrific tortures and immoral scientific investigations. Pasteur,

revered by the British medical establishment, was the central hate figure of antivivisectionism. Frances Power Cobbe, the founder of the first official antivivisection organization, the Victoria Street Society, compiled a pamphlet on Pasteur's activities in 1891. In it she condemns Pasteur personally as a butcher of innocent animals: "The inoculated dogs are shut in circular iron cages, provided with a solid network. . . . It is one of these dogs, in the paroxysm of rabies which M. Pasteur showed us, observing 'He will die tomorrow.' . . . M. Pasteur having kicked the wires of the cage, the animal dashed at him. It bit the bars, which became red with the bloody saliva. Then with its jaws bleeding, it turned, tearing the straw of its litter, back into the kennel which it had gnawed the preceding night. From time to time it uttered a piercing and plaintive cry."[27]

Such sensational material was not restricted to propagandist publications. The popular press also carried articles by antivivisectionists that were equally damning of Pasteur and his methods. The *Irish Figaro* of May 11, 1895, carried the following notice: "As I go out of the courtyard I hear the sound of a howling dog coming from a room. When I enter, the dog, a large Newfoundland, is already securely bound to the table by strong cords to each of his legs. He struggles violently, and shakes and rocks the heavy table, but to no purpose; he cannot escape. At his side one of the professors is injecting chloral, which is no true anaesthetic. Presently, a knife is taken, the skin of the animal is cut open between the ears, the flesh is carefully cut down to the skull. . . . The dog—a very powerful one—will escape, all bleeding and torn as he is."[28] Uncannily close to Prendick's recollection of Moreau's laboratory escapee, articles like this, with their explicit documentation of inhuman "foreign" science, led commentators as sober and sensible as William Carpenter to maintain "that the truly horrific examples of scientific torture of animals were from abroad, from Continental laboratories, not Britain."[29] Yet the work of Pasteur, practiced according to scientific methodology accepted throughout the Western world, was little different from British science. The satanic image is due as much to his status as outsider as to his vivisection techniques.

The antivivisection campaigners, then, utilized both imperialist ideology and feminist polemics to further their political aims. From the passage in Parliament of the Cruelty to Animals Act to the later 1880s,

MESMERISTS, MONSTERS, AND MACHINES

the public arena was almost entirely theirs. The scientific community had remained silent on the vivisection question. However, toward the end of the 1880s, they began to make their voices heard in the popular media. From this moment, the debate turned from one of univocal denouncement of animal experiments to a bitter conflict between science and the public. Nicolaas Rupke argues that once "the anti-vivisectionists were met on public ground, pamphlet was countered with pamphlet, argument with argument, slur with slur, insult with insult, exaggerated misrepresentation with unfair hyperbole."[30] No longer able to monopolize the public imagination, antivivisectionists searched for a new angle from which to attack science. Preying on general fears that science was becoming so powerful as to rule the lives of individuals, campaigners began to suggest that animal experimentation was only a point along the road to the similar use of human subjects. From about 1894 onward, the specter of human vivisection is raised more frequently in the popular press. One contributor to the *Bristol Mercury* wrote that "if vivisection of animals is allowed and approved by the 'powers that be' it is a certainty that vivisection of human beings is by no means distant."[31] Another commentator believed that scientists would be more than ready to make the short step from animal testing to human experimentation: "A physician who would cut a living rabbit in pieces—laying bare the nerves, denuding them with knives, pulling them out with forceps—would not hesitate to try experiments with men and women for the gratification of his curiosity."[32] There were also those who were convinced that human vivisection already took place, usually out of sight, either in secret laboratories or, more frequently, in foreign countries: "Whatever may be the truth about human vivisection in England, there seems no doubt that experimentation upon human beings—deliberate, repeated, painful, injurious experiments—are accepted by medical men in Germany as falling entirely within their right."[33]

It is into this complex debate, fueled by the mythology of human vivisection in the secret corners of Europe, that Wells introduces *The Island of Dr. Moreau.* His portrayal of vivisection is deliberate and exacting, a replication of the reports common in the various media of the 1890s. It is a conscious decision on Wells's part to keep his fictionalized

vivisection very close to the conflict between the scientific community and the public. Indeed, his three central characters—Moreau, Montgomery, and Prendick—each reveal some similarities with the physicians, scientists, and interested laypersons who play such a vital role in keeping vivisection firmly in the public imagination in the final decade of the nineteenth century.

From the very beginning of his narrative, Wells constructs his characters as representatives of those involved in the British vivisection controversy. Montgomery is a former medical student whose training in London saw him frequent the areas around "Tottenham Court Road and Gower Street" (7), only blocks away from the new British Institute of Preventive Medicine. However, Montgomery never did complete his training to become a physician. His role in Wells's triumvirate is as part laboratory assistant and part public representative. Prendick, too, has a dual significance: his nonscientific background immediately places him as the public representative, whereas his amateur interest in natural history allows him to feel a certain loyalty to the scientific community. Moreau, however, is rigidly categorized as the traditional SF scientist. His scientific talent, bordering on genius, is matched only by his inability to contextualize his experiments within a larger social or moral sphere. Within the context of the vivisection debate being played out in the popular press, Wells gives both the scientific community and the antivivisectionists a character on whom they can pin their propaganda. Moreau, very obviously, is a caricature of the hate-figures—such as Louis Pasteur—held up by antivivisection societies as the immoral human face of animal experimentation. In Montgomery and Prendick, the scientific community has two men whose scientific interests and sympathetic understanding of animal suffering, coupled with thoughtful defenses of its applicability, defend the correct methodologies of vivisection and provide a useful antidote to the sensationalism of the opposition.

Wells still appears to begin his interpretation of the vivisection debate with the voices of the antivivisectionists. Montgomery, forever shifting between his role as scientist and layman, reacts to Moreau's experiment on a puma with obvious distaste. His "wince" as the puma's "sharp, hoarse cry" emanates from the laboratory, coupled with his curses when "the

puma howled again" (23), parallels the horror of animal experimenta-
tion depicted in the pamphlets of the Victoria Street Society or on the
pages of national newspapers. When, only a few pages later, Prendick
catches his first glimpse of Moreau's laboratory, it is difficult to believe
that the narrative is anything other than a damning indictment of vivi-
section: "A startled deerhound yelped and snarled. There was blood, I
saw, in the sink—brown, and some scarlet—and I smelled the peculiar
smell of carbolic acid. Then through an open doorway beyond, in the
dim light of the shadow, I saw something bound painfully upon a frame-
work, scarred, red, and bandaged" (32). For Wells's readership in 1896,
such an explicit passage would seem to have been taken directly from
the writings of the antivivisectionists, in such publications as the *Irish
Figaro* or Cobbe's pamphlet. The uncanny parallels are once again con-
scious devices in the narrative. Wells's intention is to allow the voices of
antivivisection to dominate his text, just as they dominated the public
arena for so long. But there is a subtle dialogism to the discourse of the
novel that undermines the monopoly of antivivisectionist language. This
is achieved in two very different ways. First, Wells may allow the rheto-
ric of the antivivisectionists to pervade the text, but he does not allow it
to go unchallenged for long. Indeed, one of the main objectives of the
novel is to demythologize the claims of the antivivisection movement
by showing them to be unfounded and ridiculous, and to replace them
with an alternative mythology (evolutionary). Second, Prendick, who
is both outside and inside the dominant culture of the novel (outside
because he is trapped, uninvited on the island; inside because he rep-
resents the metropolitan center and the reader), provides a context for
the narrative that takes it beyond the confines of Moreau's island and
places it in contrast with the scientific culture of Britain, and specifically
with the institutional nature of (laboratory) science in the 1890s.

The process of calling into question the sensational myths of the an-
tivivisection lobby is enacted by the interrogation of possible human
vivisection, a subject very much in the public mind in the mid-1890s.
Prendick, Wells's mouthpiece for much of the rug pulling he conducts,
begins to suspect that Moreau's hideous, hidden experiments may have
a purpose more vile than he had suspected: "There was no mistake this

time in the quality of the dim, broken sounds; no doubt at all of their source. For it was groaning, broken by sobs and gasps of anguish. It was no brute this time; it was a human being in torment! . . . Could it be possible, I thought, that such a thing as the vivisection of men was carried on here? The question shot like lightning across a tumultuous sky; and, suddenly, the clouded horror of my mind condensed into a vivid realisation of my own danger" (32–33). Building this apparent revelation to a hyperbolic climax, Wells sets up antivivisectionist propaganda for a fall. The absurd mock gothic "horror" by which Prendick is transfixed parodies the exaggerated claims made in the news media. Patrick Parrinder has suggested that Prendick "concludes (quite irrationally) that Moreau is vivisecting human beings and that he himself is destined to become an experimental subject."[34] While Parrinder hits on exactly the right note in highlighting the irrationality of Prendick's belief, it would not, at first, have seemed so irrational to the 1890s reader. In the context of the antivivisection claims of human vivisection in Germany, and the distinct possibility of it arriving in England, it is understandable that Prendick (and Wells's readers) would have been willing to accept that here was an imaginative rendering of those fearful prophecies. However, Parrinder is ultimately right to advocate the absurdity of Prendick's remarks, for this is exactly what Wells aims to do as the narrative progresses. Having fled the laboratory in fear for his life, and putting himself in greater danger in the process, Prendick begins to realize that his comprehension of vivisection is, at best, rather too greatly influenced by propaganda. Persuaded by Moreau that he has been mistaken, Prendick begins to realize that human vivisection is a ridiculous notion. Montgomery has the final word, calling Prendick a "silly ass!" (44).

At this point in the narrative, with the discourse of antivivisection deflated and the early earnestness on the evils of animal experimentation rather less dominant, Wells inserts his pivotal scientific chapter. In this important section, Moreau attempts to explain his vivisection experiments through an amalgam of historical and philosophical considerations that together form a linear narrative of progress and moral defense. Yet the real vitality of Prendick and Moreau's discussion rests less on the dominance of the history and philosophy of science and

more on the hierarchy of power that Moreau constructs between the scientific investigator and the layman. Beginning with a series of questions designed to illuminate Prendick's misconceptions of vivisection, Moreau employs a manipulative narrative style that reduces Prendick to a subordinate, voiceless role and promotes science as the only meaningful discipline with the authority to talk on the subject of vivisection. Characterizing Prendick's reaction to the vivisected puma as "youthful horrors" (45) and cutting off any attempt at argument or dialogue, Moreau demolishes Prendick's moral platform by replacing it with one built on scientific knowledge. This is most clearly articulated in the comparison Moreau draws between his own research and Prendick's scientific career: "It may be, I fancy, that I have seen more of the ways of this world's Maker than you—for I have sought his laws, in *my* way, all my life, while you, I understand, have been collecting butterflies" (48). The intensely ironic tone by which Moreau demotes Prendick to the role of butterfly collector reveals an intense dislike for amateur scientific enterprise. Moreau's own professional research is validated, for him, by the simple fact of its professionalization. The only hierarchy relevant to Moreau is one of scientific authority: Prendick's concerns are irrelevant because they are spoken from a position outside the rigid boundaries of an acceptable—that is, professional—scientific community.

This hierarchy was one consciously employed by scientists defending the place of vivisection in experimental practice. Edwin Ray Lankester, for example, writing to the lord mayor of London on the subject of the Pasteur Institute in 1889, noted that "there have been two absolutely false letters in the Pall Mall Gazette during the week on the subject of Pasteur—written by persons totally ignorant of the subject and evidently prompted by the antivivisection party. That party is very small in numbers but entirely unscrupulous in regard to facts. They make a great deal of noise and do not hesitate to tell the most shameful falsehoods. It will be of very great importance that you should show that you and men like yourself attach more weight to the opinion of Paget, Lister, Roscoe and Huxley than to that of these irresponsible agitators."[35] Lankester's letter reveals a similar foregrounding of scientific authority to that found in Moreau's discussions with Prendick. Using a metaphor of moral recti-

tude (entirely without irony), Lankester condemns the antivivisection-
ists as a faceless group of revolutionaries while giving science a sturdy
authority by naming four eminent scientists whose positions are so-
cially and professionally secure. In a similar vein, T. H. Huxley, who
receives an honorable mention in Lankester's letter, writes of "the blind
opponents of properly conducted physiological experiment" who "pre-
fer that men should suffer, rather than rabbits or dogs."[36] Both Huxley
and Lankester strike at the nonprofessional status of the antivivisection
campaigners, depicting them as blind to scientific method or agitators
disinterested in empirical knowledge. That the two discourses—of the
scientific community and the antivivisectionists—can even be said to
be involved in debate is actually to acquiesce more common ground
than really existed. The two sides were writing entirely different kinds
of rhetoric: one methodological, one moral; one on particular scientific
outcomes, one on the means by which these outcomes were delivered.

Moreau's explanation to Prendick strikes that chord. Prendick's ex-
clamatory interventions, often on a moral note—"Of all the vile . . ."—are
cut off by Moreau's surgical prose, as when he tells Prendick to "be quiet"
(45). Ultimately, their positions are irreconcilable, just as the positions
of the antivivisectionists and the scientists were always to remain in op-
position. As Prendick concludes, "I looked at him, and saw but a white-
faced, white-haired man, with calm eyes. . . . Then I shivered" (45–46).
This final, concluding shudder of difference is a powerful symbol of the
disparity between the layman and the scientist. Wells's excellent evoca-
tion of that gap in understanding, which can also be read as a frisson of
recognition, gives further articulation of the complexity of the vivisec-
tion conflict in the 1890s.

Nevertheless, Wells's critique does not end here. His comprehension
of the public opposition to vivisection is based not only on questions
of morality and scientific understanding but on the controversy as di-
rected toward very specific targets. The antivivisectionists' opposition
to the building of a new British Institute of Preventive Medicine lead
Wells to believe that there were more powerful cultural currents at work
that intersected and found cross-correspondences in the prevention
of animal experiments. These correlations appeared most powerfully

around the places and sites of science that stood as monuments to an increasingly institutionalized scientific culture. Moreau's past history of institutional research and his present occupation at the island laboratory are the methods Wells uses to investigate how the institutions of science altered the position of science in the eyes of the general public.

The most important historical context for *The Island of Dr. Moreau* is the building of the British Institute of Preventive Medicine. Setting out the ruptures in communication, the transformations in perception, and the discontinuities in understanding that this proposed laboratory caused is a vital part of reading Wells's scientific critique. First discussed in 1889, the British Institute of Preventive Medicine was founded in 1891 and took hold of premises on Great Russell Street. In 1893 the institute purchased land on the Chelsea Embankment, where a new and greatly improved laboratory was to be built. It was this new construction that led to vehement public protest. The scientific community involved in the institute failed to believe there would be any opposition and therefore did not plan any response, while those opposing the laboratory did so in such a variety of ways and on such contrasting foundations that the entire episode—extended over a period of years from 1893 to the end of the century—was a fascinatingly turbulent example of the collision between science and society.

The community of scientists who were centrally involved in the British Institute's new Chelsea laboratory (led by Joseph Lister) had little time for public protest. Indeed, there is almost no evidence to show that the scientists were interested in anything more than societal control. Of course, "control" was a word full of resonance for scientists determined to grasp authority away from the wealthy, amateur community. As the embryonic stages of the institute's foundation show, scientists like Lankester, Lister, Huxley, and others were determined that any new scientific institution should be firmly in the hands of scientific leaders. The very fact that it was Sir James Whitehead, the lord mayor of London, who called the first meeting, alerted these scientists yet again to the power and influence of wealthy amateurs. Lankester's early letters to Whitehead reveal a subtle manipulation of the lord mayor in favor of the scientific community. The suggested gathering, he says, should be "a meeting of

scientific and medical men," a number of whom he lists as definite at-
tendees.[37] Some days later, Lankester also suggests the agenda for the
meeting and writes the resolutions in the hope that Whitehead will find
them useful in focusing the attention of the audience.[38]

This scientific domination of the proposed British Institute was a
calculated campaign by the scientific community to assure their own
ascendancy in the rising laboratory culture of the later nineteenth cen-
tury. Despite the important work carried out by laymen, albeit laymen
of high political and social standing, it is the scientists who are fore-
grounded in the institute's history. Even the deputation to the Board of
Trade in 1894, for the purposes of securing a vivisection license, was
characterized by Sir Henry Roscoe as a scientific body, despite the at-
tendance of many nonscientific men: "The deputation . . . is one, I think,
of exceptional importance. It represents not only the whole body of
medical opinion in this country . . . but also the whole . . . of the scien-
tific element."[39] The scientific element Roscoe highlights had little time
for public opinion. Although the opposition to the institute was in full
flow by 1894, there is no mention of it anywhere in the records of British
Institute meetings. It appears that, for the scientific community, public
relations consisted of no more than the insistence on police contain-
ment of any protest, as Lankester makes clear in a further letter to the
lord mayor: "I observe . . . that it will be necessary to have a good force
of police to guard the entrance to the meeting."[40] However, regardless
of their silence, the scientists attached to the British Institute did take
some steps to gain information on those opposing them. This appeared
to be instigated by the treasurer, Dr. Armand Ruffer, whose experiences
at the Pasteur Institute had perhaps prepared him for public outrage.
Two reports—one on a rally held by the Pimlico Radical Club to oppose
the institute's vivisection license and another on a survey of Chelsea
residents in the vicinity of the new laboratory—show that the British
Institute did at least wish to have information on its opponents, if not
understand their motives.

These reports reveal attitudes of superiority that are played out in
terms of gender, class, and scientific knowledge. A. W. Whalley's survey
of Chelsea residents begins, "In most of the flats the residents whom I

was able to see were of the female sex and bitterly opposed to the Institute. I only found two who spoke sensibly on the matter."[41] Not only are the residents female, and therefore unlikely to offer any reasonable opinion, they are also, of course, opposed to the institute (as all women were thought to be). For the reporter, it is remarkable that two sensible opinions were found amongst this group of nonscientific women, although what their opinion was is excised from the final document. The words of women were of so little consequence to the male-dominated scientific community that there is no thought to their inclusion. Likewise, the reporter at the rally in Pimlico reveals a clear prejudice against the protestors: "A few seedy looking individuals made up the walking contingent, and then came a furniture cart with a tarpaulin tent covering drawn by one horse. To the tarpaulin on each side was attached a placard about 5 feet by 4. At the top of this were too [sic] highly coloured pictures, one representing a rabbit being apparently inoculated... and the other showing a dog's head with the throat exposed. . . . The rest of the bill covering was plastered with extracts from the opinions of eminent judges and lawyers, &c, the major portion of which fell down soon after starting."[42] The wonderfully heavy-handed symbolism of the falling opinions gives us a clear indication of the contempt that the reporter holds for the protestors. These men and women in opposition to the institute not only are from nonscientific backgrounds but also belong to the working classes.

Of course the protesting groups, themselves an amalgamation of different communities, were as contemptuous of the laboratory scientists as the scientists were of them. The protestors' agendas were many and varied, but they came together around the opposition to the building of the Chelsea laboratory. The different groups involved made an uneasy alliance, held together only by a common purpose but outwardly using the moral questioning of vivisection as their motivating force. The Pimlico rally reveals the different fears that brought the protestors together. One, of course, was the opposition to vivisection, but there were others, including pollution, disease, and property devaluation. For the working classes, protesting the building of the institute was viewed as a necessary

raising of voices against continual oppression by the state. Already in Chelsea were "the gas works and the smell of gas in the drains."[43] This, allied to the suggestion of increased taxation to help fund the institute, was one more example of the persecution of the politically and financially dispossessed. Working-class protestors characterized the institute as an "abominable disease factory" that further alienated the weaker sections of society from the "healthy fine atmosphere"[44] that was the right of every British citizen.

Furthermore, the Chelsea residents most immediately adjacent to the new British Institute had other fears to allay. Largely middle-class residents were concerned that the value of their property would fall when the Institute began to invite "patients suffering from fevers and other infectious diseases"[45] into the Chelsea area. For an enclave of the middle classes to be polluted by diseased members of the working classes was a hideous specter that would "affect the status of the residents, and would depreciate the value of the flats."[46] Despite the efforts of the antivivisection societies to maintain a common purpose amongst its varied protestors it is clear that opposition arose from personal anxieties about the site of science rather than a deeply held moral code that conflicted with the methodologies of the scientific community.

It is undoubtedly the case, as Nicolaas Rupke convincingly argues, that all of these groups were concerned by "the emergence of science and medicine as leading institutions of Victorian society."[47] For some, such as the antivivisectionists, this was because the "sciences had developed a sense of professional identity, closing ranks when outsiders demanded public accountability,"[48] and for others, those more used to wielding power themselves, it was because they "saw their cultural influence waning."[49] These concerns became embedded throughout the later 1880s and grew stronger in the 1890s as the scientific community pushed ahead with its process of professionalization and institutionalization. When the British Institute began to moot the idea of a Chelsea laboratory, the strength of feeling suddenly had a specific target to attack. The real focus of opposition, therefore, centered on geography and architecture—on the site and place of the new culture of science. This

is understandable; those worried by the power of science did not rage against some vast and unseen structure but against particular examples of scientific hegemony.

The dynamics of power implicit in the geographical placement and architectural construction of the laboratory is precisely what Wells wished to investigate in *The Island of Dr. Moreau*. The importance of Moreau's English laboratory, the detailed picture of the island enclo-sure, and the concomitant freedoms and constraints of the three major characters are all designed to allow for a reading of the laboratory as a site of science that parallels the relationship between science and soci-ety typified by the British Institute of Preventive Medicine.

Moreau's early career, recalled by Prendick in one of the most im-portant sections of the novel, is a narrative of transgression and censure. His laboratory—a fictional echo of the British Institute—is targeted by the media and exposed as a place of cruel vivisection. Moreau's scien-tific method is questioned, tried on a platform of immorality, and con-demned. Such a disempowerment of the place of science is implicitly seen to be a victory for the antivivisectionists. Yet it is the lack of support for Moreau that Prendick finds so striking. Moreau's own community fails to defend his practice in the face of severe opposition. This seems remarkably at odds with the very muscular posturing of many scien-tists when faced by dissenters. As we have witnessed, Lankester was ready to call on official aid at the mere hint of troublesome protests. Nevertheless, the scientific community was ill prepared to defend the actions of errant investigators working within its disciplines. Despite Moreau's reputation as a "prominent and masterful physiologist, well known in scientific circles" (21), his failure to counter public perception made him a liability to the cultural supremacy of science. The scientists read Moreau's exposure as a sign of weakness that transgresses the rigid patterns of conduct set down by the community as a whole. A com-mentator at the Pimlico rally makes a similar point when he tells the gathered crowd that "a fairly influential doctor in the country had said that vivisection ought not to be supported[,] but he added 'Don't men-tion my name,' because he had no sufficient influence and he would be ruined. . . . There are doctors who have families to keep and feed who

dare not risk ruin by speaking out."[50] This culture of containment and censure, implemented by fear, is the focus of Wells's critique. Prendick's version of Moreau's history clearly defines the scientific community as rigid enforcers of a uniform culture that refuses to bend either to genuine public concerns or to those of its own members who fail to conform. Such a criticism of institutionalized science is bolstered by the place of science that Wells depicts. Moreau's laboratory—while not the home of the solitary investigator—is still a secure site of hidden scientific experimentation. The journalist who gains access to the laboratory must do so through subterfuge rather than invitation. Similarly, the British Institute compiled its report on the Pimlico rally by employing a private investigator to infiltrate the meeting and document its various resolutions. Concealed identities, false pretenses, and secret practices define the new institutions of science, just as Wells allows them to define the scientific culture in *The Island of Dr. Moreau*. Reading Wells in this way reinforces his antiscientific stance, which critics have suggested in the light of his imaginative rendering of vivisection. Yet, obversely, Wells's concentration on the scientific community tends to place Moreau more as a victim of a powerful political body than as the perpetrator of moral crime. In fact, in blaming the institutionalized methods of scientific discovery, Wells suggests that vivisection is not the horrific practice that it appears to be. Horror, indeed, comes from power unchecked by public liability.

The end product of a lapsed public censure is the island laboratory where Moreau conducts his experiments. In the "house of pain" (38), a phrase that clearly echoes the "school of cruelty"[51] that antivivisectionist Benjamin Bryan called the Pasteur Institute, Moreau is able to employ an experimental technique entirely free from the rule of law, out of the reach of a concerned public, and hidden from the gaze of the scientific community. His laboratory is a parody of the scientific institutions being built in England. One of the central alterations is the reversal of common laboratory architecture. At both the Cavendish laboratory in Cambridge and the British Institute at Chelsea, the leading professor had the use of a small private laboratory, one already characterized earlier in this chapter as the vestigial remains of early-nineteenth-century laboratory

culture. In Moreau's laboratory, the private space is enormous, leaving little of the enclosure for Prendick or the domesticated beast-people. The alteration in architectural dimension makes a vast difference to the perceived relationship between the leading scientist (Moreau) and his laboratory assistant (Montgomery), as well as those members of the public who may, at times, have access (Prendick):

> The main entrance to the enclosure we passed; it was a heavy wooden gate, framed in iron and locked, with the cargo of the launch piled out- side it, and at the corner we came to a small doorway I had not previ- ously observed. The white-haired man produced a bundle of keys from the pocket of his greasy blue jacket, opened this door, and entered. His keys, and the elaborate locking-up of the place even while it was still under his eye, struck me as peculiar. I followed him, and found myself in a small apartment, plainly but not uncomfortably furnished, and with its inner door, which was slightly ajar, opening into a paved courtyard. This inner door Montgomery at once closed. A hammock was strung across the darkest corner of the room, and a small unglazed window defended by an iron bar looked out towards the sea. (20)

This section, one of only a few descriptions of the architecture of the island laboratory, clearly demarcates the lines of authority and knowl- edge proscribed by spatial dynamics. There is a tripartite hierarchy ris- ing from the public to the nonspecialist to the scientific. For Prendick, the laboratory is a place of uncrossable boundaries, of locked doors and barred windows. Montgomery, although privileged enough to enter both the courtyard and enclosure, has a space separate from them for his own domestic use, as well as a limited stock of those other indica- tors of power: keys. Moreau, of course, enacts a dominant sovereignty over the laboratory. He holds all the keys, has access to every area, and his domestic space is not desegregated from the scientific space.

Recognizing that Moreau's domesticity is entirely bound up with the space of experiment is important. Not only does it register his domina- tion of the scientific work of the laboratory and suggest, in traditional science fiction fashion, the obsessive character of the central scientific

figure, it also highlights the lack of public (or even scientific) scrutiny of the practices of science. Moreau's personal possession of the space of the island laboratory drastically reduces the access of those determined to place checks and controls on his work. As the more public space is reduced, so too is the transparency of scientific investigation.

Of course the transparency of the late-nineteenth-century laboratory must also be questioned. In the British Institute at Chelsea, the architectural plans mark a number of boundaries and barriers between the public and the scientific. To enter the working spaces of the institute is to transgress not only an entrance hall and a forward office but also a segregated waiting room. These three nonscientific spaces curtail easy movement between the laboratory and the outside world. On the other side of the building, a vast wall and locked gates (much as Wells describes Moreau's enclosure) maintain a distinct division between the surrounding borough of Chelsea and the laboratory property. Yet these three anterooms, within the walls of the laboratory, do provide space for a public voice: they act as liminal spaces in the boundary between the authority of the public and the authority of science. Moreau's laboratory makes no such provision; indeed, it need not do so since there is no public or scientific community to perform the role of inspection. Prendick, whose arrival suddenly alters this situation, is clearly apprised of the boundaries: "I'm sorry to make a mystery, Mr. Prendick; but you'll remember you're uninvited. Our little establishment here contains a secret or so, is a kind of Blue-Beard's chamber, in fact. Nothing very dreadful, really, to a sane man; but just now, as we don't know you—" (20). Moreau's depreciating explanation betrays a fear of public censure linked clearly to an authoritative demand for Prendick's agreement. Implicitly, Moreau suggests that access to the laboratory may be possible, but only if Prendick is found to agree with the experiments taking place there. Knowledge and transparency is available only to those sympathetic to the practices of science. This is exactly the dynamics of inspection that the antivivisectionists always claimed were in place for the scientific institutions of the 1890s. Arthur Westcott, quoted in the report on the Pimlico rally, argues that "'the inspectors were vivisectors themselves and didn't care a fig about how the experiments were carried on.' He

[Westcott] cited the case of Doctor Poore who he said, worked at the University Hospital, and as he had only made so many inspections in a year could very nearly put them all in at his own hospital."[52] A system where scientists perform the inspection of their own community is unlikely to gain the confidence of the public. Access to the sites of science should be demonstrably available to the nonspecialist (as was Pasteur's Institute) in order for proper surveys to be carried out. The laboratory scientists, such as those at the British Institute, were entirely opposed to this, an understandable position when the sensational media coverage of the Pasteur experiments is considered. They had even made their opposition clear, on one occasion, by physically removing the protestor Arthur Westcott from their premises.[53]

Wells's position on the accessibility of the sites of science is one that allows him to critique both the scientific community and those who oppose its ascendant institutionalization. Moreau's island laboratory plays out the uncompromising position of the scientific laboratories of the 1890s to a logical, if extreme, conclusion. To deny accountability is to set up a structure of power that goes entirely unchecked other than by those, like Montgomery, who have had the ideology of scientific mastery imposed on them. The result of a methodology that denies the role of society is a return to the bestial roots of humanity. Cast in an evolutionary framework, Prendick's fate is to become "one among the beast people in the Island of Doctor Moreau" (78). However, this reading has to be set against the metropolitan laboratory from which Moreau originates. There, as we have seen, public censure did indeed take place, but led only to the barbarism of the island experiments. The narrative clearly invites the reader to make that connection. Is Wells, then, arguing that it is the sensationalism of campaigning antivivisectionists that brings about the very horrors they oppose?

To see the novel in this way is too simplistic. Wells's critical intervention in the interstices of the relationship between science and society does not allow for the domination of any monologic voice. Rather, Moreau's banishment from the center of the scientific community is seen as a result of that community's failure to accept that society has a

role to play in constructing the methodologies of science. The scientific community to which Moreau appeals expels him for his inability to defend their position as sole arbiters of experimental propriety. To use a metaphor drawn from the medical sciences closely associated with the vivisection controversy, Wells suggests that the scientific community does not acknowledge the existence of the disease of bad practice and therefore does not inoculate itself against the infection that bad practice brings. Sir John Lubbock, in remarks made to the Board of Trade on behalf of the British Institute, stated that "although Acts of Parliament may prevent us from destroying the bacteria, they cannot prevent the bacteria from destroying us."[54] For many scientific communities, the general public was as dangerous as the bacteria they were fighting in their laboratories, yet defense against disease is based on allowing that bacteria to infiltrate the physical body. For the health of the body of the scientific community, Wells suggests, the laboratory culture of the 1890s needed to allow for public intervention.

At the same time, *The Island of Dr. Moreau* is not an antivivisectionist text. Wells may well acknowledge the importance of public censure of the scientific community, especially as that community receded from public view, but he does not accept that vivisection is entirely without benefit or that laboratory culture necessitates scientific immorality. Instead, he views the increasingly distanced community of science as perpetuating the secrecy and mythology that surrounded scientific investigation earlier in the nineteenth century. *The Island of Dr. Moreau,* as an imaginative account of that mythology, illuminates both the inaccuracy of public belief and the problematic image that was beginning to attach itself to scientific culture.

Both Moreau's history and the controversy surrounding the British Institute envision moments best described as carnivalesque. They represent an uproarious, public denouncement of an elite community that appears to transgress and alter the relationships between science and society but that actually does no more than release the tensions between the privileged and the dispossessed while maintaining the structures of power already in place. For Wells, this is unacceptable. The cultures

CHAPTER 8

Conclusion
The Progress of Literature and Science; or,
A Refrain on Interdisciplinarity

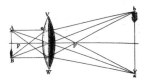

READING THE CULTURES OF SCIENCE and literature in tandem has
been the focus of this book. But what does it mean to read these two
disciplines together? How do literature and science affect each other?
It is all very well to acknowledge that fictions of science *reflect* the
contemporary scientific world, but it has been the contention of each
chapter that they also *contribute* to the construction of science within
nineteenth-century culture. Paul Fayter, in one of the very few academic
essays to address the relationship between nineteenth-century science
fiction and science, argues that SF "played a role in maintaining a com-
mon popular scientific culture."[1] Fayter's vision of "a fluid exchange of
ideas"[2] between science and literature suggests that there is a channel
of communication between the two disciplines that can be successfully
accessed and interrogated by academic scholarship. Where, though,
does this channel reside and what scholarly methodology can be used
to investigate it?

The preceding chapters have argued that scientific knowledge does not only exist within the scientific discipline that produced it. Production of knowledge within the sciences is almost always followed by dissemination of that knowledge. This, in turn, releases scientific knowledge from within a given discipline into the wider social and cultural community. Science then becomes a part of the politics, history, philosophy, and bank of public knowledge that makes up the social world. However, even when residing only in the scientific disciplines knowledge is not exempt from the influence of social and cultural forces. Scientists are social subjects like any other individuals whose decisions are influenced by prevailing concerns in the wider world. Indeed, the many historical examples of scientific knowledge being withheld from a broader audience almost always involve a consideration of potential political or cultural responses to that knowledge. Renaissance astronomers, for example, often withheld newly discovered knowledge of planetary movements for fear of opposition from a powerful clergy determined not to allow science to undermine biblical truths. Science is not, then, a separate sphere working on its own terms; it is a form of knowledge production whose fresh understandings of the workings of the world are influenced by wider society and culture. At the same time, science influences wider society and culture through the dissemination of new discoveries. There is, then, a continuously cyclical process of influence and self-reflection within scientific, social, and cultural disciplines (be they art, literature, history, or politics) that constitute a complex channel of communication between them.

Electrical research and Mary Shelley's response to it in *Frankenstein* (the subject of Chapter 3) provides a fine example of the complexity and longevity of the influences and cross-correspondences between science, literature, art, history, and politics. Shelley's novel provided a critique of the conflicts between opposing scientific philosophies with very firm doctrinal differences over the material constitution and products of electricity. Within the literary intellectual community and also in the public sphere, Shelley's critique came to stand for both a distrust of unregulated scientific experimentation and a presumption that the scientific community was still greatly influenced by occult practices.

These beliefs so successfully dominated the cultural sphere that the word "Frankenstein" was soon used to refer to the creature created by the scientist rather than the scientist himself. Frankenstein, therefore, became the monstrous and supernatural offspring of the practices of science. This new adjective was reapplied to science in the early twentieth century through a different art form: cinema. James Whale's 1931 film *Frankenstein* depicted the creature as a mechanized monster who symbolized Whale's concern about the overwhelming power of automation in contemporary society. Shelley's novel was now being used to critique a different form of science over a century after its publication. The scientific community responded to these powerful cultural critiques by stressing both its pragmatic attention to empirical and objective data and its serious contemplation of the ethics of scientific work. In the 1930s and 1940s, Isaac Asimov depicted this self-appraisal of scientific practice very positively in his series of robot stories that investigated the philosophical and ethical concerns of the creation of the artificial human.

Nevertheless the symbolic associations of the word "Frankenstein" continued to permeate popular art and culture as well as the public perception of science. At the end of the twentieth century, Frankenstein was being used as a prefix in the phrase "Frankenstein foods" to articulate concerns over the genetic modification of farmed crops. In Britain and, to a lesser extent, Europe and the United States, Frankenstein seemed an appropriate adjective to describe the grotesque and monstrous foodstuffs that may have resulted from genetic alterations to crops. Although within the scientific communities involved in the discovery of techniques for genetic modification such nomenclature seemed nothing more than a parody of the truth, there was still concern over the public and political perceptions that might result from the symbolic attachment of Frankenstein to their science. In fact, there was such political concern that the British government introduced a series of scientific trials under the leadership of its own department of agriculture. A scientific experiment was now a political process.

What had been new scientific knowledge had become a complex political struggle. Disagreements between Romantic and materialist

scientists over the nature of electricity at the beginning of the nineteenth century had been reinscribed in literary fiction, popular film, mechanics, botanical gene research, and contemporary politics. In the process, the history of the word "Frankenstein" reveals a transformation of meaning that allows it to return, at the beginning of the twenty-first century, with a potency equal to that given to it by Mary Shelley at the start of the nineteenth century.

This brief example highlights some of the complex interconnections between science and culture that constitute those channels of communication where exchanges of ideas takes place. This is not to suggest that science can be fruitfully investigated only through analysis of other cultural forms. It is vital to address science within its own discipline and in its own discourse as well as in those areas of society and culture where it has been influential. Likewise, one cannot critique science fiction with recourse only to science. One must give primacy to the imaginative discourse that is the basis for literary art. Yet there are potential points of convergence. In proclaiming themselves as valid subjects in the social and cultural world, both science and literature communicate primarily through language. Rarely are scientific experiments performed for a mass audience; rather, they are written down and disseminated in textual form. Science fiction is also predominantly textual (although it can also be visual). Certainly, in the preceding chapters, both science and science fiction have been investigated through their use of language. It is the discourses of these disciplines that provide a common ground for academic research. Not discourses in the abstract but discourses that are shaped by the disciplinary concerns of literature and science, that are contextually driven and must be historicized, that exclude and include other cultural forms, and that must be analyzed with due attention to their conflicting views and opposing opinions. What methodology would be appropriate for this project? How are the different discourses of language to be investigated so as to take account of these differences and avoid becoming a generalized and nonspecific form of close reading?

Bakhtin's theories of the construction of narrative are productive here. Bakhtin's influence on narrative theory has predominantly arisen from his two related concepts of discourse and carnival. Both of these

are concerned with conflicting voices of varying authority. In the first of these, Bakhtin sees written language as a collage of discourses from different cultural sources. Text is constructed, he claims, from a heteroglossia of these discourses that contest one another's authority as the dominant language. The second, carnival, which R. Brandon Kershner sees as "Bakhtin's most influential formulation,"[3] is based on "a kind of folk wisdom that celebrates the body and opposes all authority."[4] The medieval carnival, to which Bakhtin looked for inspiration, was a theatrical performance of disorder and anarchy designed to disrupt the usual hierarchy of power. This disruption was often contained within the ritual of the carnival which acted as a mere "'safety-valve' whose effect is to reaffirm the dominant power."[5]

Both the formulation of discourse as a collection of different voices and the notion of carnival as a potentially disruptive site of alternative authority are useful theories in an interdisciplinary investigation of literature and science. The scientific and fictional texts addressed in these chapters, for example, were undoubtedly complex, interrelated documents whose discourses often constructed a heteroglossic narrative of conflicting philosophies. *Frankenstein* revealed this conflict through its use of the discourses of Romantic and materialist science, and *Twenty Thousand Leagues Under the Sea* offered a similar structure of field and closet natural history. The scientific documents alluded to alongside *The Island of Dr. Moreau* were also complex discourses incorporating the languages of politics and class, much as the writings of Vaucanson and Kempelen in the chapter on E. T. A. Hoffmann called on the discourse of the occult as well as that of mechanical science. Bakhtin's carnival is also a profitable theory because it highlights the relationship often found between the orthodox and heterodox scientific communities. By the orthodox sciences, those on the margins were characterized as carnivalesque practices: disordered, blasphemous, and unruly in their thinking. The mainstream, in suggesting the carnivalization at the margins, both acknowledges the existence of opposition and contains it within a frame of reference that removes any real threat of revolution. For the marginal sciences, entry into the mainstream is either blocked by a ritualistic denial of their validity or else they must reject their

own margins by a process of carnivalization that mimics the center. To do that is to become as authoritarian as the mainstream, to accept its methodology and gain acceptance only on its terms. This is exactly the process described by several of the preceding chapters, especially when considering mesmerism in the work of Hoffmann and Poe or psychical research in Villiers de L'Isle-Adam's *Tomorrow's Eve*.

More investigation of the relationship between Bakhtin's theories and interdisciplinary analysis of literature and science would be profitable. Interdisciplinarity has tended to obscure Bakhtin's contribution in favor of cultural materialist or historicist readings often based on Foucauldian discourses of power. Bakhtin's narratology, I would argue, has a major part to play in the future of the interdisciplinary study of literature and science. Indeed, the present work has tried to lay some of the foundations for such scholarship. While these concluding remarks have looked forward to future academic work that may further investigate Bakhtin's utility in interdisciplinary contexts, they have also shown how the present work has attempted to begin that task. Allowing a polyphony of voices from nineteenth-century science and science fiction to speak for themselves and contribute to the discourses of one another shows that these two cultures can be both constructive in their dialogue and instructive for the interdisciplinary critic.

Notes

——•◦■◦•——

1. Literature, Science, and Science Fiction

1. Charles Joseph Singer, *From Magic to Science: Essays on the Scientific Twilight* (New York: Boni and Liveright, 1928), 3.

2. See Alison Winter, *Mesmerized: Powers of Mind in Victorian Britain* (Chicago: Chicago Univ. Press, 1998).

3. Robin Gilmour, *The Victorian Period: The Intellectual and Cultural Context of English Literature, 1830–1890* (London: Longman, 1993), 139.

4. Gillian Beer, *Open Fields: Science in Cultural Encounter* (Oxford, U.K.: Oxford Univ. Press, 1996), 8.

5. See Jonathan Smith, *Fact and Feeling: Baconian Science and the Nineteenth-Century Literary Imagination* (Madison: Univ. of Wisconsin Press, 1994).

6. See Peter Alter, *The Reluctant Patron: Science and the State in Britain, 1850–1920*, trans. Angela Davies (Oxford, U.K.: Berg, 1987).

7. Gilmour, *Victorian Period*, 135.

8. Peter Allan Dale, *In Pursuit of a Scientific Culture: Science, Art, and Society in the Victorian Age* (Madison: Univ. of Wisconsin Press, 1989), 7.

9. Kingsley Amis, *New Maps of Hell* (London: Four Square, 1963); Robert M. Philmus, *Into the Unknown: The Evolution of Science Fiction from Francis Godwin to H. G. Wells* (Los Angeles: Univ. of California Press, 1970). In the preface to the 1983 reprint, Philmus claims his monograph as the first academic study of science fiction.

10. Thomas D. Clareson, ed., *SF: The Other Side of Realism. Essays on Modern Fantasy and Science Fiction* (Bowling Green, Ohio: Bowling Green Univ. Popular Press, 1971).

11. Ibid., 9.

12. Judith Merril, "What Do You Mean: Science? Fiction?" in Clareson, *Other Side of Realism*, 59.

13. James Blish, "On Science Fiction Criticism," in Clareson, *Other Side of Realism*, 166.

14. Brian Aldiss, *Billion Year Spree: The True History of Science Fiction* (London: Weidenfeld and Nicolson, 1973).

15. Robert Scholes and Eric Rabkin, *Science Fiction: History, Science, Vision* (New York: Oxford Univ. Press, 1977), 14.

16. Mark Angenot, "Jules Verne: The Last Happy Utopianist" in *Science Fiction: A Critical Guide*, ed. Patrick Parrinder (London: Longman, 1979), 18.

17. Mark Rose, *Alien Encounters: Anatomy of Science Fiction* (Cambridge, Mass.: Harvard Univ. Press, 1981), 5.

18. Thomas D. Clareson, *Some Kind of Paradise: The Emergence of American Science Fiction* (Westport, Conn.: Greenwood Press, 1985), xii.

19. Peter Stockwell, *The Poetics of Science Fiction* (Harlow, U.K.: Pearson Education, 2000), 8.

20. Scholes and Rabkin, *Science Fiction*, 113-14.

21. Patrick Parrinder, "Science Fiction and the Scientific World View," in Parrinder, *Science Fiction*, 67.

22. Ibid.

23. Philmus, *Into the Unknown*, xiv.

24. Gary Westfahl, *Cosmic Engineers: A Study of Hard Science Fiction* (Westport, Conn.: Greenwood Press, 1996), 3.

25. Ibid., 63.

26. Gary Westfahl and George Slusser, eds., *No Cure for the Future: Disease and Medicine in Science Fiction and Fantasy* (Westport, Conn.: Greenwood Press, 2002).

27. H. Bruce Franklin, "The Science Fiction of Medicine," in Westfahl and Slusser, *No Cure*, 11.

28. Clareson, *Some Kind of Paradise*, xiv.

29. Rose, *Alien Encounters*, 7.

30. Farah Mendlesohn, "Science Fiction in the Academies of History and Literature; or, History and the Use of Science Fiction," in *Science Fiction, Canonization, Marginalization, and the Academy*, ed. Gary Westfahl and George Slusser (Westport, Conn.: Greenwood Press, 2002), 119.

31. Ibid., 124-25.

32. Gillian Beer, *Forging the Missing Link: Interdisciplinary Stories* (Cambridge, U.K.: Cambridge Univ. Press, 1992), 4-5.

33. Joe Moran, *Interdisciplinarity* (London: Routledge, 2002), 182.

34. Beer, *Missing Link*, 4; Moran, *Interdisciplinarity*, 184.

35. Moran, *Interdisciplinarity*, 19.

36. Ibid., 155.

37. Ibid., 148.

38. Ibid.

39. Barbara T. Gates, "Literature and Science," *Victorian Literature and Culture* 26:2 (1998): 485.

40. Moran, *Interdisciplinarity*, 155.

41. Gillian Beer, *Darwin's Plots: Evolutionary Narrative in Darwin, George Eliot, and Nineteenth-Century Fiction* (London: Routledge and Kegan Paul, 1983); George Levine, *Darwin and the Novelists: Patterns of Science in Victorian Fiction* (Cambridge, Mass.: Harvard Univ. Press, 1988).

42. Beer, *Missing Link*, 4–5.

43. Lawrence Rothfield, *Vital Signs: Medical Realism in Nineteenth-Century Fiction* (Princeton, N.J.: Princeton Univ. Press, 1992), xii.

44. John Limon, *The Place of Fiction in the Time of Science: A Disciplinary History of American Writing* (Cambridge, U.K.: Cambridge Univ. Press, 1990), 4.

45. Ibid., 29.

46. Beer, *Open Fields*, 187.

2. E. T. A. Hoffmann and the Magic of Mesmerism

1. Aldiss, *Billion Year Spree*, 128.

2. These magical forms of knowledge can be characterized in different ways and by a variable vocabulary. Throughout this chapter, I shall define magic in terms of supernatural and occult practice. Hoffmann's narrative discourse moves freely between the "ways of seeing" without differentiating between them, and I shall parallel this in the vocabulary I use to describe that discourse.

3. E. F. Bleiler, ed., *The Best Tales of Hoffmann* (London: Dover, 1967), xvii.

4. Science was beginning to be defined in terms of empirical or phenomenological knowledge and set apart from the "invisible" forces that are the foundation for magic and occult experiments.

5. D. Brewster, ed., *Edinburgh Encyclopedia*, vol. 1 (Edinburgh: Blackwoods, 1830), 62.

6. Ibid.

7. See Christian Bailly, *Automata: The Golden Age, 1848–1914* (London: Sotheby's, 1947) and Otto Mayr, *Authority, Liberty, and Automatic Machinery in Early Modern Europe* (Baltimore, Md.: Johns Hopkins Univ. Press, 1986).

8. Bailly, *Automata*, 14.

9. Mayr, *Authority, Liberty, and Automatic Machinery*, 55.

10. Ibid., 24.

11. Ibid., 26.

12. Brewster, *Edinburgh Encyclopedia*, 64.

13. See, for example, Robert Lambourne, Michael Shallis, and Michael Shortland, *Close Encounters? Science and Science Fiction* (Bristol, U.K.: Adam Hilger, 1990), 37.

14. See Andrew Cunningham and Nicholas Jardine, eds., *Romanticism and the Sciences* (Cambridge, U.K.: Cambridge Univ. Press, 1990).

15. Thomas Carlyle, "Signs of the Times," *Edinburgh Review* 49 (1829): 439–59.

16. Charles Babbage is credited with creating the first "thinking machine," or computer, whose mechanical processes reflected the thought processes of an intelligent animal (in the most basic terms). See Simon Schaffer, "Babbage's Dancer and the Impresarios of Mechanism" in *Cultural Babbage*, ed. Francis Spufford and Jenny Uglow (London: Faber, 1996), 76.

17. E. F. Bleiler, in *The Best Tales of Hoffmann*, points out that Hoffmann wrote "a collection of stories, connected by narrators and critics who represent Hoffmann himself (in different projections) and his friends" (xi).

18. Walter D. Wetzels, "Aspects of Natural Science in German Romanticism," *Studies in Romanticism* 10:1 (1971): 57.

19. Ibid.

20. See Martin Willis, "E. T. A. Hoffmann's 'Automata' and the Munich Séances of Johann Wilhelm Ritter," *Germanic Notes and Reviews* 28:2 (1997): 119–21.

21. See Schaffer, "Babbage's Dancer," 70–72.

22. Edgar Allan Poe, "Maelzel's Chess-Player," in *The Collected Works of Edgar Allan Poe*, ed. James Harrison (New York: AMS Press, 1965).

23. Winter, *Mesmerized*.

24. See Richard Milner, "Charles Darwin and Associates, Ghostbusters," *Scientific American* (Oct. 1996): 72–77.

25. Vincent Buranelli, *The Wizard from Vienna: Franz Anton Mesmer* (London: Peter Owen, 1976), 39.

26. Ibid., 101.

27. See Daniel Pick, *Svengali's Web: The Alien Enchanter in Modern Culture* (New Haven, Conn.: Yale Univ. Press, 2000) and Winter, *Mesmerized*.

28. Buranelli, *Wizard from Vienna*, 48.

29. See D. S. L. Cardwell, *The Organisation of Science in England* (London: Heinemann, 1972) and Alter, *Reluctant Patron*, trans. Angela Davies (Oxford, U.K.: Berg, 1987).

30. Maria Tatar, *Spellbound: Studies on Mesmerism and Literature* (Princeton, N.J.: Princeton Univ. Press, 1978), 149.

31. Buranelli, intro., *Wizard from Vienna*.

32. Ibid.

33. John Cohen, *Human Robots in Myth and Science* (London: Allen and Unwin, 1966), 59.

34. Singer, *From Magic to Science*, 3.

35. William L. Stone, *Letter to Dr. A. Brigham on Animal Magnetism* (New York: George Dearborn, 1837), 9.

36. Thomas Beddoes, "Rational Toys" in *Pandaemonium: The Coming of the Machine as Seen by Contemporary Observers, 1660–1886*, ed. Humphrey Jennings (London: Macmillan, 1995), 125–27.

37. H. Bruce Franklin, *Future Perfect: American Science Fiction of the Nineteenth Century—An Anthology* (Piscataway, N.J.: Rutgers Univ. Press, 1995).

38. Mayr, *Authority, Liberty, and Automatic Machinery*, 26.

39. Buranelli, *Wizard from Vienna*, 132.

3. MARY SHELLEY'S ELECTRIC IMAGINATION

1. Recent readings of *Frankenstein* agree with the historiographic approach taken here. For example, Carlos Seligo points out that "only by examining the history of science" can we fully illuminate Shelley's project. See Carlos Seligo, "The Monsters of Botany and Mary Shelley's *Frankenstein*," in *Science Fiction, Critical Frontiers,* ed. Karen Sayer and John Moore (London: Macmillan, 2000), 70. For other history of science interpretations see also Anne K. Mellor, "*Frankenstein*: A Feminist Critique of Science," in *One Culture,* ed. George Levine (Madison: Univ. of Wisconsin Press, 1987).

2. Mary Shelley details her own participation in such meditations in the 1831 introduction to *Frankenstein.* There she describes a conversation between herself, Percy Shelley, and John Polidori that was influential in her writing of the novel.

3. Sir Walter Scott, "Remarks on *Frankenstein; or, The Modern Prometheus,*" *Blackwood's Edinburgh Magazine,* 2:12 (1818): 613.

4. Ibid., 614.

5. Muriel Spark, "Frankenstein," in *Mary Shelley,* ed. Harold Bloom (New York: Chelsea House, 1985), 11.

6. Edith Birkhead, *The Tale of Terror: A Study of the Gothic Romance* (London: Constable, 1921), 164.

7. Radu Florescu, *In Search of Frankenstein* (London: New English Library, 1977), 83.

8. Robert Kiely, "Frankenstein," in Bloom, *Mary Shelley,* 70.

9. James E. Rieger, ed., *Frankenstein; or, The Modern Prometheus,* 1818 edition (Chicago: Chicago Univ. Press, 1982), xxvii.

10. See Maurice Hindle's introduction to the Penguin Classics edition of the novel (London: Penguin, 1995).

11. Linda Bayer-Berenbaum, *The Gothic Imagination: Expansion in Gothic Literature and Art* (London: Associated Presses, 1982), 21.

12. Ibid., 33.

13. For the purposes of this chapter, I shall use an 1831 edition of the novel, which includes Mary Shelley's preface and her final corrections. Mary Shelley, *Frankenstein,* ed. Maurice Hindle (London: Penguin, 1992).

14. Philip C. Ritterbush, *Overtures to Biology: The Speculations of Eighteenth-Century Naturalists* (New Haven, Conn.: Yale Univ. Press, 1964), 15.

15. See *Dictionary of the History of Science,* ed. W. F. Bynum, E. J. Browne, and Roy Porter (London: Macmillan, 1981), 233.

16. Ritterbush, *Overtures to Biology,* 25.

17. Ibid., 48.

18. Ibid., 24.

19. Charles Coulston Gillispie, ed., *Dictionary of Scientific Biography* (New York: Scribners, 1971–80), 15:77.

20. Ritterbush, *Overtures to Biology,* 55–56.

21. *Dictionary of Scientific Biography,* 268.

22. *An Essay, &c. (An Attempt to find a general principle to connect the*

outlines of the various branches of the science of nature, and to trace an uniform, and consistent, and intelligible explanation of the whole). Science Collection, University of Edinburgh Manuscripts, Ref. O.S. 537 ESS: 5.

23. Ibid., 10.

24. Ibid., 33.

25. Schelling's theories were also influential on the work of E. T. A. Hoffmann.

26. Maurice Hindle, "Vital Matters: Mary Shelley's *Frankenstein* and Romantic Science," *Critical Survey* 2:1 (1990): 34.

27. E. T. Whittaker, *A History of the Theories of Aether and Electricity: From the Age of Descartes to the Close of the Nineteenth Century* (London: Longmans, 1910), 59.

28. *McGraw-Hill Encyclopedia of Science* (New York: McGraw-Hill, 1987), 9:264.

29. Ibid., 265.

30. Ibid., 3:516–17.

31. In the author's introduction to the 1831 edition of *Frankenstein,* Shelley states, "Perhaps a corpse would be re-animated; galvanism had given token of such things: perhaps the component parts of a creature might be manufactured, brought together, and endued with vital warmth" (8).

32. T. H. Huxley, "On the Hypothesis that Animals Are Automata, and Its History" in *Collected Essays Volume One: Method and Results,* ed. Huxley, 247 (London: Macmillan, 1893).

33. Samuel Holmes Vasbinder, *Scientific Attitudes in Mary Shelley's Frankenstein* (Ann Arbor, Mich.: UMI Research Press, 1984), 35–50.

34. See John Keats, *Lamia 1820* (Oxford, U.K.: Woodstock Books, 1990), part II, l. 237.

35. The 1818 edition of *Frankenstein* more explicitly details the power of electrical force and those experiments currently investigating it. Before altering this section in 1831, it read: "This catastrophe of the tree excited my extreme astonishment; and I eagerly inquired of my father the nature and origin of thunder and lightning. He replied, 'Electricity'; describing at the same time the various effects of that power. He constructed a small electrical machine, and exhibited a few experiments; he made also a kite, with a wire and string, which drew down that fluid from the clouds" (Hindle 221). Here, the Romantic conception of electrical force is stronger, most especially in the comparison made between Victor's father and Benjamin Franklin's experiments. The later alterations make the text a great deal more ambiguous and suit Shelley's purpose better.

36. Vasbinder, *Scientific Attitudes,* 65–82.

37. David Ketterer, *Frankenstein's Creation: The Book, the Monster, and Human Reality* (Victoria, Australia: Univ. of Victoria, 1979), 17.

38. Morse Peckham, *Romanticism: The Culture of the Nineteenth Century* (New York: George Braziller, 1965), 27–28.

39. See Marilyn Butler, *Romantics, Rebels, and Reactionaries: English Literature and Its Background, 1760–1830* (Oxford, U.K.: Oxford Univ. Press, 1981).

40. In a note to the text, Maurice Hindle quotes Peter Brooks, who describes the creature's reading of *Parallel Lives, Paradise Lost,* and *The Sorrows of Young Werther* as constituting "a possible Romantic *cyclopedia universalis*" (259).

4. THE HUMAN EXPERIMENTS OF EDGAR ALLAN POE

1. Leo Marx, *The Machine in the Garden: Technology and the Pastoral Ideal in America* (New York: Oxford Univ. Press, 1964), 215.

2. J. Potter, "Industrial America," in *British Essays in American History,* ed. H. C. Allen and C. P. Hill (London: Edward Arnold, 1957), 274–75.

3. See John Hughes Bennett, *The Mesmeric Mania of 1851, with a physiological explanation of the phenomena produced* (Edinburgh: Sutherland and Knox, 1851).

4. See Sally Mitchell, ed., *Victorian Britain* (London: Garland, 1988).

5. The stories discussed in brief in this section can be found in *The Science Fiction of Edgar Allan Poe,* ed. Harold Beaver (London: Penguin, 1976).

6. Carlyle, "Signs of the Times," 439–59.

7. Andrew Ure, "The Philosophy of Manufactures," in Jennings, *Pandaemonium,* 192.

8. "Machinery: A Dialogue," *Chambers Edinburgh Journal* 399 (1839): 6.

9. Ibid., 7.

10. John Ruskin, "The Opening of the Crystal Palace Considered in Some of Its Relations to the Prospects of Art," in *Culture and Society in Britain, 1850–1890,* ed. J. M. Golby (Oxford, U.K.: Oxford Univ. Press, 1990), 175.

11. "*Mechanics' Magazine,* Sep. 25, 1830," quoted in Jennings, *Pandaemonium,* 177.

12. Ibid.

13. *Times,* "Dreadful Accident to Mr. Huskisson," Sept. 17, 1830.

14. Charles Dickens, *Dombey and Son* (London: Penguin, 1985), 875.

15. *Times,* "Dreadful Accident," Sept. 17, 1830.

16. Dickens, *Dombey and Son,* 121.

17. "*The Pennsylvania Enquirer,* July 1843" qtd. in *Edgar Allan Poe: The Critical Heritage,* ed. I. M. Walker (London: Routledge and Kegan Paul, 1986), 133.

18. James E. Heath, "*Southern Literary Messenger,* January 1840" qtd. in Walker, *Critical Heritage,* 130.

19. Edward H. Davidson, *Poe: A Critical Study* (Cambridge, U.K.: Belknap Press, 1957), 211–12.

20. A. H. Quinn, *Edgar Allan Poe: A Critical Biography* (London: Century, 1942), 283.

21. Joan Tyler Mead, "Poe's 'The Man That Was Used Up': Another Bugaboo Campaign," *Studies in Short Fiction* 23:3 (1986): 281–86.

22. All quotes from this story refer to the version in *The Complete Works of Edgar Allan Poe,* ed. James Harrison (New York: AMS Press, 1965).

23. Mead, "Another Bugaboo Campaign," 282.

24. Ibid.

25. Winter, *Mesmerized.*

26. Sidney E. Lind, "Poe and Mesmerism," *PMLA* 62 (1947): 1077–94.

27. Paschal Beverly Randolph, *Seership! The Magnetic Mirror* (Boston: Randolph, 1870), 28.

28. Doris V. Falk, "Poe and the Power of Animal Magnetism," *PMLA* 84 (1969): 536–46.

29. See Walker, *Edgar Allan Poe.*

30. George H. Daniels, *American Science in the Age of Jackson* (New York: Columbia Univ. Press, 1969), 6.

31. George H. Daniels, *Science in American Society: A Social History* (New York: Alfred A. Knopf, 1971), 10.

32. All quotes from this story refer to the version in Beaver, *Science Fiction of Edgar Allan Poe.*

33. Falk, "Animal Magnetism," 538.

34. Lind, "Poe and Mesmerism," 1092.

35. Thomas Capern, *Pain of Body and Mind Relieved by Mesmerism: A Record of Mesmeric Facts* (London: Mr. Bailliere, 1861), 2.

36. Ibid., 3.

37. All quotes from this story refer to the version in Beaver, *Science Fiction of Edgar Allan Poe.*

38. Lind, "Poe and Mesmerism," 1083.

39. Falk, "Animal Magnetism," 539.

40. Randolph, *Seership!* 2.

41. Lind, "Poe and Mesmerism," 1084; Falk, "Animal Magnetism," 542.

42. The narrator, discussing Templeton and Bedloe's mesmeric rapport, is "not prepared to assert, however, that this rapport extended beyond the limits of the simple sleep-producing power" (100).

43. William Edwards, *Mesmerism: Its Practice and Phenomena* (Melbourne, Australia: John Hunter, 1850), 40.

44. Ibid., 41.

45. All quotes from this story refer to the version in Beaver, *Science Fiction of Edgar Allan Poe.*

46. George Bush, *Mesmer and Swedenborg; or, The Relation of the Development of Mesmerism to the Doctrines and Disclosures of Swedenborg* (New York: John Allen, 1847), v–vi.

47. Stone, *Letter to Dr. A.,* 3.

48. Harriet Martineau, *Letters on Mesmerism* (London: Edward Moxon, 1845), 1–2.

5. VERNE'S DEEP-SEA INVESTIGATIONS ON DRY LAND

1. T. H. Huxley, "The Deep-Sea Soundings and Geology," *Nature* (Apr. 28, 1870): 657–58.

2. See David Elliston Allen, *The Naturalist in Britain: A Social History* (London: Penguin, 1976); Lynn Barber, *The Heyday of Natural History: 1820–1870*

(London: Jonathan Cape, 1980); Lynn L. Merrill, *The Romance of Victorian Natural History* (Oxford, U.K.: Oxford Univ. Press, 1989).

3. Philip Gosse is perhaps the best known of the Victorian amateur natural historians, both then and now. His works include *A Manual of Marine Zoology for the British Isles* (London: John Van Voorst, 1855); *The Aquarium: An Unveiling of the Wonders of the Deep Sea* (London: John Van Voorst, 1856); and *Evenings at the Microscope; or Researches among the Minuter Organs and Forms of Animal Life* (London: SPCK, 1877).

4. John Clute and Peter Nicholls, *The Encyclopedia of Science Fiction* (London: Orbit, 1993), 1275.

5. Edmund Smyth, "Verne, SF, and Modernity: An Introduction," in *Jules Verne: Narratives of Modernity,* ed. Smyth (Liverpool, U.K.: Liverpool Univ. Press, 2000), 3.

6. Sarah Capitanio, "'L'Ici-bas' and 'l'Au-dela' . . . but Not as they Knew it. Realism, Utopianism, and Science Fiction in the Novels of Jules Verne," in Smyth, *Jules Verne,* 63.

7. Ibid.

8. Timothy Unwin, "The Fiction of Science, or the Science of Fiction," in Smyth, *Jules Verne,* 46–47.

9. Arthur B. Evans, *Jules Verne Rediscovered: Didacticism and the Scientific Novel* (Westport, Conn.: Greenwood Press, 1988), 58–59.

10. Ibid., 33.

11. Jules Verne, *Twenty Thousand Leagues Under the Sea,* ed. Peter Costello (London: Everyman, 1996), 3. All following references to the novel will refer to this edition.

12. Alfred T. Story, "The Sea-Serpent," *The Strand Magazine* 10 (1895): 162.

13. Ibid.

14. Ibid., 163.

15. Ibid.

16. *Illustrated London News,* "Sea Serpent Sighting," Feb. 2, 1861.

17. Gosse, *Aquarium,* v.

18. George Henry Lewes, *Sea-Side Studies at Ilfracombe, Tenby, the Scilly Isles, and Jersey* (Edinburgh: William Blackwood, 1860), vi.

19. Merrill, *Victorian Natural History,* 96.

20. Peter Costello, introduction to Verne, *Twenty Thousand Leagues Under the Sea,* ed. Costello, xxii.

21. Ibid., xxiii.

22. Andrew Martin, *The Mask of the Prophet: The Extraordinary Fictions of Jules Verne* (Oxford, U.K.: Clarendon Press, 1990), 98.

23. David Forbes, "The Deep Sea," *Nature* (Nov. 25, 1869): 100.

24. Richard A. Proctor, "The German and Swedish Expeditions to the Arctic Regions," *Nature* (Jan. 20, 1870): 312.

25. Gosse, *Aquarium,* v.

26. Lewes, *Sea-Side Studies,* vi–vii.

27. Charles Kingsley, "How to Study Natural History," in *The Works of Charles Kingsley: Volume XIX: Scientific Lectures and Essays* (London: Macmillan, 1880), 302.

28. Barber, *Heyday*, 40.

29. Gosse, *Evenings at the Microscope*, iii.

30. Lewes, *Sea-Side Studies*, 15.

31. Merrill, *Victorian Natural History*, 112.

32. Roslynn D. Haynes, *From Faust to Strangelove: Representations of the Scientist in Western Literature* (Baltimore, Md.: Johns Hopkins Univ. Press, 1994), 131.

33. *Illustrated London News*, "Sea Serpent Sighting," Feb. 2, 1861.

34. See Barber, *Heyday*, 59.

35. Merrill, *Victorian Natural History*, 107.

36 Ibid., 36.

37. Barber, *Heyday*, 168.

38. Evans, *Jules Verne Rediscovered*, 43.

39. Peter Costello, *Jules Verne: Inventor of Science Fiction* (New York: Charles Scribner, 1978), 189.

40. Capitanio, "'L'Ici-bas' and 'l'Au-dela,'" 66.

41. Barber, *Heyday*, 21.

42 Angenot, "Jules Verne," 19–20.

43. Ibid., 25.

44. Ibid., 27.

45. Barber, *Heyday*, 168.

6. Villiers de L'Isle-Adam's Invention of Psychical Research

1. The version used for this chapter is Villiers de L'Isle-Adam, *Tomorrow's Eve*, trans. Robert Martin Adams (Champaign: Univ. of Illinois Press, 1982).

2. Clute and Nicholls, eds., *Encyclopedia of Science Fiction*, 1283.

3. Aldiss, *Billion Year Spree*, 128.

4. John Anzalone, "Timeless Tomes: Occult Libraries in Villiers' *Iris and Axel*," *L'Esprit Createur* 28:1 (1998): 87–88.

5. Jennifer Birkett, *The Sins of the Fathers: Decadence in France, 1870–1914* (London: Quartet, 1986), 3.

6. Murray Pittock, *Spectrum of Decadence: The Literature of the 1890s* (London: Routledge, 1993), 10.

7. Ibid.

8. John R. Reed, *Victorian Conventions* (Athens: Ohio Univ. Press, 1975), 472–73.

9. J. A. V. Chapple, *Science and Literature in the Nineteenth Century* (London: Macmillan, 1986), 151.

10. Stephen G. Brush, *The Temperature of History: Phases of Science and Culture in the Nineteenth Century* (New York: Burt Franklin, 1978), 87.

11. W. T. Conroy, *Villiers de L'Isle-Adam* (Boston: G. K. Hall, 1978), 114.

12. Carol de Dobay Rifelj, "The Machine-Humaine: Villiers' *L'Eve Future* and the Problem of Personal Identity (Robots and Criteria for Personhood)," *Nineteenth-Century French Studies* 20 (1992): 430.

13. Ronald W. Clark, *Edison: The Man Who Made the Future* (London: Macdonald and Jane's, 1977), 149.

14. Thomas P. Hughes, *Thomas Edison: Professional Inventor* (London: HMSO, 1976), 12–13.

15. Ibid., 30.

16. Clark, *Edison,* 65.

17. Hughes, *Thomas Edison,* 3.

18. Clark, *Edison,* 66.

19. Robert Martin Adams, intro., *Tomorrow's Eve,* by Villiers de L'Isle-Adam, xv.

20. "Report of the Physical Society," *Nature* 33 (1886): 552.

21. "Electrical Transmission of Energy," *Athenaeum* 3076 (1886): 471.

22. "Electricity and Clocks," *Nature* 35 (1886): 173.

23. See Anthony Hyman, *Charles Babbage: Pioneer of the Computer* (Oxford, U.K.: Oxford Univ. Press, 1982).

24. Janet Oppenheim, *The Other World: Spiritualism and Psychical Research in England, 1850–1914* (Cambridge, U.K.: Cambridge Univ. Press, 1985), 3–4.

25. W. H. Salter, *The Society for Psychical Research: An Outline of Its History* (London: Society for Psychical Research, n.d.), 13.

26. Oppenheim, *Other World,* chap. 1.

27. "Mrs. Sidgwick and the Mediums," *Science* 7 (1886): 555.

28. See Oppenheim, *Other World;* Milner, "Charles Darwin and Associates," 72–77.

29. Edwin Ray Lankester, letter to the editor, *Times,* Sept. 16, 1876.

30. "Mrs. Sidgwick and the Mediums," 75.

31. Ibid.

32. Milner, "Charles Darwin and Associates," 72.

33. Lankester, letter to the editor, *Times,* Sept. 16, 1876.

34. A. Lane Fox, letter to the editor, *Times,* Sept. 16, 1876.

35. Ibid.

36. Alfred Russell Wallace, letter to the editor, *Times,* Sept. 19, 1867.

37. Alan Gauld, *The Founders of Psychical Research* (London: Routledge and Kegan Paul, 1968), 303.

38. William James, "Principles of Psychology," in *William James on Psychical Research,* ed. Gardner Murphy and Robert D. Ballou (London: Chatto and Windus, 1961), 242–43.

39. Alison Winter, "The Construction of Orthodoxies and Heterodoxies in the Early Victorian Life Sciences," in *Victorian Science in Context,* ed. Bernard Lightman (Chicago: Univ. of Chicago Press, 1997), 24–25.

40. Ibid., 25.

7. H. G. Wells in the Laboratory

1. Peter Chalmers Mitchell, "Saturday Review, 11 April 1896," in *H. G. Wells: The Critical Heritage,* ed. Patrick Parrinder (London: Routledge and Kegan Paul, 1972), 45.

2. Ibid., 51, 52.

3. Bernard Bergonzi, *The Early H. G. Wells: A Study of the Scientific Romances* (Manchester, U.K.: Manchester Univ. Press, 1961), 111.

4. Patrick Parrinder, *Shadows of the Future: H. G. Wells, Science Fiction, and Prophecy* (Syracuse, N.Y.: Syracuse Univ. Press, 1995), 58.

5. Parrinder, *H. G. Wells*, 48.

6. Ibid., 50.

7. Ibid., 52.

8. Ibid., 47.

9. H. G. Wells, *The Time Machine* (London: J. M. Dent, 1988), 12–13.

10. Ibid., 103.

11. All quotes taken from Robert M. Philmus's scholarly edition, *The Island of Doctor Moreau: A Variorum Text* (Athens: Univ. of Georgia Press, 1993). All future page numbers that appear in the body of the text refer to this edition.

12. Alter, *Reluctant Patron*, 17.

13. Ibid., 221.

14. R. M. McLeod, "The Support of Victorian Science," in *Science and Society*, ed. Peter Mathias (Cambridge, U.K.: Cambridge Univ. Press, 1972), 171.

15. Egon Larsen, *The Cavendish Laboratory: Nursery of Genius* (London: Edmund Ward, 1962), 13.

16. I am indebted to Alter for this information.

17. See *A History of the Cavendish Laboratory, 1871–1910* (various unidentified editors) (London: Longmans, Green, 1910).

18. Ibid., 33.

19. McLeod, "Support of Victorian Science," 156.

20. Ibid., 179.

21. See Norman and Jeanne Mackenzie, *The Life of H. G. Wells: The Time Traveller* (London: Hogarth Press, 1987).

22. At the first meeting of the Steering Committee for the proposed development of the British Institute, a letter from Huxley to the Lord Mayor, defending vivisection, was read aloud. Archive of the Lister Institute for Preventive Medicine (SA/LIS) at the Wellcome Library for the History and Understanding of Medicine, C.1.

23. Archive, E.8.

24. Ibid.

25. Nicolaas Rupke, ed., *Vivisection in Historical Perspective* (London: Routledge, 1987), 188.

26. Mary Ann Elston, "Women and Anti-Vivisection in Victorian England, 1870–1900," in Rupke, *Vivisection in Historical Perspective*, 279.

27. Frances Power Cobbe, *An Institute of Preventive Medicine at Work in France* (London: Victoria Street Society, 1891), 3–5.

28. Archive, E.8

29. Nicolaas Rupke, "Pro-Vivisection in England in the Early 1880s," in Rupke, *Vivisection in Historical Perspective*, 198.

30. Rupke, "Pro-Vivisection," 193–94.

31. Archive, E.8.
32. Ibid.
33. Ibid.
34. Patrick Parrinder, "A Sense of Dethronement (*The Time Machine* and *The Island of Dr. Moreau*)," in Parrinder, *Shadows of The Future,* 57.
35. Archive, C.1.
36. Ibid.
37. Ibid.
38. Ibid.
39. Ibid., E.6.
40. Ibid., C.1.
41. Ibid., E.1.
42. Ibid., E.5.
43. Ibid.
44. Ibid.
45. Ibid.
46. Ibid., E.1.
47. Rupke, "Pro-Vivisection," 200.
48. Ibid., 202.
49. Ibid., 201.
50. Archive, E.5.
51. Ibid.
52. Ibid.
53. Ibid.
54. Ibid., E.6.

8. Conclusion:
The Progress of Literature and Science; or,
A Refrain on Interdisciplinarity

1. Paul Fayter, "Strange New Worlds of Space and Time: Late Victorian Science and Science Fiction," in Lightman, *Victorian Science in Context,* 257.
2. Ibid.
3. R. Brandon Kershner, "Mikhail Bakhtin and Bakhtinian Criticism," in *Introducing Literary Theories: A Guide and Glossary,* ed. Julian Wolfreys (Edinburgh: Edinburgh Univ. Press, 2001), 25.
4. Ibid.
5. Ibid., 26.

Bibliography

————— ◆•••◆ —————

BOOKS AND ARTICLES

Aldiss, Brian. *Billion Year Spree: The True History of Science Fiction*. London: Weidenfeld and Nicolson, 1973.

Allen, David Elliston. *The Naturalist in Britain: A Social History*. London: Penguin, 1976.

Allen, H. C., and C. P. Hill, eds. *British Essays in American History*. London: Edward Arnold, 1957.

Alter, Peter. *The Reluctant Patron: Science and the State in Britain, 1850–1920*, trans. Angela Davies. Oxford, U.K.: Berg, 1987.

Amis, Kingsley. *New Maps of Hell*. London: Four Square, 1963.

Angenot, Marc. "Jules Verne: The Last Happy Utopianist." In Parrinder, *Science Fiction*, 18–33.

Anzalone, John. "Timeless Tomes: Occult Libraries in Villiers' *Iris and Axel*." *L'Esprit Creatuer* 28:1 (1998): 87–94.

Ash, Brian. *Faces of the Future—The Lessons of Science Fiction*. London: Elek/Pemberton, 1975.

Ashton, Rosemary, ed. *Versatile Victorian: Selected Writings of George Henry Lewes*. London: Bristol Classical Press, 1992.

Bailey, J. O. *Pilgrims through Space and Time*. New York: Argus Books, 1947.

Bailly, Christian. *Automata: The Golden Age, 1848–1914*. London: Sotheby's, 1947.

Bainbridge, William Sims. *Dimensions of Science Fiction*. Cambridge, Mass.: Harvard Univ. Press, 1986.

Baldick, Chris. *In Frankenstein's Shadow: Myth, Monstrosity, and Nineteenth-Century Writing*. Oxford, U.K.: Clarendon Press, 1987.

Bakhtin, Mikhail. *The Dialogic Imagination: Four Essays*. Austin: Univ. of Texas Press, 1981.
———. *Rabelais and His World*. Bloomington: Indiana Univ. Press, 1984.
Barber, Lynn. *The Heyday of Natural History: 1820–1870*. London: Jonathan Cape, 1980.
Barrell, John, Jacqueline Rose, Peter Stallybrass, and Jennifer White. *Carnival, Hysteria, and Writing: Collected Essays and an Autobiography*. Oxford, U.K.: Oxford Univ. Press, 1994.
Bayer-Berenbaum, Linda. *The Gothic Imagination: Expansion in Gothic Literature and Art*. London: Associated Presses, 1982.
Beaver, Harold, ed. *The Science Fiction of Edgar Allan Poe*. London: Penguin, 1976.
Beddoes, Thomas, "Rational Toys." In Jennings, *Pandaemonium*, 125–27.
Beer, Gillian. *Darwin's Plots: Evolutionary Narrative in Darwin, George Eliot, and Nineteenth-Century Fiction*. London: Routledge and Kegan Paul, 1983, rev. 2000.
———. *Forging The Missing Link: Interdisciplinary Stories*. Cambridge, U.K.: Cambridge Univ. Press, 1992.
———. *Open Fields: Science in Cultural Encounter*. Oxford, U.K.: Oxford Univ. Press, 1996.
Bennett, John Hughes. *The Mesmeric Mania of 1851, with a physiological explanation of the phenomena produced*. Edinburgh: Sutherland and Knox, 1851.
Bergonzi, Bernard. *The Early H. G. Wells: A Study of the Scientific Romances*. Manchester, U.K.: Manchester Univ. Press, 1961.
Birkett, Jennifer. *The Sins of the Fathers: Decadence in France, 1870–1914*. London: Quartet, 1986.
Birkhead, Edith. *The Tale of Terror: A Study of the Gothic Romance*. London: Constable, 1921.
Bleiler, E. F., ed. *The Best Tales of Hoffmann*. London: Dover, 1967.
Blish, James. "On Science Fiction Criticism." In Clareson, *Other Side of Realism*, 166–70.
Bloom, Harold, ed. *Mary Shelley*. New York: Chelsea House, 1985.
Brewster, D., ed. *Edinburgh Encyclopedia*. Edinburgh: Blackwoods, 1830.
Bronowski, Jacob. *Magic, Science, and Civilization*. New York: Columbia Univ. Press, 1978.
Brush, Stephen G. *The Temperature of History: Phases of Science and Culture in the Nineteenth Century*. New York: Burt Franklin, 1978.
Buchanan, R. A. *The Power of the Machine: The Impact of Technology from 1700 to the Present*. London: Viking, 1992.
Bulwer-Lytton, Edward. *The Coming Race*. Santa Barbara, Calif.: Woodbridge Press, 1979.
Buranelli, Vincent. *The Wizard from Vienna: Franz Anton Mesmer*. London: Peter Owen, 1976.
Bush, George. *Mesmer and Swedenborg; or, The Relation of the Development of Mesmerism to the Doctrines and Disclosures of Swedenborg*. New York: John Allen, 1847.

Butler, Marilyn. *Romantics, Rebels, and Reactionaries: English Literature and Its Background, 1760–1830*. Oxford, U.K.: Oxford Univ. Press, 1981.

Bynum, W. F., E. J. Browne, and Roy Porter, eds. *Dictionary of the History of Science*. London: Macmillan, 1981.

Cannon, Susan Faye. *Science in Culture: The Early Victorian Period*. New York: Dawson, 1978.

Capern, Thomas. *Pain of Body and Mind Relieved by Mesmerism: A Record of Mesmeric Facts*. London: Mr. Bailliere, 1861.

Capitanio, Sarah, "'L'Ici-bas' and 'l'Au-dela' . . . but Not as they Knew it. Realism, Utopianism, and Science Fiction in the Novels of Jules Verne." In Smyth, *Jules Verne*, 60–77.

Cardwell, D. S. L. *The Organisation of Science in England*. London: Heinemann, 1972.

Carlyle, Thomas. "Signs of the Times." *Edinburgh Review* 49 (1829): 439–59.

Chapple, J. A. V. *Science and Literature in the Nineteenth Century*. London: Macmillan, 1986.

Christie, John, and Sally Shuttleworth, eds. *Nature Transfigured: Science and Literature, 1700–1900*. Manchester, U.K.: Manchester Univ. Press, 1989.

Clareson, Thomas D. *Some Kind of Paradise: The Emergence of American Science Fiction*. Westport, Conn.: Greenwood Press, 1985.

———, ed. *SF: The Other Side of Realism. Essays on Modern Fantasy and Science Fiction*. Bowling Green, Ohio: Bowling Green Univ. Popular Press, 1971.

Clark, Ronald W. *Edison: The Man Who Made the Future*. London: Macdonald and Jane's, 1977.

Clute, John, and Peter Nicholls, eds. *The Encyclopedia of Science Fiction*. London: Orbit, 1993.

Cobbe, Frances Power. *An Institute of Preventive Medicine at Work in France*. London: Victoria Street Society, 1891.

Cohen, John. *Human Robots in Myth and Science*. London: Allen and Unwin, 1966.

Conroy, W. T. *Villiers de L'Isle-Adam*. Boston: G. K. Hall, 1978.

Cooter, Roger. *The Cultural Meaning of Popular Science: Phrenology and the Organisation of Consent in Nineteenth-Century Britain*. Cambridge, U.K.: Cambridge Univ. Press, 1984.

Coslett, Tess. *The "Scientific Movement" and Victorian Literature*. Sussex, U.K.: Harvester Press, 1982.

Costello, Peter. *Jules Verne: Inventor of Science Fiction*. New York: Charles Scribner, 1978.

Cunningham, Andrew, and Nicholas Jardine, eds. *Romanticism and the Sciences*. Cambridge, U.K.: Cambridge Univ. Press, 1990.

Dale, Peter Allan. *In Pursuit of a Scientific Culture: Science, Art, and Society in the Victorian Age*. Madison: Univ. of Wisconsin Press, 1989.

Daniels, George H. *American Science in the Age of Jackson*. New York: Columbia Univ. Press, 1969.

———. *Science in American Society: A Social History*. New York: Alfred A. Knopf, 1971.

Darwin, Charles. *On The Origin of Species*. Ed. Ernst Mayr. Cambridge, Mass.: Harvard Univ. Press, 1964.

Darwin, Erasmus. *The Botanic Garden, 1791*. Menston, U.K.: Scolar Press, 1973.

———. *The Loves of the Plants*. Oxford, U.K.: Woodstock Books, 1991.

———. *The Temple of Nature*. Menston, U.K.: Scolar Press, 1973.

Davidson, Edward H. *Poe: A Critical Study*. Cambridge, U.K.: Belknap Press, 1957.

Dickens, Charles. *Dombey and Son*. London: Penguin, 1985.

Dunn, Thomas P., and Richard D. Erlich, eds. *The Mechanical God: Machines in Science Fiction*. Westport, Conn.: Greenwood Press, 1982.

Edwards, William. *Mesmerism: Its Practice and Phenomena*. Melbourne, Australia: John Hunter, 1850.

"Electrical Transmission of Energy." *Athenaeum* 3076 (1886): 471.

"Electricity and Clocks." *Nature* 35 (1886): 173.

Elston, Mary Ann. "Women and Anti-Vivisection in Victorian England, 1870–1900." In Rupke, *Vivisection in Historical Perspective*, 259–294.

Evans, Arthur B. *Jules Verne Rediscovered: Didacticism and the Scientific Novel*. Westport, Conn.: Greenwood Press, 1988.

Falk, Doris V. "Poe and the Power of Animal Magnetism." *PMLA* 84 (1969): 536–46.

Fayter, Paul. "Strange New Worlds of Space and Time: Late Victorian Science and Science Fiction." In Lightman, *Victorian Science in Context*, 256–80.

Florescu, Radu. *In Search of Frankenstein*. London: New English Library, 1977.

Forbes, David. "The Deep Sea." *Nature* (Nov. 25, 1869): 100–107.

Foucault, Michel. *The Archaeology of Knowledge*. London: Routledge, 1989.

———. *The Birth of the Clinic: An Archaeology of Medical Perception*. London: Tavistock, 1973.

———. *Discipline and Punish: The Birth of the Prison*. London: Penguin, 1991.

———. *The History of Sexuality*. London: Allen Lane, 1979.

Fox, A. Lane. Letter to the editor in the *Times*, London. Sept. 16, 1876.

Franklin, H. Bruce. *Future Perfect: American Science Fiction of the Nineteenth Century—An Anthology*. Piscataway, N.J.: Rutgers Univ. Press, 1995.

———. "The Science Fiction of Medicine." In Westfahl and Slusser, *No Cure for the Future*, 9–22.

Garnett, Rhys, and R. J. Ellis, eds. *Science Fiction Roots and Branches: Contemporary Critical Approaches*. London: Macmillan, 1990.

Gates, Barbara T. "Literature and Science." *Victorian Literature and Culture* 26:2 (1998): 485–88.

Gauld, Alan. *The Founders of Psychical Research*. London: Routledge and Kegan Paul, 1968.

The General Machinist. London: Ward Lock, 1891.

Gillispie, Charles Coulston, ed. *Dictionary of Scientific Biography*. New York: Scribners, 1971–1980, 16 vols.

Gilmour, Robin. *The Victorian Period: The Intellectual and Cultural Context of English Literature, 1830–1890*. London: Longman, 1993.

Godwin, William. *St. Leon: A Tale of the Sixteenth Century.* London: Henry Colburn and Richard Bentley, 1831.

Golby, J. M., ed. *Culture and Society in Britain, 1850–1890.* Oxford, U.K.: Oxford Univ. Press, 1990.

Gooding, David. *Experiment and the Making of Meaning: Human Agency in Scientific Observation and Experiment.* London: Klumer Academic Publishers, 1990.

Gosse, Philip. *The Aquarium: An Unveiling of the Wonders of the Deep Sea.* London: John Van Voorst, 1856.

———. *Evenings at the Microscope; or, Researches among the Minuter Organs and Forms of Animal Life.* London: SPCK, 1877.

———. *A Manual of Marine Zoology for the British Isles.* London: John Van Voorst, 1855.

Gunn, James, ed. *The Road to Science Fiction No. 1: From Gilgamesh to Wells.* New York: Mentor Books, 1977.

Hacking, Ian, ed. *Scientific Revolutions.* Oxford, U.K.: Oxford Univ. Press, 1992.

Harrison, James, ed. *The Complete Works of Edgar Allan Poe.* New York: AMS Press, 1965.

Haynes, Roslynn D. *From Faust to Strangelove: Representations of the Scientist in Western Literature.* Baltimore, Md.: Johns Hopkins Univ. Press, 1994.

———. *H. G. Wells, Discoverer of the Future: The Influence of Science on His Thought.* London: Macmillan, 1981.

Hindle, Maurice. "Vital Matters: Mary Shelley's *Frankenstein* and Romantic Science." *Critical Survey* 2:1 (1990): 29–35.

A History of the Cavendish Laboratory, 1871–1910. London: Longmans, Green, 1910.

Hughes, Thomas P. *Thomas Edison: Professional Inventor.* London: HMSO, 1976.

Huxley, T. H. "The Deep-Sea Soundings and Geology." *Nature* (Apr. 28, 1870): 657–58.

———. "On the Hypothesis that Animals Are Automata, and Its History." In *Collected Essays Volume One: Method and Results,* ed. Huxley, 199–250. London: Macmillan, 1893.

Hyman, Anthony. *Charles Babbage: Pioneer of the Computer.* Oxford, U.K.: Oxford Univ. Press, 1982.

Illustrated London News. "Sea Serpent Sighting." Feb. 2, 1861.

Jennings, Humphrey, ed. *Pandaemonium: The Coming of the Machine as Seen by Contemporary Observers, 1660–1886.* London: Macmillan, 1995.

Keats, John. *Lamia 1820.* Oxford, U.K.: Woodstock Books, 1990.

Kershner, R. Brandon. "Mikhail Bakhtin and Bakhtinian Criticism." In *Introducing Literary Theories: A Guide and Glossary,* ed. Julian Wolfreys, 19–32. Edinburgh: Edinburgh Univ. Press, 2001.

Ketterer, David. *Frankenstein's Creation: The Book, the Monster, and Human Reality.* Victoria, Australia: Univ. of Victoria, 1979.

Kiely, Robert. "Frankenstein." In Bloom, *Mary Shelley,* 65–80.

Kingsley, Charles. "How to Study Natural History. In *The Works of Charles Kingsley: Volume XIX: Scientific Lectures and Essays*. London: Macmillan, 1880.

Kuhn, Thomas. *The Structure of Scientific Revolutions*. Chicago: Univ. of Chicago Press, 1970.

Lambourne, Robert, Michael Shallis, and Michael Shortland. *Close Encounters? Science and Science Fiction*. Bristol, U.K.: Adam Hilger, 1990.

Lankester, Edwin Ray. Letter to the editor in the *Times*, London. Sept. 16, 1876.

Larsen, Egon. *The Cavendish Laboratory: Nursery of Genius*. London: Edmund Ward, 1962.

Lathers, Marie. *The Aesthetics of Artifice: Villiers's "L'Eve Future."* Chapel Hill: Univ. of North Carolina Press, 1996.

Levine, George. *Darwin and the Novelists: Patterns of Science in Victorian Fiction*. Cambridge, Mass.: Harvard Univ. Press, 1988.

———, ed. *One Culture*. Madison: Univ. of Wisconsin Press, 1987.

Lewes, George Henry. *Sea-Side Studies at Ilfracombe, Tenby, the Scilly Isles, and Jersey*. Edinburgh: William Blackwood, 1860.

Lewis, Matthew. *The Monk*. Oxford, U.K.: Oxford Univ. Press, 1980.

Lightman, Bernard, ed. *Victorian Science in Context*. Chicago: Chicago Univ. Press, 1997.

Limon, John. *The Place of Fiction in the Time of Science: A Disciplinary History of American Writing*. Cambridge, U.K.: Cambridge Univ. Press, 1990.

Lind, Sidney E. "Poe and Mesmerism." *PMLA* 62 (1947): 1077–94.

"Machinery: A Dialogue." *Chambers Edinburgh Journal* 399 (1839): 6.

Mackenzie, Norman, and Jeanne Mackenzie. *The Life of H. G. Wells: The Time Traveller*. London: Hogarth Press, 1987.

Malik, Rex, ed. *Future Imperfect: Science Fact and Science Fiction*. London: Francis Pinter, 1980.

Manlove, Colin. *Science Fiction: Ten Explorations*. London: Macmillan, 1986.

Martin, Andrew. *The Mask of the Prophet: The Extraordinary Fictions of Jules Verne*. Oxford, U.K.: Clarendon Press, 1990.

Martineau, Harriet. *Letters on Mesmerism*. London: Edward Moxon, 1845.

Marx, Leo. *The Machine in the Garden: Technology and the Pastoral Ideal in America*. New York: Oxford Univ. Press, 1964.

Mathias, Peter, ed. *Science and Society*. Cambridge, U.K.: Cambridge Univ. Press, 1972.

Mauskopf, Seymour H., and Michael R. McVaugh. *The Elusive Science: Origins of Experimental Psychical Research*. Baltimore, Md.: Johns Hopkins Univ. Press, 1980.

Mayr, Otto. *Authority, Liberty, and Automatic Machinery in Early Modern Europe*. Baltimore, Md.: Johns Hopkins Univ. Press, 1986.

McConnell, Frank. *The Science Fiction of H. G. Wells*. Oxford, U.K.: Oxford Univ. Press, 1981.

McGraw-Hill Encyclopedia of Science. 15 vols. New York: McGraw-Hill, 1987.

McLeod, R. M. "The Support of Victorian Science." In Mathias, *Science and Society*, 150–82.

Mead, Joan Tyler. "Poe's 'The Man That Was Used Up': Another Bugaboo Campaign." *Studies in Short Fiction* 23:3 (1986): 281–86.

Mellor, Anne K. *"Frankenstein:* A Feminist Critique of Science." In *One Culture,* ed. George Levine, 287–312. Madison: Univ. of Wisconsin Press, 1987.

Mendlesohn, Farah. "Science Fiction in the Academies of History and Literature; or, History and the Use of Science Fiction." In Westfahl and Slusser, *Science Fiction, Canonization, Marginalization, and the Academy,* 119–25.

Merril, Judith. "What Do You Mean: Science? Fiction?" In Clareson, *Other Side of Realism,* 53–95.

Merrill, Lynn L. *The Romance of Victorian Natural History.* Oxford, U.K.: Oxford Univ. Press, 1989.

Milner, Richard. "Charles Darwin and Associates, Ghostbusters." *Scientific American* (Oct. 1996): 72–77.

Mitchell, Peter Chalmers. "Saturday Review, 11 April 1896." In Parrinder, *H. G. Wells,* 45–52.

Mitchell, Sally, ed. *Victorian Britain.* London: Garland, 1988.

Moran, Joe. *Interdisciplinarity.* London: Routledge, 2002.

Morgan, Nina. *Thomas Edison.* Hove, U.K.: Wayland, 1991.

"Mrs. Sidgwick and the Mediums." *Science* 7 (1886): 554–55.

Murphy, Gardner, and Robert D. Ballou, eds. *William James on Psychical Research.* London: Chatto and Windus, 1961.

Oppenheim, Janet. *The Other World: Spiritualism and Psychical Research in England, 1850–1914.* Cambridge, U.K.: Cambridge Univ. Press, 1985.

Paradis, James, and Thomas Postlethwaite, eds. *Victorian Science and Victorian Values: Literary Perspectives.* New York: New York Academy of Sciences Press, 1981.

Parrinder, Patrick. "Science Fiction and the Scientific World View." In Parrinder, *Science Fiction,* 67–88.

———. "A Sense of Dethronement *(The Time Machine* and *The Island of Dr. Moreau).* In Parrinder, Shadows of the Future, 57.

———, ed. *H. G. Wells: The Critical Heritage.* London: Routledge and Kegan Paul, 1972.

———, ed. *Science Fiction: A Critical Guide.* London: Longman, 1979.

———, ed. *Shadows of the Future: H. G. Wells, Science Fiction, and Prophecy.* Syracuse, N.Y.: Syracuse Univ. Press, 1995.

Peckham, Morse. *Romanticism: The Culture of the Nineteenth Century.* New York: George Braziller, 1965.

Philmus, Robert M. *Into the Unknown: The Evolution of Science Fiction from Francis Godwin to H. G. Wells.* Los Angeles: Univ. of California Press, 1970.

———, ed. *The Island of Doctor Moreau: A Variorum Text.* Athens: Univ. of Georgia Press, 1993.

Pick, Daniel. *Svengali's Web: The Alien Enchanter in Modern Culture.* New Haven, Conn.: Yale Univ. Press, 2000.

Pierce, John J. *Foundations of Science Fiction: A Study in Imagination and Evolution.* Westport, Conn.: Greenwood Press, 1987.

———. *Great Themes of Science Fiction: A Study of Imagination and Evolution.* Westport, Conn.: Greenwood Press, 1987.

Pittock, Murray. *Spectrum of Decadence: The Literature of the 1890s.* London: Routledge, 1993.

Poe, Edgar Allan. "Maelzel's Chess-Player." In Harrison, *The Collected Works of Edgar Allan Poe,* 6–37.

———. "The Man That Was Used Up." In Harrison, *The Complete Works of Edgar Allan Poe,* 259–72.

Potter, J. "Industrial America." In Allen and Hill, *British Essays in American History,* 274–96.

Proctor, Richard A. "The German and Swedish Expeditions to the Arctic Regions." *Nature* (Jan. 20, 1870): 312.

Quinn, A. H. *Edgar Allan Poe: A Critical Biography.* London: Century, 1942.

Rabkin, Eric S. *The Fantastic in Literature.* Princeton, N.J.: Princeton Univ. Press, 1976.

Radcliffe, Anne. *The Mysteries of Udolpho.* Oxford, U.K.: Oxford Univ. Press, 1980.

Randolph, Paschal Beverly. *Seership! The Magnetic Mirror.* Boston: Randolph, 1870.

Read, John. *The Alchemist in Life, Literature, and Art.* London: Thomas Nelson, 1947.

Reed, John R. *Victorian Conventions.* Athens: Ohio Univ. Press, 1975.

"Report of the Physical Society." *Nature* 33 (1886): 552.

Rieger, James E., ed. *Frankenstein; or, The Modern Prometheus,* 1818 edition. Chicago: Chicago Univ. Press, 1982.

Rifelj, Carol de Dobay. "The Machine-Humaine: Villiers' *L'Eve Future* and the Problem of Personal Identity (Robots and Criteria for Personhood)." *Nineteenth-Century French Studies* 20 (1992): 430–51.

Ritterbush, Philip C. *Overtures to Biology: The Speculations of Eighteenth-Century Naturalists.* New Haven, Conn.: Yale Univ. Press, 1964.

Rose, Mark. *Alien Encounters: Anatomy of Science Fiction.* Cambridge, Mass.: Harvard Univ. Press, 1981.

———, ed. *Science Fiction: A Collection of Critical Essays.* Englewood Cliffs, N.J.: Prentice-Hall, 1976.

Rosen, George. "Romantic Medicine: A Problem in Historical Periodization." *The Bulletin of the History of Medicine* 25:2 (1951): 149–58.

Rothfield, Lawrence. *Vital Signs: Medical Realism in Nineteenth-Century Fiction.* Princeton, N.J.: Princeton Univ. Press, 1992.

Rousseau, G. S. "Science." In *The Eighteenth Century,* ed. Pat Rogers, 153–207. London: Methuen, 1978.

Ruddick, Nicholas. *British Science Fiction: A Chronology, 1478–1900.* Westport, Conn.: Greenwood Press, 1992.

Rupke, Nicolaas. "Pro-Vivisection in England in the Early 1880s." In Rupke, *Vivisection in Historical Perspective,* 188–208.

———, ed. *Vivisection in Historical Perspective.* London: Routledge, 1987.

Ruskin, John. "The Opening of the Crystal Palace Considered in Some of Its Relations to the Prospects of Art." In Golby, *Culture and Society,* 174–77.

Salter, W. H. *The Society for Psychical Research: An Outline of Its History.* London: Society for Psychical Research, n.d.

Sayer, Karen, and John Moore, eds. *Science Fiction, Critical Frontiers.* London: Macmillan, 2000.

Schaffer, Simon. "Babbage's Dancer and the Impresarios of Mechanism." In *Cultural Babbage,* ed. Francis Spufford and Jenny Uglow, 53–80. London: Faber, 1996.

Scholes, Robert. *Structural Fabulation: An Essay on Fiction of the Future.* Notre Dame, Ind.: Univ. of Notre Dame Press, 1975.

———, and Eric Rabkin. *Science Fiction: History, Science, Vision.* New York: Oxford Univ. Press, 1977.

Scott, Sir Walter. "Remarks on *Frankenstein; or, The Modern Prometheus.*" *Blackwood's Edinburgh Magazine* 2:12 (1818): 613–20.

Seed, David, ed. *Anticipations: Essays on Early Science Fiction and Its Precursors.* Liverpool, U.K.: Liverpool Univ. Press, 1995.

Seligo, Carlos. "The Monsters of Botany and Mary Shelley's *Frankenstein.*" In Sayer and Moore, *Science Fiction, Critical Frontiers,* 69–84.

Shelley, Mary. *Frankenstein; or, The Modern Prometheus.* Ed. Maurice Hindle. London: Penguin, 1992.

Shuttleworth, Sally. *George Eliot and Nineteenth-Century Science: The Make-Believe of a Beginning.* Cambridge, U.K.: Cambridge Univ. Press, 1984.

Singer, Charles Joseph. *From Magic to Science: Essays on the Scientific Twilight.* New York: Boni and Liveright, 1928.

Slusser, George E., and Eric S. Rabkin. *Hard Science Fiction.* Carbondale: Southern Illinois Univ. Press, 1986.

Smith, Jonathan. *Fact and Feeling: Baconian Science and the Nineteenth-Century Literary Imagination.* Madison: Univ. of Wisconsin Press, 1994.

Smyth, Edmund. "Verne, SF, and Modernity: An Introduction." In Smyth, *Jules Verne,* 1–10.

———, ed. *Jules Verne: Narratives of Modernity.* Liverpool, U.K.: Liverpool Univ. Press, 2000.

Snow, C. P. *The Two Cultures and the Scientific Revolution: The Rede Lecture, 1959.* Cambridge, U.K.: Cambridge Univ. Press, 1962.

Spark, Muriel. "Frankenstein." In Bloom, *Mary Shelley,* 11–30.

Stockwell, Peter. *The Poetics of Science Fiction.* Harlow, U.K.: Pearson Education, 2000.

Stone, William L. *Letter to Dr. A. Brigham on Animal Magnetism.* New York: George Dearborn, 1837.

Story, Alfred T. "The Sea-Serpent." *Strand Magazine* 10 (1895): 161–71.

Sussmann, Herbert. "Victorian Science Fiction." *Science Fiction Studies* 11 (1983): 324–28.

Suvin, Darko. *Metamorphoses of Science Fiction: On the Poetics and History of a Literary Genre.* New Haven, Conn.: Yale Univ. Press, 1979.

Tatar, Maria. *Spellbound: Studies on Mesmerism and Literature*. Princeton, N.J.: Princeton Univ. Press, 1978.

Taylor, Jenny Bourne. *In The Secret Theatre of Home: Wilkie Collins, Sensation Narrative, and Nineteenth-Century Psychology*. London: Routledge, 1988.

Times, London. "Dreadful Accident to Mr. Huskisson." Sept. 17, 1830.

———. "A Spirit-Medium." Sept. 16, 1876.

Unwin, Timothy. "The Fiction of Science, or the Science of Fiction." In Smyth, *Jules Verne*, 46–59.

Ure, Andrew. "The Philosophy of Manufactures." In Jennings, *Pandaemonium*, 192–93.

Vasbinder, Samuel Holmes. *Scientific Attitudes in Mary Shelley's Frankenstein*. Ann Arbor, Mich.: UMI Research Press, 1984.

Verne, Jules. *Twenty Thousand Leagues Under the Sea*. Ed. Peter Costello. London: Everyman, 1996.

Vice, Sue. *Introducing Bakhtin*. Manchester, U.K.: Manchester Univ. Press, 1997.

Villiers de L'Isle-Adam. *Tomorrow's Eve*. Trans. Robert Martin Adams. Champaign: Univ. of Illinois Press, 1982.

Walker, I. M., ed. *Edgar Allan Poe: The Critical Heritage*. London: Routledge and Kegan Paul, 1986.

Wallace, Alfred Russell. Letter to the editor in the *Times*, London. Sept. 16, 1867.

Walpole, Horace. *The Castle of Otranto in Three Gothic Novels*. Ed. Peter Fairclough. London: Penguin, 1986.

Webster, Charles. *From Paracelsus To Newton: Magic and the Making of Modern Science*. Cambridge, U.K.: Cambridge Univ. Press, 1982.

Wells, H. G. *The Time Machine*. London: J. M. Dent, 1988.

———. *The War of the Worlds*. London: Everyman, 1993.

Westfahl, Gary. *Cosmic Engineers: A Study of Hard Science Fiction*. Westport, Conn.: Greenwood Press, 1996.

———. *Science Fiction, Canonization, Marginalization and the Academy*. Westport, Conn.: Greenwood Press, 2002.

———, and George Slusser, eds. *No Cure for the Future: Disease and Medicine in Science Fiction and Fantasy*. Westport, Conn.: Greenwood Press, 2002.

Wetzels, Walter D. "Aspects of Natural Science in German Romanticism." *Studies in Romanticism* 10:1 (1971): 44–59.

Whittaker, E. T. *A History of the Theories of Aether and Electricity: From the Age of Descartes to the Close of the Nineteenth Century*. London: Longmans, 1910.

Willis, Martin. "E. T. A. Hoffmann's 'Automata' and the Munich Séances of Johann Wilhelm Ritter." *Germanic Notes and Reviews* 28:2 (1997): 119–21.

———. "Frankenstein and the Soul." *Essays in Criticism* 45:1 (1995): 24–35.

———. "Introduction." *Victorian Review* 26:1 (2000): 1–5.

———. "Scientific Portraits in Magical Frames: The Construction of Preternatural Narrative in the Works of E. T. A. Hoffmann and Arthur Machen." *Extrapolation* 35:3 (1994): 186–200.

Winter, Alison. "The Construction of Orthodoxies and Heterodoxies in the Early Victorian Life Sciences." In Lightman, *Victorian Science in Context*, 24–50.

——. *Mesmerized: Powers of Mind in Victorian Britain.* Chicago: Chicago Univ. Press, 1998.

Wolfe, Gary K. *Critical Terms for Science Fiction and Fantasy: A Glossary and Guide to Scholarship.* Westport, Conn.: Greenwood Press, 1986.

——. *The Known and the Unknown: The Iconography of Science Fiction.* Kent, Ohio: Kent State Univ. Press, 1979.

ARCHIVAL MATERIAL

An Essay, &c. (An Attempt to find a general principle to connect the outlines of the various branches of the science of nature, and to trace an uniform, and consistent, and intelligible explanation of the whole). Science Collection, Univ. of Edinburgh Manuscripts, Ref. O.S. 537 ESS.

Archive of the Lister Institute for Preventive Medicine (SA/LIS). Wellcome Library for the History and Understanding of Medicine.

Index

British Institute of Preventive Medicine, 9; opposition to, 213, 216, 223–24, 229, 231–34; struggle over new Chelsea laboratory, 224–27, 229–30
Brush, Stephen G., 172
Bryan, Benjamin, 229
Buranelli, Vincent, 49, 60
Bush, George, 129
Byron, Lord, 92, 106–7

Campetti, Francesco, 38–39
Capern, Thomas, 96, 120, 123
capitalism: influence on Verne, 165–66; knowledge as commodity in, 137, 164–67; usefulness of science and, 164–65
Capitanio, Sarah, 140–41, 163
Carlyle, Thomas, 35, 99
Carpenter, William, 217
Carter-Blake, C., 190
Cavendish Laboratory, 210–11, 229–30
Chamber's Edinburgh Journal, 99
Chapple, J. A. V., 172
clairvoyance, 116. See also psychic ability
Clareson, Thomas D., 12–14, 17
Clark, Ronald W., 176–77
Clarke, Arthur C., 15
class, social, 6, 226–27
Clute, John, 139, 170
Cobbe, Frances Power, 217
Cohen, John, 53
"The Colloquy of Monos and Una" (Poe), 98
Conroy, W. T., 176
"The Conversation of Eiros and Charmion" (Poe), 98
Cosmic Engineers: A Study of Hard Science Fiction (Westfahl), 16–17
Costello, Peter, 149, 163
A Critical Study of Animal Magnetism (Deleuze), 46
Crookes, William, 197–198
Cruelty to Animals Act (Britain), 216–18
culture: attitude toward electricity in, 83, 177; critiques of, 171, 183; debate over vivisection in, 204–5, 213–23, 226–29, 231–32; fascination with deep-sea investigations in, 151–52; impact of machines in, 95, 100, 103–5, 109–12; influences on science, 21, 236; interest in mesmerism in, 113–14, 117–18; of

laboratory science, 205–7, 210–13; machines in, 98–99, 107; natural history in, 134–39, 147–48, 162–64; obsession with unknown creatures in, 144–46; returning supernatural in, 172; science as phenomenon of, 16–17, 21, 24; science vs. spiritualism in, 188–93; science's position in, 27, 51, 201; spiritualism and psychic ability in, 186–93. See also scientific culture
cyborgs. See Androids

Daniels, George, 117–18
Darwin, Charles, 7, 22–23, 190
Darwin, Erasmus, 72, 92
Darwinism/evolution, 203–4
Davidson, Edward H., 106
Davy, Humphry, 71, 87–88
death, mesmerism suspending, 120
"The Deep-Sea Soundings and Geology" (Huxley), 133–37
Deleuze, J. P. F., 46
"A Descent into the Maelstrom" (Poe), 97
Devonshire Commission, 210–12
"The Diamond Lens" (O'Brien), 57
Dickens, Charles, 102–4
Dombey and Son (Dickens), 102–4
Donkin, Horatio, 189
dualism, 80, 129
Duffield, Alexander, 190

The Early H. G. Wells (Bergonzi), 203
Edinburgh Encyclopedia, 31–34
Edison, Thomas A., 181, 200; fictionalized in Tomorrow's Eve, 174–76, 183–85, 195; real vs. fictional, 174–78; showmanship of, 176–79
Edwards, William, 126–27
electricity, 126; Edison's showmanship with, 176–79; in Frankenstein, 63–64, 76; gothic and scientific blended in, 67–68; invisibility of power of, 181–82; powering machines, 180–81, 183–85; psychic ability vs., 185–86; public debate over, 65, 70–74; Romanticism on, 83, 85, 88, 91; scientific debate over, 68–72; in Tomorrow's Eve, 170, 179–85, 197
Eliot, George, 3, 22
Elliotson, John, 6, 45, 96, 114–15
Elston, Mary Ann, 216
Encyclopedia of Science Fiction (Clute), 139

realism: science fiction and, 12–13; Verne's
use of, 140–42
Reed, John R., 172
Rieger, James, 65
Rifelj, Carol de Dobay, 176
Ritter, Johann Wilhelm, 38–39
Ritterbush, Philip C., 69
Romanticism, 89, 155; on cosmic harmony,
80–81; decline of, 106–7; on electric-
ity, 67–68, 70–74, 83, 85, 88, 91; in
Frankenstein, 68, 81–82, 84–85, 87–91;
of Hoffmann, 30, 62; materialism and,
84–85, 87–88, 106–8; science and, 64,
76–77, 87, 106; of Shelley, 62–63; of
symbolists, 171–72; of Verne, 142; of
Villiers de L'Isle-Adam, 171, 173. *See
also* science, Romantic
Roscoe, Henry, 225
Rose, Mark, 14, 18
Rothfield, Lawrence, 23
Ruffer, Armand, 225
Rupke, Nicolaas, 215, 227
Ruskin, John, 99–100

"The Sandman" (Hoffmann), 29, 108;
androids in, 54–59; defining science
and, 35–36; magic and science in, 30,
34, 36–37, 52–54; mesmerism in, 54–55,
57–60; power of vision in, 52–57
Schelling, Friedrich, 35, 39, 71, 89
Scholes, Robert, 13, 15–16
science: alternative practices in, 34–35, 53,
173, 185–86; amateur and professional,
6, 161–64, 167, 208–12; amateur *vs.*
professional, 4, 8, 136, 139, 153–55, 159,
167, 222–25; applied (*See* technology);
art and, 142, 148; boundaries of, 11,
128, 141; characteristics of nineteenth-
century, 4–11, 40; conflicts within, 67,
92–93, 165–66, 170; critiques of, 63, 98,
108, 173, 233; as cultural phenomenon,
16–17, 21, 24; cultural position of, 51,
128, 201; culture of (*See* Scientific cul-
ture); debate over electricity in, 67–72;
debate over vivisection in, 204–5,
213–23, 226–29, 231–32; definitions
of, 15–16, 25, 35, 61; dissemination of
knowledge from, 8–9, 92–93, 236; eco-
nomic usefulness of, 164–65; education
in, 82, 85–86; as elitist, 9, 167, 211; expe-

ditions for, 151–52; field *vs.* laboratories
in, 135–37, 150–51, 153–55, 159–63; fraud
and, 97, 131–33; funding for, 9, 208–11,
227; German Romantic, 71–72; gothic's
relation to, 66–67; heterodox *vs.*
orthodox, 4, 7, 51, 178–79, 195, 198–99,
239–40; human relation to, 96–97;
humans *vs.*, 128–31; imagination and,
7–8, 144; impact of, 97–98, 114, 116,
120–22; importance in science fiction,
12, 14–18; interdisciplinary research
with literature, 19–26; laboratories in,
202–3, 205–6, 209–13, 229–31; language
of, 141, 146–47, 238; literature and, 1–3,
25, 203–4; magic and, 10, 42, 46, 51–52;
magic *vs.*, 29–31, 34, 36; materialism
(*See* Materialism, scientific); natural
history *vs.*, 139, 146–48; new, 5–6, 64,
84–85; occult and, 52, 74, 82, 86–87;
philosophy and, 35, 106; power of, 94,
201, 227–28, 232–33; professionaliza-
tion of, 8–10, 117–18, 173–74, 209–13,
216; psychic research and, 170, 187–93,
195–198; public fear of, 216, 237; public
interest in, 5–6; public perceptions of,
10–11, 31–32, 61, 179, 206, 212–13, 224;
Romantic, 2, 5, 84–85, 91–92; in science
fiction, 1–2, 83–84, 149, 163–64, 171,
202, 221–22; secrecy in, 9, 32, 51–52,
226–29, 231–33; specialization in, 6,
8–9, 207–8; supernatural and, 60–61;
vision and, 52–53. *See also* natural
history; oceanology
science fiction, 147; as genre, 13–14, 21–22,
64–65; hoaxes as, 131; Hoffmann's
role in, 61–62, 73–74, 105; influence
of, 142–43, 205, 235; Poe's role in, 105;
portrayals of scientists in, 219, 231;
science in, 1–2, 12, 14–18, 83–84, 89,
97–98; science in Verne's, 141, 149,
163–64; Shelley's role in, 73–74; status
of, 12, 169; themes of, 26; Verne's role
in, 139–40; Villiers de L'Isle-Adam's
role in, 170; Wells's role in, 201–2
science fiction criticism, 21, 170, 203; call
for different approaches to, 18–19;
history of, 11–19; Hoffmann neglected
by, 28–29; interdisciplinarity and,
24–25; on *Tomorrow's Eve*, 170–71, 173.
See also literary criticism

Mesmerists, Monsters, & Machines

was designed and composed by Darryl ml Crosby

in 11/14.5 Minion Pro with display type in Bernhard Modern Bold;

printed on 50# House Natural stock

by Sheridan Books, Inc., of Ann Arbor Michigan;

and published by

THE KENT STATE UNIVERSITY PRESS

Kent, Ohio 44242